The handbook of art therapy

Caroline Case and Tessa Dalley

Tavistock/Routledge
London and New York

First published 1992
by Routledge
11 New Fetter Lane, London EC4P 4EE

Simultaneously published in the USA and Canada
by Routledge
a division of Routledge, Chapman and Hall, Inc.
29 West 35th Street, New York, NY 10001

© 1992 Caroline Case and Tessa Dalley

Typeset in 10/12pt Times Roman by
Leaper & Gard Ltd, Bristol, England
Printed and bound in Great Britain by
Biddles Ltd, Guildford and King's Lynn

British Library Cataloguing in Publication Data

available on request

Library of Congress Cataloging in Publication Data

available on request

ISBN 0-415-06989-0
 0-415-04381-6 (pbk)

The handbook of art therapy

Art therapy is now an established profession in its own right and its practitioners have to undergo a rigorous course of training. This handbook is designed to appeal to people thinking of becoming therapists and to all who need to know about art therapy in different settings. It concentrates on what art therapists actually do, where they practise, and how and why art and therapy can combine to aid a person's search for health and understanding of their underlying problems.

The authors, who are both experienced in teaching and practising art therapy, build up a picture for the reader of the development of the profession to its present status. Using first-hand accounts of the experience of art therapy from both therapists and patients, they cover such aspects as the influence of psycho-dynamic thinking, the role of the image in the art process, and the setting in which the art therapist works. They also focus on art therapists themselves, their practice, background and training. A select bibliography gives an excellent idea of the current literature on art therapy and related subjects, and there is a glossary of psychoanalytic terms.

Straightforward and firmly rooted in practice, *The Handbook of Art Therapy* will be invaluable not only as an introduction to the profession but also as a reference for students of art therapy both during and after their training.

Tessa Dalley works as an art therapist at a consultation and therapeutic centre for children and adults in London and as a tutor at Goldsmiths' College, University of London. **Caroline Case** lives, writes and works as an art therapist in private practice in Scotland.

Contents

Illustrations

Foreword

This book is entitled *Handbook of Art Therapy* to give a clear account of the theory and practice of art therapy. It is not designed to instruct a person to be an art therapist, and anyone reading this book will be advised against thinking that it is a 'manual' for practice. The purpose of the book, however, is to give clear guidelines and a detailed understanding of how art therapy is practised and the theory on which this practice is based. Hopefully, this will be useful for people interested in all aspects of art and therapy and perhaps encourage some people to embark on training courses essential for becoming an art therapist.

Throughout the book, both client and therapist will be referred to generally as 'she' except where a specific example is being described. This is because the majority of art therapists are women, and most clients who are in therapy are also women. Also, we have chosen to use the word 'client' to describe the person in treatment with the 'therapist' but this can be interchangeable with 'patient', 'resident', 'member' and does not imply any difference in the approach although it might reflect some difference in the treatment setting.

We would like to acknowledge our clients, who have so extensively informed our experience, and also the help of our colleagues, who have made several contributions throughout the book. By working with us and giving generously of their time in describing their particular experience, we feel that this has enabled the text to become 'alive' and relate to real circumstances, and has considerably enhanced the quality of the book. Also, our thanks go to our long-suffering families whose help and support are actually immeasurable.

Chapter 1

Introduction

DEFINITION

Art therapy involves the use of different art media through which a patient can express and work through the issues and concerns that have brought him or her into therapy. The therapist and client are in partnership in trying to understand the art process and product of the session. For many clients it is easier to relate to the therapist through the art object which, as a personal statement, provides a focus for discussion, analysis and self-evaluation. As it is concrete, it acts as a record of the therapeutic process that cannot be denied, erased or forgotten and offers possibilities for reflection in the future. The transference that develops within the relationship between therapist and client also extends to the art work, giving a valuable 'third dimension' or three-way communication.

As the practice of art therapy has become established within the firm base of psychotherapeutic principles, there is a current wish to call the profession 'Art Psychotherapy'. Some people feel that this term describes our work more accurately, but as this has not yet been officially agreed, and remains under debate within the professional association, we shall refer to the practice as 'art therapy' throughout the text. We are hoping to introduce the notion of a 'standard' practice of art therapy based on the training and experience of art therapists – that is, a qualified professional who meets the required basic standards of acceptable practice as outlined by the British Association of Art Therapists. As will be seen in the text, the approaches and orientations of art therapists vary enormously, particularly in relation to the client group with whom they are working, and it is not possible to cover detailed aspects of all of these. (For this detailed information, see Waller and Dryden 1991.)

THE HANDBOOK

This handbook is designed to introduce the reader to both the theory and practice of art therapy by initially describing different work settings to

enable some imagination of the situations in which art therapists work. By putting the nature of the work in context, the scene is set for the next four chapters which discuss both theoretical and practical aspects of art and therapy which are embodied in the work of the art therapist. The reader is enabled to build up a sense of the depth and breadth of art therapy and its roots from different disciplines before concentrating on the everyday tasks and training of the registered art therapist. The chapters are planned so that the reader will have gained some basic insight and theoretical understanding before finally focusing on the art therapist herself and her work with the individual and groups of clients.

Therefore, the chapter on the art therapy room is followed by two theoretical chapters. The 'therapy' in art therapy is explained in detail using case material, covering issues of process such as boundaries, contracts, suitability of clients – and once the relationship is underway, the importance of transference, counter-transference and the art object. The influence of psychodynamic thinking is the subject of Chapter 4, introducing the work of Freud, Klein, Winnicott, Milner and Jung – all highly influential in informing our practice. 'The image in art therapy' (Chapter 5) gives an in-depth explanation of the role and power of the image and art process, which is followed in Chapter 6 by some theoretical considerations of creativity, aesthetics and symbolism. The last three chapters focus on the art therapist, her practice, background and training. Her work with individual clients and groups is also described, giving detailed process of beginnings, on-going work and termination. Specific references are given after each chapter and the bibliography on page 238 will give the reader some idea of the current literature on art therapy and other related subjects. A general glossary of mainly psychoanalytic terms is given on page 242, and details of some art therapy educational establishments are given on page 256.

It will be noticeable that there is little reference to American literature as we felt that this book is purposely designed to describe the British practice of art therapy and the statutory services in which it is currently operating.

RECENT BRITISH LITERATURE

Throughout this book, we shall be addressing the process of art therapy and shall attempt to summarise the most important points. The theoretical approach of art therapists is shaped by how 'art' and its use in therapy is understood and the orientation of the therapist in coming to this understanding. This has been central to the on-going theoretical debates within the profession as a whole.

As the practice has developed, so has the theoretical basis on which it is founded. This is demonstrated by the increasing amount of literature available in the UK. *Art as Therapy* (Dalley 1984) was an introductory text on

the subject and begins to address the development of the debate that is on-going within the profession – that is, whether it is the art that is inherently important as a healing agent or whether it is the presence, interpretation and understanding of the therapist that facilitates the working through of feelings generated by the process of making images and the insight gained from its activity.

> In simple terms, art therapy is the use of art and other visual media in a therapeutic or treatment setting. But as this activity ranges from the child scribbling to express himself, to the mentally handicapped man working with clay to the graphic painting by a woman deeply depressed, it is clearly very complex. Can this be called art and if so how and why is it therapeutic?

> > (Dalley 1984: xii)

Art as Therapy sets out to answer this question, but this leads to many further questions which begin to be addressed in *Images of Art Therapy* (Dalley *et al.* 1987). This book develops some sound theoretical ideas with a close examination of both theory and practice of art therapy by experienced art therapists. Since then several new publications have been forthcoming – for example, *Pictures at an Exhibition* (Gilroy and Dalley 1989) looks very closely at the psychopathology of art and its relationship to psychoanalytic processes. It is compiled of several different chapters exploring the subject of art and literature with some case material. *Working with Children in Art Therapy* (Case and Dalley 1990) is a recent publication which looks specifically at work with children in different circumstances but with a mutual need for help, communication and understanding. *Art Therapy in Practice* (Liebmann 1990) describes the variety of art therapy practised with different client groups based in one geographical location.

Further literature explores particular aspects of art therapy indicating personal orientation of the authors. Liebmann (1986) describes her approach to working with groups; Thomson (1990) examines her understanding of the role between art and therapy; and Simon (1991) develops her own thoughts about the art therapy process and the role of the image in reflecting this. Two further books are both based on doctorate theses. The first will be useful in informing us of the history of our profession and an in-depth study of the roots of our current theoretical and practical understanding (Waller 1990); the second extends the theoretical understanding of the importance of transference and counter-transference as contained in the image in art therapy (Schaverien 1991).

These books enable a theoretical examination of particular aspects of the art therapy process and also extend our understanding of practice through presentation of detailed case material which, in turn, contributes to the growth and solidity of our profession.

HISTORICAL ASPECTS

Although there were tentative beginnings of the profession of art therapy in the 1950s and the first post was established in the NHS in 1946, it was not until 1981 that the profession was officially recognised in the Health Service. Since then, art therapy has become more widely recognised and is now developing into social services, education and other independent agencies such as the hospice movement and voluntary organisations.

Many writers have explored different relationships between art and psychoanalysis and how the practice of art therapy has evolved to incorporate both. Edwards (1989) traces differing models of art therapy and attitudes towards art and psychoanalysis back to their origins some 200 years ago. By describing attitudes towards art and madness in the eighteenth and nineteenth centuries, Edwards demonstrates how ideas from other areas of enquiry, such as the use of art in rituals, religious customs and anthropology, form a 'more elaborate and enduring context' for art therapy that was in existence well in advance of its establishment as a discrete profession. Art history and the history of psychiatry have given rise to certain models of art therapy practice and Edwards postulates that the roots of codified, diagnostic attitude towards imagery are in the eighteenth-century neoclassicism, and in their 'rational' belief that a person's state of mind could be read from a picture. The depiction of feeling in art was formalised and enabled the painter and his audience to remain uninvolved. By contrast, the nineteenth-century romantics embraced a positive conception of the imagination and valued the artistic representation of inner experience. This attitude related to a belief in the natural healing capabilities of art.

It is true to say that in the development of the profession in the early years of pioneer work in art therapy, most art therapists emphasised the process of art and its inherent healing properties as central to art therapy practice. Influenced by such innovators as Herbert Read (1942) and Adrian Hill (1941), the two strands of art therapy developed in parallel – one in an educational setting and developed out of enlightened art teaching; the other from medical roots where art was used to help soldiers traumatised by their experiences of war (Waller 1984).

Such statements as 'art should be the basis of education' (Read 1942: 1) and 'Art, however, we may define it, is present in everything we make to please our senses' (Read 1942: 15) and the consideration of expression, imagination, spontaneity in art greatly influenced the direction of art teaching at that time. It also had the effect of highlighting the central nature of art in terms of its possibilities as communication and its inherent potential for therapeutic work. The influence of early analytic writing such as that of Jung gave support to the idea that art was an important means of both unconscious and conscious communication. Jung's work will be considered in more depth in later chapters, but during his own self-analysis,

Jung had drawn his own dreams and fantasies and encouraged his patients to do likewise. 'What a doctor then does is less a question of treatment than that of developing the creative possibilities latent in the patient himself' (Jung 1983: 41).

It was Jung's technique of active imagination – encouraging the kind of phantasy that came to his patients when they were neither asleep nor awake at a particular time when judgement was suspended but consciousness not lost – that closely parallels that of the creative process and the inspiration of artists and inventors. By mobilising the patient's creativity, the gap between conscious and unconscious can be bridged.

More recently, however, there has been a movement in the practice of art therapy to enquire why bridging this gap is so effective and to discover how the process works. This has led us to look further into psychoanalytic theory and a fundamental understanding of how the art process can be understood in terms of complex psychoanalytic processes. Consequently, some art therapists follow certain models of psychoanalytic practice according to their belief in the genesis of creativity. The orientation of art therapists might be informed by the ideas of Freud, Klein or Jung or, more recently, the Post-Freudians or such eminent writers as Donald Winnicott, Marion Milner and so on (Nowell Hall 1987, Weir 1987).

DIFFERENT CLIENT GROUPS AND WORK SETTINGS

Thus the practice of art therapy, although based on the process of art within a therapeutic relationship, is complex and wide-ranging in its implementation. The orientation of the art therapist will depend greatly on the client group with whom she is working. The idea that patients referred to art therapy must be able to draw or be 'good at art' must be quickly dispelled, as indeed some art therapists work with clients who are at such a stage of development that they cannot draw and do not have the coordinating capacity to hold a crayon or brush. For these children, or adults, emphasis is placed on activities using water, sand or other materials that can enhance the physical and mental coordination and also provide an essential avenue for communication in the presence of a skilled and sensitive therapist (Rabiger 1990).

Art therapy offers the possibility of working with many different client groups. This is one of its main advantages as a treatment process in that it can be made accessible to a wide variety of people with different needs and expectations. It is in the nature of image-making that most people are capable of making marks and therefore can use art therapy in some way. Those who cannot yet hold pencils may develop the coordination or capacity to draw, and for those who might be resistant to the activity or refuse to participate in the actual process of image-making, there is always

the possibility of using the space for play, for movement, for contemplation and self-reflection around the process itself.

It is moments of not-doing that are equally important in art therapy sessions. These are equivalent to the silences within verbal analytic sessions – they are all important aspects of the time spent with the therapist and open to interpretation and understanding. Indeed, it is unlikely that a client will spend every moment of the session involved with making art – if that was the case, the question might be asked as to why no space has been made for other kinds of communication within the time.

Art therapists work with many kinds of clients both individually and in groups. In a *Survey of Conditions of Service of Registered Art Therapists* carried out by the British Association of Art Therapists (1990), the distribution of employment reflected the main areas of work for the 64.4 per cent of the membership who replied to the questionnaire.

National Health Service	54 per cent
Social Services	15 per cent
Education	7 per cent
Adult/Higher Education	5 per cent
Home Office	2.5 per cent
Non-Statutory Services	7 per cent
Self-Employed	2.5 per cent

Six per cent had more than one employer; two-thirds who replied were in full-time employment; the other third worked part time.

Art therapists work in hospitals, schools, special schools, clinics or day centres which tend to be located in the three main caring agencies of health, education and social services. The treatment setting will obviously depend on the philosophy and ethos of the working environment and the art therapist will work alongside her colleagues accordingly. Art therapists are usually working under the auspices of some institution, but some are now working privately taking referrals from GPs, social workers and other agencies that are in touch with people in need of this kind of resource.

Clients in art therapy might include patients admitted to hospital for psychiatric treatment (Killick 1987, Wood 1990a), adults and children who have a mental handicap (Stott and Males 1984), children in clinics (Wood 1984), special schools (Robinson 1984), adolescent units (Murphy 1984), prisoners both in prison and on probation (Laing 1984) and people who generally feel unhappy or are in distress. Before looking at each of these areas of work in more depth, it is worth considering how the practice of art therapy is placed within these various institutions and how the art therapist generally relates to other professional colleagues.

The orientation of the art therapist will then depend on the client group and also the nature of the department and the professional team around

which he or she is working. In the Health Service, for example, art therapy departments are generally autonomous and function on their own independently from the other therapy services, but obviously working in close liaison with other hospital departments. Art therapists are clinically responsible to the consultant of the patient who is referred and therefore have a responsibility to attend ward rounds and case conferences to be fully in touch with the patient's complete treatment programme. Art therapy will be only one aspect of the patient's treatment within a psychiatric hospital and therefore will have to work alongside medication programmes and other kinds of therapeutic input. As an outpatient, however, it might be that the art therapist continues to work with the patient after discharge to maintain continuity of care, support and therapeutic process. If this is the case, art therapy might be the only service that the patient is receiving (Wood 1990a).

Art therapists working in social services, education (Arguile 1990, Dalley 1990) and other establishments such as day centres and assessment centres (Case 1990) will probably be working closely with a multi-disciplinary team in which art therapy is one of the many activities in which the clients may participate. Here close liaison with fellow workers is essential for maintenance of the objectives of the various treatment centres. Child and family clinics, for example, in which the child might be seen individually and the family seen together, require close professional liaison and communication between the different therapists working together (Greenway 1989, Deco 1990, Donnelly 1989).

Whatever the working situation of the art therapist, the therapeutic relationship remains of paramount importance. The contract between therapist and client must be clearly worked out to the mutual satisfaction of both. The limits and boundaries of the session is part of this contract. It involves the time (the beginning and end) of the session; the space where the session will take place; and determines whether the contract will have a time limit of so many weeks or will be open-ended and left open to negotiation. This creates the frame of the session within which the therapeutic relationship develops and without which it cannot. This is absolutely essential to good therapeutic practice.

More and more art therapy practice is developing to make sure boundaries are maintained which enable issues such as lateness, non-attendance and breaking of other boundaries initially laid down, as material to be worked with. This allows the client to clarify the reasons for his or her behaviour rather than being harshly modified with no underlying understanding. The boundaries also make room for the image to emerge in safety, confidentiality and trust that this environment promotes. Without clear messages and consistency from the therapist, it will be very difficult for the client to develop enough trust and feeling of safety for deep feelings and real issues to emerge (Schaverien 1989).

The maintenance of boundaries and limits to the art therapy session can then allow the development of transference to occur, which is explained in depth in Chapter 3. Consideration of transference in the practice of art therapy is important and indicates how it is deeply rooted in psychoanalytic origins. The presence of the third object – the art object made within the session – is equally important and it is this that makes art therapy a distinct practice from other verbal psychotherapies.

We are now going to look at the different client groups with which the art therapist works and at the way that her practice adapts accordingly.

Children and adolescents

Children with many different types of needs and disorders can benefit greatly from working with an art therapist. In general, children often have difficulty in expressing their feelings verbally. The process of art provides the child with a less problematic, more spontaneous means of communication. One of the most important aspects of the work in art therapy is that the use of art materials offers the children a non-verbal way of working through many of the difficulties that they are struggling to convey. These are frequently expressed in a way which is seen to be inappropriate, or bad behaviour. Emotional and behavioural problems are usually linked together and both aspects of the child's experience must be worked with. The children can choose to use a wide variety of media. The art work can be used as a means of safe expression for strong feelings and emotions which can then be made conscious and understood. With the presence of the therapist who is seen to be a consistent, caring figure, the child can begin to unravel the present and past difficulties that have remained pent up until then. This includes issues around early infantile experience which will involve transference relationships developing within the therapeutic process (Wood 1984, Dalley 1990, *Inscape* 1986).

Mentally handicapped children

These children, with varying degrees of difficulty, can use the process of art therapy differently. The approach would be one of using the art materials, sand, clay, water for experimentation, play, physical coordination. The therapist must be able to facilitate, but must refrain from doing anything for the child, who is struggling to achieve what she wants to do. The therapist, therefore, needs to be able to be receptive to and contain the feelings of frustration and anxiety that will be generated by the challenge of the process of using the art materials. The severely handicapped child might remain at the stage of moving water from place to place and splashing and discovering that it is possible to pour the water into a container which prevents it spilling. These simple tasks are part of their own exploration

and stimulation but also act as a form of containment and must be attended to by the therapist. With more able children, the use of painting and imagery can be used to explore problems in detail. Attention must be paid to their emotional communications and troubled behaviour which might be an indication of distress, frustration and unhappiness. It is sometimes the case that behaviour modification using punishment and reward systems are used for these children. Art therapy does not rest very easily alongside this approach but can be used by the children as an outlet for their feelings and strong emotions that are currently being expressed in behavioural or even anti-social ways (see Rabiger 1990).

Emotional and behavioural disturbance

Children who are showing signs of emotional and behavioural disturbance are often referred for help to clinics, special schools, psychologists and GPs. The distress of these children manifests itself in many different ways but it is usually noticeably disturbed or withdrawn behaviour, obsessive or compulsive activities, ritualistic and phobic reactions to situations and so on. As few children can articulate clearly their feelings and underlying difficulties, the medium of art offers them an opportunity to explore these non-verbally in a non-threatening environment. Children can feel very guilty about telling other people their problems, particularly if those problems involve their parents, teachers or other concerned people. The art therapist can provide a safe space which is contained and consistent for the child to begin to unravel the difficulties and feelings that she is experiencing (Sagar 1990, Lillitos 1990, Vasarhelyi 1990).

The emphasis on the unconscious communications of the child – the feelings, anxieties and concerns that surface through the painting – are worked through in the relationship between child and therapist. Children in art therapy place great value on their work produced in the sessions as they symbolise in a concrete way their inner experience, and great care must be taken to ensure the safe-keeping of the objects. This will add to the feeling of safety and trust established by clear boundaries and continuity of the sessions over time.

Autism

This is a particularly complex area of work in which the child is experienced by the world as withdrawn, ritualistic and internally preoccupied as though there is a glass wall between her and the people attempting to communicate. The need of the autistic child for routine is paramount as change of any sort is excessively threatening and engenders a great deal of anxiety. Indeed, anything that is perceived as causing disturbance or intrusion in the world of the autistic child can cause tantrums, screaming, biting

or any such extreme or aggressive behaviour. Autistic children often are compelled by ritual and obsession for fear of change. In art therapy, the images they make sometimes reflect this as they tend to be exactly the same. They have the same process of making them and even end with the same rituals and signals. They may even resort to the same playing rituals such as sitting in the same place or throwing dice in exactly the same way. This has the effect of blocking out the outside world.

Much work has been done in understanding the causes and origins of such acutely distressing conditions for both child and parents alike (Tustin 1981). Art therapists have long been involved with working with children and indeed adults who are in this psychic state.

Autistic tendencies can also be found in many young people and adults and art therapists work with them wherever they are resident. Some of them live in special schools, units or hospitals for mentally handicapped people. Again the same features are predominant in their need for routine and difficulty with change. An interesting example of this phenomenon in image-making is of a 20-year-old man who, each week, would begin with the same colour in the same place on the paper. He would make a frame around the edge of the paper, then draw lines in a grid-like pattern which he would then fill in with the different colours available to him. This process would finish with a blob of white paint in the corner of the paper nearest the therapist. He would then ask for another piece of paper in order to repeat this process. The therapist found herself colluding with this routine in that she would always take away his painting and provide him with another piece of paper. She considered she was responding to the intense underlying anxiety that would be felt if the routine of the session was not followed, but this had the effect of blocking her out completely. To him, it was as if she was not there. At an appropriate moment, once the pattern of the session was well established, there was a chance to introduce another medium of crayons which she suggested carefully to him. He began scribbling frantically, and as he worked on many pieces of paper he was becoming more and more anxious. The therapist felt that was getting intolerable for both client and her. His defences had been let down showing a vulnerable, undefended ego which was extremely fragile and uncontained. The therapist felt that this was potentially harmful and so suggested that he would like to use the paint again. Interestingly, he began to use the paint but the process of the painting was in reverse – that is, he began with the white blob near the therapist and finished with the grid pattern and the frame as if he were putting back his defences again. It was a most fascinating process which the therapist was both surprised and pleased about, in that he was able to gather himself back together as the therapist had felt exposed to an inner chaotic state (Plowman 1988).

Another interesting feature about the drawings of autistic children is that there are some who show exceptional technical drawing ability. There are

well-known examples, such as Nadia (Selfe 1977), who have shown skill in drawing well beyond their chronological age. The reasons for this seem to remain unknown and are explored by McGregor (1990). Art therapists will occasionally come across this phenomenon in their practice.

Adolescents

The nature of adolescence and the particular difficulties that adolescents face means that they are usually treated in separate adolescent units. The transient state between childhood and adulthood sets up many dilemmas for the art therapist. Often the unhappiness, vulnerability and distress is expressed in extreme forms of behaviour such as acting out, violent mood swings and other complications such as eating disorders and drug abuse. Feelings are intensely felt and expressed but often difficult to contain. This necessitates the adherence of very strong boundaries and close understanding of the complexity of the problems. Art therapists will often be faced with extreme reluctance to participate in image-making as the commitment to put feelings to paper can be felt to be too risky. Examples of case work with this client group will enlighten the reader further and illuminate the precise difficulties and challenges of working in this field (Murphy 1984; *Arts in Psychotherapy*, 1990, Vol. 17, No. 2).

Education

Another important area of work for art therapists is in the field of education. Traditionally there has been more scope for art therapists working in special schools or residential establishments for maladjusted children, but this domain has really remained more reserved for the specially trained teacher. The notion of therapy does not lie easily within institutions of learning in spite of the recognition that learning ability and emotional disturbance have so often been linked. In the schools that operate more on therapeutic lines (Robinson 1984) art therapy can contribute a great deal to their programmes. However, in the field of mainstream education, the swelling tide of change heralded by the Warnock Report, and the 1981 Education Act in the integration of children with special needs into mainstream schools, seems to be encountering a turn around with the Baker proposals and introduction of the National Curriculum and regular testing connected to achievement. There was an opening in the possibility of therapeutic work in schools, with the recognition that the need for working with some of the more difficult children with this approach was indeed helping their performance in the classroom. The implementation of this philosophy seems now to be disappearing in spite of some conclusive evidence of the importance of therapy or counselling in the school in helping children to be able to function at a level compatible with their age

and development (Dalley 1987, Nicol 1987, Arguile 1990). However, there is still a move among some educationalists that this approach will need to be implemented in some formalised way to prevent the widespread and growing problems that face both teachers and pupils.

Adults

Art therapists working with adult clients are generally working in the treatment settings of psychiatry (Killick 1987), mental handicap (Stott and Males 1984) and other special clinics such as regional secure units (Laing 1984), alcoholic units (Luzzatto 1989), terminally ill patients (Miller 1984), treatment centres for AIDS (Wood 1990b) and more generalised therapeutic communities which cater for people with specific kinds of difficulties. Within these the client groups vary widely and their range of needs and concerns differ accordingly. For example, in a traditional psychiatric hospital, the Victorian institutions were once used as asylums. Since the Mental Health Acts in 1959 and subsequent legislation, and the introduction of the revolutionary psychotropic drugs, their function as institutions has been gradually eroded as more and more patients are being moved into the community. So the development of the role of the art therapist within this type of institution, although hierarchically and medically confined, is now facing changes which create great challenges. The art therapist must be flexible and accept the changes and movement of the patient population and adjust her service to them accordingly. Art therapists are increasingly being required to provide outpatient and community service, which means a more peripatetic role making the art room less of a sanctuary and more a place for resolution and acceptance of dynamic change. Particularly for people who, perhaps, have lived within an institution for most of their lives, this presents a tremendous challenge and a necessary safe space in which to enable this change to take place.

Within a psychiatric hospital there are a large number of different patients with whom the art therapist will be working. These range from the acute admissions, which are largely concerned with severe depressive or manic states, to people suffering from psychotic states, dementia, self-neglect or suicide attempts that precipitate admission. If the art therapist is consigned to an acute admission ward, she must regularly attend the handovers and ward rounds as part of the team that deals with brief admission work due to the short stay and rapid turnover of patients. A lot of the work will be concentrated on stabilising the condition that brought the patients to the unit in the first place, but also some attempt to orientate the patients and allow them to begin to work on some of the fundamental issues surrounding their situation and thus their admission. Patients are often shocked and disorientated when first admitted because they have been removed from their familiar surroundings and home, relatives and immedi-

ate family. A careful balance needs to be maintained between working with the patient herself and also including work with the family and the people most closely connected to her. Art therapists might choose to work with the families, but usually the patient is included in art therapy as part of the ward programme. The referral to art therapy can be to a group or nego-tiated on an individual basis. The difficulty is knowing how long they will stay and at what level to work, but the art therapist has a prime function in being able to feed back to the rest of the ward team her impressions of the patient and contribute to the decision about treatment programmes during the stay in hospital and after discharge. By enabling them to express their feelings and immediate concerns, art therapy can offer these patients an opportunity to begin to understand their difficulties and situation and, perhaps, open up possibilities for longer term solutions. The images offer a safe space for this exploration and strong expression of feelings and inner turmoil can be contained in the activity of painting. There are many well-documented case studies that illustrate this type of work and often the images produced provide interesting sequences, illustrating quite graphi-cally the process through which patients are able to express their difficulties (Dalley 1981, Dalley 1980). Severe mood swings, from depression to elation, often prompt very different use of materials and the patient uses them for direct expression of experience. Wadeson (1971) describes this process in great detail, pointing to the use of art media for this purpose.

Art therapists working with the more long-stay patients who have been resident in the hospital for a number of years will take a different approach to their work (Charlton 1984). The condition of these people may have become more chronic in that they have adapted to being hospitalised over a period of time and have become what is commonly termed institutional-ised. Even though the psychiatric condition might now be stabilised by medication, as is sometimes the case with schizophrenic patients, they have now become people with different sorts of problems in terms of their socia-bility, ability to cope in the community and not rely on the hospital for the basic needs such as food and shelter. The work in art therapy must help the patients address these issues with a view to enabling them to move out of the hospital wherever possible. This involves working on areas of indepen-dence, fears of isolation and loneliness, making and maintaining social contacts and living outside in the community and facing the demands of the real world. Patients might spend many hours working at paintings and other media as a way of building up their own sense of self-esteem and identity. Hopefully the art therapist will be running groups which will focus on these issues which can be shared by people facing the same situation of eventual life in the community.

Art therapists working in hospitals for mentally handicapped people are working with similar issues in terms of long-term involvement. Residents in

these hospitals have often been there for a long time and regard it as their home. Many have no relatives who keep regular contact and so their main social and emotional life is invested in the hospital itself. Leaving, therefore, often becomes quite problematic for those who are considered able to sustain a life outside, and for the younger residents, programmes for rehabilitation are intensive and involve much basic learning of skills. Art therapists can contribute to this programme by again working on the issues most important for the people working towards leaving.

There are some for whom it would be inappropriate to leave the hospital – those with acutely difficult problems and whose level of handicap prevents them from being able to move towards sufficiently integrated functioning. For many of these people, art therapy provides an opportunity for their creative, expressive stimulation and occupation and can be most therapeutic in helping them with physical and mental coordination and also improve their abilities to relate to other people – either with the therapist on an individual basis or within a group. Negotiation and understanding of the needs of other members of the group can be very useful for people working together, particularly when there is so much shared living experience. The material nature of the work can encourage exchange of ideas, opinions, even generate conflict that can be looked at, worked through and understood within a group. Social understanding is an aspect of life which can be enhanced by working with art materials, and understanding interpersonal relationship is not an area that is given a high priority in the general ward life of many of these residents (Stott and Males 1984).

Working in the community

There are many art therapists who might encounter clients with the same difficulties when working in the community. Many of the people once in specialised units have been discharged to the community and are looking for a supportive network for their rehabilitation, integration and maintenance into society. Social services day centres often provide this kind of service for people whose difficulties and vulnerabilities prevent them from obtaining employment or who need help on an on-going basis without needing to be hospitalised. Art therapists work in this environment where art therapy is integrated into the programme of activities and can be introduced as closed group, individual work or some kind of activity that is chosen voluntarily by the clients outside any contractual arrangement. This is sometimes termed an 'open group'. Often clients can find some sense of self-discovery and satisfaction by experimenting with the art materials on their own, such as different sorts of paint, clay, plaster and other techniques such as silk screen, batik, printing, wood-carving, framing and so on. These activities can be seen to be more designed around skill acquisition which can help build self-confidence and can run alongside the more

intensive, enquiring therapeutic approach of an intensive art therapy session.

This can also extend further into work in the community where art therapists might visit community centres to run groups, workshops, painting sessions or run sessions in an outpatient clinic for continuity of care for clients who had previously been hospitalised. Work in the community is increasingly important, particularly with the closure of the large hospitals and institutions. Also, other services that exist in the community, such as unemployment day centres and assessment centres, need to provide good services for their clients. The main question is whether the services can be sufficiently organised to provide a comprehensive service for those people who will continue to need care and help and therapy. Art therapists have been known to visit clients in their homes, particularly where it is difficult for the clients to get out for mobility or psychological reasons. This can be a successful arrangement but it is obviously important for the therapist to feel the sense of being in the client's home and whether this is experienced as intrusive (Wood 1990a).

In the future, potential for community work will become more and more important as more patients are discharged. There are some community art therapy posts already established which involve the art therapist holding sessions in different treatment centres within the community. This, however, is different to the various schemes of community arts that are being established such as SHAPE. They can link into the work of art therapists but these are really designed more for activity-based, creativity programmes and to some degree to enhance the environment of the community generally.

Some art therapists are employed in the prison service, borstals and other penal establishments where the custodial nature of prisoners necessarily means that the aims of the therapist must be rather different. Work centres on insight and understanding of their situation, toleration of the institution in which they are confined and, to a large extent, the art process itself can provide release of pent-up feeling and frustration which builds up over time in these establishments. Expression of feeling is contained within the department and the imagery through which prisoners can begin to develop some sense of self-identity, and self-worth. The special unit at Barlinnie is a notable example of how creativity can be used to channel violent and angry feelings, but also become important in tapping the creative aspects of these people. The work of Joyce Laing and others gives some indication as to the uses of art therapy in these situations (Laing 1984, Laing and Carrell 1982, Cronin 1990).

The onset of old age and illness is another area to which art therapists can contribute in the various day centres for old people and psychogeriatrics. Often this work centres around the past and the significant events that have happened. Memories are usually connected to events a

long time ago as short-term memory often becomes impaired more quickly. The acceptance of old age and possible infirmity is one part of this work and the other is acknowledgement of the sense of loneliness, isolation and the fear of death that faces this particular age group. The issue of death is important in the work of art therapists who are working in the hospice movement either with adults or children (Wood 1990b).

Art and images have historically been the forum for the expression of much feeling around the issue of death and dying – even in its most cynical forms there has been a need for artists to explore these important issues, albeit obliquely. Similarly, through images made in art therapy, death and dying, bereavement and loss can be clearly communicated and worked through (Miller 1984, Case 1987).

There are many different working situations for art therapists who, like most professionals, tend to gravitate towards areas of personal and particular interest. The reader can be further informed by reading some of the literature that covers these specific areas in more depth.

Having given a broad introduction as to where art therapists might be working, we shall now look in close detail at their specific workplace – the art therapy room.

REFERENCES

Arguile, R. (1990) '"I Show You"; Children in Art Therapy', in Case, C. and Dalley, T. (eds) *Working with Children in Art Therapy*. London, Tavistock/ Routledge.

British Association of Art Therapists (1990) *Survey of Conditions of Employment*.

Case, C. (1987) 'A Search for Meaning: Loss and Transition in Art Therapy with Children', in Dalley, T. *et al., Images of Art Therapy*. London, Tavistock.

Case, C. (1990) 'Reflections and Shadows: an Exploration of the World of the Rejected Girl', in Case, C. and Dalley, T. (eds) *Working with Children in Art Therapy*. London, Tavistock/Routledge.

Creative Therapies with Adolescents: Arts in Psychotherapy (1990), Vol. 17, No. 2.

Charlton, S. (1984) 'Art Therapy with Long-Stay Residents of Psychiatric Hospitals', in Dalley, T. (ed.) *Art as Therapy*, London, Tavistock.

Cronin, P. (1990) 'A House of Mess', unpublished Thesis. London, Goldsmiths College.

Dalley, T. (1980) 'Art Therapy in Psychiatric Treatment: an Illustrated Case Study', *Art Psychotherapy* 6 (4), pp. 257–65.

Dalley, T. (1981) 'Assessing the Therapeutic Effects of Art: an Illustrated Case Study', *Art Psychotherapy* 7 (1), pp. 11–17.

Dalley, T. (ed.) (1984) *Art as Therapy. An introduction to the use of art as a therapeutic technique*. London, Tavistock.

Dalley, T. *et al.* (1987) *Images of Art Therapy*. London, Tavistock.

Dalley, T. (1990) 'Images and Integration: Art Therapy in a Multi-cultural School', in Case, C. and Dalley, T. (eds) *Working with Children in Art Therapy*. London, Tavistock/Routledge.

Deco, S. (1990) 'A Family Centre: a Structural Family Therapy Approach', in Case,

C. and Dalley, T. (eds) *Working with Children in Art Therapy*. London, Tavistock/Routledge.

Donnelly, M. (1989) 'Some Aspects of Art Therapy and Family Therapy', in Gilroy, A. and Dalley, T. (eds) *Pictures at an Exhibition*. London, Tavistock/Routledge.

Edwards, M. (1989) 'Art, Therapy and Romanticism', in Gilroy, A. and Dalley, T. (eds) *Pictures at an Exhibition*. London, Tavistock/Routledge.

Gilroy, A. and Dalley, T. (eds) (1989) *Pictures at an Exhibition*. London, Tavistock/Routledge.

Greenway, M. (1989) 'Art Therapy in Search of a Lost Twin', in Gilroy, A. and Dalley, T. (eds) *Pictures at an Exhibition*. London, Tavistock/Routledge.

Hill, A. (1941) *Art versus Illness*. London, Allen and Unwin.

Inscape, Vol. 11, Winter 1986.

Jung, C.G. (1983) *The Psychology of the Transference* (Collected works, Vol. 16). Ark.

Killick, K. (1987) 'Art Therapy and Schizophrenia: A New Approach', unpublished MA Thesis, Herts College of Art and Design.

Laing, J. (1984) 'Art Therapy in Prisons', in Dalley, T. (ed.) *Art as Therapy*. London, Tavistock.

Laing, J. and Carrell, C. (1982) *The Special Unit, Barlinnie Prison: Its Evolution through its Art*. Glasgow, Third Eye Centre.

Liebmann, M. (1986) *Art Therapy for Groups: a Handbook of Themes, Games and Exercises*. London, Croom Helm.

Liebmann, M. (ed.) (1990) *Art Therapy in Practice*. London, Jessica Kingsley.

Lillitos, A. (1990) 'Control, Uncontrol, Order and Chaos: Working with Children with Intestinal Motility Problems', in Case, C. and Dalley, T. (eds) *Working with Children in Art Therapy*. London, Tavistock/Routledge.

Luzzatto, P. (1989) 'Drinking Problems and Short-term Art Therapy: Working with Images of Withdrawal and Clinging', in Gilroy, A. and Dalley, T. (eds) *Pictures at an Exhibition*. London, Tavistock/Routledge.

McGregor, I. (1990) 'Unusual Drawing Development in Children: What Does it Reveal about Children's Art?', in Case, C. and Dalley, T. (eds) *Working with Children in Art Therapy*. London, Tavistock/Routledge.

Miller, B. (1984) 'Art Therapy with the Elderly and the Terminally Ill', in Dalley, T. (ed.) *Art as Therapy*. London, Tavistock.

Murphy, J. (1984) 'The Use of Art Therapy in the Treatment of Anorexia Nervosa', in Dalley, T. (ed.) *Art as Therapy*. London, Tavistock.

Nicol, A.R. (1987) 'Psychotherapy and the School: an update', *Journal of Child Psychology and Psychiatry* **28** (5), pp. 657–65.

Nowell Hall, P. (1987) 'Art Therapy: A Way of Healing the Split', in Dalley, T. *et al.*, *Images of Art Therapy*. London, Tavistock.

Plowman, K. (1988) 'A Case Study of P: An Autistic Young Man', unpublished Thesis, Herts College of Art and Design.

Rabiger, S. (1990) 'Art Therapy as a Container', in Case, C. and Dalley, T. (eds) *Working with Children in Art Therapy*. London, Tavistock/Routledge.

Read, H. (1942) *Education through Art*. London, Faber and Faber.

Robinson, M. (1984) 'A Jungian Approach to Art Therapy based in a Residential Setting', in Dalley, T. (ed.) *Art as Therapy*. London, Tavistock.

Sagar, C. (1990) 'Working with Cases of Child Sex Abuse', in Case, C. and Dalley, T. (eds) *Working with Children in Art Therapy*. London, Tavistock/Routledge.

Schaverien, J. (1989) 'The Picture within the Frame', in Gilroy, A. and Dalley, T. (eds) *Pictures at an Exhibition*. London, Tavistock/Routledge.

Schaverien, J. (1991) 'The Revealing Image', in *Analytical Art Psychotherapy* (in press).

Selfe, L. (1977) *Nadia, a Case of Extraordinary Drawing Ability in an Autistic Child.* London, Academic Press.

Simon, R. (1991) (in press).

Stott, J. and Males, B. (1984) 'Art Therapy for People who are Mentally Handicapped', in Dalley, T. (ed.) *Art as Therapy.* London, Tavistock.

Tustin, F. (1981) *Autistic States in Children.* London, Routledge and Kegan Paul.

Thomson, M. (1990) *On Art and Therapy, an exploration,* London, Virago.

Vasarhelyi, V. (1990) 'The Cat, the Fish, the Man and the Bird: or How to be a Nothing. Illness Behaviour in Children; the Case Study of a 10 year old Girl', in Case, C. and Dalley, T. (eds) *Working with Children in Art Therapy.* London, Tavistock/Routledge.

Wadeson, H. (1971) 'Characteristics of Art Expression in Depression', *Journal of Nervous and Mental Disease* **153** (3), pp. 197–204.

Waller, D. (1984) 'A Consideration of the Similarities and Differences between Art Teaching and Art Therapy', in Dalley, T. (ed.) *Art as Therapy.* London, Tavistock.

Waller, D. (1991) *Becoming a Profession. History of Art Therapy.* London, Routledge.

Waller, D. and Dryden, W. (1991) *Handbook of Art Therapy in Britain.* Open University Press.

Weir, F. (1987) 'The Role of Symbolic Expression in its Relation to Art Therapy: a Kleinian Approach', in Dalley, T. *et al., Images of Art Therapy.* London, Tavistock.

Wood, C. (1990a) 'The Beginnings and Endings of Art Therapy Relationships', *Inscape* (Autumn).

Wood, M. (1984) 'The Child and Art Therapy', in Dalley, T. (ed.) *Art as Therapy.* London, Tavistock.

Wood, M. (1990b) 'Art Therapy in One Session: Working with People with AIDS', *Inscape* (Autumn).

Chapter 2

The art therapy room

THE CREATIVE ARENA OR 'POTENTIAL SPACE'

The art therapy room or department is the space in which the relationship between therapist and client develops. The notion of the art therapy room, art therapist and client immediately introduces a concept of a triangular relationship, with art forming a vital third component in the therapeutic relationship developed between two people. In itself this seems quite straightforward concerning practical issues but the way the space is set up and organised is important to enable the relationship to take place.

In this chapter we are going to illustrate this by placing the reader in various different settings where art therapy takes place. By using the descriptions of art therapists, it is clear how and why their rooms and working spaces have developed in a particular way. Here are three vignettes of clients using the art therapy room in an adolescent unit in a psychiatric hospital.

> Nusrat is upset. She can't face anybody. She doesn't want to be in this stupid place. I offer her my area, a desk built into a corner, shielded by side walls and a low ceiling. It is densely packed with ephemera and memorabilia; mostly images of faces. Around the edge are pinned fifty-two different playing card Jokers. She begins to draw 'the shadow of my father'.

> Sarah brings a bundle of magazines, her own felt tips, her own sketch pad. She covers the desk with pages from the magazines, being careful not to touch the table with her hands. She places the sketch pad on the covered surface and begins to draw. She bends at the waist, thighs well clear of the table and holds the pen at its top, between thumb and fore-finger. When she finishes she picks up the magazine pages using her hands like a crane's mechanical grab and drops the sheets into a wastebin. She leaves by opening the door with her foot. For weeks only her shoes touched the room.

> Nigel comes back to see us every six months or so. He comes into the

room and looks up at the ceiling where his fibre glass face (cast from life) looks back down on him. He was admitted to the unit after a suicide attempt following the death of his friend, who fell through a factory roof where they were both trespassing. Nigel left us to take up a YTS in Roofing.

(Letter to the authors from Patrick Goodall (1990)
Hollymoor Adolescent Unit, Birmingham)

Each person entering an art therapy room uses the room individually and forms a unique relationship with the therapist. Although the same space will be experienced differently by each client it will have the same role in each relationship, being not only a practical space containing client, therapist and art materials but also a symbolic space.

All therapy needs to be contained within a framework of boundaries. It takes place at a particular time each week, and for the same length of time each session. The client, who may have experienced great lack of constancy of relationships, finds that this space in the week is kept for her regularly; it is her session. The therapist is a constant person for the client in that space. The art therapy room offers as near as is possible the same choice of possibilities from the same range of materials and work spaces in the room.

Entering the room, one enters a particular framework of safety, through the boundaries that are protecting this space for the client's use. Within this framework, there is the potential to explore preoccupations, worries, problems and disturbances through using the art materials and the relationship with the art therapist.

Whatever happens here is split off from everyday existence and is observed, rather than acted upon. This is crucial because, without this space set apart, there is the inclination to behave and respond spontaneously, as we do in our social relationships. Here the frame provides a setting where the therapist can maintain a certain objectivity, a therapeutic distance. This allows the client to make a split which enables her both to regress and also to function as an observer of her own behaviours.

(Schaverien 1989: 149)

Later we shall see how the picture or art object made provides a further framework for the client containing representations of experience and symbolising aspects of inner life. For the moment let us look at this description of the 'creative arena' which is set in St Mary's School for children with various special needs. Roger Arguile is the art therapist, and also practises as an artist (Arguile 1990).

Nearly all of my work is one-to-one therapy. The main art therapy room is approximately 20×20 feet. It is divided in half by a 6 foot high partition with a gap at one end enabling easy access between the two halves. (See Figure 2.1.)

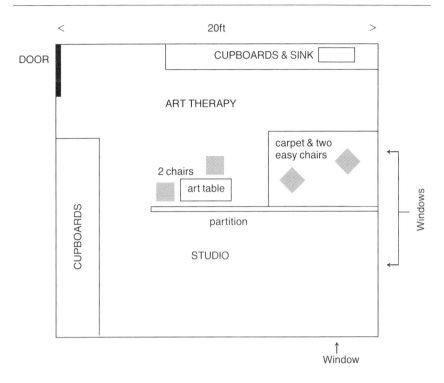

Figure 2.1 The art therapy room, St Mary's School for Children with Special Needs, Bexhill-on-Sea

One half is my studio space. I paint and write. In addition to on-going art work I have a desk, record player and books in the studio. Children are not banned from this area but generally use the accepted art therapy space in the other half of the room.

I like my own space being, to an extent, part of the art therapy room so that the child can see a distinction between my personal space and the more anonymous art therapy space. Also, I like the feeling of the room better because I paint in it. I think it is important for children to see art work in progress. I do not work on my own work while children are in therapy, but should they go into the studio area, they can see on-going painting. I like there to be a sense of life. It should be a space for creative living. Many children have not experienced the vitality of the potential space; the creative play space; the area where outer and inner realities and needs meet. They sometimes discover such an area for themselves in therapy and it becomes a whole and nourishing exercise being in the safety of that experience for their set time each week. They know they won't be interrupted by visitors, other staff or their peers.

The room is relatively clean for an art room. This is so that if children make a mess, it is seen as their mess, their chaos, and isn't blurred or lost in other people's chaos as may be their normal experience. Children learn the art of bringing order from chaos. For many, their experience of mess and disorder has always been negative because of deprivation. The lack of emotional holding has meant they live wrapped in chaos. In therapy the space is clear for them to put down their own chaos and creatively find their own order from it, and so readjust to their newly resolved situation. The layout of the room assists in this process.

I have basic materials – pencils, crayon, charcoal, paint, glue, card, plasticine, paper. I also have available music, video, and drama if sessions develop that way. Drama often springs naturally from the drawings. The drama is improvised performance, based in the here and now. I don't suggest drama as such, it unfolds three-dimensional art from two-dimensional art.

The central division of the room, the small carpeted sitting area and the larger open floor area all change into things such as a treasure island, a bedroom, a shop, space, a cave, the stage, the sea, a street, etc.

So the whole room is a creative arena set in the fine art context, in which children can battle through their own personal trauma and in the process discover a creative spark that sometimes ignites. Through the process of art-making they can cultivate a greater confidence and self-reliance to deal with events at school, home, and personal life. They do the work – at their pace. It is most worthy.

(Letter to the authors from Roger Arguile (1990)
St Mary's School, Bexhill-on-Sea)

SETTING UP A DEPARTMENT

Issues such as light, warmth, space to move around, access to materials, wash basins and water in the room, places to sit and work must all be thought through to maximise the function of the room for its intended purpose. The possible variations are enormous and will reflect the way the art therapist works and how the environmental conditions will affect the therapeutic alliance.

Firstly, it is important that the space fits the client in that the organisation of the room gives opportunity for the particular client group to make full use of their potential in therapy. All clients coming for the first time need to be shown around the department and the room in which they will be working. They should be shown where the various materials are, the way that various cupboards can be opened, usable storage space and so on. If this is not done at the beginning then the client will feel less orientated to the space and materials and will possibly feel even more anxious about beginning to use the materials.

Many art therapists set up their own autonomous department. In their previous job or even within the same hospital it is possible that they have been connected to another department which took the administrative responsibility for budgets, ordering of materials, etc. Nowadays it is much more common for this to be the job of the senior art therapist, if there is more than one in the department, and this management of budget and administration is onerous but necessary in setting up and running a separate art therapy department.

There are materials and equipment that are essential for the work in art therapy. These will include paints, palettes, paint brushes, water pots, crayons, pencils, clay, a variety of paper and so on. Consideration should be given to the particular properties of the materials such as free-flowing paint that washes out of clothes, a range of crayons including some that can be easily picked up, overalls if a lot of mess is anticipated, clay that is self-hardening in the absence of a kiln. Many art therapists stress the need for good-quality art materials with a variety of availability, otherwise the art-making is seen to be devalued (Schaverien 1991). These kind of issues need to be thought about and very soon become second nature to the art therapist already familiar with the various properties of art materials.

Where particular client groups are involved, special adaptation to the department might be needed. Aids for easy access in and out of the department for the less mobile will include wheelchair ramps, hand rails and so on. One art therapist working with the visually impaired and completely blind people designed her department so that everything within it could guide the client to where she wanted to be. Hand rails all round the walls, tables with lips to enable them to feel the edges and to prevent things falling on the floor out of reach, coded paint brushes and pallettes to indicate different colours and so on (Broadbent 1989). Children in particular will need protection from access to sharp instruments and dangerous liquids which should be locked or be out of reach so that they know where they are and can be used under the therapist's supervision.

A well-organised and thoughtfully laid-out room forms the basis of the atmosphere of the department. There is a striking variety in the way that art therapists set up their departments. The following example shows an 'ideal' working space in that it has been purposefully designed for the art therapist to work in a large hospital for people with a mental handicap.

The large room, which is suitable for group work, has been furnished with four large formica-topped (white) tables which can be taken down and folded up and placed against the wall. There are eight small chairs and an easy chair (low armchair), a plan chest with six drawers and a small upright piano in the room. Usually there are only three tables in use as four does not leave enough space for movement about the room. Some individual work is conducted in this room.

The large room is ideal for small closed art therapy groups. It will hold six people comfortably. In the groups, clients usually choose to sit round the three tables and there is a tendency to choose the same chair each week. When someone is absent there is often an empty chair by the table to remind the group. All the clients have good access to the materials on the sink surfaces and in the cupboard. The higher shelves are usually used for storage of work. Art work from sessions in the recent past is stored in the plan chest and clients have immediate access to this. Pictures can be taken down and pinned up during the session. The adjacent speech therapy room is sometimes used as a waiting area by clients who arrive early for the group.

The one-way screen enables the session to be viewed from the office and there are microphones on the ceiling that allow the therapist to make a recording. The screen can be used by key workers to watch assessment sessions. Nursing students and art therapy students have been able to witness the art therapist at work. It has provided security when working alone with a challenging client. Some transcripts have been made of sessions and when using the screen and microphones, the art therapist negotiates with the client concerned, but there are some clients who attend the department who would not understand such communications. The small room is quiet and allows two people to work together round a table. There is wall space which can be used for display of work and there are shelves which can hold paper. There is a sink and cupboards and therefore everything that is needed for art work can be made readily accessible. Some clients like the intimate atmosphere that can exist in this room.

The reforms in the NHS have increased the administration considerably and so a decent office is very important. It is essential to have a quiet space where notes can be written, reports compiled, returns completed. Lockable filing cabinets for confidential information, bookshelves, and storage shelves are useful which can all be locked when treatment is in process. This includes the use of an answerphone which means messages can be received when working with clients. This was once thought of as a luxury but, without a secretary, it is a necessity.

(Letter to the authors from Robin Tipple (1990)
Harperbury Hospital, Herts)

Many departments are not specifically designed and in fact are often areas that have been originally built for a different purpose. Examples include mortuaries, laundries, warehouses, operating theatres – but it is the space and atmosphere that is important and once the art therapy room has been converted their history within the institution is soon forgotten – except perhaps by the older residents who might have some difficulty in attending

sessions with associations of the original function of the building still in their minds.

With the implementation of plans for hospital closures as clients are being moved out into the community, many art therapists find their departments set up in 'temporary' spaces for two to five years. This description of 'H' block at Leytonstone House is a good example of the creative use of a temporary placing of the department. The art therapist is Sue Hammans.

The present art therapy department at Leytonstone House is temporary and is situated in a vacated house/ward. This description of 'H' block was the building used for the department for around three years. Figure 2.2 shows the layout, and how art therapy used the whole ground floor, therefore being accessible to wheelchair users. The client group included a full range of people who would be considered mentally handicapped/ people with learning difficulties. This includes adults with superimposed mental illness, sensory and physical disabilities and those with difficult behaviour, all of whom were long-stay residents. The climate of the institution was that of transition and impermanence as the place will close in 1993 and 'H' block was known to be a building due for demolition when it was taken over by the art therapy department, so there was a freedom 'to do what we liked with it'. This was particularly useful for establishing the large psychodynamic art therapy group setting, as the environment could grow like a living organism, reflecting the group processes and relationships as they developed in time and space.

Before describing the space, it should be mentioned that in the past this building had been used for other purposes, e.g. dental, chiropody and medical clinics, a mortuary, speech therapy and physiotherapy. So the art therapy department did not start off as a 'blank space', it was important to acknowledge that previous experiences our clients had in this building could have significant influences either consciously or unconsciously within the therapy.

One day I took an elderly client into the department through the back door. She was absolutely horrified as I opened it, as it later emerged that she had known this door as being the mortuary door and had never realised that from our usual entrance the art therapy department occupied the same space.

In the space chosen for the large psychodynamic art therapy session, we decided to allow a volunteer to fulfil a dream, creating a 'picture-wall' prior to moving in. The last bits were carried out after we moved to enable our clients to see how it had been made, and as a subtle way to encourage clients to use the walls themselves without actually directing them (which was exactly what happened). Spontaneously, so much began to happen to the walls, pictures were added, replacing or hiding

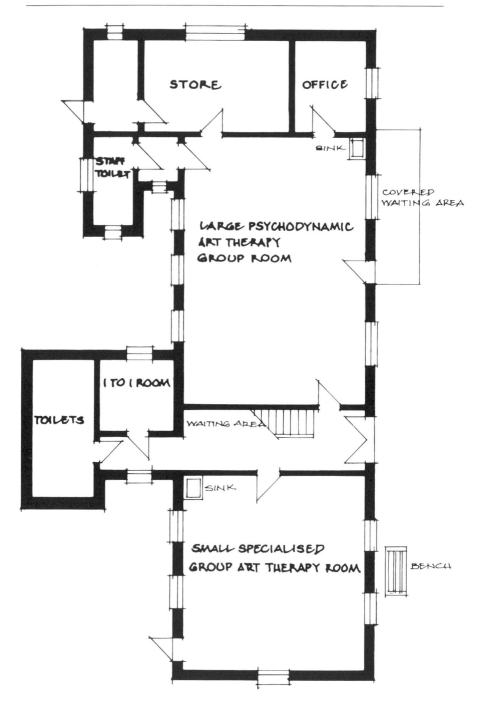

STORE

OFFICE

STAFF TOILET

SINK

COVERED WAITING AREA

LARGE PSYCHODYNAMIC ART THERAPY GROUP ROOM

1 TO 1 ROOM

TOILETS

WAITING AREA

SINK

SMALL SPECIALISED GROUP ART THERAPY ROOM

BENCH

Figure 2.2 The art therapy room, Leytonstone House, London

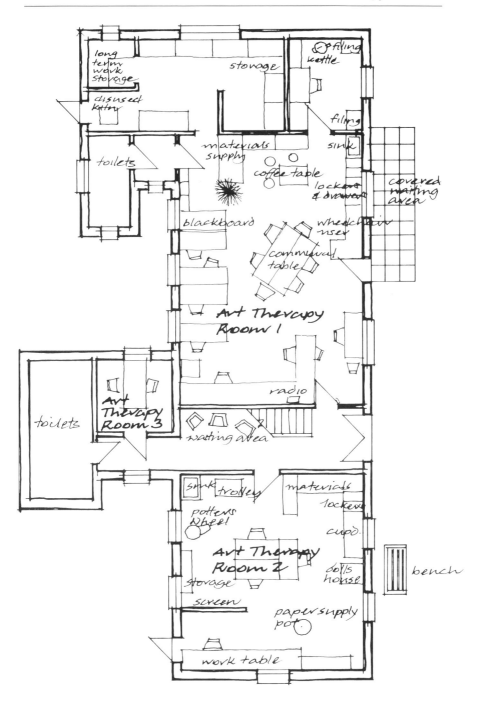

others, some removed and spaces left, some were doodled and written on and some were used as communication aids.

The clients gradually considered that they too could really influence and change their own environment. There was little scope for walls to be personalised in other areas of life, not even wallpaper choices, so the walls in the art therapy room were very important. These are several more detailed examples of how some clients used them.

Andrew painted a complete corner of the room, creating what he called his 'office' and organised and obtained a desk as his work surface. The walls would change from day to day, as he repainted them influenced by his moods; new items were added too, swivel chair, old telephone, waste bin, etc.

Barney began overlapping large strips of cardboard, paintings and collage work into the previous clients' painted wall. This did not cause conflict as there was a degree of respect and appreciation of creativity between the two men.

Clare occupied a row of three school type desks adjacent to the picture wall. She was fond of collages and created her own picture wall on a small scale, using her unique sandwiches of pictures and coloured/textured papers loosely stuck together to form a type of relief, sometimes several inches thick.

Doreen worked in the central communal areas of the room but was attracted to Clare's wall and frequently added to it. Brief negotiation would take place between the two ladies to achieve this. Doreen would also scatter herself all over the room through her drawings, paintings and collages, sometimes heavily pasted, other times loose and vulnerable.

Ellen was physically disabled and needed a wheelchair, so her choice of workspace was limited to a number of areas which allowed easy access, and the opportunity for her to be viewed as a person and not an obstacle in the room. Some changes from her original position became preferable through practice, mainly because she developed a new style in her art work which was very messy and resulted in paint splattering everywhere. After acknowledging her physical difficulties and her pleasure at causing powerful effects, her tables were turned round allowing a highly personalised area to be formed. The paint crept from the tables up the walls onto the floor and generally all about her.

Parts of the walls became battle-grounds through the art work, strong characters dominating prime viewing areas, private works in corners, sociable people displaying anywhere and everywhere, vulnerable characters displaying near doors or well-used areas where they could be easily damaged and knocked down. People with wheelchairs tending to display at their eye level and sometimes ladders would be used and therapists directed to reach desired spots. In fact, most work would never reach the

walls but would be stored in safe places, usually in folders. Even the floor has staged many noteworthy events; it held the invisible boundaries of personal territories, reflected the 'accidental' effects, the results of conflicts and careless actions. Each item of furniture also held a story of its own about how it came to be in any one place and looking the way it did.

Therapists acted as important facilitators to the working space and there were times when the degrees of handicap/level of abilities made it necessary for them to impose environmental changes or participate in certain actions for special reason. Mostly these decisions were planned and implications considered carefully but were normally due to health and safety responsibilities, either directly or indirectly. The reasons for therapist interventions were also shared with the group.

Within the art therapy room space was allocated for sixteen fixed working areas (not necessarily to be all used at once, but to enable a space to be left untouched for a couple of days if a person only attended twice weekly for example), an area for serving teas, a relaxing area for breaks away from client's work tables if desired, an area for individual lockers (for their art materials or personal possessions), sink and washing-up area, places to soak brushes, etc., a supplies table, shelves for papers, a lockable cupboard for equipment requiring supervised use, the trimmer, sewing machine, foot rest, easels, blackboard, coat hooks, safe smoking area, waste bins and storage boxes, buckets and bowls. This was the result of learning from the experience of our previous working space.

In fact an area designed to accommodate approximately fifty different personalities within any one week needed to utilise space with a degree of planning and negotiation, to be workable. However cramped the space sometimes felt, therapists needed to influence seating and objects which prevented clear access in case of emergencies. Images earmarked important signs as most of our clients were unable to read, such as the descriptive photograph of a fireman in action was stuck above the fire extinguisher.

Apart from the ways the spaces within the room were subdivided, there was always a great appreciation for the environment to contain a wide range of tables and chairs to enable clients to discover their own preferred work surfaces and seating. No less than five types of chairs were available, and a variety of types of work surface which gave more scope for developing decision-making and negotiating skills for a client group who had been denied the use of initiative for many years.

The therapist's office occupied a small glass-fronted room by the sink and tea-serving area which was probably the most used and congested area of the room. The office was mostly open to clients if they respected the therapist's privacy but it was not positively encouraged, and those

who entered and attempted to rummage drawers, etc., were told to leave with clear reasons. The store room was also an area from which we preferred to discourage clients, mainly because of theft and rummaging, but it was an area that could not be locked as it was a fire exit. Windows in the department were very high and revealed leafy trees on one side; the other side had either frosted glass or overlooked the waiting canopy outside.

Another of the art therapy rooms was used for individual art therapy sessions and consisted of one table, two chairs, hand basin and art materials. All of the art therapy rooms were self-contained as far as materials were concerned but sometimes additional special things would have been taken into the rooms too.

The small group room was used for a long time by two men whom it was felt needed the opportunity to work with minimum supervision. Out of all the space in 'H' block it was this room which perhaps underwent the most changes due to more varied uses, and the two men who dominated this room for much of the time took many risks to transform the room's appearance from the ceiling to the floor. Both were frequently occupied with 'whole wall paintings' either jointly or individually. Even the windows were painted at times.

This was also the room where most of the clay was kept, although it was taken into the other rooms; the main bulk and potter's wheel were occupying a clay area within the room. This room also housed an 8 foot table, a piano (kept well tuned), display screen, and plenty of open shelving, a doll's house and folder storage. This small group room was used for specialised closed art therapy groups and everything would be cleared away after a session to enable other groups to take place as well. It was also used for one-to-one sessions for people who might have presented a risk in the smaller confines of the one-to-one room, or whose hyperactivity would have made the other room unsuitable for sessions.

Student/in-service training/visitors would have talks in this space, providing it did not clash with the therapy programmes, as it was felt important for people to get a 'feel' for the art therapy environment.

Some areas of the department were seldom or never ventured into by some residents and if client movement had been charted, some residents had a very limited area into which they were prepared to move, whereas others would have been everywhere. This would have made an interesting study in itself.

(Letter to the authors from Sue Hammans (1990)
Leytonstone House, London E11)

Some art therapy departments are interesting to visit as they are visually stimulating, bright and are hives of creativity and concentrated activity. The

department at Leytonstone House is unique in the sense of its atmosphere and the feelings of containment and safety that is provided by, superficially, such unsatisfactory premises. The work and the relationship that the staff have managed to build up with the residents over the years is displayed by the feeling generated in the room in which they are working.

SHARING SPACE

There are many different styles of rooms and ways to organise the working space. However, some art therapists are not able to have their own room and so have to organise the space accordingly. Multi-purpose use of rooms can occur, particularly when room space is limited. The art therapist must keep the room in order as colleagues would find any mess incompatible with their own work. Sometimes, a messy and chaotic art therapy room can be an indication of some process going on in the therapy that the therapist is leaving around and 'not clearing up'. One example of this was when a visiting student, using an office, found it extremely difficult, in the beginning, to leave the room in a satisfactory state for other users. After several complaints by cleaning and other staff, she managed to organise sufficient time to clear up the space. At the end of the day, however, she found dirty footprints on the carpet leading to the door, which she came to understand might be some indication of material spilling out from the sessions as she was working with a particularly problematic child.

These are important issues to think about if the art therapist is working in a space not specifically designed as an art room. Where therapists are working on wards, and space is found to work in the dining room for example, this problem is exacerbated. An example of this is working as an art therapist on a paediatric ward in a general hospital where the use of art materials appeared incompatible with standards of hygiene and cleanliness of a medical ward. However, by confining the activity to one area, it was possible to enable the children to work with the materials freely, without too much concern as it was possible to use them in a contained way. Leaving practical considerations aside for a moment, sometimes this anxiety is based in the possibility of what might emerge and the potential for spilling out or non-containment of feelings and emotions in art therapy. This can be projected into the materials as a need to keep them under control and contained.

Many art therapists work part time, sometimes working for the rest of the week on their own art work, and many work sessionally either in different institutions or in different parts of the same institution. There is an acute shortage of space in many settings and a well-equipped studio permanently set up for sole use of the art therapy department may not be possible. Camilla Connell works for twelve hours a week with cancer patients at the Royal Marsden Hospital.

My facilities are extremely limited. I have a small walk-in three-cornered cupboard for storage and the use of a close carpeted 'Group therapy room' one afternoon a week. It has a table plus a folding table and some chairs, most of which are low and upholstered. No water, no use of walls, but at least I can shut the door and have some control over who comes in. Here I conduct a small group comprising patients from the Rehab. ward and anyone sufficiently well and ambulant from the rest of the hospital. I offer Redimix type paint in lidded transparent plastic pots, safely anchored in wooden racks, to avoid spillage. Also crayons of several types, charcoal, felt tips, coloured tissue paper, glue, clay, etc. I have had a lot of drawing boards made in softboard by the Works department for use with larger paper and also offer A4 pads of cartridge paper.

The larger part of my work is on the wards, mostly at the bedside, sometimes with a small group at a table in the centre of the ward. For this I carry a canvas bag stuffed with all the aforementioned, plus masking tape, scissors, glue, pads, the A4 notebook, my own notebook and under my other arm a drawing board or two with several pieces of paper taped to each. Jam jars, paper towelling and plates for mixing paint I find on the wards as required. I have considered a trolley but decided the bag was simpler. It is quite easy to fix up board and paints for patients in bed and with limited physical capacity. I offer the pots of paint in shallow cardboard trays in this situation, as they can't fall over. There are twelve in a box and with the lids off they are an inviting range of colours and the paint keeps well and there is no wastage or clearing up afterwards. I keep it fairly thick and viscous so it doesn't run off the paper and can be applied thickly and vigorously, or thinned with water. I think attention to these details enhances the appeal and use of the colours.

(Letter to the authors from Camilla Connell (1990)
Royal Marsden Hospital, London)

Each art therapy room will be formed by the forces within it and outside it. These will be as various as the personalities of art therapists, their theoretical orientation of practice, the effect of the client group as users of the service and the attitude of the institution to art therapy. The outer environment in which the institution is set will also directly and indirectly impinge upon and influence the sessions as clients make use of the content of the rooms and whatever is offered by the external environment. Aleathea Lillitos (1990) was working part time at St Thomas's Hospital, London, where the acute shortage of space means that most rooms have multipurpose functions. This is her description of a corner room mainly used for art therapy, but also by other professionals.

Although the room is nondescript, entering it from the ward is some-

times literally breathtaking because the large windows that run along two sides of it offer a panoramic view across the River Thames in both directions and to the Houses of Parliament and Big Ben opposite (Figure 2.3). This view of the outside world has evoked memories, feelings and fantasies in a great many clients and has often played a vital part in their art therapy sessions.

As other professionals occasionally use the room, materials have to be put away at the end of the day and the floor and walls kept clean of paint. There is a cupboard in which the materials are kept and some shelves above it on which the clients' work is stored. The furniture is basic and, unfortunately, there is no sink in the room. Apart from most of the usual materials used in art therapy (bottled paints, clay, plasticine, sand, crayons, and empty boxes and oddments for collage) I also provide some simple toys. If a client continually expressed the need for something that I have not provided (or brings his or her own materials) this can, if appropriate, be interpreted and worked on in the sessions.

Children have used the room and the furniture in a wide variety of

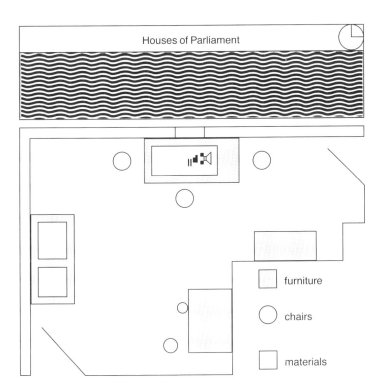

Figure 2.3 The art therapy room, St Thomas's Hospital, London

ways; some have accepted the room as it is and have sat week after week in the same place, whereas others have wanted to rearrange the furniture to build a house, a boat, a camp or, like one little girl, to make 'an office like the one that Mummy works in'. The locked cupboard also invites projections: a 7-year-old boy who had difficulty in accepting younger siblings expressed curiosity about what was inside it and made cardboard and clay models of it. Painstakingly, over several weeks, he constructed a model whose doors and drawers could be opened. Inside his cupboard he put 'lots of babies' bottles' imagining that this is what the one in the room contained. It became clear that the cupboard symbolised both his mother's body and mine as the 'mummy' therapist who had other sibling clients. With the aid of his model of the cupboard we were able to work through his fantasies about the inside of his mother's body, his envious feelings about her ability to have babies and his jealousy towards the babies that she had had subsequent to him.

Although some seem to be oblivious to it, the view from the windows can and has played a large part in many of the children's art therapy sessions. The Houses of Parliament and Big Ben are potent images in our society and are ripe for projection. Water, boats, and bridges have symbolic meanings as well. The River Thames that flows past the window can literally be a calm, pleasant strip of water where pleasure boats sail, or symbolically a deep, dark river with dangerous currents that can drag you under, or full of sharks and crocodiles that may bite.

Looking out of a window may seem to be an escape from the difficulties of therapy, but the external landscape can lead a child back into the fantasies he or she may be wishing to escape from. Much to my exasperation, because I thought she was wasting time, a girl of 5 who was concerned about the disappearance of her step-father constantly gazed out of the window (looking for him). Then, in one session, she pointed to a small tug pulling a huge container and said 'Isn't that little boat clever, it's pulling that big boat.' I realised that she had, as it were, pointed out to me how small she herself was to be looking after her mother. Subsequently, we were able to go on to talk about how she felt responsible for the disappearance of her step-father and the fact that she took on the burden of looking after her mother now that he had gone. Rather than being an escape, the time she spent gazing out of the window was reflective and important.

There is no clock in the art therapy room and I do not need to wear a watch since Big Ben can both be seen and heard and marks the passing of each quarter hour by chiming. This in itself can produce tension in clients who may either be wishing that the time would pass, or be anxious that it is doing so. Symbolically, Big Ben is phallic and seems to stand for authority; it also represents the superego. I remember an 8-year-old boy who was extremely competitive with his mother (and me

in the transference). He had been alone with his mother since birth, but she had recently remarried. Towards the end of the session time, when I warned him that it was nearly over, he would get extremely angry with me, question the time and tell me that he would not go. Yet, when Big Ben 'struck' he became compliant, prepared to leave and accepted 'his' authority. Obviously he felt that he could not argue with Daddy Big Ben's chimes but, sometimes, in wordless rage stuck his tongue out at 'him'. This behaviour mimicked his attitude towards his step-father with whom he felt angry, but dared not verbally challenge.

According to Circlot's *A Dictionary of Symbols* [Circlot 1971], a room is a symbol of individuality – of private thoughts – and the windows symbolise the possibility of understanding and of passing through to the external and beyond. Although I have been lucky to work in a room with such a view because it has stimulated the children's fantasies, I believe that what the child or adult has to speak of in art therapy will find its way to consciousness whatever the surroundings are like. A blank wall, like a pristine sheet of paper, can render a projection of an internal image and will not remain blank for long.

(Letter to the authors from Aleathea Lillitos (1990)
St Thomas's Hospital, London)

WORKING PERIPATETICALLY

Earlier in the chapter, we mentioned the hospital closures programme and the moving, where possible, of long-term patients as well as short-term patients back into the community. This has not only led to changing accommodation for art therapy departments within the hospitals but also to the widening of an art therapy service to community centres. Sometimes art therapists are based at such a centre with a purpose-built art therapy room, but sometimes some staff will only use this as a base, travelling to visit clients in day centres or their homes. The difficulty of obtaining funding in other sectors of care has also meant that one art therapist will often be working across a borough in a different school or centre or across a region.

Pauline McGee works for Aberlour Child Care Trust, a Scottish voluntary organization funded by local authorities, urban aid, bequests, etc. The work stretches across Scotland covering family centres, intermediate treatment projects, two dependency units for women, residential homes for young people and children with learning difficulties, and also similar homes for emotionally disturbed children and adolescents, and, lastly, a drop-in centre and counselling service for young people. She is the sole art therapist and works in several different projects over a normal week. In this situation the art therapist has to adapt her working method to each client group and staff team as she moves about the country during the week. She also has to fit in to the often cramped space available. These practical diffi-

culties add enormously to the normal pressures of working as a therapist. Undoubtedly the client groups benefit from their experience in the art therapy sessions whatever the working conditions. The voluntary agency brings aid to client groups with enormous needs which are less catered for by the statutory services. It was an innovative move in deciding to appoint an art therapist in this part of the United Kingdom where art therapy is less established.

> The question of space and rooms to use is often a big issue in all of the projects as many are based in the middle of housing schemes where the need for services is greater. I'll start with a Monday and the dependency units for women. The first is in a council tenement building in Edinburgh. The flats, apart from the bottom floor, are where the women live with their children. The front door of the building is always locked and the women have to say when they are going out and when they expect to be back. This sounds a bit like a prison but I have since realised the need for this as the estate is a big drug-using community and temptations for the women are literally on the doorstep. The locked door serves to protect the philosophy of the house in being completely drug and alcohol free. Women have been asked to leave the house when found to be bringing in drugs or being under the influence of alcohol.
>
> The bottom two flats have many uses. One bedroom is for the overnight worker to sleep in. One room, originally a living room in the tenement, is fairly cramped with chairs and a large table. This room, which opens onto a little kitchen area, serves as a meeting room for staff, a meeting room for residents and staff and on a Monday morning as the art therapy room. The big table takes up virtually all the floor space and everyone works at the table. There are many limitations as everyone has to do fairly small clay pieces or struggle round the table with boards for painting and drawing. One woman who needed to move on to bigger paintings had difficulty in negotiating more space round the table and this required the cooperation of the other women.
>
> While the group is on, staff stay out of this area and younger children are minded by a playworker in the flat across the landing. The sink in the kitchen area is not ideal as dishes have to be washed in there after staff lunch. It feels difficult to leave a mess there as it is not very nice for staff to cook lunch in an area covered in clay or paint. As the staff get little enough time to themselves, this space should always be clean and tidy.
>
> Once everyone has started working at the big table people cannot move around and so they stay in the same place until the end of the group. The end of the session is tricky as paintings and clay work have to be moved around as we tidy up. There is nowhere to store work but the women always seem happy to take things back to their flats. One

woman is really proud to have all her paintings hanging on her living room wall. She was one who never felt she could get involved in painting, never mind be proud of efforts.

Pauline works in a similar, but slightly larger room, in the sister project in Glasgow in the afternoon. On Tuesday morning she runs a group for parents in a family centre in Aberdeen. Here she uses a meeting room, clearing it of chairs before she begins, as well as covering the carpeted floor and protecting the walls.

Tuesday afternoon I work in a semi-detached house. The house is for independent living for three boys with learning difficulties. Colin has recently been thrown out of his workplace for his angry outbursts (this is his fourth placement). The house has three bedrooms, living room, kitchen, etc. The first two sessions I had with him were working in his bedroom. This did not feel at all comfortable and again carpets, etc., had to be protected from paint and clay. Eventually I got him to help me clear out the garage and we now work there. It is very cold but has advantages of wall space and a stone floor. We can also walk through to the kitchen for water and Colin certainly makes good use of the space.

Wednesday I work in two residential homes for adolescents. Space and privacy are a problem in both houses. In the first house I have to use an 'office'. This also has a bed which overnight staff use. There is a sink in the room and a tiny bit of floor space which is not carpeted. I now use the wall which, again, I have to cover with plastic sheets. The other house has even less room and the girl and I work in her bedroom.

Thursday and Friday I'm back at Falkirk in a family centre. Having been part of the team for two and a half years I feel I am given a lot of privacy for art therapy work to take place. As a team we change the rooms around to suit various uses and to accommodate the specialist work which does go on. The family centre is four council houses with small rooms. The room I use for art therapy is in the house where we hold adult groups and I have adapted the room as best I could. It houses a kiln in one corner, cupboards for materials and shelves for daywork. Children love to use the room as it is cut off from the rest of the house and somehow feels 'special'. The parents' art group and sewing group use the room in the afternoons so it does have a creative feel about it. I usually work on the floor with the children; there is a sink and toilet next door to the room and there are shelves for storage space. Another room, which was a kitchen, stores bags of clay and a sand tray. This part of the house offers most privacy and space for one-to-one sessions and although not ideal certainly feels like a bit of sanity in comparison with my first days of the week.

(Letter to the authors from Pauline McGee (1990)
Aberlour Child Care Trust, Stirling, Scotland)

It can be seen from these descriptions that the 'set apart' space need not be 'ideal' but needs to be 'good enough' to provide an outer framework to the 'inner space' that is created between therapist and client. Some degree of difficulty in the environment can give a sense of solidarity and aid group identity, as is seen in the first example of the working week above. There is, though, a fine line between this and the dissolving of the boundaries that make work possible. Poor conditions and poor materials can add to the lack of sense of value, lack of identity and worth already experienced by clients.

One way of solving the problems of space for art therapists working peripatetically would be to set up art therapy centres in each geographical area for use by all services – health, education and social. Organisation would be needed to 'bus' clients, but it should be possible. In the meantime, art therapists working for the different services struggle with accommodation difficulties. Helen Thomas works in a London borough.

> I am part of a team specialising in working with children with emotional and behavioural difficulties. I am the only art therapist on the team and receive referrals from other support and psychological services. As I cover a large borough, I visit and work with my clients in their schools or units.
>
> Schools often look spacious with masses of room, but usually every part is designated to work going on within the school and is booked for other peripatetic and remedial teachers. It is extremely difficult to find a quiet room where I can work undisturbed for an hour.
>
> Only one room given to me has a sink and water, which means I have to take in a water container, plus art materials. The accommodation varies in each school and the following describes three examples of the different spaces used.
>
> 1. Prefabricated building used as a dining hall separate from the school – situated on the edge of a large playing field. The child I worked with used all of the space. The room was filled with tables and chairs, the main kitchen was locked. My client would begin to paint – sometimes sitting with me or at the far end of the room. He appeared to like the uniformity of the rows of furniture as he had a deep anxiety about mess and getting paint on his hands. Often he would fantasise and act out situations, pacing around the room, trying to make sense of his own relationships within his family and peer group. When he made secondary transfer, we had to use a small medical room in the new school, and his behaviour changed completely which resulted in his exclusion from school. I now work with him in a disused canteen attached to my office.
>
> 2. Two basements, both used as pottery workshops/store rooms – one very cold, poor lighting and no water. In one of these rooms I work with a girl who is an elective mute – she presents herself to be shy and

timid and I was rather concerned that going down into the bowels of the school with a stranger might alarm her (possibly more about my own anxiety and discomfort). However, she skips and laughs and appears to feel quite safe in the room.

3. An attic – my client always says how much he likes being up in this room. He calls it 'Our special place'. As it is an attic it is used to store everything not used in the school. The child often dresses up in the stage costumes and acts out harrowing scenes from a 'family' where he plays all the parts.

> *(Letter to the authors from Helen Thomas (1990)*
> *E.B.D. Team, Barnet Social Services)*

In contrast to this working situation, the following description gives a clear account of how a permanent space can be designed to fulfil its maximum therapeutic potential. Vera Vasarhelyi (1990) also works with children at Bloomfield Clinic and this is her account of her working environment.

Setting up the therapeutic space seems to me one of the most important prerequisites of a safe and fruitful therapeutic relationship. My room in the Department of Adolescent and Child Psychiatry was designed by me after careful consideration (Figure 2.4). My purpose was to express some of my therapeutic aims in the environment and therefore provide a space which was not only continuously available but also congruous with the content of therapy.

Figure 2.4 The art therapy room, Bloomfield Clinic, London

Although the room itself is just one of a number of identical rooms, the colours are very different. The floor is dark blue Pirelli rubber, designed to withstand heat, acid, etc., and therefore strong enough to take destructive 'attacks' without being destroyed. The other major feature in the room is the red, L-shaped working surface, resting on storage shelves. It fulfils the role of a container as well as making available an empty space to welcome the appearance of images.

A large selection of white and coloured paper is available on the surface of the bench, together with paint, crayons, pencils and felt tip pens as well as brushes, pots, and water jugs. The full selection of art materials – including clay – are visibly displayed on wall racks and metal baskets, with the aim that this would facilitate free choice.

Finally there are three red folding chairs for the children to arrange in whatever combination they might wish. I work with both out- and in-patients, but the feedback from both groups of children is the same: the 'red and blue art therapy room' means a 'different' space, which they are eager to use freely and appropriately to formulate and express their inner world.

(Letter to the authors from Vera Vasarhelyi (1990)
Bloomfield Clinic, Guys Hospital, London)

The final example of the art therapeutic space is a detailed account of how this working environment is closely matched to the client group and careful consideration is given to their needs and how these can be most appropriately met. This well-established department gives a real sense of the separate space essential for the establishment of relationship and good therapeutic alliance. There is a sense of the 'asylum within the asylum'.

The hospital

Hill End Hospital is an old Victorian red brick asylum, set in Green Belt land that rings outer London. The hospital caters for adult psychiatric patients from the North West Hertfordshire catchment area.

Art therapy has been established in the hospital for many years but over the last 10 to 12 years has developed to specialise in work with psychotic and borderline psychotic patients. The geographical location, the layout of the hospital and of the rooms of the department within it make it a highly valuable space to accommodate our particular approach to this patient group. Equally it is flexible enough to meet the needs of other patients able to negotiate boundaries and relationships at a more ordinary symbolic level.

The department

The department itself is at the back of the hospital, a 'spur' off a long

corridor to one side of the administration block. It is a more or less self-contained set of eight rooms which many years ago were part of a larger ward area. These rooms function as a large main studio space with at one end a kitchen and to the side an office and two small therapy rooms, each with a door adjoining the main department. To complete the number there are two locked store cupboards for patients' work just beyond the kitchen, and across the corridor is the toilet area which is shared with another department nearby.

Despite the old ward status there is little that is clinical about the department though its style is certainly recognisable as institutional. The fittings are solid, the proportions generous and the rooms thoughout are light and airy. The department as a whole is pleasant to the eye and has a certain neutral solidity that can accommodate much of what takes place within it.

The main studio is spacious and quiet with room to walk around as well as to sit in. The therapy rooms (and office) are small, creating an atmosphere of privacy and the safety of self-containment. The rooms are usually warm, and sometimes too warm so that even in winter the windows may need to be opened to let fresh air circulate. Net curtains and fluted glass give some privacy to those inside from people walking by outside.

Entrances and exits

The main entrance and exit is by the outside garden doors, as they are called. These are double wooden doors which open onto a grassed area where wooden benches line the outside wall and sit irregularly placed under the many huge lime and chestnut trees. Patients from the department use this outside space to leave and enter the main room, to walk around outside, to sit alone or to soak up the sun. Very occasionally to draw. There is little disturbance from other hospital activities and empty wards and an abandoned OT department stand around us.

Another door from the main room leads to the kitchen on one side and the toilets on the other. A large room, infrequently used, leads off from them. This room, unless being used by another department, is locked, as is the outer door beyond the kitchen leading to the main hospital corridors. This area constitutes a series of spaces, all of which can be 'used' differently from their intended function by patients – e.g. to be alone, to hide, to create distance, to look in mirrors, to talk to oneself and so on.

Rooms and tables

The large room has within it approximately twenty-one tables, many of

them old wooden, oval and rectangular, each with a chair. The staff table is near the office and is side onto the room. The centre of the room is marked by a table with several large pot plants. The tables each have qualities inherent to their size, location relative to each other and the spaces between, to social areas of congregation and to the staff table. Consequently, some table spaces are more 'open', some further from traffic, some in more containing corners (or claustrophobic depending on your view). These qualities and possible perceptions are taken into account when allocating space to new patients (Figure 2.5).

The walls have ample space for patients to put up images after selecting and perhaps negotiating for the desired place. The mantelpieces and shelves, too, are laden with unfired clay and other made objects.

The office, which is located between the two therapy rooms, has within it all the paraphernalia required of an office but remains too small for the needs of four members of staff. It is sometimes the only available space for detaching oneself from the main room to work on reports and administration or to speak privately on the phone and, equally important, to confer in private on some aspect of room management or therapeutic strategy that needs immediate attention. It is possible to have visual contact with the main room via the netted glazed door and also to be more available and in touch by having the door open while working.

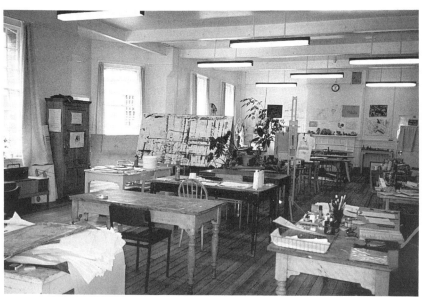

Figure 2.5 The art therapy room, Hill End Hospital, St Albans

The two individual therapy rooms are where patients bring their work and in which in-depth therapy is most usefully carried out. Each room has two easy chairs and a coffee table between them for placing work. On the walls and shelves there are various objects and images which the patients have requested and negotiated should remain. The rooms are more or less soundproofed and the glazed but netted doors give a veiled visual access both to the therapist into the events in the main department should she be the only staff member available, as well as providing a visual link for patients remaining in the main room.

The space as 'studio'

For patients whose level of functioning is sufficiently integrated, i.e. who are clinically best described as neurotic rather than psychotic, this department is most readily understood as a studio type space. Here, referred patients are expected to be present during their programme times. After the initial introduction to the department, its facilities, the materials and sometimes the discussion as to how they may best use this time for themselves, they are then left free to find their own preferred level of relating to what is available within the limits or 'rules' of the department.

They are free to sit at their designated table space and make images or read from the selection of books provided, make tea when they wish, sit in the easy chairs in the 'social space' and so on. There is room to walk around and to move in and out of the main room, in all to have a variety of levels of engagement in personal exploration in different spatial contexts. Work that is produced is kept safely and doubly private by being kept in a personal folder, also kept in the main room on shelves for that purpose. Each folder is laid out on the patient's table in readiness for the session. After assessment, therapy is embodied in the form of a verbal contract which defines times, duration and focus of therapy where this is possible and desirable. There is then an overall expectation that patients are present at the agreed times both for sessions in the main room and for individual therapy, and that we are kept informed by them of changes that affect the contract. The relationship between the department, therapist and the patient is one of the 'whole person'. Bearing in mind the tremendous differences between people's ability to take personal responsibility for themselves (perhaps the meat of therapy in this context), negotiations and explorations of relationships, boundaries, time, spaces and meanings are possible at a level that is symbolic and is between people who experience their 'selfhood' as more or less separate and boundaried.

Concepts of 'private space for personal material' of 'sharing inner experiences with another person' and of 'exploring the meaning of

imagery' are all relatively understandable and negotiable although the content may be fraught with difficulty. The avoidance and disruption to those processes that may be made manifest in their relations to the contract (e.g. not keeping to session and therapy times) and in relation to the content of therapy (e.g. in the transference material) all take place in the context of a developing 'whole person' relationship. Here, feelings, thoughts, actions are experienceable and attributable as such, though distorted to varying degrees.

Consequently, the rooms exist as spaces in which what is inside a person can be put outside in an atmosphere of containment and safety, the level of which is dependent on that person's own self-experience, the differing function and significance of the rooms and relations with the therapist as well as on our ability to maintain the experienceable structures (e.g. timing, confidentiality, care of work).

To work in the department is understood as constituting a spatially defined area, a level of privacy, a behaviourally 'loose' connection with staff and an internally experienced world that may or may not be laid bare externally, in images or forms. Moving into an individual session room involves a shift in that definition to allow for an increase in the level of privacy as well as an intensification of the relationship experiences and a context in which an intention to explore the work more deeply can be 'framed'.

Space and body spaces – the psychotic experience

However, for a person who is struggling with psychotic anxieties, loss of self-structure and of the 'ordinary' notions and experiences of 'inner' world and 'outer' reality the concepts outlined above, necessary for therapeutic engagement, are rendered useless. There is not a sufficiently and viably integrated 'self' with whom to 'do business' in the ordinary therapeutic manner, and attempts to activate this will usually be met with an increase and an intensification of psychotic fragmentation. For example, the psychotic person may experience a compression of meaning with the 'signified' so that an expectation to 'express yourself' for them might as well be a request to 'have your guts ripped out', not as a metaphor but as a description of the experiential level involved in this kind of relationship contact.

However, what is possible, and it is part of the way in which this department works, is to defer the expectation in the therapist of a 'whole person' relationship and to concentrate instead on building on 'concrete' areas of negotiation between therapist and patient. In this way the 'currency' of this exchange is made up of the 'concrete' realities within the environment.

The whole department and everything in it then becomes available in

a different way from that described earlier. The concept of 'personal space' is viable here as a concretised location, as literal space that can be available for manipulation at an experiential level and may have to be defined by 'concrete' boundaries. The spaces and real objects or substances that exist can be focused on as felt extensions and repositories of body experiences in a relatively safe context. When 'control' of them is not 'challenged' (including by therapists who want to attribute a symbolic meaning or relational connectedness to them) they may become parts of the 'self'. It becomes important in a different way, then, that the space and the objects within it are the property, not just the territory, of the patient.

The programme for this kind of functioning state may be designed so that the table is kept entirely for that person's use and that the work and other objects put on or near the table are left totally undisturbed. The table and its environs (including any images) may be experienced as an extension of the psychotic person's self-structures. To interfere with, or to make unsafe, that safe area of experiencing is to risk gross intrusion into fragile 'self' defining structures, to impose expectations and therefore to bring demands of a 'whole person' relationship order. To support it can enable the psychotic person to relax some of the defensive strategies and experiment with others that later may be more viable in the world of relationships and symbolic structures.

Despite the psychotic person's avoidance or inability to relate at an ordinary level, it is inevitable that some contact is made over issues of table space, folders, materials, opening and closing times, tea-making and so on. It is here that boundary setting, 'rules' of the department and other structure-creating communications are entered into and where the therapist can participate in building a relationship with the patient in the form of negotiating to accommodate the wishes of the patient within the boundaried structures of the department.

A further level of negotiating takes place in relation to how to deal with imagery. These negotiations or exchanges too may be concretised and can be approached at the same level by the therapist. An example could be the perceived 'power' or 'evil' of imagery that is created. Where should it be kept so that it does not harm those who see it? may be a crucial consideration. A department with many different kinds of rooms or spatial contexts, with cupboards, shelves, drawers, corners and alcoves and with a table space that is sacrosanct and kept safe for the patient, can provide numerous possible solutions to this consideration, which can be negotiated, again concretely, with the therapist.

The studio type space where entering and exiting can be done autonomously allows psychotic people to come when they 'feel ready' and leave when they have 'had enough', their relationship with the spaces being controlled by whatever aspects of themselves they are presently

driven by. The proximity of the individual rooms to the larger space allows a similar disengagement without that person having to leave the whole departmental space entirely. In this way any engagement that the psychotic person is able to make, even if it is only with the inanimate room space itself, is an engagement and therefore a basis for negotiations that can be capitalised on by the therapist.

To have to arrive at a pre-set time, to knock at a door to gain entry for engagement in an intensive relationship and to have to be able to 'contain' the contents at a symbolic level, having perceived that therapy is finished until next time, is an expectation placed upon one to function at a highly integrated level with another.

In a system of this kind – where patients have to exert a reasonable degree of responsibility to adhere to specific days and times, where the layout of rooms means that the person is either in or out, engaged or not, where table space is fought for and 'unstable' and where all the work with the therapist requires a relationship at a highly symbolic level perhaps in a small closed room – there is little room for manoeuvre of the negotiation type described earlier.

There is indeed less ambiguity, and perhaps the opportunities for patients to 'test' or 'push the boundaries' is reduced and rendered more explicit in a space that is therapeutically 'clear cut'. In the less 'clear cut' but none the less boundaried structure of the department at Hill End Hospital, we can focus on the increased opportunities afforded us to mediate between concrete and symbolic structures. Through the recognition of the value of working with the 'concrete' level of functioning we aim to utilise the actual spatial locations and their experiential components as part of the basic 'work' and not only as the 'frame' or context of the work. In this way the department itself 'participates' in our techniques by enabling us to reduce the otherwise implicit demand, that 'clear cut' therapeutic spaces make, for high-level functioning of a more integrated 'self' than can be immediately achieved by these patients.

Acknowledgement

The specialised work of the department and the development of its facilities in work with psychotic and borderline psychotic patients was pioneered by my predecessor Ms Kathy Killick. Her work is described more accurately and cogently in 'Art Therapy and Schizophrenia: a New Approach', unpublished MA Thesis, 1987, Hertfordshire College of Art and Design Library, St Albans.

(Letter to the authors from Anna Goldsmith (1990)
Hill End Hospital, St Albans)

SUMMARY

The art therapy rooms and working spaces that we have looked at in this chapter vary enormously but all of them provide a 'set apart' space or a 'creative arena' for interactions to take place with materials and therapist.

It seemed so important that the room was a safe container for the work that took place within it. The patients came, making their own inner journeys and deciding what they wanted to do with their work. They could take it away, more often they put it away, or hid it somewhere, knowing it could be found, sometimes just leaving it – but knowing that it was safe, until they came back, maybe the next session, or it could be a year or two later that someone would come and view their object or picture and then perhaps take it away. It has meant that over the years many images have gathered within the room, and for some that might appear a little chaotic. Yet I have found the room to be a very special place to work.

*(Letter to the authors from Claire Skailes (1990)
Coney Hill Hospital, Gloucester)*

Other long-established departments such as Gogarburn 'bulge with the accretions of almost twenty years of creative work' and offer a protected space for long-term clients:

One man has requisitioned a corner of the main room, where he keeps his collection of fossils, books and other personal objects in preference to keeping them in his ward.

*(Letter to the authors from Simon Willoughby Booth (1990)
Gogarburn Hospital, Edinburgh)*

In contrast, many part-time art therapists and those working peripatetically adapt to an extraordinary variety of spaces offered to them which do not have the same sense of permanence. Within the space of the art therapy room, art materials offer the opportunity for the client to seek out further intimate private space. In the process of painting, it is not uncommon for a client to work silently on her own, away from the public gaze of the other members of the group and/or the therapist and re-emerge when she feels she has finished. This is a qualitatively different experience from sitting in silence, as making images sets up a deep internal dialogue, the product of which has now been externalised and made public in the form of an image or object. It is like putting one's intimate thoughts or even dreams on paper and it is too risky to allow those to be seen during the process.

The art therapist must respect this fact and the importance of the privacy and space that she can allow for the client for this dialogue to emerge. One boy persistently sat with his back to the therapist in the corner of the room and for weeks did not want anyone to see what he was doing. The therapist

sat at the other corner in the usual place, and soon realising that she was not going to intrude on his space he began to turn around, check if the therapist was still there, and return to his work. As time went on in this way, he began to let the therapist see what he had done, began to turn towards the therapist while he was working, but hide it quickly if he felt an intrusion imminent. He developed into a child that was more able to share his space and thoughts and even become spontaneous about his work in the interaction with the therapist. Intrusion by the therapist would have interfered with his developing ability to trust and gain some understanding that what he did was acceptable. It can now be appreciated that the consistency of the therapist, as well as the room and the space in which this happens, is of paramount importance.

DISPLAY OF ART WORK

Given that the consistency of the space in the art therapy room enables the feeling of safe keeping of the objects made, some consideration should be given to where the art work is kept and whether it should be displayed, or even open to view by other clients using the room. We have had descriptions of the way the spaces can accommodate different ways of working with these issues and can see that images hung on the wall affect the therapeutic process in terms of how the images are related to by therapist and client. Ideally, there should be as few images on the wall as possible, particularly the most recent work of clients still in therapy. When the room is being used as a studio where on-going work remains hanging, it is often advisable to cover them up or turn them to the wall. For example, several groups might be meeting in a room where images are placed from other ongoing work and the group dynamics can be strongly affected by the powerful imagery that surrounds it. Any working environment is visually affected, but where the images are very strong, this is more extreme.

In schools or educational establishments, putting pictures on the wall is taken more for granted, but the art therapy room should be an exception. Display of art work invites comment, comparison and judgement which should not be part of the images made in art therapy. If a child asks to hang her picture on the wall, this can be seen as some indication of what is happening in the therapy and her relationship to the therapist and space in which they meet. As she should be given the sense that she has control over what she does and chooses to do in the room, then asking for the picture to go on the wall is part of the material to be worked with. Similarly, when wet paintings are placed to dry or clay models put by to harden, this sets up difficulties for other clients. Touching or commenting on the work should be kept to a minimum, but this is difficult if it is included in the therapeutic space which children and adults have to share and often serves as a crude reminder of that fact. These are all considerations to be thought about

when setting up the room, its on-going use and function of the space. This will be considered in more depth in the chapter concerning the image (Chapter 5) but, firstly, we shall turn to examine the reasons for this set apart space and consistency of experience and why they are important for the therapeutic process of art therapy.

REFERENCES

Arguile, R. (1990) '"I Show You": Children in Art Therapy', in Case, C. and Dalley, T. (eds) *Working with Children in Art Therapy.* London, Tavistock/Routledge.

Broadbent, S. (1989) 'Certain considerations using art therapy with blind adults', unpublished Thesis, Herts College of Art and Design.

Circlot, J. (1971) *A Dictionary of Symbols.* London, Routledge and Kegan Paul.

Lillitos, A. (1990) 'Control, Uncontrol, Order and Chaos: Working with Children with Intestinal Motility Problems', in Case, C. and Dalley, T. (eds) *Working with Children in Art Therapy.* London, Tavistock/Routledge.

Schaverien, J. (1989) 'The Picture within the Frame', in Gilroy, A. and Dalley, T. (eds) *Pictures at an Exhibition.* London, Tavistock/Routledge.

Schaverien, J. (1991) 'The Revealing Image', in *Analytical Art Psychotherapy* (in press).

Vasarhelyi, V. (1990) 'The Cat, the Fish, the Man and the Bird: or How to be a Nothing. Illness Behaviour in Children: the Case Study of a 10 year old Girl', in Case, C. and Dalley, T. (eds) *Working with Children in Art Therapy.* London, Tavistock/Routledge.

Videos

Art Therapy (1985) Tavistock Publications (shows Sue Hammans working with clients in an art therapy department, Leytonstone House).

Art Therapy – Children with Special Needs (1987) Tavistock Publications (shows Roger Arguile working with children in the art therapy department at St Mary's School).

Chapter 3

The therapy in art therapy

Having considered the 'space' of the art therapy room, this chapter will look at the process of therapy that takes place within it. The essence of art therapy lies in creating something, and this process and its product are of central importance. The art process facilitates the emergence of inner experience and feelings which might be expressed in a chaotic raw form. The art materials provide a tangible means through which conscious and unconscious aspects of the person can be expressed.

Making marks is an activity common to all human beings. Since ancient times, humans have drawn, carved and scratched as forms of individual expressions and communication. The impact of these primitive marks is important in the understanding of how art is used as a means of communication. Roger Cardinal (1989) refers to 'that rudimentary yet expressive mark incised by a human hand upon a surface' as the 'primitive scratch'. 'To investigate some of the ways in which minimal traces seemingly mute, indigent, even paltry – can achieve eloquence may be good groundwork for the construction of a model of the Primitive and, indeed, of our reception of human signals at large' (Cardinal 1989: 113). By comparing graffiti, prehistoric Camunian rock incisions as 'picture making at its most basic' and also drawings by Miro and Michaux he argues that it is the first-hand experience of seeing and absorbing pictures which creates their impact and meaning – the mark has its own significance as well as that of the time, place, and original reason for its creation.

This provides the basis for using images in therapy. The significance of the mark and the place in which it is made, the therapy room, and how it is received, the therapist response, sets up the essential parameters of the art therapeutic process. The various components of this will be considered here in some detail. One of the most important aspects of images is that they can hold many meanings at different levels; reflecting the culture within which they were made and in which they are viewed. In a therapy relationship, the artist/patient brings her own meaning to the image from her own 'culture' into the 'culture' of the therapy room where it is viewed with the subsequent impact and resonance in both patient and therapist.

The importance of remaining open to these many levels of communication in a picture, and being aware of them, is central to the practice of art therapy.

> Pictures, even when apparently finished, evoke movement and relationship but cannot be read. Maps can be read; on maps the figures and marks do not necessarily signify something outside themselves. Even a two-dimensional image is three-dimensional in the sense that it is full of multiple potential meanings which reverberate and echo against one another. No picture can be fully explained in words; if it could there would be no need to make it.
>
> (Schaverien 1989: 153)

So art work produced in therapy embodies subtleties, ambiguities and multi-dimensions of expression which can be hard to articulate verbally. To some extent this can be explained by the origins and complexity of creativity and what happens to the artist/patient when she begins to paint and draw. Tchaikovsky wrote in a letter from Florence, 17 February (1 March 1878):

> Generally the germ of a future composition suddenly comes and unexpectedly. If the soil is ready – that is to say, if the disposition of work is there – it takes root with extraordinary force and rapidly shoots up through the earth, puts forth branches, leaves and finally, blossoms. I cannot define the creative process in any other way than by this simile. The great difficulty is that the germ must appear at a favourable moment, the rest follows of itself.
>
> (Newmarch 1906: 274)

Here we can understand creativity in its unpredictability, potential chaos, novelty, newness and indeed experimentation. 'Creativity is the ability to bring something new into existence for that person' (Storr 1972: 11). Another way of looking at this stresses the influence of the environment in which this inner process may occur. 'My definition, then, of the creative process is that it is the emergence in action of the individual on the one hand, and the materials, events, people or circumstances of his life on the other' (Rogers 1970: 139).

The creative experience will be discussed in more detail in a later chapter, but one aspect of creating something or the process of image-making involves tapping some inner reality of the person and therefore some expression of unconscious processes. For our purposes in understanding how art and creative processes can be used therapeutically, it is useful to draw comparisons between art processes and dreams, particularly in relation to the expression of the unconscious. There is an obvious difference which lies in the fact that art activity is a conscious process which gives concrete form to feelings, which are often unconscious. The dream

equivalent of this would be an attempt to make sense of a vivid dream on waking, but there is no tangible form such as painting that can act as a record of this experience and thereby facilitate the process. Describing a dream is a different experience to that of dreaming it – similarly, describing an image is a different experience from making it, but reflecting on a completed image can evoke the same feelings and associations even though these are formulated in a more rational way when it is put into words. When the events of the dream or image are verbally articulated then some outer sense is made of inner, often uncontrolled sensations and experience. 'The artist himself is cast in the role of the spectator faced with the chaos of newly created art' (Ehrenzweig 1967: 80).

The process of making sense of an image is helped by the fact that its concrete form outlasts the actual experience of making it. A picture does not evaporate like a dream, even though the effect of the dream might stay with the dreamer for quite a long time during the waking hours. One often has the experience of being wakened in the middle of a dream and just wanting to go back to sleep to continue the dream. Painting an image can be interrupted in the same way but it can be returned to, although some state might have been altered by the interference. Indeed it can happen that images have a particular association for the artist/patient while it is being made, but this can change over time and the image can take on a new significance with increased insight and understanding. They therefore last over time in a different way to the momentary experience of dreaming. It is for this reason that 'it may be that the analysis of art continues where the analysis of the dream left off' (Ehrenzweig 1967: 4).

It is the presence of the art form which creates the complexity and essentially the uniqueness of art therapy, and the intensity of this relationship is fundamental to the art therapy process. Art therapists who use a psychoanalytic approach encourage the process of pictorial expression of inner experience, and in this sense art is recognised as a process of spontaneous imagery released from the unconscious. This is similar to processes of free association developed by Freud as the fundamental rule of psychoanalysis. In free association the patient says anything and everything that comes to mind, however trivial or unpleasant. This gives access to unconscious chains of associations, to the unconscious determinants of communication. In interpreting a dream, although symbolism may be important, access to its meanings is through the patient's free associations. A dream involves the gathering together or 'pooling' of unconscious events in the patient's mind and the associations to it are externalised in words. Painting provides another way to externalise these feelings and events but as parts of dreams might be committed to memory, the concrete nature of images mean that they take on a life of their own. Paintings or images from patients in art therapy can be understood and approached in the same way in terms of the patient's associations – images that are produced may be one-off sketches,

doodles, accidental marks and can be destroyed or significantly changed. They might be accomplished completed paintings that have been worked on over a number of weeks but it is not always a finished considered piece of work that the art therapist and the patient will be reflecting on at the end of a session.

This clarifies the position that making art in a therapy session has a different purpose from that of, for example, painting with a view to public exhibition where the painting is likely to be looked at in terms of its aesthetic quality. It is not just the art product but also the process that is important. The art process in a therapeutic situation will be affected by many considerations which include the setting, the client and most prominently the therapist. Schaverien (1989) emphasises this point in terms of showing the finished art product:

> The artist who has finished her picture has now to consider where to show it. She may choose not to show it, keeping it private. It exists then as her private framed experience which perhaps feels too precious or powerful to risk showing. It may be a dialogue with herself, or something of which she is ashamed, or maybe she anticipates others' rejection of it. Quite possibly her motivations are unclear; it just feels wrong to show it. The client in therapy may well go through similar feelings in deciding whether to show her picture to the therapist. This transition from private to public is a common feature of all art. It is a step from the process of image-making to acceptance of the picture as a product.
>
> (Schaverien 1989: 152)

It is thus the process of image-making and how the final product is received within the bounds of a therapeutic situation which forms the basis of the art therapeutic process. It is here that the orientation of the therapist is of most importance in terms of how she receives and works with the images produced. The different theoretical perspectives will place different emphases in terms of understanding this art process. Some art therapists today work from a psychoanalytic perspective – that is they bring to the therapeutic situation some theoretical understanding of psychodynamic processes. This involves the importance of clear boundaries and working with transference and counter-transference responses.

The first psychoanalytically oriented art therapist was Margaret Naumberg, who pioneered her work in the USA. She described art as a way of stating mixed, poorly understood feelings in an attempt to bring them into clarity and order. 'The process of art therapy is based on the recognition that man's most fundamental thoughts and feelings, derived from the unconscious, reach expression in images rather than words' (Naumberg 1958: 511).

It must be said that all art therapists do not agree with this approach and indeed it has been suggested that art and therapy form an 'uneasy partner-

ship' (Champernowne 1971). Many art therapists are uncomfortable with what they consider to be reductive or projective interpretations of fine art and art therapy when viewed from an analytic perspective. They would lay greater emphasis on the healing qualities of art and on the importance of the dialogue that the artist/patient establishes in the privacy of her own creative activity. However, as the profession and practice of art therapy has evolved, it is more and more based in the psychoanalytic framework through which the process of image-making and the relationship with the therapist can be understood. Art therapy therefore involves using images to facilitate the unfolding and understanding of psychic processes. It is not so much a matter of art making the unconscious conscious, or to widen and strengthen the ego, as of providing a setting in which healing can occur and connections with previously repressed, split off and lost aspects of the self can be reestablished. Events, associations, feelings from the past can emerge through the imagery while the art therapist as artist allows an understanding of this process. It is important that space is allowed for free choice of self-expression when using analytic theory to understand the nature and content of the imagery of the artist/patient. The ability of the therapist to provide a setting where this might occur depends on her capacity to understand this. This capacity, in turn, depends on her personal knowledge of how it feels to create images in the same way as her patients, and also the understanding and application of rigorous models of treatment practice in the consideration of boundaries and transference relationships.

BOUNDARIES

Before entering into the therapeutic situation, contractual arrangements are made between therapist and client. Social interaction is maintained by codes of behaviour that are learnt or acquired and are based on patterns of expectations which are somehow informal and usually unverbalised. The therapeutic encounter, however, is different in that some rules are carefully laid down and agreed to in a contract worked out between art therapist and patient. This involves the time of the session, where it will take place and how long over time this arrangement will continue. If payment of fees is involved, this makes an additional commitment in that the client agrees to pay for the sessions whether she comes or not.

These conditions establish the frame inside which therapeutic work occurs. The frame acts as a container and if this feels unsafe and is experienced by the client as moveable or negotiable, then she will be affected by this rather than using the boundaries of the session as a framework on which she can depend and begin to express inner difficulties and vulnerabilities. The session becomes a safe space in which feelings and thoughts are allowed to emerge.

The art therapist therefore has the outer frame of the session and the inner frame of the art work with which to work.

The therapeutic frame includes the time, space, place and the limits of therapy. Part of this frame, responsible for it but also a part of the picture within, is the therapist. In any psychotherapeutic encounter, the setting and the person of the therapist are the main constants. In art therapy, in addition to these, and central within the frame, are the pictures made by the client. At times when boundaries of the outer frame are unclear, such as very often in a psychiatric hospital, the picture, the inner frame of therapy, remains the stable factor.

(Schaverien 1989: 148)

Some art therapists work in situations where it is not possible to have a regular time and space to the sessions – in open groups in large institutions, for example. They will be working within different parameters than the art therapist who can maintain safe boundaries and may be working with a transference model. Both, however, will be looking at the images produced as the focus of the session. ·

Time boundaries

The maintenance of the boundaries means that the sessions start and finish on the agreed time. This sets the frame around the psychic container. Both therapist and client will know when the session will start and finish and so part of the work might focus on how this time is used. For example, if the time is changed by either client or therapist, if the client is late or indeed arrives very early and perhaps interrupts a previous session, this should be worked with in the session itself. The therapist must hold in mind that this has happened and make use of it in terms of understanding the material of the session as a whole. Although consciously there might be a very good 'reason' for lateness, the underlying reasons will have to be explored. Similarly with the therapist; if for some reason she finds herself dreading seeing a particular client, finds herself unwittingly late or unreasonably early and well prepared, the feelings of the therapist towards the client – that is, the counter-transference – must be looked at. Why is this happening? What is the client doing to make her feel this way? These responses must be considered in her work with this client.

At the end of the session, there might be the temptation to finish early as 'nothing seems to be happening'. This could be understood as a possibility of cutting off material before it has been allowed to surface. The therapist must be able to sit and wait and stay with the feelings of the impact of the end of the session and separation that follows. This may be an area of diffi-culty for the client and must not be cut off prematurely by the therapist's anxiety. Equally, if the session is allowed to overrun because something

terribly important came up at the last minute, why is this tolerated one week and not the next? This makes the client feel unsafe and certainly unsure, and does not permit her to reflect on why she chose to bring this important material just as the session was ending.

There are many examples of the way that clients use the time of the session which give important indications as to their unconscious processes. The client who is constantly turning up for the last 10 minutes, or leaves early without being able to stay with the difficult feelings that have arisen, could be said to be resisting looking at these issues. The therapist must remind her of the boundaries of time to ensure that she understands the impact of her behaviour in terms of the messages she is bringing to the therapeutic situation. 'Acting out' or breaking of therapeutic boundaries is one of the most overt ways the client expresses her difficulties. This is made obvious by the behaviour, although the underlying causes may be denied. The therapist uses these as important indicators of the psychic processes of the patient.

Setting the scene or therapeutic space

Both place and time create the therapeutic space. This is a term used in different ways according to the orientation of the therapist. Moreno used it to describe the 'stage' upon which psychodrama is enacted whereas others use it to describe intrapsychic space – that is, that realm within the personality in which there is room for manoeuvre and growth. Cox (1978) defines the therapeutic space as a term which can be used metaphorically to describe an invisible boundary to the 'space' within which the therapist and patient meet, and where the phenomena of transference and counter-transference are 'housed' (Cox 1978: 42). He goes on to say that the term refers to that space within and between those who share in a formal psychotherapeutic alliance. In other words, it includes the intrapsychic space of both patient and therapist and the interpersonal space between them. 'It is the shared air they breathe.'

In concrete ways, the interpersonal space can be clarified. The room to which the patient is introduced initially, should remain as constant as possible. Many different types of working space have already been described, but within the limitations of the therapy room some rules should be made clear over its use. For example, the art therapist might say that the materials are there for the patient to use as she wishes, but that they must stay in the room and any images or objects that are made will also remain in the room until the therapy has finished. Usually art therapists offer the patient the opportunity of a personal folder, or shelf for the safe storage of their art objects made in therapy, which emphasises the safe-keeping. Usually, clients will be curious and fantasise about who else uses the room, and this brings up strong feelings for the client. One way of expressing this

is to be curious about other clients' work and so consideration must be given to how much the work of other patients using this space is in evidence. Similarly, if the patient chooses to destroy her own work, that is her choice, but where the activity becomes extremely messy, with water, sand, paint spilling and running everywhere, this might be an opportunity for comment by the therapist to enable the client to gain some understanding of this activity. Other examples – such as a child choosing to use the whole bag of clay, defacement of the tables by an angry adolescent, drinking the paint water by a dementing man, mixing all the materials together by a severely psychotic patient – these are all times when the therapist must stay within the limits of what she considers appropriate or tolerable. Otherwise this activity will be experienced as being out of control and the anxiety will be too great to tolerate. Setting limits enables the anxiety to be contained.

Therefore, as with the physical place of the therapy room, the way the materials are used can be useful in understanding the mental processes and inner experience of the client (Sagar 1990). Other issues might be considered such as smoking, bringing food or drink into the session. Unless this is clarified initially, there is not room for understanding how these are being used. In some situations, for example, making a drink in the session is an important and integral part of the process. For another client, such as a resident in an alcoholic unit, bringing a drink into a therapy session would have a very different message. Smoking, eating and drinking can be 'used' by clients as ways of filling up the space, defending against the anxiety of being in the session and against the 'hunger' of dependency. During the work of the session, some infantile feelings might be experienced as painful and difficult. Smoking, for example, might serve to block issues that are emerging at important times and therefore affect the work of the session. The therapist can observe and, if necessary, interpret when cigarettes are used for this purpose.

There are other considerations, such as how much touching is tolerated or the degree of physical violence. If boundaries have not been clearly established then there are no guidelines and the therapist has to work from the position of trying to correct the behaviour or telling the patient not to do it rather than asking why they are choosing to do it now when it was mutually agreed that it was not acceptable in the session.

A good example of this was shown through some work with children in a primary school. It was felt necessary by the therapist to be clear about two conditions: no fighting and no swearing. This was the agreement made between therapist and children and if it occurred then it could be worked with as material for the session in terms of trying to help the children understand why it was happening. Why did they feel the need to break the agreement? Sweets were brought into the group although they were not allowed in school. Knowing that it was against the school rules meant that

the limits of the sessions and the relationship between therapist and children were being tested out. What was acceptable in the sessions had to be restated and how the group was affected in terms of the dynamics of the wider institution.

The therapy space provides a microcosm of the society at large and it was helpful for a child to be able to understand how the therapist, the school and the outside world fitted together. When these more 'concrete' things are established within the therapeutic space between therapist and client, it frees the path for the illusory quality of that space. Both therapist and client have a feeling about the therapeutic space based on the fantasy and experience of it. It is a concrete and existential fact for both therapist and client. In a paper entitled 'The Role of Illusion in the Analytic Space and Process', Khan (1974) writes:

> Clinically the unique achievement of Freud is that he invented and established a therapeutic space and distance for the patient and analyst. In this space and distance the relating becomes feasible only through the capacity to sustain illusion and to work with it ... It is my contention here that Freud created a space, time and process which potentialise that area of Illusion where symbolic discourse can actualise.

The clinical experience of the therapeutic space has a much firmer reality than is conveyed by the word illusion. Khan suggests that the relational process through which the illusion operates is the transference. The transference might be an illusion, but without genuineness, which endorses reality, transference might not have a chance to grow. The setting in which therapy takes place is 'secure' in the sense that there are physical walls and a door which is closed which serve as constant reminders to both art therapist and client that therapeutic space has physical limits. The physicality of the walls, doors, windows provides the possibilities of going in or out through the physical boundaries of the space. Remaining physically within the boundaries, similar tendencies can be expressed but are not seen as acting out or violation of boundaries but a means through which the patient expresses the same feelings within relative safety and the confines of the therapeutic space. In this sense the therapeutic space is an exact opposite of an illusion and the confinement to a space of a room intensifies rather than diminishes the feeling of safety. There is the symbolic illusion of therapeutic space and the mixture between symbolic and literal intensifies transference phenomena and therefore facilitates the therapeutic process.

Winnicott describes this in terms of the feeding of an infant:

> I think of the process as if two lives came from opposite directions, liable to come near each other. If they overlap there is a moment of illusion – a bit of experience which the infant can take as either his hallucination or a thing belonging to external reality.

(Winnicott 1945: 133)

This early nurturing situation frequently parallels the experience of therapeutic space or potential space – that which happens between mother and baby – also therapist and client.

In art therapy there is also the space created by the image-making process – the inner frame within the outer physicality of the session. The materials that are used to make objects or images – the paper, clay, and the objects used for the activity – also enhances the feeling of space. The activity of painting sets up a relationship between client and the paper, which can be exclusive of the therapist, but the therapist, attentive to the process at all times, holds the safety of the scene like the mother ever attentive to her infant.

Wood (1984) describes how painting in the presence of the therapist alters the intention and the dynamic balance. Dyad become triad, and this may be described as a triangulation around the potential space.

> Painting ceases to be part of the general flow of playing and becomes the focus of therapy. As the precipitate of the interaction between inner and outer worlds, the painting becomes a third world, unchanged by attitude time or distortions of memory, yet different aspects of meaning and relating can be discovered on different occasions. As the centre of triplex structure, the painting can survive a degree of impact from denials and distortions, and hold together fragmented elements from the other worlds, while continuing to make a statement about the contents as a whole ... The presence of the therapist produces a complementary triangulation in the mirroring process. The child is caught in response to self or to experience as reflected in the painting, and in response to the therapist's receptivity, whether or not interpretation is made.
>
> (Wood 1984: 68)

THE THERAPEUTIC PROCESS

If the art therapist maintains the safe space for the client, then the therapeutic process will become established. This refers to the sequence of integrating energies released in a patient as a result of her interaction with the therapist (Cox 1978). It is a process in which the patient is enabled to do for herself what she cannot do on her own. The therapist does not do it for her, but she cannot do it without the therapist. The task of the art therapist is to facilitate a re-engagement with the past. This facilitating process implies that the art therapist must be receptive so that the patient feels she can disclose anything. The art therapist must tolerate these disclosures and must be prepared for them to be understood in terms of the present – the here and now of the situation – but also in terms of the patient's past, particularly in terms of the patient's early experiences as an infant. As the focus of the session is narrowed onto the object of the image and onto the

person of the therapist, early infantile experiences will be experienced in the exploration of original relationships. This is how the transference relationship becomes established.

Transference

Transference occurs when the patient transfers strong, infantile feelings that originate from childhood experiences or early relationships onto the therapist. From Freud's original understanding of the phenomenon, he more specifically referred to transference as something that happens in the therapeutic exchange – a reliving and repossessing of stages of development that had been experienced at earlier times in psychosexual development. In his 'Fragment of an Analysis of a Case of Hysteria', Freud defines the transference situation in the following way:

> What are transferences? They are new editions or facsimiles of the tendencies and phantasies which are aroused and made conscious during the progress of the analysis, but they have this peculiarity which is characteristic for their species, that they replace some earlier person by the person of the physician. To put it another way: a whole series of psychological experiences are revived, not as belonging to the past, but applying to the physician at the present moment.
>
> (Freud 1905: 116)

So the phenomenon of transference occurs in the present situation between therapist and patient but involves aspects of the patient's life in terms of the relationships that occurred in the past. The therapeutic use of transference is to interpret these earlier stages or experiences, to integrate them and to understand them so that they become part of the conscious ego-controlled content of psychic life.

> The characteristic of psychoanalytic technique is this use of transference and the transference neurosis. Transference is not just a matter of rapport or of relationships. It concerns the way in which a highly subjective phenomenon repeatedly turns up in an analysis. Psychoanalysis very much consists in the arranging of conditions for the development of these phenomena at the right moment. The interpretation relates the specific phenomenon to a bit of the patient's psychic reality and this in some cases means at the same time relating it to a bit of the patient's past living.
>
> (Winnicott 1958:158)

Klein's ideas on transference differed somewhat from that of Freud. Particularly in the case of Dora, Freud came to understand that transference was linked to early traumas in the patient's history and how the trauma is re-lived, re-experienced, re-enacted as real life in the transference to the

therapist. Klein's emphasis is not, as in Freud's work, on the reconstruction of a past relationship which is transferred onto the therapist, but rather on the development within the setting of a relationship which displays all the mechanisms, anxieties, love, guilt, and phantasies which characterise the patient's way of dealing with life in the world outside.

One important reason for this revision of transference is that she was working with young children, when it is assumed the traumatising events were actually taking place and thus the re-enactments of the children were from their immediate present. The whole of their play was a series of enactments of all kinds of happenings and relationships. The vigour of this re-enactment made Klein convinced that children were enacting their phantasy life and this was the children's own way of relating their own worst fears and anxieties. The relationships enacted in the sessions were the expressions of the children's efforts to encompass the traumatic way they experience their daily lives.

In the practice of Kleinian analysis, the transference is therefore understood as an expression of unconscious phantasy, in the here and now of the session. The transference, however, is moulded upon the infantile mechanisms with which the patient managed her early experiences: 'The patient is bound to deal with his conflicts and anxieties re-experienced towards the analyst by the same methods he used in the past. That is to say, he turns away from the analyst as he attempted to turn away from his primal objects' (Klein 1952: 55).

These methods can be transferred onto or into the analyst and the setting and worked through so that they become less severe, and negative aspects can become more acceptable and be allowed to coexist with the more positive qualities. Klein emphasised one of the most important points in her play technique has always been the analysis of the transference.

> As we know in the transference on the analyst the patient repeats earlier emotions and conflicts. It is my experience that we are able to help the patient fundamentally by taking his phantasies and anxieties back in our transference interpretation to where they originated – namely in infancy and in relation to first objects. For by re-experiencing early emotions and phantasies and understanding them in relation to his primal objects, he can, as it were, revise these relations at their root and thus effectively diminish them.
>
> (Klein 1955: 16)

In her paper 'The Origins of Transference', Klein describes clearly the manifestations of transference:

> It is characteristic of psychoanalytic procedure that, as it begins to open up roads into the patient's unconscious, his past (in its conscious and unconscious aspects) is gradually being revived. Thereby his urge to

transfer his early experiences, object relations and emotions is reinforced and they come to focus on the psychoanalyst; this implies that the patient deals with the conflicts and anxieties which have been reactivated, by making use of the same mechanisms and defences in earlier situations.

(Klein 1952: 49)

She states that it follows that the deeper we are able to penetrate into the unconscious and the further back we can take the analysis, the greater will be our understanding of the transference. She continues:

The analysis of very young children has taught me that there is no instinctual urge, no anxiety situation, no mental process which does not involve objects, external or internal; in other words, object relations are at the centre of emotional life. Furthermore, love and hatred, phantasies, anxieties and defences are also operative from the beginning and are *ab initio* indivisibly linked with object relations. This insight showed me many phenomena in a new light.

(Klein 1952: 50)

As art therapists, this can inform our understanding of how the process of transference operates within art therapy and the effect of the introduction of the art object made within the relationship (Weir 1987). The process of making the image will set up three lines of communication: between therapist and client, client and painting, therapist and painting. The image often becomes the focus through which the transference relationship is explored. It holds the significance of feeling in that it acts as a receptacle for the phantasies, anxieties and other unconscious processes that are now emerging into consciousness for the client in therapy – it therefore must not only contain aspects of the transference relationship but a separate response also takes place in terms of the painting in its own right. Schaverien makes the distinction between two sorts of images:

There are times when the pictures merely exhibit the transference. These pictures enhance and widen the scope of psychotherapy but are distinct from the pictures which embody feeling. When the picture embodies feeling, and movement starts to occur in relation to the image created, it is then that change is possible through the medium of the picture itself. This is similar to the transference relationship to the therapist but here the focus is the picture.

(Schaverien 1987: 80)

Counter-transference

We are therefore concerned with the presence of an image within the therapy relationship – for both patient and therapist. In art therapy, both

transference and counter-transference develop through the response to the image itself. Counter-transference is the therapist's own feeling response to the client and the image in a therapeutic situation. This concept has gone through many changes in terms of its importance in modern psychoanalytic thinking. This came about through an increased emphasis on the human side of the interaction between therapist and patient and discarding the old idea of the need of the therapist to be a blank screen, which was perceived to be a defence (Ferenczi 1919, Fenichel 1941).

'The aim of the analyst's own analysis is not to turn him into a mechanical brain which can produce interpretations on the basis of a purely intellectual procedure, but to enable him to sustain his feelings as opposed to discharging them like the patient' (Heimann 1960). Her main thesis was that by 'comparing the feelings roused in himself with the content of the patient's associations and the qualities of his mood and behaviour, the analyst has the means for checking whether he has understood or failed to understand his patient (Heimann 1960). The therapist's feelings or counter-transference can be understood as a useful indicator of the patient's state of mind in terms of being a specific response rather than the intrusion of the therapist's own neurosis and neurotic transference into the psychoanalytic work.

Bion (1959) later formulated clearer pictures of the analyst as a container for the patient's intolerable experiences. Through the analytic process of putting these experiences into words, they are thereby contained. Bion developed the idea of the analyst as a maternal container and so it became possible to formulate in intrapsychic terms the interpersonal situation of the analytic setting. By being able to discern something of what is wrong, the important ego function involved in mothering, she can act in such a way as to relieve something of the distress. The mother's capacity of defining the distress is communicated in the act of dealing with the infant and this projects back the distress in the form of an understanding action. The child can then take back his experience of distress but in a form that has now been modified by the mother's function of defining and understanding the distress expressed and acting appropriately. It is now an understood experience and in the interaction between these two intrapsychic worlds, meaning has been generated. By taking in this understood experience he can now understand through mother's actions what a certain experience means; for example hunger. The accumulated occasions that these experiences have been understood begin to amount to an acquisition, inside himself, of an internal object that has the capacity to understand his experiences. This, as Segal puts it, 'is a beginning of mental stability' (Segal 1975: 135) and she described this mother–child interaction as a model for the therapeutic endeavour.

This 'model' of maternal containment gives a clear account of how the counter-transference is an important instrument for understanding the

therapeutic process. One problem might be whether the therapist's feelings may result in defensive evasion of her own feelings with subsequent harm to the progress of therapy. However, it is now understood that the mind of the therapist, with its fallibilities as well as its interpretations, is an extremely important aspect of the total situation. Clients can be sensitive to the therapist's feelings and the ways of coping with them. The patient's perception of the ability of the therapist to modify anxiety is an important factor. But it is usually not as simple as this as the patient does not just project onto the therapist, but is often quite skilled at projecting into particular aspects of the therapist – into the therapist's wish to be mother, the wish to be all-knowing or to deny unpleasant knowledge, or into her defences against it. Above all she projects into the therapist's internal objects (Brenman Pick 1985: 161).

Recently, ideas are developing of the importance of projective identification in this process. This is clearly described by Christopher Bollas:

> It is my view, and one shared by many British psychoanalysts, that the analysand compels the analyst to experience the patient's inner object world. He often does this by means of projective identification: by inspiring in the analyst a feeling, thought or self state that hitherto has only remained within himself. In doing this the analysand might also re-present an internal object which is fundamentally based on a part of the mother's or father's personality, in such a way that in addition to being compelled to experience one of the analysand's inner objects, the analyst might also be an object of one feature of the mother's mothering, and in such a moment the analyst would briefly occupy a position previously held by the analysand.
>
> (Bollas 1987: 5)

Interestingly, it is this issue that has created much debate recently within the understanding of counter-transference in art therapy. In a recent paper by David Mann (1989), he contends that the counter-transference response to the image is in fact a process of projective identification.

Interpretation

Interpretation involves making conscious unconscious processes and puts the understanding of this process into words. It can come from either the artist/patient in an attempt to make sense of the significance of her own work, or from the therapist who might see some important aspects emerging either in the picture or within the relationship. This can be either clarification of the transference process that has been going on between therapist and client or some feelings that are emerging through the image itself, in terms of symbolic statements. One of the advantages of using images in therapy is that they are concrete and are open to visual interpret-

ation more obviously than any verbal process. The disadvantage of this is that they are more vulnerable to misinterpretation in terms of the objective understanding of content. Care must be taken not to make rapid interpretations which might prevent or even deny the client the satisfaction of discovering and finding out for herself. Images are statements that have different layers of meaning, which can only be gradually unfolded. As the image is unique to the patient, it is only she who can ultimately come to understand its full significance, and premature interpretation can easily interfere with this delicate process. It is therefore important that the art therapist waits, receptive to the communication of the patient through the imagery until the patient is ready to begin to understand and let the meaning unfold.

The therapist's role is to remain open to the imagery and all its potential meaning for the patient and contain the anxiety and feelings that are generated in attempting to understand it. It is possible that a clear meaning will not emerge – much of the imagery produced in art therapy is a raw expression of unconscious material which only surfaces to consciousness after many weeks when connections can be made and understanding takes place. It is the importance of staying with the uncertainty or not knowing what it 'means' or 'says' which is central to the therapeutic process. Making things concrete can be harmful and pre-empt real understanding. How often one hears in a gallery: Well it's very nice – but what is it? The viewer is moved by the image but cannot stay with the uncertainty or lack of clarity because there is a need to understand it. The strength of feeling or impact of the image is in some way modified or even relieved if its content or form can be identified or 'named' in a similar way to Bion's idea of generating 'meaning'.

It is here that the counter-transference response of the therapist to the image is actually very important. Staying with the feelings that are brought up by the image acts as a very good indicator as to what might be going on in the communication through the image. The following example of work with a 10-year-old boy will serve to illustrate many of the points made.

> Peter was referred to art therapy as his behaviour was becoming increasingly unmanageable at school. This had occurred since his twin brother had been in therapy following a depressive episode. It was felt that art therapy would provide Peter with a space for himself to work out some of his own difficulties away from his brother and the home environment. He attended weekly and the session took place after the summer break, but in the knowledge that an end date for the sessions had been agreed. At this stage, Peter usually chose to work in clay which he modelled one week and left to dry ready for painting the next week. This was seen, by the therapist, as one way of continuing the session, making the links from one week to the next. He had carefully made two 'heads' which

he had put by the window to dry, and when he came the following week he rushed in and went straight towards them to see if they were still there. He picked them up and a piece broke off in his hands. 'Oh dear,' he said, 'need to get some glue.' He spent some time with the glue, sticking on the mouth and hat. He was distracted by the rim of the glue pot and became absorbed picking off the glue around the edge of the pot. He suddenly said, 'Why am I doing this?' and put it down. He began to paint each head very carefully, but having stuck on the head realised that this was stupid as he wanted to paint it and so took it off again. As the heads were carefully painted, the therapist was struck by the feeling that these were some kind of epitaph or heads of tombstones. As they were closely fixed together on the same base they could have represented the therapist and him, he and his brother, stuck together in their unconscious relationship or, alternatively, two aspects of himself which he was struggling to understand.

The therapist remained silent with her thoughts and as he completed the process, he stuck on the heads and painted the base black. His fingers once again were covered in glue, and as he propped the heads up with a pencil against the table, he became anxious about his sticky fingers and went to the toilet to wash off the glue. He spent a long time there, going 'Yuk, what a mess,' etc., leaving the therapist 'abandoned' with the full impact of the image.

When he returned the therapist asked him if he wanted to say anything about them. He described them as kind of underground people – Bill tells Bob what to do all the time – he is a sort of servant for Bill – rather peculiar really.

Th: Are they sunglasses? It looks as though they can't see or speak.
Peter: Well that's their sort of uniform. Underground – sort of criminals I think – don't really know what they feel or think.
Th: Are they like anyone you know?
Peter: I don't think so – Bill tells Bob what to do neither of them is like me.

He looked embarrassed – got up – wrote the names on a piece of paper and cut them out and stuck them onto the plinth with Blu-Tack. It was time to go and so he put them carefully back by the window. The next few sessions he worked on a house for Bill and Bob which had black windows – the house of a secret society which you could not see into or out of.

In the completed image (see Plate 5) there might be many interpretations that could be made about fusion and separation, aspects of double identity and twinship, internal aspects of conscious and unconscious processes, feelings which were kept underground which he cannot see or speak about.

But, importantly, while the image was being made the therapist felt that Peter was struggling with endings, burial, going underground. As the sessions were ending, he now had to face the integration of himself. He had experienced a space separate from his brother to which he now had to return, and these were threads on which the therapist was able to comment at appropriate moments. The image thus contained many layers of meaning but the therapist felt that the black was the clue to the fact that the ending was being addressed and worked towards.

Both therapist and patient will feel a whole range of feelings and responses to the images produced and this indicates the multiplicity of meanings that are being conveyed. Feelings, attitudes, even phantasies which occur to the therapist in the therapeutic relationship and through the image are evoked as a response to the patient's transference. If this is accepted and acknowledged, it deepens the patient's relation to the unconscious as held in the imagery.

It is in this transference and counter-transference response to the image that the complexity of the art therapy process lies. Kuhns (1983: 92) puts forward some definitions of transference in terms of the art object by referring to ways in which the artist reacts to, makes use of, re-interprets and restructures aesthetically the tradition within which the work is carried out. From this he defines counter-transference as the relationship between the audience and the work, which involves the viewer's response to the peculiarities of the object in terms of his or her associations and interpretations. A deeper understanding of those objects becomes clear through the transference relationship between therapist and patient and what is of interest to art therapists is Kuhns's idea of 'cultural' transference which he says occurs as objects become more fully integrated into the conscious awareness of individuals through psychoanalytic interpretations:

> The process is one of 'mirroring', reverberating and reflecting back and forth through several layers of consciousness; the consciousness of the object, of the artist, who creates the presentation of the self through the object or in the object, and of the beholder, who responds to all the layers with an accumulation of conscious and unconscious associations which include deeply private nodal points in the unique experience to which there are correspondences, but not identities, in others.
>
> (Kuhns 1983: 21)

Art therapy involves working towards some understanding of this, the process of communication between therapist, patient and image. As has been described, this is more than the essentially 'talking cure' of Freudian psychoanalysis that involves two people speaking together. Following the ideas of Bion, Winnicott and the later psychoanalysts, the idea of mother–infant relationships moves us closer towards understanding the complexity of the process of interpretation or making unconscious processes

conscious. For Winnicott, the mother–child relationship in which commu-
nication was relatively non-verbal changed the role of interpretation in
psychoanalytic treatment. Language, in Winnicott's theory, was merely an
extension of the child's capacity for communication and separateness, but
is not in itself considered formative of his identity. It is the sociability from
the very beginning that pre-dates language, that his work is based on. The
infant does not speak but survives because he communicates with a recep-
tive object (Winnicott 1965a: 117).

There is a language of maternal care that is not made only of words and,
for Winnicott, verbal interpretations were a form of mothering. The ther-
apeutic setting is a medium for personal growth, not exclusively the provi-
sion of a convincing translation of the unconscious. The therapist, like the
mother, facilitates by providing opportunity for communication and its
recognition. Just as a feed can be seen as an interpretation of the infant's
cry by the mother, so the therapist's verbal interpretations can be like a
feed for the patient in language.

By extending this analogy, Winnicott also warns against the dangers of
early interpretations:

> It is very important except when the patient is regressed to earliest
> infancy that the analyst shall not know the answer except insofar as the
> patient gives the clues. Magical interpretations pre-empt the patient's
> separateness, he is robbed of a mind of his own. The mother does not
> give the infant a feed, the infant gives the mother the opportunity to feed
> him. The clues provided by the patient facilitate the analyst's capacity to
> interpret. It is not so much a question of giving the baby satisfaction as
> of letting the baby find and come to terms with the object.
>
> (Winnicott 1965b: 59–60)

Winnicott implies that language, in the form of an accurate interpretation
for which the patient is not ready, can reach his innermost being, evoke his
most primitive defences and acquire an unexpected potency.

> Here there is danger if the analyst interprets instead of waiting for the
> patient to creatively discover. If we wait we become objectively
> perceived in the patient's own time, but if we fail to behave in a way that
> is facilitating the patient's analytic process (which is equivalent to the
> infant's and child's maturational process) we suddenly become not-me
> for the patient and then we know too much, and we are dangerous
> because we are too nearly in communication with the central still and
> silent spot of the patient's ego-organisation.
>
> (Winnicott 1965c: 189)

In this context language is potentially a terrifying maternal object. The
over-interpretive analyst becomes a tyrannical mother and language is
integral to her power. The unacceptable interpretation, like a maternal

impingement, can only be reacted to by the patient, not taken in and used. A good interpretation is something the patient can entertain in her mind. The child needs to escape into himself from the intrusive mother which forms the origins of the capacity to be alone and the person's relationship with himself.

This can be seen from the example given that an early interpretation of Peter's heads would have prevented him from working with their meaning for him over several weeks and for him to come to understand their significance for him. He experienced mother as intrusive, which was an aspect that was worked with in the transference. The counter-transference response in the therapist might have been to verbalise her feelings about her understanding of Bill and Bob without waiting until the many meanings were allowed to emerge into consciousness for both therapist and Peter. In his relationship with the therapist, Peter was able to work with some aspects of his relationship with mother by thinking about different aspects of himself, his relationship with his twin and also in terms of the therapist. The image represented the symbolic content of all these expressions of feeling in one object and thereby holds the therapeutic significance in the product but also in the process of making it. The image can literally 'speak' for itself.

REFERENCES

Bion, W. (1959) 'Attacks on Linking', *International Journal of Psychoanalysis*, **XL**, pp. 308–15; republished (1962) in *Second Thoughts*. London, Heinemann.

Bollas, C. (1987) *The Shadow of the Object: Psychoanalysis of the Unthought Known*. London, Free Association Books.

Brenman Pick, I. (1985) Working Through in the Counter Transference, *International Journal of Psychoanalysis*, **LXVI**, pp. 157–66.

Cardinal, R. (1989) 'The Primitive Scratch', in Gilroy, A. and Dalley, T. (eds) *Pictures at an Exhibition*. London, Tavistock/Routledge.

Champernowne, I. (1971) 'Art and Therapy: an Uneasy Partnership', *American Journal of Art Therapy*, **X** (3) April, pp. 131–43.

Cox, M. (1978) *Structuring the Therapeutic Process: Compromise with Chaos*. Oxford, Pergamon.

Ehrenzweig, A. (1967) *The Hidden Order of Art*. London, Paladin.

Fenichel, O. (1941) *Problems of Psychoanalytic Technique*. New York, Psychoanalytic Quarterly.

Ferenczi, S. (1919) 'Theory and Technique of Psychoanalysis', in *Further Contributions to Psycho-Analysis*. London, The Hogarth Press.

Freud, S. (1905) 'Fragment of an Analysis of a Case of Hysteria', in *Standard Edition*, Vol. VII. London, The Hogarth Press.

Heimann, P. (1960) 'Counter Transference', *International Journal of Psychoanalysis*, **XXXI**, pp. 81–4.

Khan, M. (1974) 'The Role of Illusion in the Analytic Space and Process', in *The Privacy of the Self*. London, The Hogarth Press.

Klein, M. (1952) 'The Origins of Transference', in *Works of Melanie Klein*, Vol. III, pp. 48–56. London, The Hogarth Press.

Klein, M. (1955) 'The Psychoanalytic Play Technique', in Klein, M., Money-Kyrle, R.E. and Heimann, P. (eds) *New Directions in Psychoanalysis* (1977). London, Maresfield Reprints.

Kuhns, F. (1983) *Psychoanalytic Theory in Art.* New York, IUP.

Mann, D. (1989) 'The Talisman or Projective Identification?', *Inscape* (Autumn).

Naumberg, M. (1958) 'Art Therapy: its Scope and Function', in Hammer, E.F. (ed.) *Clinical Applications of Projective Drawings.* Springfield, C.C. Thomas.

Newmarch, R. (1906) *Life and Letters of Peter Illich Tchaikovsky.* London, John Lane.

Rogers, C.R. (1970) 'Towards a Theory of Creativity', in Vernon, P.E. (ed.) *Creativity.* Harmondsworth, Penguin.

Sagar, C. (1990) 'Working with Cases of Child Sexual Abuse', in Case, C. and Dalley, T. (eds) *Working with Children in Art Therapy.* London, Tavistock/Routledge.

Schaverien, J. (1987) 'The Scapegoat and the Talisman: Transference in Art Therapy', in Dalley, T. *et al. Images of Art Therapy.* London, Tavistock.

Schaverien, J. (1989) 'The Picture within the Frame', in Gilroy, A. and Dalley, T. (eds) *Pictures at an Exhibition.* London, Tavistock/Routledge.

Segal, H. (1975) 'A Psychoanalytic Approach to the Treatment of Schizophrenia', in *Studies of Schizophrenia.* Ashford, Headley Bros.

Storr, A. (1972) *The Dynamics of Creation.* Harmondsworth, Penguin.

Weir, F. (1987) 'The Role of Symbolic Expression in its Relation to Art Therapy: a Kleinian Approach', in Dalley, T. *et al. Images of Art Therapy.* London, Tavistock.

Winnicott, D.W. (1945) 'Primitive Emotional Development', *International Journal of Psychoanalysis,* **XXVI**, pp. 137–43.

Winnicott, D.W. (1958) 'Transitional Objects and Transitional Phenomena', in *Through Paediatrics to Psychoanalysis.* London, Tavistock.

Winnicott, D.W. (1965a) 'Child Analysis in the Latency Period', in *The Maturational Processes and the Facilitating Environment.* London, The Hogarth Press.

Winnicott, D.W. (1965b) 'Ego Integration in Child Development', in *The Maturational Processes and the Facilitating Environment.* London, The Hogarth Press.

Winnicott, D.W. (1965c) 'Communicating and Not Communicating, leading to a Study of Certain Opposites', in *The Maturational Processes and the Facilitating Environment.* London, The Hogarth Press.

Wood, M. (1984) 'The Child and Art Therapy: a Psychodynamic Viewpoint', in Dalley, T. (ed.) *Art as Therapy.* London, Tavistock.

Chapter 4

Art and psychoanalysis

When art activity is understood in terms of spontaneous expression giving access to unconscious material, the links with psychoanalytic practice become clearer. The following sections offer an exploration and introduction to some of the literature and background of ideas on art and psychoanalysis that have influenced and formed present thinking about art and therapy. It is intended to be more of an introduction for prospective art therapists to encourage them to make their own forays into the subject, rather than a critical review, but inevitably the authors' bias will be apparent at times. Emphasis is placed on those writers who have made significant contributions to the debate, tracing the re-evaluation of primary process thinking and its implications. Links are made from Freud's view of art as symptomatology – 'Every psychoanalytic treatment is an attempt at liberating repressed love which has found a meagre outlet in the compromise of a symptom' (Freud 1907: 113) – to the influence of later writers, such as Adrian Stokes (1972), who give full value to notions of destructive and reparative forces in art and the interplay of primary and secondary processes.

For the person getting lost in new terminology and concepts, it may be helpful to consider that the basis of the discussion is about the nature and interplay of 'desire' in a painting. It is a study of feelings, mental processes which accompany and formulate those feelings and particularly of the intense loves and hates of the infant and their repetition and interplay in later life.

FREUD AND THE CLASSICAL ANALYTICAL VIEW OF ART

The visitor to the Freud museum in Hampstead will be delighted and surprised by Freud's study and consulting room which contains evidence of his interest in ancient and near Eastern *objets d'art*. These antiquities are placed around his desk and shelves and divert interest from the couch.*

*The Freud Museum, 20 Maresfield Gardens, London NW3 5SX.

Gombrich (1966) comments on how 'The mysterious dream-like aura of these images, of course, retained its fascination for the explorer of dreams'. The pleasure that Freud gained from these tiny statues, and evidence in his letters of his enjoyment of visiting galleries, is at variance with his well-known uncompromising hostility to modern art movements and his famous comments on the artist.

Freud wrote a number of books and papers on art and artists in which his understanding is based on his working model of the mind. One of Freud's earliest and most fundamental ideas was the assumption of a primitive psychic apparatus which had the function of regulating states of tension, by discharging instinctual impulses. There were two modes of discharge, primary and secondary. Primary processes are characteristic of unconscious thinking and occur earlier in each individual than secondary processes which are characteristic of conscious thinking. Primary process is governed by the pleasure principle and reduces the discomfort of instinctual tensions by hallucinating wish-fulfilment. Secondary process thinking is governed by the reality principle and reduces the discomfort of instinctual tension by adaptive behaviour. Freud believed that, as an individual matures, progression could only be made by the repression of this earlier infantile way of dealing with instinctual demands. Primary process is therefore seen as inherently maladaptive, something to grow out of. Dreaming is most characteristic of the primary process where images may be subject to condensation and displacement, i.e. they can become confused and can replace and symbolise one another, ignoring categories of space and time. Thought is most characteristic of secondary processes, using words and the laws of grammar and formal logic.

Freud saw the human ego as being slowly educated by the reality principle and external necessity to renounce a variety of objects and aims of the pleasure principle. One of the processes by which instinctual energies are discharged in non-instinctual forms of behaviour is that of sublimation. This process is described by Anna Freud as 'the displacement of the instinctual aim in conformity with higher social values'. As the ego has to give up these primitive sexual and aggressive instincts, they are given further existence in the form of phantasies, by compensation. Freud compares the creation of the 'mental realm of phantasy' to a 'nature reserve', rather poetically it seems, yet 'everything, including what is useless and even what is noxious, can grow and proliferate there as it pleases' (Freud 1916: 372).

This rather harsh view of a human jungle of the unconscious echoes the social mores of his time where to be a 'creature of reason' was vastly superior to being an 'animal of pleasure'. It is in his discussion of 'symptom formation' that Freud's famous sayings on artists reach their zenith.

For there is a path that leads back from phantasy to reality – the path,

that is, of art. An artist is once more in rudiments an introvert, not far removed from neurosis. He is oppressed by excessively powerful instinctual needs. He desires to win honour, power, wealth, fame and the love of women, but he lacks the means of achieving these satisfactions.

(Freud 1916: 375)

Freud thought that neurotic symptoms arise out of a conflict between the pleasure and reality principles. The need to satisfy the libido is filled by a compromise between the two forces that are reconciled in the form of a symptom. Of artists Freud thought: 'Their constitution probably includes a strong capacity for sublimation and a certain degree of laxity in the repressions which are decisive for a conflict.' Whereas other people only have a limited satisfaction from phantasies, the artist 'understands how to work over his day dreams in such a way as to make them lose what is too personal about them and repels strangers and to make it possible for others to share in the enjoyment of them' (Freud 1916: 376).

In Freud's view, the artist gains pleasure from this representation of unconscious phantasy gaining relief of his repressed instincts. To summarise, Freud formulated the classical analytical view of works of art being the product of sublimation, substitutes for primitive sexual and aggressive instincts. The original instinctual aim is displaced in conformity with higher social values. As other people view the pictures they desire consolation and alleviation from their own sources of pleasure in their unconscious which have become inaccessible to them. 'He earns their gratitude and admiration and he has thus achieved through his phantasy what originally he had achieved only in his phantasy – honour, power and the love of women' (Freud 1916: 376-7). Put into these terms Freud is seeing the artistic process as a regression to an early infantile state of consciousness, a turning away from reality to fantasy, dominated by the primary process. Therefore 'he turns away from reality and transfers all his interest and his libido too, to the wishful constructions of his life of phantasy, whence the path might lead to neurosis' (Freud 1916: 376).

'Clearly to Freud there was no artistic value in the primary process as such' (Gombrich 1966). In 'An Autobiographical Study', Freud (1925) writes of a temptation to make a general analysis of poetic and artistic creation, but this was never fulfilled. In fact, Freud later developed his mapping of the inner world to a less rigid system. The ego, the id and the superego replacing the two mental processes, primary (unconscious) and secondary (conscious). The ego, which replaced the 'conscious', becomes 'that part of the id which has been modified by the direct influence of the external world' (Freud 1923). In this new configuration, what is unconscious is not necessarily repressed and the ego is not necessarily conscious. Later writers, such as Rycroft (1985) and Wollheim (1970) reject the idea that the primary processes are archaic and maladaptive and have regretted

that Freud did not reconsider the constructive role and value of uncon-
scious processes.

Freud was unable to embrace artistic activity as anything except the
product of sublimation, and neither distinguished between good and bad
art, nor, more importantly, between a work of art and a neurotic symptom.
His comments about art have to be gleaned from the main issues of his
writings but the most central description of his views can be found in his
three studies of artists and their work. The first two are the studies of Leon-
ardo da Vinci (Freud 1910) and the Moses of Michelangelo (Freud 1914).
Wollheim suggests that the main distinction between these two different
studies is in terms of expression. In Leonardo, Freud explores what the
artist does in his works and, in Moses, he studies what is expressed by the
subject of the work. The whole Leonardo paper originates from the anal-
ysis of a childhood memory or possible phantasy, and what is known of
Leonardo's infancy. It is both speculative and a very clear vehicle for
exploring Freud's current thinking about the genesis of one particular type
of homosexuality and the first full emergence of the concept of narcissism.
Freud gives a detailed construction of Leonardo's life from his earliest
years and relates it to later known characteristics of his personality. For
instance, it is known that Leonardo did not finish his paintings and worked
very slowly. Freud writes that through Leonardo's identification with his
father (who had abandoned him and his mother in his early years), he too
'left' his paintings by not finishing them. He thinks that this 'rebellion'
against his father established his scientific researcher attitude and quotes
from Leonardo: 'He who appeals to authority when there is a difference of
opinion works with his memory rather than with his reason.'

This keenness as a researcher and his lack of sexual interest are
connected, in Freud's view, as passions transformed into a thirst for know-
ledge. His libido was not repressed but sublimated from the beginning into
curiosity and attached to the powerful instinct to research. The first wish to
research is seen as the infant's original sexual researches, curiosity about
parental intercourse.

> We should be most glad to give an account of the way in which artistic
> activity derives from the primal instincts of the mind if it were not just
> here that our capacities fail us. We must be content to emphasise the fact
> – which it is hardly any longer possible to doubt – that what an artist
> creates provides at the same time an outlet for his sexual desire.
>
> (Freud 1910: 226)

Freud defends himself against possible accusations of having written a 'psy-
choanalytical novel' by the 'attraction of this great and mysterious man'
(Freud 1910: 228). The Leonardo paper starts a tradition of 'analytic
biography' on great artists and writers. Like his clinical case studies it

attempts to exhibit the dependence of the adult capacities and proclivities on infantile sexuality. Leonardo's paintings become another item of Leonardo's symptomatology. Freud explores the 'Mona Lisa' and the 'Madonna and Child with St Anne' and uses 'evidence' from the pictures to confirm the link he has postulated between Leonardo's later painting and a certain 'infantile complex'. Gombrich suggests that Freud approaches these two paintings as if they were the phantasies of a patient: 'He always took it for granted that what we must seek in the work of art is the maximum psychological content in the figures themselves' (Gombrich 1966: 33).

This paper on Leonardo is the clearest exposition of Freud's views on the nature and workings of the mind of the creative artist. The problem with the 'analytic biography' tradition is that it does not account for Leonardo's extraordinary gifts and achievements or explain the origin of the creative impulse. However, when a work of art had a powerful effect on him, Freud needed to try to explain what caused that effect.

> Whenever I cannot do this, as for instance with music, I am almost incapable of obtaining any pleasure. Some ritualistic, or perhaps analytic, turn of mind in me rebels against being moved by a thing without knowing why I am thus affected and what it is that affects me.
>
> (Freud 1914: 253)

He asks almost in some exasperation why the artist's situation could not be communicated and comprehended in words 'like any other fact of mental life'. He therefore has to know the meaning of the work and he has to be able to 'interpret' it. An example of this was Freud's fascination for the Moses of Michelangelo, visiting it every day for three weeks, studying it, measuring it and even drawing it. 'I have often observed that the subject matter of works of art has a stronger attraction for me than their formal and technical qualities' (Freud 1914: 253).

Interestingly, Freud describes 'Moses' as 'Inscrutable' and also comments on his 'inward fire' and 'outward calm of his bearing'. His conservative approach to art was, in the nineteenth-century tradition, judging a painting on its 'spiritual content' but, influenced by Giovanni Morelli, the founder of scientific connoisseurship, Freud drew up a 'scientific method', a schedule of forms. Freud felt that this was closely related to the technique of psychoanalysis: 'It too is accustomed to derive secret and concealed things from despised or unnoticed features, from the rubbish dump, as it were, of our observations' (Freud 1914: 265).

The whole paper on Moses sets out to explore whether 'Moses' is a 'character study' or 'a particular moment in his life'. Freud's argument that Moses is a study of a particular moment in his life is based on small touches that would normally 'slip past the barriers of attention' (Wollheim 1970). It rests on the positioning of the right hand on his beard and the angle of tablets and he infers that the 'moment' of the statue is not the inception of

a violent action but the remains of a movement that has already taken place. Freud concludes:

> ... so that the giant frame with its tremendous physical power becomes only a concrete expression of the highest mental achievement that is possible in a man, that of struggling successfully against an inward passion for the sake of a cause to which he has devoted himself.
>
> (Freud 1914: 277)

Peter Fuller (1980), in *Art and Psychoanalysis,* explores 'Moses' and also more briefly 'Leonardo' to discuss Freud himself. He suggests that the two very different approaches to the papers represent two sides of Freud's investigations. The Leonardo, the intuitive, imaginative, and the Moses, an empirical study of observation and measurement. It is possible that Freud perhaps tried to control his emotional response to the Moses by scientifically trying to unlock its secret. (Fuller also posits that the Moses paper reflects the position and schisms in the psychoanalytical movement at the time. With the split over Adler and Jung, Freud was having to hold the movement together.)

These two very different papers do offer insight into Freud's view on art and artists, into the rationalist approach over emotions of the Western Intellectual Tradition and also insight into the workings of Freud's mind. The third study of an artist and his work is that of the author Jensen and his novel *Gradiva.* This study of creative writing has been included because it is in such stark contrast to Freud's writings on the visual arts. Of the writer, Freud (1907: 68) says: 'The description of the human mind is indeed the domain which is most his own; he has from time immemorial been the precursor of science, and so too of scientific psychology' (in his knowledge of pathological mental states and the frontier between these and normal life that we cross several times a day).

In 'Delusions and Dreams in Jensen's *Gradiva*', Freud (1907) interprets the dreams of the character Norbert Hanold, the hero of the story. The story is an enjoyable romance and Freud's analysis with accompanying theoretical material from the Interpretation of Dreams is meticulously detailed. It is the story of a young man who has repressed his erotic instincts and put all his life's energies into archaeology. Hanold is attracted to a relief of a young girl stepping along revealing her sandalled feet. He enters into a search for her, travelling to Pompeii, unaware that his infatuation with the girl on the relief is actually a repressed affection for a childhood playmate, Zoe. His love and thought for Zoe appear disguised in his dreams, and it is these fictional dreams that Freud analyses. In the story, Hanold flees to Pompeii only to find what he has flown from, the real Zoe. She gradually cures him of his delusions and reveals herself to him in a manner similar to psychotherapy, making conscious what has been repressed, and awakening his feelings to love.

Throughout this paper Freud praises creative writers for their insight 'but creative writers are valuable allies and their evidence is to be prized highly, for they are apt to know a whole host of things between heaven and earth of which our philosophy has not yet let us dream' (Freud 1907: 34).

It is perhaps both frustrating and disappointing that Freud's admiration for the creative writer and appreciation of his ability to work with his unconscious should not have been extended to include a study of all the arts which would have been such a valuable contribution. For instance, he compares the workings of Jensen's mind and Freud's own approach to studying the mind:

> Our procedure consists in the conscious observation of abnormal mental processes in other people so as to be able to elicit and announce their laws. The author no doubt proceeds differently. He directs his attention to the unconscious in his own mind, he listens to its possible developments and lends them artistic expression instead of suppressing them by conscious criticism ... But we need not state these laws, nor even be clearly aware of them; as a result of the tolerance of his intelligence, they are incorporated within his creations.
>
> (Freud 1907: 115)

Both in his paper on 'Leonardo' and in 'An Autobiographical Study' Freud admits the limits of his knowledge about artistic gift, work and function. Saying that although psychoanalysts study the artist's life, experiences and works and construct his mental constitution and instinctual impulses at work, 'It can do nothing towards elucidating the nature of the artistic gift, nor can it explain the means by which the artist works – artistic technique' (Freud 1925: 65), and 'Since artistic talent and capacity are intimately connected with sublimation we must admit that the nature of the artistic function is also inaccessible to us along psychoanalytic lines'(Freud 1910: 228). He follows this with the suggestion that the answer might lie in 'biological research' and this path has been followed by later writers (Fuller, and close observers of early human relationships such as Winnicott and Milner).

MELANIE KLEIN

Melanie Klein was a pioneer of child analysis, discovering that all child's play had symbolic significance. This led to the development of her play technique in which the main task is to understand and to interpret the child's phantasies, feelings, anxieties and experiences expressed by play, or, if play activities are inhibited, the causes of the inhibition.

Her work developed particularly from the Freudian concept of Life and Death Instincts ('Beyond the Pleasure Principle': Freud 1920). She was to lay great stress on the ambivalence between love and hate and emphasised

the child's powerful innate 'instincts' more than the environment. Later, object-relations theorists were to give the actual external environment greater importance, which was to include the mother and the care for her new-born baby as a first environment (Winnicott 1988).

The terminology of object relations can be confusing. The reader might reasonably think that it refers to 'things' rather than people. 'In psychological writings, objects are nearly always persons, parts of persons, or symbols of one or the other' (Rycroft 1977: 100).

Objects can be external, where the subject recognises the object as being outside herself, or internal. An internal object has acquired the significance of an external object but is a phantom (Rycroft 1977) – an image occurring in phantasy which is reacted to as real. They are images, derived from external reality through introjection and conceived to be located in internal reality. Kleinian theory is an object theory, not an instinct theory, because it attaches central importance to resolution of ambivalence towards the Mother and Breast. It does, however, attach little importance to the infant's experience of actual mothering which later object-relations theorists were to do (Fairbairn 1939, Winnicott 1988). Kleinian analysis, therefore, follows Freud in having a dual instinct theory but prefigures later object-relations theory in attaching great importance to the first year of life.

The difficulty for the infant is how to cope with the overbearing instinctual drive in relation to the Mother and the Breast. Love and desire for it when it satisfies; hate and destructiveness for it as it frustrates. Envy at weaning that the 'giving' breast does not belong to it, is not under its control and fear at the loss of it. The infant has phantasies about Mother and the Breast. Phantasies are seen to be the mental representation, the psychic representative of instinct. Phantasies colour the infant's experience of real objects and the impact of reality constantly modifies phantasy life. Phantasy life expresses itself in symbolic ways: 'All art is symbolic by its very nature and it is a symbolic expression of the artist's phantasy life' (Segal 1975: 800).

In Kleinian terms the ego is innate, not formed by the reality principle as we saw earlier in Freud. The growth of the ego is a product of a continual process of projection and introjection. Through these mechanisms a whole world of internal objects is formed with their own phantasised relationships: 'It is this internal world, with its complex relationships, that is the raw material on which the artist draws for creating a new world in his art' (Segal 1975: 800).

Klein emphasises two worlds, an inner and outer reality, whereas Freud uses the terms unconscious and conscious. Freud outlines libidinal phases – oral, anal, genital – through which the infant develops. Klein describes two positions between which the infant oscillates in the first year of life. The first of these is the paranoid-schizoid position where the infant deals with her ambivalence towards the breast by splitting it into two separate part

objects. The infant also splits the ego and projects the destructive feelings onto the bad object (breast) by which she then feels persecuted. It is a defence against realising that the 'good' breast is not as idealised as she would like it to be in her phantasy. The second is the depressive position. The infant learns to accept ambivalence, that good and bad are aspects of the same whole object – the mother – who has an independent life of her own. In the depressive position the infant experiences total desolation. She feels that her destructive hateful feelings have destroyed the good breast and feels loss and guilt. This leads to a desire, a wish to restore and recreate, the lost loved object both outside and within the ego. 'These reparative impulses lead to growth' (Segal 1975: 800) and she stresses their importance in human functioning. Reparative impulses contribute to good relationships, sublimation to work 'and are a fundamental drive in all artistic creativity'.

In her discussion of 'Art and the Inner World', Segal refers to Melanie Klein's work on the rebuilding of the inner world in mourning. Every time we experience loss we are taken back to the depressive position and our original loss is relived. In mourning, we have to build our inner world as well as our external world of relationships. She feels that the artist is working through again the infantile depressive position every time a new piece of work is embarked on: 'The artist's aim is always, even if he is not quite aware of it himself, to create a new reality. It is this capacity to create and impose on us the conviction of a new reality that is, to me, the essence of art.'

In Klein (1948) she discusses the experience and work of the painter Ruth Kjar, written about by Karin Michaelis. Kjar suffered depression in the midst of happiness, feeling 'an empty space which she could never fill'. In a house full of pictures, space was suddenly created as an artist removed one of his pictures which he had only lent the family. 'This left an empty space on the wall, which in some inexplicable way seemed to coincide with the empty space within her' (Klein 1948: 232). She decided to paint in the space until a new picture could be obtained as the effect of the empty space was so devastating to her. This started her career as an artist and she went on to paint as part of her life. 'She was on fire, devoured by ardour within. She must prove to herself that the divine sensation, the unspeakable sense of happiness she had felt (while painting) could be repeated' (Klein 1948: 233).

All Kjar's work was either of women or female relatives. Klein makes a connection between the 'empty space' and the profound anxiety experienced by girls, the equivalent of castration anxiety. In the early stages of the Oedipus conflict the little girl wishes to steal the imagined contents of her mother's body for herself and destroy the mother. This is followed by anxiety and fear of retaliation, that her own body will be destroyed and mutilated. Klein concludes: 'It is obvious that the desire to make repara-

tion, to make good the injury psychologically done to the mother and also to restore herself was at the bottom of the compelling urge to paint these portraits of her relatives' (Klein 1948: 235).

Artists are therefore able to recreate their own inner worlds and to give them life in the external world. This latter quality is important because it mirrors the original recognition that mother has an independent life of her own.

Peter Fuller (1980) makes a very readable investigation of the Venus de Milo, tracing its history, damage and installation in the Louvre. He outlines attempts to date it, place it, and the varieties of reconstruction in following decades with their justifications which makes a fascinating detective story. He questions how it is that the fragmented Venus can appear to us as more 'vivid and authentic than the lost whole'. He finally concludes, after an exposition of Kleinian thought, that the Venus is a representation of the internal mother who has survived the ravages of phantasised attack. Despite fragmentation the reparative element remains dominant – she has endured throughout the centuries.

For true reparation to take place there must be admission of the original destruction or there will only be denial. Elements of ugliness and beauty need to combine in a picture, the destroyed and the made whole. For Segal a certain 'incompleteness' is essential in a work of art: 'We must complete the work internally; our own imaginations must bridge the last gap' (Segal 1975: 800).

Adrian Stokes (1972) took up a similar position to Segal on the depressive position and restoration of the mother's body but differed in finding elements also of the paranoid-schizoid position in both artistic creativity and aesthetic experience. He associated the two modes of art, carving and modelling, with the paranoid-schizoid and depressive positions respectively. The expression is of both fusion with mother and sadistic attacks. So one can experience both a feeling of 'oneness with the breast', and therefore the world, and recognition of a separate object, the whole person of the depressive position. Segal saw this as 'manic defence – the oceanic feeling against the depressive experience' and also manic reparation disguised in sentimentality and over-sweetness (Stokes 1972: 424).

MARION MILNER

Marion Milner is a central figure in any enquiry into art and psychoanalysis. She embodies and links the development of thinking about analysis, creativity and the artistic process. Starting her working career with children and research into learning and social experience in schools, she had a brief Jungian analysis before entering into a full Freudian analysis and eventually trained as a Freudian analyst. While training, and after, she attended supervision and seminars with both Melanie Klein and Donald

Winnicott. Her personal explorations into painting and her analysis of the experience make absorbing and refreshing reading in *On Not Being Able to Paint* (1950). She later extended and revised the ideas through an illuminating presentation of a treatment of a schizophrenic patient who spontaneously began to draw in *The Hands of the Living God* (1969). Her collected papers, *The Suppressed Madness of Sane Men* (1989), complete her life's work on analysis, creativity and the artistic process and provide essential reading for any would-be art therapist. As Honorary President of the British Association of Art Therapists, Marion Milner is a figurehead and a person to emulate for many art therapists.

Whereas previous analysts had seen psychic creativity above all 'to preserve and re-create the lost object', Marion Milner saw this as a secondary function of art. The primary function was in 'creating what has never been seen' by means of a newly acquired power of perception through the interaction of conscious and unconscious modes of thinking typified in the creative process. The controversy centres around whether one is merely re-making what one has previously had, but lost, or whether there is a creation of new attitudes and relationships on the basis of the newly created powers of insight into the inner world. This is, of course, of crucial importance to analysts and artists because this poses the question whether change is possible. Can something new and original be made?

To trace the genesis of her ideas, it is useful to start with her own experience as a novice painter. Through her own experience of painting, she realised that the artist's feelings could be conveyed through spatial representation. She discovered that artistic skills, such as how to draw outline or the nature of colour, are not only learnt about the outside external world but 'underwent revisions and learning' in the inside world. She began by trying to draw spontaneously, not to have preconceived ideas, but she found that the drawings 'expressed the opposite of the moods and ideas intended'. The discovery of spatial relationships between objects in painting led her to an exploration of the relationship between the self and the world and problems around distance/separation, having/losing.

> In play there is something half way between day dreaming and purposeful instinctive or expedient action. As soon as a child has moved in response to some wish or fantasy, then the scene created by play is different, and a new situation sets off a new set of possibilities; just as in free imaginative drawing the sight of a mark made on paper provokes new associations; the line, as it were answers back and functions as a very primitive type of external object. (Milner 1955: 92)

She thus found that there are spiritual dangers in painting. Working with outline forces the knowledge that only an imposed outline separates the world of fact from the world of the imagination. New experiments in painting arouse such opposition because there is a fear of letting in

madness. (For example, the furore over the 'Bricks' (Carl André) in the Tate.) Because one interacts with a painting during the process of making it, giving it something of oneself, it can then take one by surprise, and one has to then face a loss of control of what is given. Monsters within the imagination can be discovered, '. . . the imaginative body could often feel contracted to a tight knot inside, like a spider hiding deep in its hole' (Milner 1955: 42). When a painter begins to work on something in the external world, the medium and the imagination work together to produce something not quite as one expected so that the artist has to come to terms with 'nature inside'.

Milner explores the early relationship between mother and child discussed in the prevous section, the illusion of separateness and eventual disillusion and recognition of independent existence. She suggests that 'spreading the imaginative body around what one loves' is a way of dealing with separation and loss, and states one of the functions of painting as restoring and recreating what one had loved and internally hurt or destroyed.

Milner further discusses the educational tradition which separates subject and object, fostering an intellectual knowing that is only half of our relation to the world. Reason and logic can make for a stultifying deadness when separated from feeling. What is the role of the intuitive image? She feels that it is quicker, and it takes much longer to describe something in logical terms. It is more comprehensive, stretching back through the whole of one's experience, connecting past with present. It also embraces a bodily experience, a deeper rooted kind of knowing than any purely logical method. Drawings are intuitive rather than logical reflections about living, a 'wholeness of certain attitudes, experiences is expressed whereas logic abstracts from the whole, eliminating the personal'.

Milner stresses in her book the importance of the interplay between mind and body, a whole body attention is needed in order to let the 'spontaneous ordering forces' work. The attention that she gives to a biological function and experience was taken up and used by Peter Fuller in his explorations into *Art and Psychoanalysis*, particularly in his examination of abstract painting. In order to let the spontaneous ordering forces work, a mixture of conscious attention is needed with a certain absent-mindedness – dreams, but with action. In the drawing activity there is an antithesis between a pull to total merging – mystical union and to individual will – fear of loss of identity. This is experienced in all individual and group relationships and a similar antithesis is felt between dream and external reality. Drawing can be a bridge between these states and inner and external realities.

Milner connects with her earlier work in helping children to discover a social place in school. She feels that everyone's task is to find a niche in the social world as they pass through a transition from child to adult. She sees the primary function of the creative arts to provide a perpetual well for the

renewal and expansion of our psychic powers both in our own making and in our aesthetic experience. In this earlier book, she begins to explore 'frames in time and space'. What is within a frame is to be taken symbolically; what is outside, literally. What is inside is symbolic of feelings and ideas. In painting, one creates one's own gap and frame and fills it. In analysis there is a reflection of the framing made in the arts by the analytic time and space which becomes a constant for the patient, framing a symbolic mode of relating in the transference. Her summary at the end of the book states:

> Then it is perhaps possible to say that what verbal concepts are to the conscious life of the intellect, what internal objects are to the unconscious life of instinct and phantasy, so works of art are to the conscious life of feeling, without them life would be only blindly lived, blindly endured.
>
> (Milner 1950: 159–60)

In *The Hands of the Living God*, Milner (1969) combines an unusual keenness of thought with a capacity for reflection and allows feeling to diffuse both so that we are allowed into the patient's and the analyst's experience of therapy. She saw her patient's drawings as containing the essence of what they were trying to understand and work with, but in a highly condensed form, with one symbol having many meanings. The drawings were like Susan's private language and one needed to learn how to read and speak it. Milner discusses throughout the book the role and function of the therapist and the body/mind relationship, the need to have a whole state of attention in the patient including a body-ego perception. In the preface she quotes Masud Khan saying of the book: 'This is not really an account of an analysis but of a research into how to let oneself be used, become the servant of a process.'

She believed that 'the process' was the patient's 'self-cure', her belief in the possibility of living creatively and being able to review oneself psychically. Susan had an inability to accept duality of symbols and things symbolised. As a child she had been unable to be in a state of reverie, of absent mindedness in which the distinction between phantasy and actuality can be temporarily suspended. She had been unable to leave the care of the outside world to others. Milner describes the need for this surrender of discursive logical thinking to allow the emergence of non-discursive modes of thinking and a surrender to creative force. She describes in detail the difficulty of allowing a 'not-knowing', the 'empty headedness' which is part of the rhythm of all creative activity. This can be difficult for the therapist too; there is a need to make interpretations as a defence against 'not knowing'. One had to give this patient a body attention – 'a kind of deliberate filling out of one's whole body with one's consciousness' (Milner 1969: 45).

From the richness of the book, the story and the treatment, it is interesting to select how Marion Milner perceived the drawings – over 4000 – during the course of treatment. She saw Susan achieving a momentary integration through the medium of the painting. It provided an 'ideal' but also an 'other' with whom to have an interchange ... 'even if, or perhaps because, it is only on a "part object" level ... thus the finished picture can when successful ... embody an ideal state of a restored self and restored inner loved object, a permanent monument to the ideal being striven for' (Milner 1969: 96).

Drawing gave the patient a bit of contact with external reality, which she was desperate for, which was 'other' and yet completely responsive to her. She saw the paper as having a particular role, as it were a substitute for the responsive ideal mother, receiving from her hands and giving back to her eyes, a give and take on a primitive non-verbal level. It could always be there as long as paper and pencils were available. The drawings were reparative for all destructive intentions or actions. They also created a bridge between the patient and the analyst, a basis for communication, having potential meaning. The drawings were a substitute for the mirror that her mother had never been able to be to her and a substitute for the analyst between sessions. There was also a defensive aspect to the work, in reliving feelings for her mother, she was saved from destructive rages. The drawings were a foundation in communication so that she was able to get in touch with the deep layers of her self-knowledge from which she had been cut off. The drawings could also be seen as a placatory gift; the drawings, instead of herself, also might avert phantasised aggression from the analyst or aggressively make the analyst crazy. They were finally a non-discursive affirmation of her own reality.

Milner explores the frame of the protective environment that is needed by the baby from its mother, and how this framework is needed for analytic work and for artistic creative activity. This links also with her thinking on body/mind relationships as she felt that one's own inner body awareness takes over the role of the external mother. With this framing, the two modes of thinking, discursive and non-discursive, conscious and unconscious, can alternate and allow a new ordering and integration to take place. She saw this interplay between articulate and inarticulate levels of functioning as basic in all creative activity. Intrinsic to this is a belief in a bigger self than the ego; in Susan's words, 'the Self which thinks and grows regardless of conscious choice' (Milner 1969: 376).

The *Suppressed Madness of Sane Men* (1989), her collected papers, develops, completes and restates much of the theoretical material inherent in the earlier works. Art provides a method in adult life for reproducing states that are part of everyday experience in healthy infancy. The withdrawal from the external world and the temporary loss of self, as conscious control by the ego, is given up. Whereas classical analysis limits the symbol

to a defensive function, it is seen by Milner and other analysts as being essential for healthy growth out into the world, not defensive regression but an essential recurrent phase of a creative relation to the world. Freud saw primary process thinking as a chaotic, undifferentiated state, an 'oceanic feeling', to be a regression to an early infantile state of consciousness rather than a process of psychic renewal, a constructive element in creative life. In this latter way of looking, the two processes – primary and secondary, conscious and unconscious – are seen as complementary, both having constructive aspects but also limits.

Adrian Stokes saw the finished work of art as an encouragement to the ego. Marion Milner described it as an enshrining of an ideal integration rather than necessarily a permanent achievement of it – the real work remained to be done in the analysis and also that the actual work of art, 'the finished creation, never heals the underlying lack of sense of self'. In contrast to this view, the work of actually painting can be seen differently:

> Representation transposes a given state from the virtual to the actual, thus fixing it in the world of phenomena ... Once he has exteriorised an inner state the latter state for him becomes a new point of departure ... Under all circumstances the mere fact that an inner reality has been exteriorised means that growth has passed beyond it. Thus spirit must create world upon world in order to realise itself.
>
> (Von Keyserling: 1932)

Milner's work on the creative process and symbolisation and those with whom she had on-going dialogue and who influenced her – particularly Stokes, Ehrenzweig and Winnicott – are taken up in the following section and in Chapter 6.

DONALD WINNICOTT

In the sections describing the work of Melanie Klein and Marion Milner, we discussed the interplay between inner and outer realities in the formation of the inner world and the interplay between the two modes of thinking and feeling, conscious/unconscious, discursive/non-discursive, primary and secondary mental processes. Winnicott's special contribution to a study of the artistic process is his delineation and description of an intermediate area of 'experiencing' between inner and outer realities. He started work as a paediatrician and has made an invaluable contribution to our understanding of the nature of mother/child relationship and the importance of the real external environment in the baby's growth adding a balance to the Kleinian emphasis on the inner world. These issues will be the subject of this section and with the study of transitional objects and phenomenon, the 'location' of cultural experience.

In his, at one time, unique position as paediatrician and psychoanalyst,

Winnicott was able to make an extensive study of the early mother–child relationship. He developed the concept of 'primary maternal preoccupation' for a state of reverie which the mother has for the baby before and during the early months of life. During this time the mother is enabled to identify with the dependence of the baby drawing on experiences, partially relived, as an infant herself. This preoccupation makes her vulnerable herself and she needs father to take care of external reality and impingements on her primary task, the care of her baby. In placing importance on the actual environment for the healthy growth and development of the baby, Winnicott postulated that the mother was the earliest environment for the baby, who could not live without the care only a devoted mother could give. He coined the term 'good enough mothering' for the mother who was able to offer this support and protection and reverie for her baby to enable normal health and development. As the baby grows and begins to move on from this early state of merging, the supportive ego of the mother-figure has to alter, allowing a carefully graduated failure of adaptation to the baby's needs.

It was at this stage, as the baby makes first moves towards independence and separation from the mother and the mother adapts to this, that Winnicott made such interesting observations of the interplay between them. He and Marion Milner have written on the importance of illusion in symbol formation (Milner 1955, Winnicott 1988). There is an early illusion between mother and baby that the breast is part of the infant, because, if the mother can adapt well enough, the gap between wanting the breast and it being there is necessarily small. Later, the infant can begin to develop a capacity to experience a relationship to external reality, as mother's adaptation allows objects to be separate and real, hated as well as loved.

Winnicott postulated a 'play area' of intermediate experience that is not interrupted by adults, which relieves the strain of the infant of relating inner and outer reality. He studied the 'transitional objects' and 'transitional phenomenon', objects that the baby becomes possessively attached to, for example, blanket, teddy bear. He wrote brilliantly about the feeling relationship the baby has to them and how they were essential to baby's growth and development.

Transitional objects are of significance both for the early stages of object-relating and because they are the earliest form of symbol formation. Some babies use their thumbs or parts of their hands to stimulate the oral-erotogenic zone; others use a special object or blanket fringe which Winnicott describes as the first 'not-me' possession. He wrote that transitional objects are evidence of the 'capacity of the infant to create, think up, devise, originate, produce an object' (Winnicott 1988: 2). It was also the 'initiation of an affectionate type of object-relations'. The object is often used for comforting, stroking the baby's face and helps sleep. Transitional objects have special qualities. The parents and family allow the infant to

have complete rights over the object and do not disturb illusions about it, an area that is not challenged. Therefore the infant has 'omnipotence' over it. It is affectionately cuddled and mutilated. It must never change unless changed by the infant and must survive loving and hating. It must be seen to have a vital reality of its own. It does not come from within or without. It exists in the space between mother and baby. It is gradually allowed to be decathected as the infant naturally matures.

Winnicott has made more accessible to the general public some of the innovations of Melanie Klein in her 'play technique' with young children in psychoanalysis. His own ability to play with children as an equal imaginative 'player' has been captured in the case study of *The Piggle* (1980). He has managed to maintain the freedom and delight of play while presenting it seriously and drawing from it theoretical points of importance to any study of art and culture generally, as well as to therapy and analysis in particular. The importance of play is that it erases the boundaries between inner and external realities. He could importantly distinguish it from 'fantasy'.

'It will be observed that creative playing is allied to dreaming and to living but essentially does not belong to fantasising.' He saw fantasising as interfering with actions and with life in the real external world, 'but much more so it interferes with dreams and with personal or inner psychic reality, the living core of the individual personality' (Winnicott 1988: 32).

Fantasy is seen as wish-fulfilment; that is, instead of action, an alternative to an interaction with the real world: 'in fantasy an object has no symbolic value as in a dream'. He saw that playing has a space and a time. It is a development of earlier transitional phenomena and takes place in the 'potential space' between mother and child – that is, it is not 'inside' or 'outside' a person but in the 'place' in between. He felt that it is only by 'doing' things that one can control what is outside, and 'playing is doing'. Play facilitates growth, is universal and leads into group relationships. He saw it as being the basis of communication in psychotherapy and that psychoanalysis is a highly specialised form of play (Winnicott 1980).

> Psychotherapy takes place in the overlap of the two areas of playing, that of the patient and that of the therapist. Psychotherapy has to do with two people playing together.
>
> (Winnicott 1988: 44)

He saw that, where play was not possible, the work of the psychotherapist was directed to bringing the patient 'into a state of being able to play'. He knew that children played more easily when the other person also has the freedom to play. In play, the child is free to be creative. For both children and adults, in creativity there is the use of the whole personality and one can discover the 'self': 'Playing is always the precariousness of the interplay of personal psychic reality and the experience of control of actual objects' (Winnicott 1988: 55).

The transitional object is the child's first use of a symbol and the first experience of play. At the stage of separation of mother and baby the transitional object becomes a symbol of union. The 'potential space' designated as the play area between mother and child becomes and develops as the 'location of cultural experience'. Both Milner and Winnicott have written about the interplay between originality and the acceptance of a tradition as the basis for inventiveness – the precursor of this is the experience of separateness and union with mother. Winnicott saw creativity as a feature of life and total living. Like Milner, Winnicott saw the need for experience of a non-purposive state, a ticking over of the unintegrated personality, experience of formlessness. This needs to be reflected back, a role that is performed by mother in infancy and the therapist in analysis, and by the conscious mind in a healthy growing individual. It is the mirror role of mother and therapist in treatment. Winnicott saw that cultural experience begins with creative living first manifested in play.

> Freud did not have a place in his topography of the mind for the experience of things cultural. He gave new value to inner psychic reality, and from this came a new value for things that are actual and truly external. Freud used the word 'sublimation' to point the way to a place where cultural experience is meaningful, but perhaps he did not get so far as to tell us where in the mind cultural experience is.
>
> (Winnicott 1988: 112)

In summary, Winnicott explored and gave names to a series of concepts of importance to art therapy, from the child's first use of symbol, transitional object, the necessity of illusion, the importance of play to the location of cultural experience. As the child matures, this area of experiencing in the child widens to take in experience of art, religion, philosophy – all ways of 'working' with inner and outer realities. This can be seen by Winnicott's idea of art as a vital aspect to man's adaptation to the world. This is clearly expressed in his views of artists:

> They do something very valuable for us because they are constantly creating new forms and breaking through those forms only to create new ones. Artists enable us to keep alive, when the experiences of real life often threaten to destroy our sense of being alive and real in a living way. Artists best of all people remind us that the struggle between our impulses and a sense of security (both of which are vital to us) is an eternal struggle and one that goes on inside each of us as long as our life lasts.
>
> (Davis and Wallbridge 1981: 50)

JUNG, SYMBOLS AND THE TRANSCENDENT FUNCTION

We began this chapter with the idea that the explorations of psychoanalysis into the artistic processes was a search for meaning of the component of desire in a painting. Up to now we have been intensely aware of the loves and hates of the infant and their permeation through adult life. One of the differences between Freud and Jung was in their understanding of personal development: 'Neurosis is the result of the compromises and distortions which personal history forces on our archetypal nature' (Stevens 1986: 135).

Jung agreed with Freud that the origins of neurosis lay in childhood but felt that the aim of treatment was to discover what aspects of the archetypal programme for the individual life cycle had not been activated or experienced. Therefore the aim of analysis was not to purge the patients of infantile frustrations but to release blocks and aid them to live unlived lives (Stevens). He felt that the key to treatment lay in a dialogue between analyst and patient and, conscious and unconscious, through the language of symbols.

Jung's ideas developed partly through his special concern with patients of middle-age. He saw neurosis as a 'self-division' or the suffering of a soul that had lost its meaning. The purpose of therapy was to heal this split, to re-establish the natural dialogue between conscious and unconscious in order to obtain 'psychic' equilibrium; a balance could be achieved through mobilising the 'transcendent function' of symbols. In working with his patients he felt that it was, 'less a question of treatment than of developing the creative possibilities that live in the patient himself' (Jung 1970: 70). Many of his patients would come to analysis feeling 'stuck' in their lives and he would work with dream images to reveal hidden possibilities, what was forgotten or lost in the personality which had led to a one-sided development. They would experience this one-sidedness as a feeling of 'senselessness and emptiness' (Jung 1970: 70).

In exploring a Jungian approach to imagination one is immediately involved in a whole new terminology. Central is the importance of a search for meaning, encompassing religion and concepts of soul and spirit. In this section we will describe some of his key concepts to allow his picture of the mind to contribute to our understanding of creativity, symbols and the workings of the unconscious. Mental illness was seen as having a subjective meaning representing an individual's solution to the problems of life at a particular stage in that person's personal history. He saw 'the psyche' as a self-regulating system that maintains itself in equilibrium 'as the body does'. He felt that when a narrow one-sided conscious attitude to life developed, the individual's unconscious would attempt to balance this by giving a true picture of the subjective state. Dreams could therefore be seen as compensating a conscious attitude. His idea of psychic energy can be seen as a play of opposites.

The inherent goal of the human psyche is seen as a quest for wholeness, for individuation which would usually be a process developing in the second half of life. Jung differentiated stages of life, in that the young develop particular aspects of themselves in order to establish life in their work, family, social relations, etc. The ideals and values that they build on become unsatisfactory in the second half of life when people often feel a need to find a new purpose and meaning. It is often in the 'neglected, inferior and undeveloped' side of the personality that the qualities they now need are to be found. 'The individuation process is sometimes described as a psychological journey' (Fordham 1966: 79). During the journey the individuals meet with their shadows (all the unrecognised aspects of themselves) and the archetypes of the collective unconscious. If they are able to meet and understand these unlived contents of their unconscious the goal of individuation, self-hood or self-realisation will be known, often designated as the self. By this term Jung suggests that the ego is a part of the self and not the whole. But it is a dangerous and difficult path presenting the travellers with fear and madness as they encounter all the terrifying and unwelcome aspects of themselves in chaotic dreams and fantasies.

> The psychological elucidation of these images, which cannot be passed over in silence or blindly ignored, leads logically into the depths of religious phenomenology. This history of religion in its widest sense (including therefore mythology, folklore and primitive psychology) is a treasure-house of archetypal forms from which the doctor can draw helpful parallels and enlightening comparisons for the purpose of calming and classifying a consciousness that is all at sea. It is absolutely necessary to supply these fantastic images that rise up so strange and threatening before the mind's eye with a sort of context so as to make them more intelligible.
>
> (Jung 1980: 33, CWI2: Para. 38)

Jung felt that the best way to do this was to make use of comparative mythological material as well as to work with the parallels he discovered between individual dream symbolism and medieval alchemy. Alchemical symbolism could provide a key to the symbolism in dreams. Jung saw it as essentially a philosophical system inspired by the hope of solving one of the mysteries of life, the connection between good and evil, or how base aspects of life can be transmitted into the noble. Clearly, within the unconscious the neglected and unwanted aspects of ourselves, if accepted consciously, could provide the key to meaningful life in the future, within a new organisation of the personality.

In Jungian terms the psyche is seen as having a symbol-forming capacity, symbols being the natural mode of psychic expression. Jung rejects the Freudian idea that symbols were forbidden wishes in a disguised form. He

saw them as having a 'higher' purpose than a manifest content concealing a latent or repressed desire. Symbols were channels for unconscious processes to become conscious. He found that it was very limiting to attempt to pin down a meaning of a symbol in words, and that it was possible to express dream images directly in visual forms rather than sentences. In this way their emotional charge was kept alive and the possibility of many meanings which might emerge. When working with people who felt stuck, ill and divided, out of touch with their vitality, Jung would see his work as mobilising inner psychic resources through the transcendent function of symbol-making towards greater integration and individuation.

Being trapped in a play of opposite feelings, of ambivalences often makes human problems seem insoluble. If this happens, one needs a new perspective; perhaps they cannot be solved as such, but outgrown or transcended.

Symbols are a unification of opposites in a single entity. They can be seen as natural attempts by the psyche to reconcile and reunite often widely separate opposites. This capacity of symbols to unite conscious and unconscious into a new synthesis is what Jung called the transcendent function. In his work Jung made use of two techniques. One was the way of creative formulation which encompassed phantasy, dreams, symbols, art and active imagination. The second was the way of understanding which used intellectual concepts, verbal formulations, conscious awareness and insight. He felt that these two capacities of the mind were bound in a compensatory relationship. Jung felt that the creative activity of the imagination freed man from his critical stance towards the 'playful' side of his nature, the dismissive 'nothing but' with which one could ignore dreams, phantasies, etc.:

> My aim is to bring about a psychic state in which my patient begins to experiment with his own nature – a state of fluidity, change and growth, in which there is no longer anything eternally fixed and hopelessly petrified.
>
> (Jung 1970: 176)

One of his methods was that of 'active imagination' where he would try to release creative possibilities latent in the patient, a deliberate use of phantasy and dream as a method of healing.

Jung's method of treatment was firmly based in a sense of self-healing being possible. If analysis was necessary to define conflicts and complexes, then after that the main body of work consisted of activating unlived elements of the self. Stevens suggests that in Jungian work there is less dependence on the transference relationship with the analyst as the patients have increasing security in their inner relationship to the archetypal components being activated in their lives and their growing recognition of the creative potential of the self. When individuation is on its way, transference is superseded. It is essential for patients to learn to 'let things happen'

in the psyche. The art of action through non-action could be seen as a basic tenet of art therapy too. Jung (1972) describes in very human terms the enormous difficulty of letting things happen because consciousness is always interfering. He goes on to describe the objections of the cautious mind however determined the individual is to continue and the criticisms and depreciations afterwards, all states of mind familiar to the the artist and art therapist. It is because of the difficulties in learning this process that he introduced the idea of writing, visualising, drawing and painting the fantasy fragments.

Jung felt that while the patient relied on the analyst to explain dreams, he or she would remain in a state of childhood dependence. He would wait for the patient to have a special or colourful dream and then suggest that the patient painted it.

> Although from time to time my patients produce artistically beautiful creations which might very well be shown in modern 'art' exhibitions, I nevertheless treat them as wholly worthless according to the tests of serious art... It is not a question of art – or rather it should not be a question of art – but of something more, something other than mere art: namely the living effect upon the patient himself. The meaning of individual life, whose importance from the social standpoint is negligible, is here accorded the highest value, and for its sake the patient struggles to give form, however crude and childish, to the 'inexpressible.'
>
> (Jung 1970: 79)

Like all the clearest and most inspired writers about art, Jung based his theories on his own experience of painting and rcflcctions on the process. His 'Red Book' contains images made during a disturbed period of his life, after his split with Freud. He therefore had his own experience to draw upon when encouraging his patients to paint. In painting, his patients left a childish passive state for an active one; busying themselves with the fantasy increased its effect upon them. It also taught them a method that they could use again and so aided a growth of independence on the way to psychological maturity. He thought that the pictures patients painted of dream images had special qualities. They had often barbaric colours and an intense archaic quality, a primitive symbolism. They were formed from symbolistic currents in the evolution of man, from the collective unconscious. These pictures spring from a need to reconcile the psyche part of our primitive past with present-day consciousness. In treatment the pictures needed to be intellectually understood as well as accepted emotionally and then they could be consciously integrated, helping to form a new centre of equilibrium in the personality.

Jung posited a division in the unconscious between a personal unconscious – containing repressed memories, wishes and emotions as well as subliminal perceptions of a personal nature – and a collective unconscious.

The collective unconscious contains psychic contents which are not common to one individual, but to many. These he perceived to be at a deeper level to the personal unconscious. An archetype is a content of the collective unconscious which is the psychological counterpart of an instinct. Archetypes are expressed as collective images or symbols. This can be understood not so much as a question of inherited ideas but of a functional disposition to produce the same or very similar ideas. Symbols, therefore, can be either collective or individual.

In 'Psychology and Literature' (1970), Jung turned his reflections to looking at art made outside the analytic context. Jung saw the work of art, 'the vision', as coming from outside personal experience. He argues that if we look at 'the vision' as coming from personal experience it then becomes 'a substitute for reality', stripped of its primordial quality, it is 'nothing but' a symptom of the artist's disposition. It becomes impossible for us to explore the work of art in its own right. He argues that 'the vision' 'is true symbolic expression – that is, the expression of something existent in its own right, but imperfectly known' (Jung 1970: 187). He thought that it was contents from the collective unconscious that formed 'the vision' and that these manifestations of the collective unconscious were compensatory to a conscious attitude, bringing a one-sided consciousness into equilibrium in a purposive way:

> The personal idiosyncrasies that creep into a work of art are not essential; in fact, the more we have to cope with these peculiarities, the less it is a question of art. What is essential in a work of art is that it should arise far above the realm of personal life and speak from the spirit and heart of the poet as man to the spirit and heart of mankind. The personal aspect is a limitation – and even a sin – in the realm of art.
>
> (Jung 1970: 194)

Jung saw the artistic disposition as involving 'an overweight' of collective psychic life as against the personal. He thought that art was a kind of innate drive, an instinct, that seized a human being and made him its instrument. Artists were not people endowed with free will who could seek their own ends, but people who allowed art to realise its purposes through them. He therefore saw a 'ruthless passion for creation' and the artists' 'personal desires' as being at war within them. Rather than art arising from the artists' personal problems, he saw art giving rise to problems in the artists by the developments of their abilities in one direction leading to a heavy drain on their other capacities which gave rise to difficulties in the personality.

Jung therefore saw artists as drawing upon the healing and redeeming forces of the collective psyche that underlies consciousness. Artists are subordinate to these forces and through their work bring a balance to an epoch.

The work of Jung was a major influence on the early development of art therapy in Britain, particularly inspiring the Withymead Centre where art therapy acted as an adjunct to psychotherapy during its twenty-five years. Irene Champernowne was instrumental in the founding of Withymead and starting the work of the Champernowne Trust, which still continues. She painted a great deal in her training analysis with Jung and felt that it had a profound effect upon her. She was aware that words were a difficult medium through which to convey our deepest experience of life:

> It was clear that the mind was filled with visual and oral images, which are comprehensive and suitable containers for emotions and ideas that are otherwise inexpressible.
>
> (Champernowne 1969: 1)

She was also aware of the compensatory nature of the arts to the current conscious attitude which valued words and logic:

> Perhaps even more today when the intellect and cerebral activity is too highly valued to the exclusion of feeling, man is turning for very life to the means of expression in the arts.
>
> (Champernowne 1969: 2)

She did, however, characterise the work of art therapy and psychotherapy as an 'uneasy partnership'. She felt anxious about art therapy without the support and help of psychotherapy because of the possibility of the overwhelming nature of images produced. As the profession has developed in Britain, so has the understanding of the importance of experience of personal therapy for art therapists whereas, in the early days, outside special situations, like Withymead, there was considerable overlap of art therapy, remedial art, recreation and art teaching so that the role and functioning of art therapists was less clear, work being carried out at many different levels of insight.

SUMMARY

This chapter has attempted to encompass a range of psychoanalytic thinking about art processes, starting with Freud and moving through the object-relations school into the analytical psychology of Jung. Many art therapists work within one of the analytical frameworks described and many also draw upon inspiration and understanding from more than one. It is unfortunate that the split between Freud and Jung seems to have cut off Jungian insight into the spiritual dimension of man's life from British mainstream psychoanalysis so that it often seems difficult to find bridges between a classical analytical approach and his work that had such early influence on an older generation of art therapists which still permeates art therapy in Britain today.

The Arts, coupled with Psychotherapy, is a road to greater conscious-
ness and brings about a more creative participation of each human being
in his individual spiritual destiny within this world of time and space.

(Champernowne 1969:10)

REFERENCES

Champernowne, I., (1969) 'Art Therapy as an Adjunct to Psychotherapy, *Inscape*,
 I.
Champernowne, I. (1971) 'Art and Therapy: An Uneasy Partnership', *American
 Journal of Art Therapy*, **X** (3) April, pp. 131–43.
Davis, M. and Wallbridge, D. (1981) *Boundary and Space*. London, Karnac.
Fairbairn, W.R.D. (1939) 'The Ultimate Basis of Aesthetic Experience', *British
 Journal of Psychology*, **XXIX**, p. 100.
Fordham, F. (1966) *An Introduction to Jung's Psychology*. Harmondsworth,
 Penguin.
Freud, A. (1979) *The Ego and Mechanisms of Defence*. London, The Hogarth
 Press.
Freud, S. (1907) 'Delusions and Dreams in Jensen's *Gradiva*', in *Art and Liter-
 ature*, Pelican Freud Library, Vol. XIV. Harmondsworth, Penguin.
Freud, S. (1910) 'Leonardo da Vinci and a Memory of his Childhood', in *Art and
 Literature*, Pelican Freud Library, Vol. XIV. Harmondsworth, Penguin.
Freud, S. (1914) 'The Moses of Michelangelo', in *Art and Literature*, Pelican Freud
 Library, Vol. XIV. Harmondsworth, Penguin.
Freud, S. (1916) 'Lecture XXIII: The Paths to the Formation of Symptoms', in
 Standard Edition, Vol. XVI. London, The Hogarth Press.
Freud, S. (1920) 'Beyond the Pleasure Principle', in *Standard Edition*, Vol. XVIII.
 London, The Hogarth Press.
Freud, S. (1923) 'The Ego and the Id', in *Standard Edition*, Vol. XIX. London, The
 Hogarth Press.
Freud, S. (1925) 'An Autobiographical Study', in *Standard Edition*, Vol. XX.
 London, The Hogarth Press.
Fuller, P. (1980) *Art and Psychoanalysis*. London, Writers and Readers.
Gombrich, E.H. (1966) 'Freud's Aesthetics', *Encounter*, **XXVI**, 1 (January)
Jung, C.G. (1955) 'Mysterium Coniunctionis', in *Collected Works*, Vol. XIV.
 London, Routledge and Kegan Paul.
Jung, C.G. (1966) 'Two Essays on Analytical Psychology', in *Collected Works*, Vol.
 VII. London, Routledge and Kegan Paul.
Jung, C.G. (1970) *Modern Man in Search of a Soul*. London, Routledge and Kegan
 Paul.
Jung, C.G. (1972) *The Secret of the Golden Flower*. London, Routledge and Kegan
 Paul.
Jung, C.G. (1980) *Psychology and Alchemy*. Princeton, Bollingen Series.
Klein, M. (1948) 'Infantile Anxiety Situations Reflected in a Work of Art and in the
 Creative Impulse' (1929), in *Contributions to Psycho-Analysis 1921–1945*.
 London, The Hogarth Press and the Institute of Psychoanalysis.
Milner, M. (1950) *On Not Being Able to Paint*. London, Heinemann.
Milner, M. (1955) 'The Role of Illusion in Symbol Formation', in Klein, M. *et al.*
 (eds) *New Directions in Psychoanalysis*. London, Maresfield Reprints.
Milner, M. (1969) *The Hands of the Living God*. London, Virago.

Milner, M. (1989) *The Suppressed Madness of Sane Men.* London, Tavistock.

Rycroft, C. (1977) *A Critical Dictionary of Psychoanalysis.* Harmondsworth, Penguin.

Rycroft, C. (1985) *Psychoanalysis and Beyond.* London, Chatto and Windus.

Segal, H. (1975) 'Art and the Inner World', *Times Literary Supplement*, No. 3827 (18 July), pp. 800–801.

Stevens, A. (1986) *Withymead: A Jungian Community for the Healing Arts.* London, Coventure.

Stokes, A. (1972) *The Image in Form: Selected Writings of Adrian Stokes.* Harmondsworth, Penguin.

Stokes, A. (1977) 'Form in Art', in Klein, M. *et al.*. (eds) *New Directions in Psychoanalysis.* London, Maresfield Reprints.

Tuby, M. (1975) 'A Jungian Definition of Symbols', *Inscape*, No. 13.

Von Keyserling, E. (1932) *South American Meditations.*

Winnicott, D.W. (1980) *The Piggle.* Harmondsworth, Penguin.

Winnicott, D.W. (1988) *Playing and Reality.* Harmondsworth, Penguin.

Wollheim, R. (1970) 'Freud and the Understanding of Art', *The British Journal of Aesthetics*, **X** (3) (July), pp. 211–24.

The image in art therapy

Images made in art therapy embody thoughts and feelings. It is the capacity of art, and the arts in general, to be a bridge between the inner world and outer reality which gives the image the role as mediator. The image mediates between unconscious and conscious, holding and symbolising past, present and future aspects of a client. In a picture, ambivalence and conflict can be stated and contained. In art therapy the client tries to give form to what seems inexpressible or unspeakable through the process of making. Also important is the inner experience of seeing outwardly – the aesthetic experience. It is essentially through an aesthetic experience that the art therapist, with the clients' permission, can enter and share the clients' worlds and that the clients can make themselves known and found. 'In art, maker and beholder share the comprehension of an unspoken idea' (Langer 1963: 250).

To describe the therapy process, let us follow an image in the way it was made, as observed by the art therapist, and the client's subsequent understanding of its significance and the insight that was gained when he came to speak about it. A young man who was attending an art therapy group for the first time made the following model during one session. He took some clay and shaped it into a bowl. He then made a figure bending over the bowl as if vomiting into it. The 'vomit' was made of curled up tissue paper of different colours, adding paint to make a rich mixture. Another figure was made to one side, watching. He then moved the second figure to feed the first figure with a spoon from the bowl. The contents of the bowl had changed from 'vomit' to 'food'. He added another hand to the second figure who now was also feeding itself. Sitting back from the scene he had made, the client, as though feeling vulnerable, took a piece of very fine transparent film to put a cover over the bowl. Sitting back from his model again there was a sense of awe as the 'vomit-food' had now changed as if it were glittering precious jewels (the paint was wet on the tissue). The model felt extraordinarily important to him, he had made a profound discovery during the process of making.

It described the therapy process using the analogy that Jung often used comparing therapy and alchemy, the transmutation of base matter into

gold. In therapy it can feel as if one spews out angry, sad difficult feelings in a jumble like vomit. These feelings need to be contained by the therapist for the client within the room, the bowl. The therapist needs to help the client re-incorporate these unwanted thoughts and feelings, the parts of ourselves that we don't want or like, to understand them, the food. Their understanding and re-incorporation at a different level of meaning and experience is like jewels in the development and growth of the individual, becoming precious matter. The client takes an active participation during the therapy process. The healthy part of the client aids the sick part, feeding it and, in doing so, feeds itself.

The image presented these thoughts and the accompanying feelings to the client during the process of making and afterwards in exploring it with the group. What qualities do images have that enable them to do this? It is useful at this point to picture the mind as having two processes or ways of working. These were described by Freud as primary process and secondary process and have been explained fully in Chapter 4. The symbolism of the secondary process is discursive, conscious rational thinking which is symbolised through words which have a linear discrete successive order. Our description of the way the image was made is described by our use of this process. The image itself, however, presents its constituents simultaneously, not successively; it operates imaginatively but cannot generalise. The symbolism of the primary process is therefore non-discursive, expressed in visual imagery rather than words. Its complexity is not limited by what the mind can retain from the beginning of an apperceptive act to the end (see Chapter 6, 'Symbolism').

Images made in art therapy continue to reveal new meanings or suggest different thoughts and feelings as one works with them throughout the therapy process. They are a concrete product at the end of the session that can be referred to later or seen afresh as they take their place within a sequence of images made. Several authors (Milner, Rycroft, Langer) have written about the difficulty of using words to describe image-experience. In this chapter we shall attempt to struggle with this difficulty and present some ways in which the image works in art therapy and ways in which the art therapist works with the image.

In art therapy both therapist and client are responding aesthetically to the image made. It is being perceived and re-perceived by therapist and client, entering our imaginative lives on a different level from a verbal exchange. We are sharing an experience, an unspoken idea. The value of this exchange must not be lost for many of our clients have no speech, are inarticulate about feelings or do not trust words. The client mentioned above had already been 'influenced' by previous images made in his group. They had entered his imaginative life. He had unconsciously taken in parts of other people in the group. These dynamics will be described more fully in Chapter 9. Here let us look at two aspects of this influence.

Earlier in the group, another man had made a clay model of a dream he had had the previous night. In the dream he had gone into a restaurant and asked for a particular fruit to eat, but he had been given a strange fruit in a bowl which he had never tasted before. This dream and the making of it in clay within the group helped to give meaning to the art therapy process he was experiencing for the first time. Here the dream image presents the thought of it being like a strange fruit which tasted good. One can see how this dream experience had entered the imaginative life of the first client and how he had taken it from the containing bowl. The fine plastic film used by the first client had entered the group after being requested by a woman who wanted something to protect her clay model. It was then used by another woman to cover her bare legs painted in a picture, because they felt exposed and vulnerable. The first client then used the film to cover his bowl which transformed its contents to precious jewels and protected his own feelings of vulnerability.

In an art therapy room the contents of the room, practical art materials and psychic contents of the group interact and affect each other and influence the imaginative lives of each individual that uses the room. The art therapist is also part of this process. In the first image described, the therapist appears as the watching figure, which is also the part of the client which forms a working alliance with the therapist. The therapist feeds back the spewed out material in the form of food. The therapist also feeds herself. The therapist has previously worked herself in therapy and has made a similar 'journey' to the one the client is making. She also continues to learn by going to supervision and continuing her own therapy when necessary. In this way she feeds herself while feeding the client who is also feeding himself in the image.

MESS AND MATERIALS

The materials in art therapy have a profound purpose and can be used in many different ways to indicate states of mind, feelings, thoughts and ideas. The room must feel safe enough to do this and open access to all the materials can make available many possible avenues of expression. Clients will often use quite different materials in sessions following each other or within the same session, and their style of working may well change considerably through a period of time, at different stages of the therapy.

Let us first of all look at the power and qualities of some different mediums that will form part of the choice offered to the client. We have already seen that clay has the advantage of being a malleable three-dimensional medium. Figures can be moved, new parts can be added or taken away and it can have colour added or can be combined with many different materials. It can be hollowed out to contain, or one can use poles inside it to build a structure. New clays are available that are self-hardening so that

a kiln may not be necessary. It can be kept damp at the end of a session and one can continue to work on it over a period of time. Clay encourages a very physical involvement that aids release of body tensions which helps emotional release. For this reason it can be a most powerful medium with which to work.

Two further examples illustrate this process. A 5-year-old boy rushed into an individual session, eager to find the cup that he had made out of clay the previous week. On finding it he cried out with disappointment: 'Oh no, it's broken.' He showed the cup to the therapist in dismay, pointing to a tiny hole which was almost indiscernible. It was as if his whole world had shattered, to which the therapist responded, 'Don't worry. It doesn't look broken to me, we can mend it.' The child then suddenly said, 'Yes I can paint it' and proceeded busily to mix thick paint and restore his precious object. Symbolically this was very significant for him. His world was a constant experience of being let down and disappointed. His reaction to the 'broken' cup was predictable as this had come to be his expectation of the world generally and in this sense was his defence against the pain of constantly feeling let down. The fact that he could do something about it for himself enabled him to feel that he could control his world to some degree and this helped him to feel less hopeless and powerless.

Another example was a woman in her twenties who came to work in a five-day art therapy workshop. She came the first day and took clay from the bin and, sitting in the same place with her back to the therapist and most of the rest of the group, began making what looked like a small figure. For the whole week she worked on this figure, only four inches long, taking great care over details of features of the face, ears, hair, fingers. She made a perfect figure, and crying silently throughout began to tear sheets of material and bind it round and round. She then made a small box, carefully out of cardboard, and placed the embalmed figure into it, shaking with grief. At the end of the five days, she had completed what was now obviously a coffin. The group respected her sadness and did not enquire too deeply about her image, but at the end she was able to tell the group that the figure she had made was that of her younger sister to whom she was devoted, and who had died as a young girl. In their grief the family had sent the other siblings away, preventing them from attending the funeral and therefore mourning her death. Making the image had enabled her to look at this again and say 'goodbye' to her sister. It was as though the group became her family in the sharing in and support of her grief.

In both these examples, reconstruction can enable reparation and working through of loss. In other circumstances, art may be used to aid defences at particular times, and for this a specific medium might be chosen. An adolescent girl of 14 made the following image using felt tip pens (Figure 5.1). The stencils were part of an 'infant set'. Each one was carefully placed on the A4 size paper and drawn around. Then it was

Figure 5.1 Stencil

coloured in with pink felt tip. Finally each item was carefully framed in its own square. During this session, a court hearing was taking place to decide whether she would remain in care, as she was currently under a 'place of safety' order, or whether she was to go home. Her intense anxiety about the hearing was contained through the making of this image.

We have already seen how the art therapist and room act as a container for the client. The picture or model act as a further frame within which emotions may be disclosed and held. In her intense anxiety each item from her childhood, kitten, home, ball, teddy, doll and pram is framed within the picture frame so that nothing might break out. The babyhood items are comforting, filled in with baby pink, but also communicate her level of need to be held and contained by the therapist as if she were a baby. In drawing round and filling in these stencil items her more mature self shelters and cradles the baby parts inside. Felt tips are a useful medium for this purpose because they are controllable, feel safe and are more predictable. Unlike paints and paint brushes, one colour will not suddenly run out and mix with another.

It may take many months of working in therapy until a client feels ready to disclose emotions. During this long waiting process the images may embody and reflect, as well as present to the client the defended position taken by them. It is not the job of an art therapist to encourage spilling out of emotions but, in fact, to help the client feel that her feelings, however difficult to express, will be contained, listened to and understood. Each person in therapy will develop at her own pace, when she has trust in the therapist and setting and feels ready inside.

A child of 10 made the three images of castles shown in Plate 1. The first was made on grey paper reflecting his sad angry feelings. The portcullis on the doorway can be seen like teeth barring entry to the castle. It reflects that he was unable to talk about his situation to the therapist. The uneven black windows stare like sad upset eyes at the viewer. The tower of the castle stands up, a phallic shape, pushing into the whirly black sky which rages like a tempest above. This child was in the difficult situation of being the only offspring of parents who had divorced and remarried, both having started new families within their new marriages. He lived alternately with each parent for six months. The strain of this way of living with no settled home took its toll and his unhappiness was expressed by his delinquent behaviour. He was eventually taken into care and the pictures were made in an assessment centre.

He dressed as a miniature 'skinhead' with cropped hair and large boots. His pictures as castles seemed to present a similar 'fortress' in terms of his self-image. The upstanding phallic towers reflect his macho stance to the world of invulnerability and toughness, hiding the sad little boy inside. The next image is calmer, on white paper. He painted his name above it but wiped it out in an arc, like a black rainbow. It has no windows, as if the

'child inside' has retreated, but to a safer place; the fortress image remains like a statement.

He continued to draw castles. The next uses colour for the first time and larger paper. The doorway is blank but there is a drawbridge into the castle, suggesting a possible way of making contact. He is beginning to feel more secure with therapy now and more contained in the sessions. It sometimes feels as though clients are not progressing in therapy when they draw repetitive images. This could indicate that they feel stuck, but it is usually found that each picture is different and that tiny changes will reflect movements internally in the client's understanding or progress. This child was stuck with a defended image of the castle which reflected his internal defences to a situation in the external world. It didn't change during his short time at the assessment centre because his external situation was at an impasse at the time. The changes shown reflect his entry to the centre and the way that he was able to become a part of that community in that the castles grew larger and larger and became peopled. His defences were needed until he would be able to explore his family situation in depth.

We can see from the above description how colours take on a symbolic value that has individual significance to the client and they may also reflect

Figure 5.2 Finger paints

Figure 5.3 Death's Head mask

cultural values. This child uscd black paint on grey paper to express his initial angry sadness. The pictures lightened and became coloured as he felt more stable and had a place within the centre. Paint has more subtle possibilities in aiding the expression of feelings than, for example, felt tip. It flows more readily and large areas can be covered with a variety of brush sizes and paper sizes. Clients may change mediums within a session as they search for the material that will match their mood or feeling. It is a common experience when one has been immersed in a painting with intense involvement to feel that it was as if the medium, clay or paint, has taken one over, directing one in what to do. It is at times like this, when one starts out to consciously make one thing and then finds something else being made, that unconscious preoccupations surface.

An adolescent girl who had been referred to a mixed age art therapy group helped some younger chidren to use finger paints (Figure 5.2) over several sessions spending time playing with them and not directly working on her own problems. She had been referred after the death of her mother. When her mother died, the girl had gone to live with her father and his girl-friend but had not been able to settle into the new order of life. One session, after helping the younger children to use finger paints, she started

First

Second

Third

Plate 1 First castle, second castle, third castle

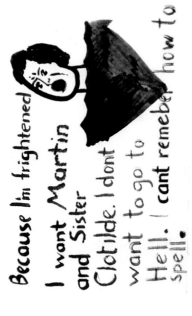

a

c

Because I'm frightened
I want Martin
and Sister
Clotilde. I dont
want to go to
Hell. I cant remeber how to
spell.

b

d

e

g

h

i

f

Plate 2 (a)–(i) Red, black and yellow sequence

Plate 3 Mother

Plate 4 Elephant princess

Plate 5 Bill 'n' Bob

Plate 6 Abstract pattern

Plate 7 (a)–(h) Windmills

a

b

c

d

e

f

g

h

Plate 8
Rosie: Forest
Rosie: Me
Rosie: Therapist
Rosie: Rabbit

to use them herself, creating a line of happy people and a smiling sun. As the picture seemed to come to an end she moved on to the other paints and swiftly painted another two pictures. The first is an extraordinary vivid portrait of her mother (Plate 3) who had frequently been drunk and had died of alcohol-related problems. The clownish smiling face of her mother, the eyes lacking focus, is a skilled portrayal of someone suffering alcohol abuse. The second picture, of a Death's Head mask (Figure 5.3), was an attempt to give form to her loss. When one feels a loss it often doesn't have a shape in the mind, but an emptiness. Her interaction with the medium enabled her to personify death. Once these 'inexpressible' feelings have a shape it is a beginning to be able to explore them verbally as well as through a sequence of images.

It is not necessary to list all the types of materials that will be available in an art therapy room. Here we have just looked briefly at the qualities of clay, felt tips, paint and finger paints. Artists considering training will already have experienced the different qualities of various mediums making their own art work and will be familiar with the usual range available for clients' use. Each art therapist will make available as wide a choice as is possible, depending on the environment and resources, as we have already seen in Chapter 2, 'The art therapy room'.

The work in the art therapy room involves deep exploration and expression of feelings within the space, using the materials freely for this purpose. But the reason for choosing certain materials and the way the feelings are expressed are essential parts of the communication. If the art therapist is unable to understand and contain these, then spilling out occurs, which can involve spilling and messing of materials to an unacceptable level. One example is a child who took bottles of paint and squeezed them out, one after the other, with no intention of using the paint for any other experience. The therapist came to understand that the child was experiencing acute anxiety, and that by non-intervention she had permission to continue doing this, which made her anxiety intolerable. The therapist had to decide whether it was her own anxiety about waste of paint or something that was being communicated by the child in terms of her inner chaos and fear of lack of control. Did she feel that she was emptying out or being emptied out – these were questions that the therapist had to consider in her own counter-transference response. By intervening and pointing out to her the consequences of her actions, maybe asking her why she was doing this and what it meant to her, the child was able to get hold of something for herself. Rather than just let it pour out, she was able to feel what it was like to put a limit on herself and feel contained – something she found very difficult.

These incidents are all part of the process of working with the client's interaction with the materials and facilitating an understanding. An opposite example is the child or adult who refuses to use anything except felt tip or crayon to prevent getting dirty or in a mess. This usually centres around

anxiety about mess and losing control, but only by exploring the possibilities and risking losing control by using paint, mixing the colours and so on can the experience of regaining it be successfully negotiated. With those clients who are very tightly controlled, the way they use, or resist using, materials is often a useful indicator of the inner feelings that are being experienced at the time. The dread of getting dirty, feeling clay on hands, or being able to put hands into the clay bag are developments that only alter through time and a loosening of anxiety.

The interesting thing about art materials is that 'accidents' can happen and this often can help the situation, even though difficult at the time. One 10-year-old boy cut into a padded envelope and was very surprised to discover small polystyrene granules which began to spill out and cover his sweater. His anxiety and distress at the event was obvious as he hopped about trying to remove it, saying it was harmful and poisonous. The fact that he was able to survive and experience this helped him to face other unpredictable situations which were beyond his control.

If working in a group, members might choose to work together, and profound points of interaction can take place. One person can help a less able one to do a particular piece of clay, for example, and this opens possibilities for co-operation, building self-esteem, feeling able to ask for help, looking at dependency and independency issues. The materials or the tasks offer an important way for this to happen. With children working in groups, interaction using the materials tends to reflect the group dynamics and also the building of interpersonal relationship, as is clearly described in Chapter 9. This process is particularly important in art therapy because of the materials they choose to use. For example, two boys, one black and one white, chose to make a ship together using black and white paint. The disputes and bitterness with which this project was accomplished, in terms of how much of which colour was to go where, was a most complex and deep exploration of some personal issues for them both. The end product was to some degree a resolution of this but the process in which they became engaged was a fascinating and interesting one.

In a less competitive situation with two boys, one timid 7-year-old decided to work with a 'macho' yet deeply vulnerable 9-year-old. On the paper they shared their passion for football by drawing a match with two teams playing hard and tackling each other fiercely, saving goals and being off-side. In this interaction, each child looked to the other for aspects of self which they felt they lacked. The feelings between them would probably have been enacted in the playground in the anti-social behaviour that each had been displaying there. These could now be channelled and expressed within the safe bounds of the therapy room and by the containing presence of the therapist, who was experienced as holding the situation, they could also feel that their feelings and behaviour were being heard and understood by an adult. Likewise, copying and wanting to do the same as the others is

a strong dynamic in some groups and again brings up issues of assertiveness, creativeness, independence, self-confidence and so on. These are enacted openly and it is interesting to work with this, particularly when the child or adult might not be speaking. Indeed, the fact that this all takes place at a level which is non-verbal, or might not even be conscious, gives an indication of the power of using materials when closely observed in this way.

The following short vignettes illustrate the importance of the non-verbal communication that is conveyed through the use of the art materials.

> An anorexic girl had found it very threatening to make any spontaneous move at all. During one session she began to scrape the dry clay off the tools. She made heaps with the bits and began to play as a small child, transferring the bits from one heap to another. At the end of the session she swept all the bits into one tidy heap at the corner of the table. She was amazed when she returned to her next session to find the heap had remained untouched and this allowed her to make further spontaneous moves.
>
> Similarly, another girl used a session picking at the paint on the palette and mixing it, not able to actually paint on the paper. It didn't matter – the mixing of the paint was relevant to the session. When she came to her next session she was delighted that the palette had remained unwashed. The paint was of a particularly quality that enabled the client to lift the paint off the palette as one whole piece, and this piece of paint became precious to her.
>
> *(Letter to the authors from*
> *Claire Skailes (1990))*

Arthur is a 29-year-old man who could be described as moderately mentally retarded. He resides in the locked ward because his violent behaviour is regarded as being dangerous to others. He is a large person and physically well developed, although one arm is slightly withered. Arthur has difficulty in co-ordinating his movements and controlling his enthusiasm for tasks. This combination often results in him knocking things over or breaking delicate mechanisms. He enjoys working on several sheets of paper joined together to make a larger sheet. In the room, this large sheet is placed over the three tables and powder paints are mixed in tins by the sink with the help of the art therapist. Arthur uses large house-painter's brushes. We move the chairs to the side of the room and he works round the three tables, calling out for more paint as he busily and excitedly adds colour to his picture, using large expansive movements. Sometimes he knocks a tin over and it spills on the floor; sometimes he splashes the wall or chest with his brush. The large sheet of paper usually has a life sized figure outlined upon it, sometimes this is

drawn by the art therapist tracing around his (Arthur's) body and sometimes it is drawn by Arthur himself without any tracing. The figures are cut out and pinned on the wall. They represent his father and sometimes his mother and he talks to them. He can get angry with the figure of his father, swearing at him for not visiting.

William is 25 years old and is severely mentally retarded. He has no speech and does not use a conventional sign language. When he wants to go to the toilet he pulls his trousers down. He can become very anxious during a session, biting his hand and crying out in protest if he feels unduly pressured. The activity that seems least demanding and most comforting for him is water play. He sometimes pours water over his head and he blows into the water held in the can making 'raspberry noises'. By allowing him periods of free play with the water and cans, he can be persuaded and cajoled into more constructive and creative play, experiencing materials he would otherwise deny himself. William is an absconder, and if the doors are left open he would run off down the road. The large room allows him space to retreat from an interaction and sometimes he sits on the easychair, rocking until he feels confident enough to use the materials again.

(Letter to the authors from
Robin Tipple (1990))

MEANING WITHIN A RELATIONSHIP

The process of using materials and the completed images which may emerge all happen within a relationship to the therapist. Let us look at this process through the work of two clients in therapy. The first image made is similar to the significance of a first dream in psychotherapy in that it may contain a coded statement of the presenting problem, although this will not be known at a conscious level to the client but will take weeks or months of unpacking through a further sequence of images and interactions with the therapist. Images have personal meaning for the client which is symbolically presented in the picture.

Four children were taken into care by Social Services and referred to the art therapist. These children had parents who both suffered psychiatric disturbance and who resented and feared contact with the authorities. The children had been discouraged from attending school and were dressed eccentrically. The door was never answered and they lacked any social contact outside the home. Here, we are only concerned with the eldest girl, of 13 years, who had the physical weight and size of an average 9-year-old. In the presence of her mother it became apparent that there was a symbiotic relationship as they clung together, talking in a strange gutteral language of noises.

Figure 5.4 Nuns

In art therapy she began by drawing 'elephant princesses', 'elephant babies' or 'elephant people'. The first of these is depicted in Plate 4. She seemed to have this as a schema, so that if asked to draw something else a row of 'elephant people' followed. Psychological tests concluded that she had moderate learning difficulties and her pictures with their crayon patterning suggested a mental age of 5 to 7. One can see from the picture that no arms or hands or legs or feet are apparent, just a face and long dress and crown.

She was very resistant to any attempt at normalisation or socialisation. She could in fact talk quite clearly when she chose. There were battles over anything that might aid her own independence, such as learning to tie shoe-laces. As the relationship developed it became clear that everything hinged or pivoted around 'babies'. The art therapist was called 'Baby Casey' with great affection and 'baby' prefixed any endearment to other staff too. One day she started to talk to the art therapist about the past and drew a picture of a time when she and two siblings had lived with nuns while their youngest sister was born (Figure 5.4). This led to an exchange of baby memories: 'Tell me about the time when you were a baby.' The art therapist would recall a memory or incident, and the girl would tell the ther-

apist about the time her mother thought she was the baby and put her in the pram instead of her little sister. Gradually it became clear that this regression to babytalk was a way of adapting to her mother's illness. This severe adaptation and accompanying deprivation of school and normal behaviour had stunted her mentally and physically, but made sense within the home environment. By being a 'big baby' she kept in contact with an otherwise uncontactable mother during psychotic episodes. She helped her mother in some way by being a 'more responsive baby' and also helped herself by staying loved and not alienated from mother.

We can see from the illustrations (Plate 8) that an internal change might be shown through a change of style in painting or the way that things are made. This development can be seen through four stages. A family of three children were referred to an assessment centre while their mother was unable to cope. Their father was frequently hospitalised with mental illness and their mother would take to her bed at these times, leaving the eldest child of 9 to run the household. Rosie's first picture is of herself in a stormy forest. She is lost. One can see from the illustration that she feels lost in a storm of emotions and confusion, but on entry to the centre she is still in some control of herself and her siblings. Her figure has an outline that only just distinguishes her from the background.

As the staff at the centre took over her responsibilities Rosie regressed to ever younger stages, losing her veneer of maturity until she was crawling around the floor making animal and baby noises. During this quite manic stage of behaviour, when all her actions were quite unpredictable, she painted the second picture. The figure is smiling, somehow orchestrating the chaotic background colours which show through the transparent body. The black outline to the figure, although apparently a firm boundary, shows the same chaos within and without so that actually there is no boundary between inside and outside. Her chaos inside is projected outside and she soaks up the reactions to her manic behaviour from those around her.

The third illustration is a picture of the therapist. She is surrounded by a protective arc. She is idealised with blonde hair in pigtails and has a row of 'baby' buttons down her front. In the transference the therapist is holding and representing the sane good little girl that is trying to work with the therapist to explore the chaos. The protective arc is separating this part off, in the form of the therapist, to keep it safe from the manic, often destructive, behaviour. Case studies in the literature show other aspects of transference phenomena held in the images (Case 1987, 1990).

The fourth illustration, later in therapy, was made using an animal stencil and pen and ink. The pen and ink medium aided a reverie for Rosie on the death of a pet rabbit and what it had meant to her. A stencil was chosen so that it should look exactly like a rabbit and the long doodling marks and patches of ink suggest her despondency and digging at the paper as she allowed herself to feel its loss. It also represented the loss of her own

cuddly soft self, not allowed to be while she held such family responsibility, and a gentle part that was hidden during her manic behaviour. Some order is beginning to emerge in that a specific loss and feelings attached to it can be discriminated from a general emotional state.

COMMUNICATION WITH THE IMAGE

Clients quite often come into therapy having been under enormous strain in trying to hold together some disparate elements in their lives. This is true of children as well as adults. Under these conflicting wishes, children and adults often regress in therapy, as the therapist takes some responsibility for containing these mixed feelings. Regression is the returning to an earlier stage of development so that one can be in control of it; it is easier to master this earlier known role and situation. Clients may go through a period of messy paintings or work with materials where the old order that enabled them to contain the conflicting emotions will be broken down. In Rosie's case this was a kind of false maturity, a pseudo-adulthood that she had to develop to try to cope with the demands made on her. Using the materials, and allowing them to be messy and chaotic, it is possible for a new order to develop.

Some case studies in the literature clearly describe this process where regression takes place to the point at which re-integration can begin to take place (Dalley 1980, 1981). Kris (1953) has called this 'regression in the service of the ego' and describes how the creative process is so important to facilitate this (see Chapter 6, 'The creative experience'). The image enables a series of reflections and powerful feelings to be experienced. Images sometimes replace or supplement words or actually have words on them to call the therapist's attention to something the client wishes to talk about. In this way they can be a signal to the therapist.

Figure 5.5 depicts two parents arguing. They are separated and about to divorce. Father has visited on a Sunday; they argue, Mother tells him to 'Get out', and he replies 'No'. This was drawn by their daughter, a client in therapy on Monday morning. It enabled her to talk about her fears while they were arguing and her feelings about each of them and the separation. Naming the parts of the picture and giving it a date is an attempt to keep some control in events within which she feels powerless, in a similar way to the naming of the baby toys in the picture discussed earlier.

We have seen how important the process of making is in therapy. It can enable many self-discoveries, such as when Rosie was making her rabbit stencil, the boys working together, the working through of grief in the symbolic 'burial'. Sometimes the completion of an image will present a thought to the person who made it. The abstract pattern shown in Plate 6 was made by a 16-year-old girl who had been taken into care and felt responsible for the break up of the family. As she finished the picture, she

Figure 5.5 Divorce

stepped back and said 'everything inside is also outside' and realised that this applied to the people around her. It was important for her to under-stand that she was not all bad and everyone else good. This realisation gave her a sense of relief as it is easy for an adolescent to feel the 'bad girl', especially when 'bad' feelings are projected onto her.

This brings into focus the whole question of interpretation. What is the therapist doing when she sees an image that is being made or is completed by a client? At the beginning of the chapter we mentioned the importance of the aesthetic experience. It is through the aesthetic experience that the therapist can enter and share the client's world; that is, it can be a non-verbal sharing. Part of art therapy could be said to be about acknowledging 'what the heart says', which might not be expressible in words. It might be necessary, through the making of a sequence of images by a client, to respond with a silent devotion to the images. The danger for the art thera-pist is getting wrapped in a web of silence because to speak too soon might betray the process. One must wait until the work is complete as it is so vulnerable while it is being made. The art therapist is part of the art process for the client, which is demonstrated by such comments as 'the picture we did last week' or 'the picture we did together' when in fact only the client painted.

During the process, the therapist may 'see' many different things in the image or have realisations about the image and the client. What is important is that the client is enabled to make self-discoveries rather than the therapist gaining satisfaction from clever interpretations. Verbal comments should clarify rather than impose, relieve tension rather than cause a client to withdraw. Part of the power of the aesthetic response for the client is seeing an aspect of oneself in an image, seeing that an image has been given life, seeing and knowing that the other (the therapist) has seen that which is normally hidden. This seeing and knowing that the other has also seen is a re-experiencing of one of our earliest responses, looking at mother's eyes and seeing the reflection of her looking at us. She perceives 'a particular brightness' and we gain a sense of ourselves, of identity, worth, value, through this look. The image is the mediator of the 'looks' between therapist and client. The therapist gives value to the art therapy process by the quality of her attention.

Throughout the process of therapy images are made and when looked at in sequence they can be seen to embody the changes that have occurred during the therapeutic journey for both client and therapist. Images act as a means of recording this process and some clients choose to look back over their work, particularly after the therapy has finished. They hold their significance over time and are therefore extremely important for the understanding and insight gained during the weeks or months of therapy. The following examples illustrate clearly the way that the images have been used by the clients to work through their particular difficulties and can be seen to have been received by the therapist in her containing function. In a sense the pictures 'speak' for themselves but can be seen to contain many different levels and potential meanings which language cannot describe. The commentaries made by the clients themselves offer another way of understanding how powerful the use of images can be in times of distress, confusion and unhappiness.

Most of my paintings consist of only two or three colours – red, black and occasionally yellow [see Plate 2]. When I am depressed, black represents total despair and a great sense of personal worthlessness: red represents anger of an almost suffocating kind – anger directed mainly at myself because of this sense of worthlessness: the occasional use of yellow suggests feeble and rare glimmers of a hope for a future. Where I have drawn a figure, it is usually a black silhouette. I think that the figure is a silhouette because I do not want to acknowledge that the figure bombarded by despair and anger is myself.

When I was in hospital I found art therapy very valuable, with an almost cathartic element. Frequently I went to the art therapy sessions in a very anxious, depressed frame of mind, not really wanting to make an effort to do anything. Yet, once I had made the initial effort – which I

was allowed to do in my own time – I found that my hostile and even aggressive feelings were quickly translated into colour on paper.

It is difficult to look back to a time when one was really unhappy, desolate, alone and remember how it felt. One sees days as grey, which were in fact blackest misery; one remembers only the paralysis of depression and forgets the turmoil. One forgets the aggression. It is especially difficult to remember how I hated myself; how sure I was that once I'd been obliterated, forgotten, the world would be a better place.... And they tell you to paint.... You resist.... You feel ashamed as you sit numbed, stunned in front of a blank sheet ... so you write your life upon it, perhaps you don't mean to but it happens. The painting cannot exist independently divorced from your life, it is a part of you and therefore a part of distress, fear, anger, frustration, past and future shock. And when these things appear on paper you may recognise them for the first time. I say you may, but it's a gradual process [Figure 5.6].

Art therapy was very much my last hope, because I didn't feel I had the energy to carry on much longer. I had spent so many years trying to sort out my problems on my own, by avoiding them.

I can't remember if the first painting I did was at this session or not, but I do remember how I felt about illustrating something in front of someone. Initially I was very reluctant, I didn't have much regard for my illustrating abilities.

Once that was done and the therapist had accepted my drawing, I was then able to start loosening up because I knew I was going to be helped and that no one was going to laugh at my pictures. After that I gave the sessions everything I had and started getting something in return. This picture represents different aspects of my life and feelings about myself.

Some of the feelings shown are quite negative and are to do with situations I find difficult. I find making images in this way can be a way of putting things into perspective and seeing them in a different way.

Even if you are depicting something which is quite difficult, it can be quite satisfying to make an image about it. I find it often leaves me with a feeling that I am more in control of whatever feeling or situation is shown – channelling them into a different way of expression, something creative can be drawn from even the most difficult situation or feeling.

I attended art therapy for approximately one year, initially going because I had an obsession with food which had made my life a misery for ten years (I am 23 years old now). However, after my first couple of sessions the food problem was practically forgotten, as a host of other problems, of which the food had been the symptom, appeared. None of

a

b

Figure 5.6 (a)–(f) Isolation, degradation, despair . . .

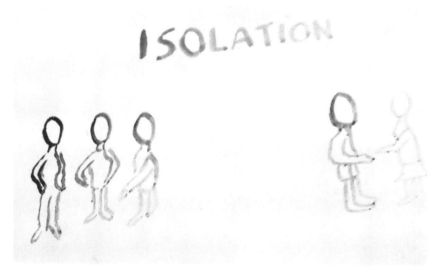

c

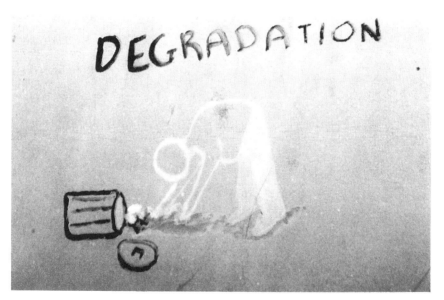

d

e

f

these was essentially serious, but I had let them take over my life to the point where I had twice seriously contemplated suicide.

I found it very hard to begin with, as I was not used to drawing or painting to express my emotions, but after a couple of sessions it became easier. I started to find painting very relaxing.

To begin with, therapy was relatively 'pain free' but after a while going there was really quite traumatic for me, and I wanted to give up. I think I was very honest with my therapist and told her how I was feeling throughout the treatment, and this helped me to realise that what I was experiencing was part of the process, that I almost had to get worse before I got better.

I developed a relationship with my therapist so that I trusted her with details of my life that no-one else knew about, and with her help and my perseverance I saw it through.

I ended therapy before I thought I would. It was the hardest thing I ever did and also really the most selfish, but I am really proud of myself now that I have found the strength to seek help and accept it. My final day there was frightening and exhilarating, because I could now put into practice what I had learnt about myself. I still paint in order to carry on the therapy in a sense, it also helps me to focus on my problems and sort them out. Now whenever I am particularly sad or depressed I mentally paint a picture if I cannot actually draw one, or imagine I am talking to my therapist and what she would say to me.

The last sequence of paintings, showing how the process of image-making can facilitate change, was done by a 15-year-old girl, completely withdrawn in her psychotic confusion. Without speaking, she made a series of paintings of the windmill that she could see from the window, leaving them for the art therapist in the art room (see Plate 7). They show how she regained her sense of reality and emerged from her inner chaos to an outer world of clarity, order, people and potential relationships.

REFERENCES

Case, C. (1987) 'A Search for Meaning: Loss and Transition in Art Therapy with Children', in Dalley, T. *et al. Images of Art Therapy.* London, Tavistock.

Case, C. (1990) 'Reflections and Shadows', in Case, C. and Dalley, T. (eds) *Working with Children in Art Therapy.* London, Tavistock/Routledge.

Dalley, T. (1980) 'Art Therapy in Psychiatric Treatment: an Illustrated Case Study', *Art Psychotherapy,* **VI** (4), pp. 257–65.

Dalley, T. (1981) 'Assessing the Therapeutic Effects of Art: an Illustrated Case Study', *Art Psychotherapy,* **VII** (1), pp. 11–17.

Kris, E. (1953) *Psychoanalytic Explorations in Art.* London, Allen and Unwin.

Langer, S.K. (1963) *Philosophy in a New Key.* Cambridge, Harvard University Press.

Development of psychoanalytic understanding

When working with images made in art therapy, the art therapist needs to be able to enter the 'world' of the client. She does this partly through an empathetic way of sharing image-experience with the client. To enter the process of making with the client it is essential to have felt the same stages of chaos, uncertainty and vulnerability as well as the stages of feeling that something has worked and been made successfully. The art therapist needs a theoretical understanding of the creative process together with her personal experience of her own work (Gordon 1989, Hershkowitz 1989). This chapter will start with a tracing of the understanding of the creative process through psychoanalytic writers, which may be less accessible to the artist considering training and the general reader than artists' own accounts of their working processes. We continue with an introduction to some related work on the aesthetic experience as this is the twin component to the creative process, being the way that the client can make herself known, to externalise previous internal thoughts and feelings, and to be seen and comprehended by the art therapist. Finally, we begin to explore the changing and developing theory about the symbolisation process by which one object can come to stand for another, carrying with it the feeling force originally attached to the first object. The last section of the chapter looks at the processes behind the extraordinary power that can be felt and held in the picture as invested emotionally by its maker.

THE CREATIVE EXPERIENCE

The experience of creativity is not limited to artistic activity. Indeed, Winnicott saw it as a feature of life and total living. Cultural experience begins with 'creative living first manifested in play'. However, in this section we are going to restrict ourselves to the more immediate concerns of artists and art therapists and attempt to explore the nature of creative experience and motivation in the making of a piece of art work. We have seen previously that Freud felt unable to apply psychoanalysis to creativity. Psychoanalysis is able to take the interrelations between the impressions of

the artist's life, chance experiences and works, and from those things to construct the (mental) constitution and the instinctual impulses at work in it, but 'it can do nothing towards elucidating the nature of the artistic gift, nor can it explain the means by which the artist works – artistic technique' (Freud 1925: 65). Freud felt that artistic talent and capacity were intimately connected with sublimation and that they were inaccessible to study. However, later analysts have built on these tentative conclusions of Freud and have been able to use his deeper work on dreams and jokes as patterns for exploration, particularly in aesthetics. Kris suggests that there is a subjective experience common to all manifestations of creative imagination. The characteristics are a limitation of conscious effort, a high emotional charge, and a mind working with high-precision problem-solving (Kris 1975).

To illustrate the second point, he takes Freud's study of Leonardo as an example. In the history of Italian painting there had been little previous solution to the artistic problem of arranging a composition for Mary the Virgin, St Anna and the Infant. Leonardo's personal history gave him compelling inner necessity for finding a solution as he had experienced 'two' mothers as an infant. Kris sees form and content being united and both a personal and artistic solution found.

There has been some opportunity to study artists in psychoanalysis, also artists who have become psychotic and psychotic patients with no previous art training who start to paint spontaneously during their illness. The artist has 'the capacity of gaining easy access to id material without being overwhelmed by it, of retaining control over the primary process' (Kris 1975: 25).

Kris suggests that artists may have psychological characteristics of a definite kind. It seems that they have the capability of making rapid shifts in levels of psychic function. The only statement that Freud really made on this issue was to comment on the artist's 'flexibility of repression'. Kris expanded his influential ideas of the artist's ability to tap unconscious sources without losing control by 'regression in the service of the ego'. The artist/patient can be seen as someone who 'lets go' allowing aspects of personality, other than the social aspect, to take over. It is because of this collapse of ego-control that it is essential for the therapist to have empathy with the creative process. Kris did not depart from Freudian principles of free association in a controlled situation, but speculated that the relaxation or regression in all artistic activity, in contrast to the phantasy or dream, is purposive and controlled. He suggests that this happens in a continual interplay between creation and criticism and implies a 'controlled regression of the surface faculties towards a primary process'. This idea that creativity not only controls the regression but also the work of the primary process itself points to a more dynamic role of the ego which departs from Freud's more pessimistic view of involuntary unconscious. Kris believes that the unconscious

turns its potentially disruptive effect into a low structure and highly efficient instrument for making new links and shaping new, more comprehensive concepts and images. The conscious and unconscious are not merely linked. Surface thought is wholly immersed in the matrix of the primary process.

(Kris 1953: 262)

Another of Kris's interesting explorations is his tracing back to antiquity the role and function of the artists in society. He particularly explores the artist's mythological base. He starts by looking at the Greek division of poets and musicians as 'inspired creators' and of painters, sculptors and musicians as 'great artisans'. He feels that it reflects mythological traditions where painters and sculptors are descendants of cultural heroes, who competed with the Gods – Prometheus, Hephaestus, Daedalus: 'artist as a creator is endowed with the powers of a magician and is penalised by the Gods for rebellion and rivalry' (Kris 1953: 150). He suggests that this is the foundation for the artist living on the fringe of society in a Bohemian reservation. It is the ramifications of the belief in image magic; firstly, the power over memory and, secondly, the ability to externalise human appearance. 'Gestures must be seen when they are made; words must be heard when they are spoken. Pictures can be read in aftertime. They persist, control time, and overcome its passage. In this very fact there is magic' (Kris 1953: 50).

The artist is able to preserve that which vanishes. Kris sees a close relation of mythological tradition concerning the artist and the psychological processes active in the artist.

The artist does not 'render' nature, nor does he 'imitate' it, but he creates it anew. He controls the world through his work. In looking at the object that he wishes to 'make', he takes it in with his eyes until he feels himself in full possession of it. Drawing, painting and carving when it has been incorporated and is made to re-emerge from vision, is a two-pronged activity. Every line or every stroke of the chisel is a simplification, a reduction of reality. The unconscious meaning of this process is control at the price of destruction. But destruction of the real is fused with construction of its image. When lines merge into shapes, when the new configuration arises, no 'simile' of nature is given. Independent of the level of resemblance, nature has been recreated.

(Kris 1953: 51)

Ella Sharpe (1950a, b) was also writing papers on art and psychoanalysis over a similar period to Kris (1930–1950s) but with a Kleinian rather than Freudian perspective. She describes how art makes 'representations of life', suggesting that 'Sublimation and civilisation are mutually inclusive terms; cannibalism and civilisation mutually exclusive. Civilisation begins with the

first art forms, and these first art forms are inseparable from the problems of food (life) and death' (Sharpe 1950a: 9). She felt that art provided a service to the community, a magical reassurance and that great art has a self-preservative functioning: 'From a world of apprehensions and anxiety, a world of temporal things, of vicissitudes and death, we temporarily escape. In these few moments of conviction, immortality is ours' (Sharpe 1950a: 128).

Through art, a delusion of omnipotence can find a reality channel. The ego seeks relief from the hostility of the incorporated parents by the power to externalise into an art form. The creative experience is of 'omnipotent life giving' to these internal images, a 'restoration, milk, semen, child'. She suggests that the pictures were originally outer images, the images of infancy, incorporated then in adult life projected out onto a blank sheet.

> Art, I suggest, is a sublimation rooted in the primal identification with the parents. That identification is a magical incorporation of the parents, a psychical happening which runs parallel to what has been for long ages repressed, i.e. actual cannibalism. After the manner of cannibalistic belief, psychically the same magical thing results, *vis* omnipotent control over the incorporated objects, and a magical endowment with the powers of the incorporated.
>
> (Sharpe 1950a: 135)

During creative periods, the omnipotence of the superego, needed to counteract anxiety about the hostile incorporated objects, is transferred to the ego and makes a symbolic re-creation of the images that have been destroyed in phantasy. Art, therefore, has to be seen as an ordering of emotional experience.

The work of Ella Sharpe links with Marion Milner in an exploration of the 'body-basis' of the art process. This is an interest in the biological base of art, not just in the sense of having a self-preservative function but also in how the artist works with body perceptions, an inner knowledge and experiencing based on the body's sensations. For instance, Milner writes of 'spreading the imaginative body around what one loves' as a way of dealing with separation and loss. She too felt an imaginative connection between this spiritual enveloping and eating. Milner also writes of this experience both in feeling oneself into the object one is trying to create while painting, as well as using the deep body ego to enter imaginatively the experience of the analysand in analysis.

In *The Hands of the Living God*, Milner (1969) explores this question in terms of techinique, feeling that it was only by giving this type of attention to her patient that the patient was able to get in touch with primitive psychic and body-ego experiences. Sharpe saw the artist as having vivid sensuous response and 'body knowledge' so that he or she can produce lifelike representation in any sensuous medium. She felt that the sublima-

tion of the artist arises from the early stages of infancy, before speech was acquired. Therefore the artist is communicating an experience which did not occur in words.

> The child communicates it by crooning, gurgling, crying, screaming, by gesture, urinating, defecating. The artist, the 'pure' artist, communicates his emotional experience by manipulation of sound, gesture, water, paint, words. The same bodily powers are used as in babyhood but infinitely developed, the same substances, symbolically (as in water and oils) are used.
>
> (Sharpe 1950b: 142)

If the artist is able to maintain contact with reality through sublimation, then art has to be seen as a self-preservative impulse. Sharpe felt that creative art represented a triumph over aggression and it gave a repeated assurance of the ability to restore the good introjected object, in Kleinian terms, which is a restoration of the good experience threatened by hate and fear. To sum up her view on the artistic process and creative experience: 'the artist deals with his instinctual problems and the psychical phantasies allied to them in terms of his body. He uses a knowledge that is diffused in his body, a body intelligence and bodily experience in dealing with emotional states' (Sharpe 1950b: 148).

Marion Milner shared with Anton Ehrenzweig and Adrian Stokes the deeper understanding of the creative process that comes from making art works at first hand. All three combined this inner knowledge with a full experience of psychoanalysis and their writings challenged existing theories and pushed forward a re-evaluation of the functioning of the primary process by other questioning analysts. In *The Hidden Order of Art* Ehrenzweig (1967) attempts an 'aesthetic analysis of art's deep substructure'. Ehrenzweig was interested at first in exploring the two modes of thought of the primary and secondary processes and how they interacted in creative work. He thought that in creativity there was a conflict between conscious and unconscious control. Conscious thought is sharply focused and highly differentiated analysis. Unconscious thought is syncretistic, having the ability to comprehend a single structure rather than analyse details. It branches in unlimited directions so that in the end the structure appears chaotic. Ehrenzweig thought that creativity requires a diffuse, scattered kind of attention that contradicts our normal logical habits of thinking. He saw a 'deceptive chaos in art's vast substructure', deceptive because there was a 'hidden order in this chaos', the hidden order of the unconscious. He took the explorations of Frazer in the *Golden Bough* around the theme of the dying god as a mythology of the process of creating itself. The 'self-destructive' imagery of the dying god can be read as the self destructive attack of unconscious functions on the rational surface sensibilities. So, to create anew, means casting aside old patterns of thought and being.

Ehrenzweig explores a child's early vision of the world, which he describes as 'global'. It is syncretistic, with an undifferentiated structure. He feels that there is a change to an analytic vision at latency with the weakening of libidinal drives, vision detached from concrete individual objects to generalised patterns. The ability to select a form from a background, a good gestalt is encouraged educationally. Yet, the original syncretistic vision is the base of artistic vision; it can, for example, accommodate a wide range of incompatible forms. The artist needs to be able to move freely between attention to detail and to scatter attention over the whole picture plane. 'It is the privilege of the artist to combine the ambiguity of the drawing with the tensions of being fully awake' (Ehrenzweig 1967: 12).

Ehrenzweig thought that during the artistic process there was a time of 'unconscious scanning' where integration of the work, the picture and of the artist's personality took place. 'This total integration can only be controlled by the empty state of unconscious scanning which alone is capable of overcoming the fragmentation in art's surface structure' (Ehrenzweig 1967: 30).

During the artistic process a conflict between the two types of thinking is experienced, as one or the other is in ascendancy. The medium in which the artist is working plays an important part. Ehrenzweig has written that 'something like a true conversation takes place between an artist and his own work' (Ehrenzweig 1967: 57). The interaction of artist, idea and medium allows contact with the unconscious.

> The medium, by frustrating the artist's purely conscious intentions, allows him to contact more submerged parts of his personality and draw them up for conscious contemplation. While the artist struggles with his medium, unknown to himself he wrestles with his unconscious personality revealed by the work of art. Taking back from the work on a conscious level what has been projected into it on an unconscious level is perhaps the most fruitful and painful result of creativity.
>
> (Ehrenzweig 1967: 57)

Ehrenzweig postulated three phases in creative work. The first phase is one of projection of fragmented parts of the self into the work, because of the fragmentation it has a schizoid character. The second phase is one of unconscious scanning and integration where an unconscious substructure is formed. This gives the work of art an independent life. This he has described as a manic phase. The third phase is one of secondary revision. There is a partial re-introjection of the work into the surface ego. So there is feedback on a higher mental level. This is a depressive phase as the gap between the ideal and real is come to terms with, mixed with acceptance of imperfection and hope for future integration.

We have already come across the problem of how to observe the workings of the primary process in secondary process terms. Here the problem

is how to observe unconscious structure of art with the gestalt techniques of the secondary process. He feels that the 'integration of art's substructure is only observed through its conscious signal: pictorial space' (Ehrenzweig 1967: 76).

Ehrenzweig thought that the bulk of creative work was carried out in oceanic states of undifferentiation. The creative ego rhythm swings between this and a focused gestalt. The art work acts as a receiver, a womb for the artist's projections. He comments on the work of art having a life of its own, which is similar to Adrian Stokes on the 'otherness of a work of art'.

Anna Freud (1950), Marion Milner (1950) and Ehrenzweig (1967) have all made comparisons and comments on the relationship between the analysand in the analytic situation and the artist and his works of art. What are the creative characteristics which they share? Anna Freud saw the same need to be absent-minded, for conscious logic and reason to be absent. There was the same unwillingness to leave secondary process and to accept chaos as a temporary stage. The same fear to plunge into no-differentiation and disbelief in the 'spontaneous ordering forces' which emerge. The same terror of the unknown was experienced. Just as the painter interferes with the process when he or she cannot bear uncertainty, prematurely seeking a whole in the painting, so does the analysand interfere with the process and the analyst, through premature interpretation. Ehrenzweig compares the role of the analyst's 'free floating' attention. Like the artist the analyst's attention refuses to focus on the obvious, dissipates and scatters impartially over the entire material. The analyst will extract some inconspicuous detail that may contain the most significant symbols. The detail is fitted into place in the interpretation and the patient re-introjects her own fragmented projection on a higher structural level. All three phases of creativity are present, the analyst, like a work of art, serves as a receptacle to receive the projections. In Milner's words: 'to receive the pain, when it became unbearable, and then give it back to her in a more bearable form – as the tragic work of art does, *Macbeth*, for instance' (Milner 1969: 219).

There is some controversy among analysts over whether psychic creativity seeks above all 'to preserve, recreate the lost object' or, as Marion Milner suggests, whether this is a secondary function of art, the primary function being to create 'what has never been seen'. However, Anna Freud concludes that both the creative venture and the analytic process aim at more than mere recovery of lost feelings and abilities but for the creation of new attitudes and relationships on the basis of the newly created powers of insight into the inner world. Interestingly, whereas Freud found the most fruitful comparison between psychoanalysis and the arts to lie in creative writing, later analysts have found these most productive parallels in the visual arts.

Another large area of interest is that of 'Outsider Art', 'Art Brut' and

Psychotic Art. This is not within the bounds of this chapter to explore, although it is of interest to us in the motivation for creative activity. Kris devotes a section to psychotic art in *Psychoanalytic Explorations in Art.* His findings differ from the enthusiasm of a collector like Prinzhorn (1972), who saw art as redressing a balance, a force for healing in the psychotic. He rather sees the psychotic loosening his relation to the world and making vehement attempts to recathect objects outside, e.g. in an increased production of pictures. Storr (1978) has tried to delineate the many varied reasons why people might wish to create, exploring types of personality giving examples of famous artists and scientists. He sees that creativity can be for wish-fulfilment, imagination used to create substitutes for reality, as abreaction, the ridding of the psyche of impulses which cannot find expression in ordinary life. He investigates an area which Kris thought should be explored – that is, 'the character traits of the artist'. One discovery is that artists are thought to have a 'strong ego' and that this separates them from persons with equally fluid boundaries between id and ego who might get overwhelmed by primary process.

With a strong ego an artist might have the following traits: independence, inner direction, aesthetic sensitivity, ability to tolerate tension and anxiety. The artist, genius and madness have often been connected yet Storr considers 'One of the reasons that creative people are apt to be labelled neurotic even when they are not is that their psychopathology is also showing; but it is showing in their works, and not in the form of neurotic symptoms. The work is a positive adaptation whereas neurosis is a failure in adaptation' (Storr 1978: 204). He found that, usually, the creative person had easy access to his or her inner world and did not repress it as much as most people. He concluded that 'creative work tends to protect the individual against mental breakdown' (Storr 1978: 31).

Storr suggests that creativity can be used as a defence to ward off 'unpleasure and anxiety'. The depressive personality may try to replace a world he or she feels has been destroyed by creating something. The schizoid personality will seek for meaning and significance in things rather than other human beings and will need to create an internally self-consistent system, whereas the obsessional may start creative work as an action for defence or insurance, a protective measure. Part of the process may be symbolic, ritualistic activity that may be linking the outer and inner worlds of the subject. His examples of famous artists and scientists perhaps only conclude that we might all have a reason to create, whatever our basic personality.

Storr also enquires into our babyhood. He suggests that a 'divine discontent' may be inherent in our long infancy. It is likely that the price of our developed and inherited culture is our delayed maturity. Human children have a long dependence on adults and, in consequence, a long period of frustration. He sees our 'inner world' developing as a direct result. There is

a need for imaginary satisfaction. 'It is not the suppression of adult sexuality which leads to creativity but of its childhood precursors' (Storr 1978: 181).

Storr posits a childhood residue of dissatisfaction which is carried into adulthood and which can only find resolution in symbolic ways. Perhaps creative people have less secure identities, more of a divided self, but a greater tolerance of ambiguity which allows them to move flexibly between conscious and unconscious processes. Storr makes a firm link to the work of Jung. He finds particular correspondence in the Jungian approach of trying to develop the creative possibilities latent in the patient. The concept of 'individuation' – the coming to terms with oneself by means of recon-ciling opposing factors within – is crucial here. For through this, the work of art is seen to be adaptive, to unite opposites within the self, and to integrate the personality.

THE AESTHETIC EXPERIENCE

Discussion of the 'aesthetic experience' historically centres around a concept of the 'sublime' and of the 'beautiful'. The sublime was originally thought of as an experience seated in feelings aroused and produced by contemplation of nature in her deeper awe-inspiring moments, whereas the beautiful was to be found in contemplation of artifacts, man-made objects for contemplation, that had characteristics of being felt complete or perfect. Difficulties arose over what is thought to be beautiful, what is good 'taste' and how to find a general agreement. Psychoanalytic writings on aesthetics have partly side-stepped issues of whether aesthetics can be reduced to ideology by their focus on the mental processes through which emotions are felt. Questions still remain over whether the art of a particular period is structured to represent the dominant factor in a society or whether art struggles to subvert the dominant consciousness. Possibly it emerges from the fusion of the conflict of opposing trends. Adrian Stokes comments:

> The sublimation is highly wrought. Art is, of course, a cultural activity; the 'good' imagos at the back of Form are identified with the actualities or potentialities of a particular culture.
>
> (Stokes 1978: 110)

In this short section we are only able to trace some development of psycho-analytic contribution from within the vast subject of aesthetics.

It might seem strange to begin with Freud's paper on 'The Uncanny', which does not have an inspiring opening:

> It is only rarely that a psychoanalyst feels impelled to investigate the subject of aesthetics, even when aesthetics is understood to mean not merely the theory of beauty but the theory of the qualities of feeling. He

works in other strata of mental life and has little to do with the subdued emotional impulses which, inhibited in their aims and dependent on a host of concurrent factors, usually furnishes the material for the study of aesthetics.

(Freud 1919: 219)

The subject of 'The Uncanny' deals with experiences that are frightening, familiar, concealed and usually hidden. Examples that he discusses are doubts as to whether something is animate or inanimate, experiences of meeting one's 'double', experiences of coincidence and repetition. It is a fascinating paper, though one might wonder about the precise connection to these experiences and the aesthetic experience. Interestingly, Peter Fuller (1980) in *Art and Psychoanalysis* begins his discusison of Natkin's paintings by discussing them in terms of desire. He describes the sensual almost sexual experience of his painting, penetrating the skin, being drawn in to reach the illusionary space 'contained within the painting'. He finds it 'tinged with an elusive unease', 'familiar' and evoking 'fear' – precisely Freud's description of 'the uncanny'. We shall return to Fuller later, but first follow through Freud's formulations in his paper.

Many instances of 'the uncanny' can be explained by the general term 'omnipotence of thoughts' – the old, animistic conception of the universe where the world was peopled with the spirits of human beings, by the

subject's narcissistic over-evaluation of his own mental processes; by the belief in the omnipotence of thoughts and the technique of magic based on that belief; by the attribution to various outside persons and things of carefully graded magical powers or 'mana'.

(Freud 1919: 240)

All of us, in our individual development, have been through one animistic phase and have preserved certain traces of it. Freud concludes that the secret nature of the uncanny is that it is something frightening, repressed, which recurs. So it is something that has been familiar and has become alienated through the process of repression. So when an uncanny experience happens to us, it is an infantile complex revived by an impression or association.

Freud made a further contribution to the study of aesthetics in two further papers, 'Creative Writers and Day Dreaming' (1908) and 'Jokes and their Relation to the Unconscious' (1905). Later writers, Gombrich (1966) and Wollheim (1980), have built on these points and extended them to consider the aesthetic experience in art particularly.

Kris suggests that the public view in reverse order to the artists making their work; they move from the edge to the centre. They move from passivity to activity. The audience experiences some of the excitement and release of tension which arises when barriers between conscious and unconscious are loosed. The public is identified with the artist, and is also

re-creative. There is a large emotive potential because the audience reaches unconscious mechanisms, and mastery of them experienced by the artist and their reactions may be richer. Kris partly explains this by a comparison of 'Dreamwork and Artwork':

> What in the dream appears as compromise and is explained in terms of overdetermination appears in the work of art as multiplicity of meaning, which stimulates differentiated types of response in the audience.
>
> (Kris 1953: 25)

Kris also discusses the importance of the 'aesthetic illusion', 'a firm belief in the "reality of play" can coexist with a certainty that it is play only. Here lie the roots of the aesthetic illusion' (Kris 1953: 42).

Kris looks at the use of the word 'kathartic' by Aristotle and, later, Freud and how art is often viewed as releasing unconscious tensions and 'purging the soul'. The 'purging' enables the ego to re-establish control which is threatened by clammed up instinctual needs:

> The maintenance of the aesthetic illusion promises the safety to which we were aspiring and guarantees freedom from guilt, since it is not our own fantasy we follow.
>
> (Kris 1953: 45–6)

Kris makes an interesting discussion on caricature, in many ways related to the psychological mechanisms behind the making of jokes. He explores the psychology of caricature and the technique behind it of 'unmasking' another person, a technique of degradation. In relation to caricature there is a saving in mental energy, a saving of energy for suppression as aggression is liberated. He describes it as midway between pleasure and unpleasure. The caricature traces back to the world of effigy and magic. The most primitive attitude towards image magic is to act upon the image in the belief that image and person are one, e.g. 'hurting' a wax doll to hurt an enemy. The next stage would be to make an effigy and to make hostile action on the image instead of on the person. Kris describes this as a communication rather than an action. The third stage is the caricature proper where hostile action is confined to an alteration of the person's likeness. Here, Kris suggests, aggression remains in the aesthetic sphere, we laugh rather than make a hostile act against the person. It is not uncommon to find all these stages at work in art therapy and the popularity of caricature and effigy can be seen for instance in 'Spitting Image' where the audience's frustrations and feelings of impotence in relation to political figures, for instance, are relieved.

We shall now consider the contributions to the study of aesthetics from two interesting papers which have had influence on later writers. The first is Fairbairn's 'The Ultimate Basis of Aesthetic Experience' (1939) and the second, Rickman's 'On the Nature of Ugliness and the Creative Impulse'

(1940). Fairbairn bases his whole thesis around the surrealists' use of 'found objects' in their art work. Freud had been very hostile to the surrealists despite their efforts to contact him because of his pioneering work into the unconscious. Gombrich comments that 'clearly to Freud there was no artistic value in the primary process as such' (Gombrich 1966: 35). Freud dismissed as lunatics Expressionists and Surrealists because he suspected they confused the mechanisms of the primary process with art, rather than using technical mastery to invest a preconscious – that is, a communicable idea with a structure devised from unconscious mechanisms. Fairbairn, however, sees the surrealists using 'found objects' in which they discovered a hidden symbolic significance which the artist 'preserves and frames'. To those who discover a found object, it represents a union between the 'world of outer reality and the inner world of dream'. Fairbairn continues to describe how the discovery is accompanied by an intense emotional experience. He suggests that the emotional attitude to the found object represents 'an intermediate point between the attitude of the artist and that of the beholder'. The found object possesses features which enable it to represent a fulfilment of the artist's emotional needs. He then widens out his 'found object thesis' to encompass all art, wherein lies the weakness of the paper because it does not allow for the capacity to create something new, posited by later writers such as Stokes (1978), Milner (1950) and Ehrenzweig (1967). In terms of creativity, his paper is interesting as a stage on the way to later thinking and offers thoughts on the aesthetic experience which are of value:

> Aesthetic experience may accordingly be defined as the experience which occurs in the beholder when he discovers an object which functions for him symbolically as a means of satisfying his unconscious, emotional needs.
>
> (Fairbairn 1939: 173)

In his discussion of the 'failure' of aesthetic experience Fairbairn suggests (a) an over-elaboration of disguise which precludes any appeal to the repressed urges, i.e. symbolism has 'form without content', or (b) inadequacy of disguise, where the requirements of the superego are unsatisfied, i.e. symbolism has 'content without form'. Fairbairn sees artistic activity as having a double function of providing a means of expression for the repressed urges of the artist and of simultaneously enabling the ego to pay a tribute to the supremacy of the superego – essentially a means of restitution – the ego making atonement to the superego for the destruction implied in the presence of repressive destructive impulses.

> The aesthetic experience is thus seen to be an experience that occurs when a person finds himself confronted with an object which presents itself to him, not simply as a 'found object' but also as a 'restored object'.
>
> (Fairbairn 1939: 178)

Ultimately, then, a work of art is a synthesis of the life and death principles or of destruction and restoration. In aesthetics the concept of beauty is defined through such terms as order, symmetry, wholeness and supplies the need for restitution in the beholder. Catharsis is also experienced through such emotions as pity and fear as, for instance, in tragedy. Tragedy needs to unite a sense of uncontrollable destruction at work but to impress the beholder must also produce an impression of completeness and perfection, an impression of 'the integrity of the object'.

> ... to appear beautiful, the work of art must be able to produce in the beholder an impression of the 'integrity of the object'; but, in order to do so, it must at the same time provide a release for the emotions which imply the destruction of the object. Otherwise the conditions of restitution remain unsatisfied, and aesthetic experience is accordingly precluded.
>
> (Fairbairn 1939: 180)

The artist represents in a neutral medium the interplay of creative and destructive instincts and this allows us, the beholders, to comprehend better our conflicts. Rickman saw art as the triumph of the creative forces over destruction, not a denial of pain but a determination to master it. In his paper he explores the quality of feeling we experience on seeing something ugly and looks at the underlying mental processes which are at the base of these feelings. It is an area of experience connected to Freud's exploration of 'The Uncanny' as roots of the word 'ugly' come from Icelandic words meaning 'fear' and 'like'. One experience he studies is of feelings aroused by the 'incomplete image', i.e. ancient broken statues (Fuller (1980) elaborates on this beginning in his chapter on Venus de Milo in *Art and Psychoanalysis*.) Rickman suggests that such statues can arouse unconscious phantasies of remutilation from infancy. The reawakened phantasy of destructive impulses is more disturbing than the defects in the object itself. The phantasy remains unconscious and the effect of fear or horror becomes attached to the statue: 'the phantasy is kept from consciousness at the expense of the richness of the subject's emotional relation to an external object' (Rickman 1940: 298). (Art therapists will be familiar with the difficulty of getting clients to 'own' disturbing pictures.)

Rickman suggests that there are three satisfying factors in a work of art. There is, firstly, sensuous pleasure from viewing. Secondly, relief of tension gained from the solving of a conflict through the interplay of constructive and destructive tendencies:

> a work of art appeals to us in proportion to the depth of emotional level which is stirred in our minds, the artist cannot take us where he himself has never been.
>
> (Rickman 1940: 307)

Thirdly, there is an 'eternal' factor. In seeing the triumph of creative forces over destruction we are helped to struggle with despair. Artists are driven to create to make sure their internal objects are alive and healthy and not destroyed by hate and envy.

> In all nature death is the only irreversible reaction, the triumph and the illusion of art is that it can turn back the dead into the world of the living.
>
> (Rickman 1940: 308)

Rickman concludes that

> fear which ugliness arouses is due to the irrefutable evidence which it provides that the will to destructiveness has been let loose.
>
> (Rickman 1940: 234)

It is useful at this stage to re-cap some of the thinking on aesthetics from writers we have already looked at – Hanna Segal, Marion Milner and Donald Winnicott – before going on to look at the contribution from Adrian Stokes. We have seen that in Kleinian terms the artist is working again through the infantile depressive position: the stage of development where the infant becomes aware of love and hate directed towards the same object. Total desolation is felt at the destructive impulses to hurt the loved object, so these are followed by impulses to reparation, to recreate, reconstruct and regain the harmonious inner world. Hanna Segal sees these reparative impulses as a 'fundamental drive in all artistic creativity'. In making a work of art, its independent external existence is important, it is allowed to be separate, as mother had to be allowed to be separate. Hanna Segal thought that in the aesthetic experience we identify with the artist's inner world. This is not, as Rickman suggested, to do with sensuous pleasure but involves psychic work; and from this work comes our feeling of enrichment and lasting satisfaction. She thought that a necessary condition for a work of art, for reparation to take place, was the admission of the original destruction, otherwise there could only be denial of destructive impulses. She felt that an element of ugliness, which corresponds to what is destroyed or fragmented in the inner world – as well as an element of beauty, which corresponds to what is whole, the experience of a loved whole good object in the inner world – were both essential as part of the aesthetic experience. Similarly to Ehrenzweig she thought that the viewer of the work of art must complete the work internally: 'our own imaginations must bridge the last gap'. This suggests a necessary incompleteness on the part of the artist, psychic work for the beholder, as an integral part of the aesthetic experience.

Donald Winnicott and Marion Milner have both contributed to the psychoanalytic understanding of aesthetics by particularly commenting on the role of the 'illusionary area' and of the role of 'framing' respectively

(Winnicott 1958, Milner 1950). Winnicott, in his study of 'Transitional Objects and Transitional Phenomena' (1958) delineated the inner world, outer reality, and a third area of experiencing to which both the former contribute. An area that is not challenged, it exists as a 'resting place' for the individual in the perpetual human task of keeping inner and outer reality separate yet related. This intermediate area, the 'illusionary area', is in direct continuity with the 'play' area of the small child who is 'lost' in play: 'At this point my subject widens out into that of play, and of artistic creativity and appreciation and of religious feeling and of dreaming' (Winnicott 1958: 233).

Marion Milner saw the withdrawal from the external world as a necessary part of play or art so that inner work of integration could be carried out. The aesthetic moment for maker or viewer was during this temporary loss of self. She thought that art provided a method in adult life for reproducing states that are part of everyday experience in healthy infancy. By using art one could keep the perception of the world from becoming fixed and no longer capable of growth. Paint, a pliable medium, provides feedback; it is a basis of communication, waiting for the painter to become more sensitive to its real qualities, and by this means it does some of the things that a good mother does for her baby. The painting provides a framework of time and space, what is within is to be taken symbolically; what outside, literally. Inside is symbolic of feelings and ideas. Many forms of therapy give a similar 'framing' to experience. She thought that in creative activity one was trying to find an order in one's own loves and hates, in appreciation observing how someone else has tackled the problem and sharing their experiences imaginatively.

The writings of Adrian Stokes, painter and aesthetician, contributed to and influenced psychoanalysis as well as artistic thinking. He had similar ideas to Hanna Segal on the depressive position and the reparation and restoration taking place in both artistic creativity and the aesthetic experience (but differed in also finding elements of the paranoid-schizoid position). He thought that we could also experience a feeling of fusion, at oneness with the breast and the world, as well as recognition of a separate object, the whole person of the depressive position in both art and appreciation. The artist strives to recreate a senses of fusion, thus renewing the oceanic feeling but combined with object 'otherness'. It is from this state of fusion, in which ideas are interchangeable, that 'poetic identifications' can flow. Stokes saw the work of art itself as an individual separate object, differentiated, yet made of undifferentiated material.

> We can always discover from aesthetic experience that sense of homogeneity or fusion combined in differing proportions with the sense of object-otherness.
>
> (Stokes 1973: 104)

and:

> Because it combines the sense of fusion with the sense of object-other-
> ness, we might say that art is an emblem of the state of being in love: this
> seems true if we emphasise the infantile introjections and reparative atti-
> tudes that are strengthened by that state. These attitudes are the fount of
> Form. When the artist joins them in the creative process, infantile
> psychic tensions concerning sense-data renew in him some freshness of
> vision, some ability to meet, as if for the first time, the phenomenal
> world and the emotion it carries.
>
> (Stokes 1973: 110)

In his writings on aesthetics, Adrian Stokes (1978) also spoke of the 'invi-
tation in art'. He saw this as an invitation to identify empathetically, and of
the 'process of heightened perception by which the willing spectator
"reads" a work of art'. He saw it as an 'inner' as well as a 'physical' process.
The value of an art object was a 'model of a whole and separate reconsti-
tuted object'. Hanna Segal differed from Adrian Stokes in seeing the
'oceanic feeling' as a manic defence against depressive experience and also
manic reparation resulting in sentimental 'over sweet' works of art. Stokes,
however, associated two modes of art, the modelling and the carving with
the paranoid-schizoid and the depressive positions respectively. He there-
fore saw a return to a much earlier mode of experiencing to be one possi-
bility of artistic and aesthetic ways of being. He thought similarly to Hanna
Segal on the necessity for an element of destructiveness to be present, to
have left its traces in the art work but describes it more in terms of the
problem facing the artist:

> I believe that in the creation of art there exists a preliminary element of
> acting out of aggression, an acting out that then accompanies reparative
> transformation, by which inequalities, tensions and distortions, for
> instance, are integrated, are made to 'work'.
>
> (Stokes 1978: 275)

As Fairbairn, earlier, had explored when an art work 'worked' or not,
Stokes describes it thus:

> But we soon reach the strange conclusion that if attack be reduced
> below a certain minimum, art, creativeness, ceases, equally, if sensibility
> over the fact of attack is entirely lulled, denied.
>
> (Stokes 1978: 276)

Art is seen integrally to be about the work of uniting conflicting trends: 'The
homage to Eros would be formless were the heavier gifts from Thanatos
excluded' (Stokes 1973: 115).

Adrian Stokes makes a bridge from the psychoanalytic view of the inner
world to the outer world where art objects also exist in a particular culture

and point in historical time. His contribution is important because it is based on his experience as a practising artist, as well as trying to develop thought about aesthetics through his writing.

Peter Fuller's interest in art and psychoanalysis (Fuller 1980) is partly an exploration of 'abstraction', asking the question 'Why do certain types of art which seem to bear no discernible relationship to the perception of the objective world appear good and give intense pleasure?' In his book, Fuller is trying to find a materialist basis to aesthetics. He explores how object-relations theory may illuminate his enquiry. Here we can only pick out some stages of his thinking in the space available. He is led to explore abstract art as being about the affective meaning of space through the influence of Marion Milner's work. Cubism was an attempt to struggle out of the old perspective-based fine art conventions towards a half-expression of a new way of seeing. He sees Cézanne painting landscapes in a stage of change and becoming a mingling of inner and outer worlds.

Fuller finds object-relations theory of interest, particularly its focus on a transient stage of development between the 'subjectivity' of the earliest moments and the more objective perceptions of late childhood. Fuller sees that, from Cézanne onwards, some painters are not just involved in an 'epilogue to fine art' but are exploring a new capacity of painted images to explore aspects of human experience. In Stokes' terms, fusion and object-otherness. This is in line with Milner's view that painting is a way of experiencing relationships. We return to Fuller's description of the experience of viewing particular paintings by Natkin, mentioned earlier in connection with 'The Uncanny'. Fuller felt the painting drawing him into an illusionary space 'contained within the painting'. His experience of the painting was almost as if a person was in relationship to the viewer. Fuller discusses the ideas of Winnicott on 'potential space', the hypothetical area of me and not-me, and on the two experiences of mother. Winnicott terms, object mother (use of mother at height of id tension) and environment mother (mother warding off the unpredictable and actively providing care in handling, etc.) (Winnicott 1965b, 1988). He suggests that the two aesthetic experiences, Beauty (classical, order, form, carving mode) and Sublime (romantic, fusion, colour, modelling mode) correspond to experiences of the object mother and environment mother respectively. Returning to Natkin's painting which inspired his investigations, Fuller describes it as giving an experience of 'potential space' in the emotions and paradoxes it arouses in the viewer. In exploring these early experiences Fuller follows the work of Milner and Ehrenzweig in seeing the creative potential working with the primary process rather than seeing it as archaic and regressive (Milner 1950, Ehrenzweig 1967). We shall be looking at the work of Rycroft who sees the two processes as complementary – creative people hold onto the imaginative in the midst of the rational – in the next section, on symbolism. It is possible that abstract painting is a necessary phase of

'emptiness' and 'exploration of inner space' on the way to a new integration.

SYMBOLISM

The analogy of art being a bridge between inner and outer worlds is sometimes used by art therapists to describe their role as mediator and to describe the function that a picture can have, holding and symbolising past, present and future aspects of a client, linking unconscious to conscious imagery. All this, with its ambivalences and conflicts, can be mutely 'said' in a picture. Theory about the symbolisation process has changed significantly since Freud. Charles Rycroft (1968), in *Imagination and Reality*, delineates past and present thinking around this subject with great clarity. He begins by describing Freud's classical theory of symbolism which rests upon one of his earliest and most fundamental ideas, mentioned earlier in Chapter 4, of a primitive psychic apparatus which regulates states of tension by discharging instinctual impulses. Symbols are formed by the displacing of investment of psychic energy from the object of primary instinctual interest onto other objects that have been seen in the outside world. Once it has been formed, a symbol can be used by either the primary or the secondary process. If it is used by the primary process, its meaning becomes independent of the object originally represented and it becomes joined to the fantasy systems underlying neurosis and dreaming. If it is used by the secondary process, it continues to represent the object it is linked to in the outside world and becomes part of our adaptation to reality serving conscious and unconscious imaginative processes.

Impulses discharged by way of the primary process bring immediate but temporary relief of tension but remain unrelated to the outside world, e.g. tension is relieved through dreams to guard our sleep; in psychosis fantasy is used in the forming of a defensive denial of reality. In infancy, the immature ego hallucinates wish-fulfilment; in neurosis, a fantasy life is developed to fulfil wishes. However, impulses taking the pathway of secondary processes become conscious wishes. There are two parts to this process. Firstly, external reality is perceived and analysed in the search for an appropriate object and then skills are used so that the wish is satisfied. It can be seen that the secondary process leads to communication, contact and interaction with an external object.

Rycroft feels that the classical theory of symbolism became untenable with the changes and developments made in Freud's metapsychology described in 'The Ego and the Id' (1923). In this paper his ideas became less rigid, suggesting that

(a) what is unconscious is not necessarily repressed;
(b) the ego (replacing the conscious) is not necessarily conscious;

(c) instead of a clear duality of conscious and unconscious, the ego became 'that part of the id which has been modified by the direct influence of the external world'.

Before moving on to look at Rycroft's revision of the classical theory of symbolism we would like to look at some of the influential writers who have contributed to present-day thinking.

The seminal paper is Ernest Jones' 'The Theory of Symbolism'. He approaches the subject with a global vision.

> If the word symbolism is taken in its widest sense, the subject is seen to compromise almost the whole development of civilisation. For what is this development but a never-ending series of evolutionary substitutions, a ceaseless replacement of one idea, interest, capacity, or tendency by another?

> (Jones 1919: 181)

Jones explores the many uses of the term 'symbolic' and finds six common attributes. A symbol is a representative or substitute for some other idea. A secondary element represents a primary idea by having something in common, which can be internal or external, i.e. significance of feeling. A symbol is characteristically sensorial and concrete whereas the idea symbolised may be relatively abstract and complex, and therefore has been condensed. He considered symbolic modes of thought to be more primitive and to represent a reversion to some simpler and earlier stage of development. They are therefore more common in fatigue, drowsiness, illness, neurosis, insanity or dreams. In most cases a symbol is a manifest expression for an idea that is more or less hidden, secret or kept in reserve. Lastly, he thought that symbols 'resemble wit', in being made spontaneously, automatically and unconsciously.

Jones makes a distinction between two different kinds of symbolism. The first is 'true symbolism' which arises as the result of intrapsychical conflict between the repressing tendencies and the repressed. The interpretation of the symbol usually evokes a reaction of surprise, incredulity or repugnance. Feeling has been undersublimated and repressed. In the second, 'functional symbolism', regression proceeds only to a certain distance, remaining conscious or preconscious; it becomes metaphorical. Inhibition is overcome and some feeling force is released. In the formation of metaphor, feeling is oversublimated. Jones thought that the same image could be employed for both of these functions but that they are different.

In his paper he distinguishes operative factors in the genesis of symbolism. Firstly, 'mental incapacity', by which he means that it is *easier* to symbolise, it is a mental process costing least effort. Secondly, the 'pleasure–pain' principle, i.e. what interests the mind is easier, so that to

find 'likenesses' takes less effort than to perceive something in its separate qualities if it is strange or new. Thirdly, the 'reality principle': the appreciation of resemblances facilitates the assimilation of new experiences. He sees symbolisation as a regressive phenomenon – for instance, the identification of 'likeness' was originally useful to children but should be outgrown. He sees it as a primitive means of adaptation to reality. To summarise, he saw that ideas that are symbolised are the most primitive and the most invested, the result of intrapsychical conflict between repressing tendencies and the repressed. All symbols represent ideas of the self and immediate blood relatives, or of the phenomena of birth, love, death. The most primitive ideas and interests imaginable.

Jones's paper on 'symbolism' is interesting historically because it was quite a vigorous examination of what he calls the 'post-psycho-analytical school of writer' (Jung is included among those to whom he is referring). He says that what they are doing is to 're-interpret the psycho-analytical findings back again into surface meanings'. One of their interests in the value of symbolism was to explore the mystic, hermetic or religious doctrine contained in a symbol. Here the symbol would be understood as a striving for a higher ethical ideal which fails to reach this ideal and halts at the symbol instead. The ultimate ideal is seen to be implicit in the symbol and to be symbolised by it. But to Jones this was simply sublimated interests and activities. He disagreed also with Jung on the subject of 'anthropological symbolism', which Jung thought to be inherited. He believed instead that individuals recreate afresh in each generation and that stereotyping is due to the 'uniformity of the fundamental and perennial interests of mankind'.

The idea that symbols are innate implies either the 'inheritance of acquired knowledge' or a 'collective unconscious'. Rycroft (1956) has also explored this question, agreeing with Jones but also adding that the 'universality of symbols' is better explained by the uniformity of the effects and sensations accompanying instinctual acts and the uniformity of the human mind's capacity for forming gestalts and seeing resemblances between them than by a 'collective unconscious'. Jung's distinctive approach to symbolism and its place in analytical psychology has been outlined in Chapter 4.

These classical approaches to symbolism were challenged by later analysts, particularly of the object-relations school. For this reason it will be useful to recap briefly on the work of Melanie Klein, Marion Milner and Donald Winnicott and to look at the thinking of Susan Isaacs on 'Phantasy' (1970). The theory that it is only secondary process thinking that is concerned with reality adaptation was turned about by the studies of mother–infant behaviour of the object-relations theorists who saw that the infant engages in realistic adaptive behaviour from the beginning. As Rycroft explains in 'Beyond the Reality Principle' (1962), present-day thinking now starts from an assumption of primary integration and regards

maturation as proceeding not from chaos (the id) but from simple to complex forms of organisation.

Klein discovered in the analysis of small children the richness and dynamic importance of unconscious phantasy. In her paper 'The Importance of Symbol Formation in the Development of the Ego' (1930) she starts by looking at the work of Ferenczi who held that 'identification, the forerunner of symbolism, arises out of the baby's endeavour to rediscover in every object his own organs and their functioning' (Klein 1968: 237). She was also influenced, as all later writers, by Ernest Jones's work on symbolism – his view that the pleasure principle 'makes it possible for two quite different things to be equated because of a similarity marked by pleasure or interest' (Klein 1968: 237). Klein concludes that symbolism is the foundation of all sublimation and of every talent, since it is by way of symbolic equation that things, activities and interests become the subject of libidinal phantasies. Klein thought that the anxiety arising from the sadistic phase sets going the mechanism of identification. Anxiety equated with the organs in question equates them to other objects and forms the basis of interest in new objects, so that through a spread of feeling there is an enrichment of new objects encountered by means of symbolism.

> Thus, not only does symbolism come to be the foundation of all phantasy and sublimation but, more than that, upon it is built up the subjects' relation to the outside world and to reality in general.
>
> (Klein 1968: 238)

She thought that for a favourable development in the child there needs to be a balance between anxiety, abundance of symbol formation and of phantasy and an adequate capacity on the part of the ego to tolerate anxiety. Klein saw the compulsion to make symbols and their constant development as 'the driving force in the cultural evolution of mankind'.

One way of understanding autistic children is that they have never been able to form appropriate symbolic relationships firstly with mother and then subsequently with other objects. Klein showed that from the earliest stages the infant begins to search for symbols and does so in order to be relieved of painful experiences. The conflicts and persecution in the phantasy with primal objects (i.e. mother's body) promote a search for new relationships with substitute objects (symbols). These conflicts tend to follow and often affect the relationship with the substitute object (the symbol), which eventually sets up further search for yet another substitute. In this case she described a process of substitution similar to displacement, which Freud also thought was one of the factors underlying the process of dream symbolisation.

In her astute analysis of Dick, Klein describes how this child showed absolutely no emotion about anything and therefore at first how difficult it was to build any therapeutic alliance. He showed no feeling as he was not

attached to anything – his early infancy had been fairly traumatic and he showed no emotion towards either his mother or his nanny. His one interest was in trains and door handles and it was starting at these points that Melanie Klein gradually built up a relationship with him so that he could begin to show anxiety, guilt, love and other feelings towards people and things (Klein 1968).

In her paper on 'The Nature and Function of Phantasy', Susan Isaacs makes an important distinction between 'phantasy' which is unconscious mental content; and 'fantasy' such as conscious day dreams, fictions and so on. Also, in *Playing and Reality*, Winnicott states: 'It will be observed that creative playing is allied to dreaming and to living but essentially does *not* belong to fantasying' (Winnicott 1988: 32).

Unconscious phantasies are a mental representation of instinctual life; they are active from birth. For instance, the comprehension of words long antedates their use, phantasies are active along with the impulses from which they arise. Unconscious phantasies colour the infant's experience of real objects and the impact of reality constantly modifies phantasy life. Phantasy life expresses itself in *symbolic* ways, as Hanna Segal says, on art: 'All art is symbolic by its very nature and it is a symbolic expression of the artists' phantasy life' (Segal 1975: 800).

Susan Isaacs' definitions of phantasy and fantasy are important in clarifying the difficulties that can arise when 'phantasy' is used as a contrast to reality. By this she intends external, material or objective facts. It then denies to psychical reality its own objectivity as mental fact. Or, she goes on to say, it can undervalue the dynamic importance of phantasy, physical reality, and the significance of mental processes as such. Isaacs describes how the earliest phantasies 'spring from bodily impulses and are interwoven with bodily sensations and affects'. An infant has few ways of expressing desire and aggression and has to use bodily products and activities to express powerful, often overwhelming wishes and emotions. These primary phantasies are far removed from words and conscious relational thinking. Both Freud (1923) and Jones (1919) have commented on how much older 'visual memory' is to thinking in words. Freud states:

> It approximates more closely to unconscious processes than does thinking in words, and it is unquestionably older than the latter, both ontogenetically and phylogenetically.
>
> (Freud 1923: 23)

Isaacs sees phantasy as the 'operative link between instinct and ego-mechanism':

> An instinct is conceived as a border-line psycho-somatic process. It has a bodily aim, directed to concrete external objects. It has a representative in the mind which we call a 'phantasy'. Human activities derive from

instinctual urges, it is only through the phantasy of what would fulfil our instinctual needs that we are enabled to attempt to realise them in external reality.

(Isaacs 1970: 99)

It can therefore be seen that reality-thinking or secondary process thinking is inextricably linked to supporting unconscious phantasies, primary process thinking. The theory about phantasy and unconscious processes is based on direct observation of children's play and inferences drawn from it. Susan Isaacs describes how the spontaneous make-believe play 'creates and fosters the first forms of "as if" thinking'. In 'make believe' a child will select elements from past experience which can embody his emotional and intellectual present needs. She continues:

This ability to evoke the *past* in imaginative play seems to be closely connected with the growth of the power to evoke the *future* in constructive hypothesis, and to develop the consequences of 'ifs'. The child's make-believe play is thus significant not only for the adaptive and creative intentions which when fully developed mark out the artist, the novelist and the poet, but also for the sense of reality, the scientific attitude and the growth of hypothetical reasoning.

(Isaacs 1970: 111)

We have seen earlier that Winnicott's particular achievement and contribution to the theory of symbolism has been to explore this intermediate area of experiencing between inner and outer realities. Inventing the term 'transitional object' in looking at the significance of the early stages of object-relating and of symbol-formation, he was therefore able to 'locate' the area of cultural experience and to explore the necessity of 'illusion'. In his exploration of 'true' and 'false' selves the importance of early relations and the capacity to use and to form symbols is poignant (Winnicott 1965a). He describes how a truc self begins to have life through the strength given to the infant's weak ego by the mother's implementation of the infant's omnipotent expressions. A false self develops when a mother repeatedly fails to meet the infant's gesture and substitutes her own gesture. This is given sense by the compliance of the infant. The true self has a spontaneity. The infant is able to abrogate omnipotence and can begin to enjoy the 'illusion' of omnipotent creating and controlling, through playing and imagining. This is the basis for the symbol 'which at first is both the infant's spontaneity or hallucination, and also the external object created and ultimately cathected'. The healthy individual develops a capacity for using symbols in this intermediate area between dream and reality and this is the basis of cultural life. The infant who has developed a false self has a poor capacity to use symbols and, therefore, a poverty of cultural living. Winnicott describes the resulting behaviour as extreme restlessness, an inability to

concentrate, a need to collect impingements from external reality and a living time filled by reactions to these impingements.

Let us remind the reader of Marion Milner's particular contribution to this discussion. She was able to mesh her analytic insights with her experience of practising as an artist and, like Adrian Stokes, was able to push thinking further forward with a fresh and original vision. She saw that one continually works on the inner and external world and that there is a free movement possible between them by which they can enrich one another. One is able to assimilate and integrate new experiences into the gradually growing self, to form an inner constant core. An encounter with reality might take prolonged activity to work through in the inner world. The reverse also happens, new motivation comes from the inner world through dreams, art and phantasies and leads to reality-oriented behaviour. Most importantly she gave a new positive emphasis to the primary process as being the necessary other half to a way of functioning healthily. She saw the art process as being able to create something 'new' through the process of symbolisation. Like Winnicott, she drew many parallels between the healthy mother/child relationship and its framework, to that of the analytic session and also, of course, the similar necessary framework that is needed for creating something new in art. Instead of the symbol being limited to a defensive function it is now seen as being essential for healthy growth out into the world. Marion Milner saw through her clinical and artistic practice that a regression to the 'infantile unconscious tendency to note identity in difference may be to take a step forward' (1955).

Rycroft, in *Imagination and Reality*, suggests that Jones's distinction of two different kinds of symbolism is in fact the same process of symbolism but is being used in different ways. He then formulates a theory of symbolism as a general tendency or capacity of the mind which can be used by primary or secondary process, neurotically or realistically, for defence or growth; for self-expression or to maintain fixation. He summarises (1968: 54):

> The process of symbol formation consists in the displacement of cathexis from the idea of an object or activity of primary instinctual interest on to the idea of an object of less instinctual interest. The latter then operates as a symbol for the former.

A symbol carries affect displaced from the object it represents.

Both Milner's and Rycroft's theories have been influenced by Suzanne Langer, whose study of symbolism, *Philosophy in a New Key*, is relevant here (1963). Part of her argument is to look at various impractical, apparently unbiological activities of man – i.e. religion, art, magic, dreaming – as languages, arising from a basic human need to symbolise and communicate. With the re-evaluation of the primary process and the acceptance that its manifestations are not necessarily unconscious, dreams, imaginative

play and artistic creation are able to be looked at anew. Langer discusses discursive and presentational forms of symbolism. The symbolism of the secondary process is discursive; conscious rational thinking is symbolised through words which have a linear, discrete successive order. The symbolism of the primary process is non-discursive, expressed in visual and auditory imagery rather than words. It presents its constituents simultaneously not successively, it operates imaginatively but cannot generalise. Therefore complexity is not limited by what the mind can retain from the beginning of an apperceptive act to the end.

Language is the only means of articulating thought; in this picture she draws of the mind, everything which is not speakable thought, is feeling. She describes this as the inexpressible world of feeling. 'Not symbols of thought but symptoms of inner life' (Langer 1963: 85). From this sphere of subjective experience only symptoms come to us in the form of metaphysical and artistic fancies.

In defining 'a picture' as an example of 'non-discursive symbolism' she describes it as having units which do not have independent meanings like a language, i.e. the vocabulary. There is no fixed meaning apart from content. 'It is first and foremost a direct *presentation* of an individual object' (Langer 1963: 96).

In responding to presentational symbolism the mind reads in a flash and preserves in a disposition or attitude. 'Feelings have definite forms which become progressively articulated.' Or, in the words of Adrian Stokes, '... the insistence by its form that distinguishes the communications of art from other embodiments of phantasy or of imagination' (Stokes 1978: 266).

Rycroft sees the function of the primary process, of non-discursive symbolism as being expression, explication, and the communication of feeling attached to experience. The secondary process has the function to analyse external reality into discrete elements, to categorise them and formulate statements about the relations existing between them. Both have a realistic function and are adaptive. If the secondary process is disassociated it becomes intellectual defence and if the primary process is disassociated it becomes pre-logical animistic thinking. Rycroft in his revisioning of theory around these processes concludes that 'the aim of psychoanalytical treatment is not primarily to make the unconscious conscious, not to widen or strengthen the ego, but to re-establish the connection between disassociated psychic functions, so that the patient ceases to feel that there is an inherent antagonism between his imaginative and adaptive capacities' (Rycroft 1962: 113).

This leads us back to the beginning of this section where we suggested the image of art therapy as a bridge between inner and outer worlds, between imagination and reality.

REFERENCES

Ehrenzweig, A. (1967) *The Hidden Order of Art.* London, Paladin.

Fairbairn, W.R.D. (1939) 'The Ultimate Basis of Aesthetic Experience', *British Journal of Psychology*, **XXIX**, p. 100.

Frazer, J.G. (1987) *The Golden Bough* (abridged). London, Macmillan Papermac.

Freud, A. (1950) Foreword to Marion Milner, *On Not Being Able to Paint.* London, Heinemann.

Freud, S. (1905) 'Jokes and their Relation to the Unconscious', in *Standard Edition*, **VIII**. London, The Hogarth Press.

Freud, S. (1908) 'Creative Writers and Daydreaming', in *Standard Edition*, **IX**. London, The Hogarth Press.

Freud, S. (1919) 'The Uncanny', in *Standard Edition*, Vol. XVII. London, The Hogarth Press.

Freud, S. (1923) 'The Ego and the Id', in *Standard Edition*, Vol. XIX. London, The Hogarth Press.

Freud, S. (1925) 'An Autobiographical Study', in *Standard Edition*, Vol. XX. London, The Hogarth Press.

Fuller, P. (1980) *Art and Psychoanalysis.* London, Writers and Readers.

Gombrich, E.H. (1966) 'Freud's Aesthetics', *Encounter*, **XXVI**, 1 (January).

Gordon, R. (1989) The Psychic Roots of Drama, in Gilroy, A. and Dalley, T. (eds) *Pictures at an Exhibition.* London, Tavistock/Routledge.

Hershkowitz, A. (1989) 'Symbiosis as a Driving Force in the Creative Process', in Gilroy, A. and Dalley, T. (eds) *Pictures at an Exhibition.* London, Tavistock/Routledge.

Isaacs, S. (1970) 'The Nature and Function of Phantasy', in *Developments in Psychoanalysis.* London, The Hogarth Press and the Institute of Psychoanalysis.

Jones, E. (1919) 'The Theory of Symbolism', *British Journal of Psychology*, **IX**.

Klein, M. (1968) 'The Importance of Symbol Formation in the Development of the Ego (1930), in *Contributions to Psycho-Analysis 1921–1945.* London, The Hogarth Press and the Institute of Psychoanalysis.

Kris, E. (1953) *Psychoanalytic Explorations in Art.* London, Allen and Unwin.

Kris, E. (1975) 'Psychoanalysis and the Study of Creative Imagination' (1953), in *The Selected Papers of Ernst Kris*, New Haven, Yale University Press.

Langer, S. (1963) *Philosophy in a New Key.* Cambridge, Harvard University Press.

Milner, M. (1950) *On Not Being Able to Paint.* London, Heinemann.

Milner, M. (1955) 'The Role of Illusion in Symbol Formation', in Klein, M. *et al.* (eds) *New Directions in Psycho-Analysis.* London, Maresfield Reprints.

Milner, M. (1969) *The Hands of the Living God.* London, Virago.

Prinzhorn, H. (1972) *The Artistry of the Mentally Ill.* Berlin, Springer-Verlag.

Rickman, J. (1940) 'On the Nature of Ugliness and the Creative Impulse', *International Journal of Psychoanalysis*, **XXI**, pp. 294–313.

Rycroft, C. (1956) 'Symbolism and its Relationship to the Primary and Secondary Processes', in *Imagination and Reality: Psychoanalytical Essays 1951–1961.* London, The Hogarth Press.

Rycroft, C. (1962) 'Beyond the Reality Principle', in *Imagination and Reality: Psychoanalytical Essays 1951–1961.* London, The Hogarth Press.

Rycroft, C. (1968) *Imagination and Reality: Psychoanalytical Essays 1951–1961.* London, The Hogarth Press.

Segal, H. (1975) 'Art and the Inner World', *Times Literary Supplement*, 3827 (18 July), pp. 800–801.

Sharpe, E. (1950a) 'Certain Aspects of Sublimation and Delusion' (1930) in *Col-*

lected Papers on Psychoanalysis. London, The Hogarth Press and the Institute of Psychoanalysis.

Sharpe, E. (1950b) 'Similar and Divergent Unconscious Determinants underlying the Sublimations of Pure Art and Pure Science' (1935), in *Collected Papers on Psychoanalysis.* London, The Hogarth Press and the Institute of Psychoanalysis.

Stokes, A. (1973) 'Form in Art: a Psycho-Analytic Interpretation', in *A Game that must be Lost: Collected Papers.* Manchester, Carcanet.

Stokes, A. (1978) 'The Invitation in Art', in Gowing, L. (ed.) *The Critical Writings of Adrian Stokes,* Vol. III. London, Tavistock.

Storr, A. (1978) *The Dynamics of Creation.* London, Secker and Warburg.

Winnicott, D.W. (1958) 'Transitional Objects and Transitional Phenomena', in *Through Paediatrics to Psychoanalysis.* London, Tavistock.

Winnicott, D.W. (1965a) 'Ego Distortion in terms of True and False Self' (1960), in *The Maturational Process and the Facilitating Environment.* London, The Hogarth Press.

Winnicott, D.W. (1965b) 'Communicating and Not Communicating, Leading to a Study of Certain Opposites' (1963), in *The Maturational Processes and the Facilitating Environment.* London, The Hogarth Press.

Winnicott, D.W. (1988) *Playing and Reality.* London, Tavistock.

Wollheim, R. (1980) *Art and its Objects.* Cambridge.

Chapter 7

The art therapist

The art therapist faces a complex and difficult task in the practice of her profession. The theory and practice of art therapy has evolved to require that the practitioners of art therapy are highly trained and experienced people whose skills continue to develop after their initial training programme.

Art therapy has emerged as a profession through the two disciplines of art and psychiatry and this tends to reflect the interests of those entering the profession. Most art therapists have an art training but there are some who have other relevant degrees such as social work or psychology, but all applicants for the various training courses must show an on-going commitment to their own art work and its development.

The importance of this stems from the early days of art therapy when theories in art education were making links between primitive and child art and a growth of interest in expression and imagination among art educators (Viola 1944).

> Art was a means for developing a seeing, thinking, feeling and creative human being, a logical development of the ideal of the early twentieth-century American philosopher John Dewey and an ideal well suited to a world war and immediately post-war period: let the children, at least, have their freedom.
>
> (Waller 1984: 4)

In the 1940s writers such as Herbert Read and John Dewey saw art as vital in developing the 'whole' personality. The idea was that the person concerned, either teacher or therapist, was to stimulate the development by holding back and not influencing, by providing materials and a stimulating environment. Followers of the Dewey school could be identified within the education system as a progressive art teachers, but in the health service the role of artists in hospitals was far more uncertain. Were they art therapists merely because they could bring educational ideas into the treatment setting, which also involved encroaching on the existing occupational therapy services?

At that time paintings were only being used for analysis and diagnosis by psychiatrists with no respect for the understanding of the need for the patient to make sense of it, or seeing that the picture was made within a relationship and must necessarily reflect the dynamics of this relationship. Indeed, the first art therapist who was employed at Netherne Hospital in 1946, Edward Adamson, adopted the recommended approach of Dewey and advocates of the child-centred approach. For although he was working in a hospital he provided an environment which facilitated the creative process but he did not intervene (Adamson 1984).

As Waller (1984) explains, the doctors at the time of his appointment had quite clear views about his role – he was to produce paintings under standard conditions with minimum intervention and they were anxious that he should be more than an occupational therapist but should not analyse, interpret or show any special interest in the psychological problems of the patients. This was the job of analysts because the doctors thought that these were pure representations of the patient's state of mind which completely denied the presence or absence of the therapist and the effect this had on the output of the patient.

This position was frustrating for artists and art teachers working in hospitals and led them to form a central association in 1964 with a view to clarifying the role of the art therapist in hospitals. Part of this clarification would be to initiate a suitable training and structure for employment. The British Association of Art Therapists (BAAT) allied with the National Union of Teachers for a time, and then joined with then ASTMS, now MSF, to reflect its more central role as the paramedical profession. When BAAT was formed, the DHSS still had the official view of art therapy as an *ad hoc* grade of occupational therapy, maintaining the view that art was merely a hobby or form of recreation and was only used as a diagnostic aid for doctors. The link with teachers evolved through the need of those artists and art teachers who saw themselves as having a more dynamic role in the possibilities of using art in the treatment of patients and were not primarily the passive providers of art materials. At that time, art teaching provided the nearest model for the development of art therapy as a separate profession.

Art therapy theory and practice developed gradually in the direction of psychotherapy in the 1970s. This indeed reflected the shifts in thinking in the increasingly professional body of working and practising art therapists. The gradual separation from art teaching came about as the practice of teaching was becoming more geared to active participation in the classroom with clear goals and objectives. This was not felt to be such fertile ground for the development of art therapy. The growing understanding that art therapy had many basic links with that of psychotherapy led to the establishment of specialist training in art therapy in the early 1970s (Waller 1991).

Thus, training courses for art therapists were set up, two of which evolved out of existing art education establishments. The essence of the training relies on the requirement of at least three years at art school where much of the foundation work in terms of personal understanding, aesthetic appreciation, critical awareness and creative problem-solving will be achieved. Without this foundation, the art base of the profession of art therapy is eroded. It also requires art therapists to have gained a high degree of personal understanding in terms of their own creative and internal processes which are based on trusting the intuitive.

At the best art colleges in the UK, the student learns to court discomfort, to abandon obvious or well-tried solutions and to test that which is new and different in her experience. Such an approach fosters emergence of inner reality, however chaotic, this being shaped into outer, more objective, imagery and objects once the raw material is manifest.

(Schaverien 1989: 147)

The experience of an art training will also have allowed the future art therapist to develop in an environment which is predominantly male, and to a degree an anarchic one. This ensures that the student emerges with some understanding of how one proceeds in this environment and, as a result, has come to some personal decisions as to issues such as resourcefulness, the need for boundaries, limits and rules, roles of men and women in society and so on. An art student cannot fail to have confronted at least some of these issues in her educational journey.

This is essentially a different experience to that of a psychiatrist whose background is one of a medically trained doctor. In contrast to the artist, the formative experiences of the medical training are scientific where knowledge is gained from facts and learning that is taught through books, lectures and observation of other people's behaviour. There is little onus on the medical trainee to reflect or analyse, and indeed it seems there is little time to think about what one is doing or how one is responding to the demands and long hours necessary for this sort of training. Indeed, there is often precious little time given over to the feelings of the patient or recipient of this medical approach in the interests of accumulating the knowledge required to graduate in the medical field: 'To become a psychotherapist such a person will need to relinquish the primacy of the outer world to allow space for acceptance of inner experience' (Schaverien 1989: 147–8).

She suggests that the artist/therapist may feel the need to relinquish the artist part of her experience in the face of an institution or system dominated by the scientific approach. In this situation it is imperative to establish that what we bring as artists to therapy is special and unique in terms of its therapeutic value and contribution.

It is within this difference of experience and cultures that art therapists

may face misunderstanding and potential difficulties within their working environment. The art therapist is usually the only one in the team whose background is of art training. The art therapist must articulate this strength of experience rather than deny its existence. It is her responsibility to colleagues to help them understand her perspective and ways of working. She must carefully inform and communicate the importance of her work. One common cry from art therapists is that they are isolated, experience lack of communication with other departments and professionals and their work may be misunderstood, undermined and not represented in its true light. The reality of working environments is that these factors are usually connected and one of the most important tasks of the art therapist is the energy they put into promoting understanding of the work in art therapy throughout the institution in which they are employed. This can take the form of leaflets or handouts to inform the various disciplines of the nature of art therapy and how referrals are accepted, etc. Many art therapists set up staff training days or inset days to inform other staff of the approach in their work. Art therapy is generally known about but often staff remain uninformed of what actually happens in the art therapy department.

Art therapists increasingly must be skilled in describing their profession and practice to others through presentation of material at clinical meetings, inviting visits from other staff and so on. In the past more threatened departments might have felt inclined to fend off visits by other departments but this does not achieve development of understanding and therefore the support of colleagues, for other professionals too may face these difficulties in large institutions.

In his chapter about surviving the institution as an art therapist, David Edwards (1989) points out that the problems art therapists face appear to fall into three main areas: the problems of recognition, integration and validation. He argues that many of the problems are not in fact misunderstanding of their work, but often more institutionally based in terms of the isolated location of some of these departments in huge, psychiatric institutions. This sense of isolation does not necessarily have only a geographical basis. Similar feelings of being 'isolated' can happen when working in a team of people whose approach is perceived to be different in the fundamental approach to practice.

In the smaller institutions and clinics, some art therapists are working alongside colleagues who work from an analytic base and might be taking a Freudian or Kleinian view of art which does not encompass and take into account the full impact of the visual component of the image in the therapeutic process. These colleagues may be perceived as critical to the notions of creativity, the articulation of unconscious process through the imagery because of a misunderstanding of the art therapists' task of being available to the multiplicity of meanings contained in one image. It is this ambiguity, remaining open to many possibilities and holding the many layers of

meaning, without a definitive interpretation, which sometimes might make art therapists appear defensive of their theoretical approach or position, but it is important that they hold the image central to their concerns in the understanding of the processes involved.

However, the work of the analyst and the art therapist should be able to inform each other as they share common ground in the recognition of unconscious processes and fundamentals of transference. Indeed, there are some interesting parallels between the history of the establishment of the British Association of Art Therapists and the early development of the British Psychoanalytic Society founded in 1919 by Ernest Jones. In the first ten years of its existence, the society had to face two overriding related issues. First there was the question of lay analysis, whether psychoanalysis should be conceived of as a branch of medicine, a science only to be prac- tised by doctors. And, secondly, prompted largely by the arrival of Melanie Klein in London in 1926, the new question of child analysis arose and its legitimacy as a branch of psychoanalysis. It began to seem that advances in psychoanalytic theory might increasingly come from child analysts and yet Anna Freud and Klein, who had virtually founded the new discipline, were both lay analysts. Winnicott was a strong member as a paediatrician training to be an analyst and played an essential part in what he called the interplay between separateness and union of the various groups that were to emerge in the British Society.

Although the British Society was keen to ally itself to the recognised and respectable medical profession, in 1927, according to Jones, 40 per cent were lay analysts. 'The British Psychoanalytical Society is practically unani- mously of the opinion that most analysts should be medical but that a proportion of lay analysts should be freely admitted provided that certain conditions are fulfilled' (conclusion of the Abbreviated Report of the Subcommittee on Lay Analysis). Similar issues were evident in the early formation of BAAT, as it was felt that art therapists should be qualified teachers and the establishment of the professional art therapist was under similar scrutiny (Waller 1987).

In her chapter, Waller writes in depth about the internal ramifications and also the part played by the professional association in establishing the profession within the National Health Service. Art therapy, unlike psychotherapy, has developed a structure within the National Health Service and has produced a register of qualified practitioners belonging to its professional organisation.

An art therapist is a person who is responsible for organising appro- priate programmes of art activities of a therapeutic application with patients, individually or in groups, and possesses a degree in art or design or a qualification considered equivalent for entry to an accepted postgraduate training course, and also a qualification in art therapy

following the completion of an accepted course at a recognised institution of further or higher education.

(DHSS 1982)

The qualified art therapist is therefore now trained to work using certain accepted codes of clinical practice to a standard defined by the British Association of Art Therapists, and aspects of this work will be considered in the following sections.

REFERRALS

According to the way the art therapist works, she must have an appropriate procedure for referrals. Most art therapists have now established separate autonomous departments in hospitals and are clinically responsible to the Consultant Psychiatrist. This means the art therapist must be available to consider referrals coming from all hospital departments such as occupational therapy, social work, psychology, the nursing staff, self-referrals. And, as has already been mentioned, this process will be much clearer if the art therapist has informed the various colleagues about her work and also the means through which patients can be referred to her. Some departments work out their own referral form which contains the relevant details and background on which to base initial decisions about acceptance to art therapy.

In the early days of art therapy, the idea was prevalent by many professionals that referrals were made on the basis that the patient was good at art – or showed some interest in this activity. Many times the comment has been overheard that 'This patient should go to art therapy', 'Have you seen how good she is at art?' or 'She really enjoys it.' However, the criteria for accepting patients into art therapy are manifold and require careful consideration by both therapist and patient. If it is felt that using art therapy will be appropriate to the needs of the particular patient then this will be central to the decision that is made. The patient must not feel coerced into coming and entering into a contract – nor must the therapist feel obliged to accept the patient. There is sometimes pressure in an institution to accept referrals as staff and resources are limited and possible treatments are therefore limited, which may be frustrating for staff in charge of day-to-day care on the wards. So each art therapist might have some clearly worked out strategy for dealing with referrals that come into the department. Again, according to the client group, this will vary (see Stott and Males 1984, Lillitos 1990).

Assessment of the suitability of the referral will be broadly based on the client's needs, symptoms, and current situation. Acceptance will obviously depend on the therapist's case load, and whether the client is being considered for individual or group work. The art therapist should also liaise with

her colleagues and gain as much information as possible about the client from the referring agent or the people who have been centrally involved in her treatment so far. This will help in building up the overall picture of the client and her suitability to come to art therapy.

Some art therapists work in an environment such as a therapeutic community or day centre in which all members are involved in the treatment programme. This does not allow for the same degree of selection of clients although when they enter the community, the knowledge that art therapy is part of the programme will be specified for both staff and members.

Another form of working is the art therapist who might go to a closed community such as a locked ward, a geriatric ward, or a school for severely handicapped children who cannot move and have little choice about the activities they are involved with. In this case the art therapist might make herself available to anyone who would like to join in the activity. Here it is the art therapist who comes to the patients and so she must be sensitive and aware of their need to make choices within the confines of their own environment. This creates a different sort of boundary – a locked ward is a stultifying atmosphere at the best of times – apathy and boredom are often the most noticeable malaise of the patients' existence here. Art therapy can offer interest, stimulation, even some motivation for those closed in their environment. In this situation the art therapist makes a commitment in terms of her time and appearance – this regularity is often something very powerful in the routine of the day and in the routine of the lives of these people. In our experience some old, non-ambulent, psychogeriatric patients who seem unapproachable and non-attentive in any way become accustomed to the visits by the art therapist and begin to unfold from their enclosed worlds in their art activities and general enjoyment. This work was based on an understanding of meeting person to person through the art activity .

MEETING THE CLIENT

First impressions of the clients are very important. Initial meetings in any relationship have an effect on both people. The same happens between therapist and patient – what is the response of the therapist to the patient and what is the patient's response to the therapist. This will mark the beginning of the therapeutic relationship which can, for some, be a long journey.

The therapist will need to assess many aspects of the person's situation, bearing in mind the background to the referral and the amount of detail she already knows. If this is lacking, she will need to ask the patient to fill in relevant details without going into too much depth at this stage. The art therapist must carefully explain what will be involved in coming to art

therapy, the commitment that is required and how she works. She might say something like 'the sessions are here for you and you can choose to use the materials in whatever way you wish'. Issues such as time, limitations on the use of the room such as physical damage might be explained and she will probably show the patient the room in which they will be working. Confidentiality will be stressed: whatever happens in the session will not be discussed – except within the clinical team in which the art therapist is working. This helps to create a feeling of safety for the patient who will probably be feeling quite anxious at this stage. Mention of the art work might also occur – what happens to it, where is it kept and the fact that it should not go out of the room during the duration of the work in art therapy.

What needs to be established is the suitability of the working relationship in terms of time, number of sessions and, depending on the client group, whether the patient understands and is motivated to attend the sessions. The choice must ultimately rest with the patient although the therapist could make the decision based on her clinical judgement that the person would not benefit from coming to art therapy. This might be for a number of reasons – poor motivation, acute disturbance, or the art therapist might feel that different sorts of treament might be more suitable like a behavioural modification programme, verbal psychotherapy or another form of creative work such as music therapy. Based on this overall assessment, a contract will be negotiated with the patient and the treatment will begin from the arranged first session.

Where an art therapy group is being established, either for the first time or by some spaces being filled in a group that is already running, often many prospective members are interviewed and the whole group is kept in mind in terms of numbers, balance of sex, presenting problems and these are used as a basis for acceptance into the group. Again the same details of boundaries, time, attendance are explained to all participants before they commit themselves to joining the group.

APPROACH OF CLINICAL TEAM

This is an important factor in terms of how art therapy is perceived among other colleagues and professionals. Where the art therapist is working in a close, supportive multi-disciplinary team where the work is shared between colleagues and there is a good professional understanding between them, then the referral to art therapy, and also the patient's view of it, will be supported and encouraged. This ethos will be an influential process in the beginning of the art therapy relationship and will affect the way the patient views the prospect of this treatment. This support will also be seen in the information exchange that goes on between colleagues not only before the treatment starts but also while the work is progressing.

The art therapist might be working in isolation, in a large hospital for example, and even though staff nearest to the interests of the patient might be supportive of the referral, it is sometimes the case that changing shifts and ward personnel do not have the same understanding and therefore the work will not be so clearly supported. Again this can be avoided by good communication networks by the art therapist, but the unwieldy nature of some of these institutions can militate against the smooth flow of referrals and initial meetings. So often one hears of situations of non-attendance by new patients, and the ward staff say 'Oh, he has gone to the dentist' or 'He is just seeing the doctor for a moment'. These are very common, and it must be made clear how unsatisfactory is this arrangement for patient and therapist alike; if possible nothing must come in the way of the regular meeting of the session, and the beginning of this is equally important. Staff misunderstanding may be encountered where art therapists are working on locked wards or in areas where the patients remain within the nursing environment. The art therapist must endeavour to ask the staff to make a commitment themselves to join the group – or to keep away. The establishment of boundaries needs to be discussed with the staff concerned as well as the client group, and the membership of the group must be clearly established before the work begins.

Interruptions must be avoided and can be prevented by making sure that staff are informed as to the time of the session and the limits around attending for all ward personnel. Obviously, a closed room is more satisfactory, but where the work is done in the open ward – or more often in the dining room – it is far more difficult to maintain the boundaries of the session and prevent interference not just by other staff but by inquisitive patients, noise and other general ward activities. It is for this reason that it is preferable to hold the sessions within the department, but sometimes it is absolutely impossible for patients to get there and so the art therapist must decide whether to work on the wards where the patients are resident.

CASE CONFERENCES

One of the main responsibilities of the art therapist's work is the attendance and contribution to case conferences where her patients are likely to be discussed. This can cause problems for the art therapist working single-handedly as it means that the department is closed for the duration of the case conference and patients are not being seen during this time. However, it is important that the art therapist attends and contributes to the general discussion on the care of the patient. Hearing from the different clinical perspectives gives a valuable insight into how a patient is functioning within the various treatment programmes. In particular, it seems important that the art therapist, who will have a close and understanding relationship with the patient, can suggest and guide treatment policy for the future in terms

of further programmes, discharge and outpatient treatment. Case conferences or team meetings therefore can further understanding of the work but also have the function of deciding about treatment policy for the particular patient. It can be the case that patients in an acute admission ward, for example, will be discharged as soon as possible, and in the art therapist's view, although the symptoms may have disappeared, the work is by no means finished. She might therefore suggest that the patient can come to art therapy on an outpatient basis, if this was felt to be appropriate, but as termination of any therapeutic relationship can cause difficulty, the reason for this suggestion must be carefully thought through (Wood 1990).

Some art therapists are working in situations where getting better or discharge is neither a possibility nor even appropriate (Rabiger 1990, Stott and Males 1984, Miller 1984). But in this case sharing information with colleagues in a case conference is equally important to understand the view of others working with the frustrations of not seeing any noticeable results or obvious movement for weeks and weeks on end. Feedback with colleagues helps understanding of the patient from everyone concerned, which promotes the coordination of treatment and consistency of approach. Working with severely handicapped children, for example, can involve a lot of unspoken and often unacknowledged frustration in the close daily contact the staff have with these children. The weight of human dependency which many of the care staff experience is often left unsaid and unacknowledged. The therapists are sometimes seen as having the answers or cures – and when this doesn't happen there is disillusionment and possible resentment which can lead to rifts within the working team. Sharing the difficulties and frustrations of working with someone in whom there has been little change, for example, can help the whole team to come to some understanding about this.

FEEDBACK

Regular meetings, conferences and feedback incorporates all aspects of the therapeutic and care input for the particular client concerned. Some art therapists attend daily staff meetings, others attend more formal case conferences which are organised in advance to ensure attendance of all the necessary people, which might include members of the family. The art therapist must give as clear an account as possible of the development of the relationship between herself and her patient and what she perceives is happening. This might be in terms of some change in the patient, something that she doesn't understand herself in terms of what is happening or some things that have occurred in her own responses to cause some change in her understanding of the process. The communication of the images remains central to her feedback, and it can be very useful to hear from

others what is happening with them, which might clarify some aspects of the process in art therapy. A classic example of this is where an art therapist is working in a school and something happens in the classroom which the child cannot talk about, does not understand but in the session is obviously affected by it. The art therapist must work with the material that is presented to her at the time, but her overall understanding can be enhanced by informal liaison with the teacher concerned, and each can share their experience of the effect of this.

Another form of feedback is that of notes and note-taking and pooling these in a central file, as is the practice in most hospitals, assessment centres and residential settings. After the art therapist has terminated work with a client, it is particularly important that a full account of the treatment process is given. Confidentiality must also be maintained and what should be included, therefore, is detail about how the patient used the sessions, what were the major issues that she was working on and how or if these were satisfactorily resolved. Detailed content does not have to be included, but it is often useful for the person reading the notes to be informed of how the patient used the sessions and the central processes involved. Where one art therapist is handing over to another art therapist, as with doctor to doctor, the details can be made more explicit in terms of the materials, the use of the sessions and the approach the art therapist used. For other colleagues this does not have to be so detailed but they must be informed and the reports could perhaps be written in a way that can assist the understanding of their work as well. For example, within a school setting, a report was written every term on each child with whom the art therapist was working, and a copy was given to the teacher concerned and to the head. This enabled each of them to read about the sessions, to know the main themes that had emerged during the time, and to see what the child was particularly grappling with in the sessions. This enabled them to be involved and informed, but they did not have to worry about the weekly progress of the children.

In our view, feedback and good communication with other colleagues is one of the most important tasks of the art therapist. We hope the days are gone when the art therapist encloses the department in a sense of mystery and non-articulation of treatment process and objectives. They must be an equally important and valued member of any working team and this can be maintained by meticulous standards of communication and feedback.

Occasionally the art therapist is caught in a difficult ethical situation in terms of providing 'evidence' that children have been able to articulate through their imagery or in the sessions. For example, in physical or sexual abuse the confidential and safe feelings within the sessions have facilitated these distressing revelations. Other professions, in social work for example, are asking children to draw their experiences as concrete evidence, and this technique has long been used for psychological testing. However, this diag-

nostic approach, where the child is aware of judgement and result, does not involve the same process of communication as when the child is able to express aspects of inner experience in the safe containment of a relationship with a therapist. This is clearly pointed out by Case and Dalley:

> Art therapists do not accept that drawings can be used automatically as literal statements and put the sanctity of the therapeutic relationship, trust, and space as paramount. There may be pressure from other members of the therapeutic team to contribute 'evidence' of this because of the urgency and concern for the child, but what is fundamental is that the information is derived through the relationship and might be communicated through the images.
>
> (Case and Dalley 1990: 3)

They continue that in the case of child abuse, for example, it is far more likely that the abuse will be expressed through 'making a mess' and an understanding can be reached through the transference and counter-transference process, rather than through a drawing depicting who did what to whom, on a particular occasion (Sagar 1990).

> The art therapist is trained to pick up communications of great sensitivity through the processes of image making, and more importantly waiting with, holding and containing the anxiety and uncertainty of the child struggling with the unfolding of their deepest difficulties. Therefore most art therapists hesitate to leap into early interpretation and judgement as to the meaning of the communication because of the delicacy of the process. This would suggest that the art therapist may need to work to a point where the child can verbalise the experience with the support of the therapist through the ensuing months rather than use the actual art material obtained from one particular session.
>
> (Case and Dalley 1990: 4)

This point is backed up by another case with an art therapist. A 10-year-old arrived late for his session, having missed the last one, which was quite unlike him. He was jumpy and unsure of what to begin to do – he seemed distracted and aimlessly leafed through a book, seizing on a picture of a man beating a dog. He worked on it with great care and attention, trying to copy it exactly, but began to get extremely upset and could not complete the image. He was also unable to speak about his feelings, and dismissed them as nothing. It emerged he had missed school as he had been physically beaten by his father but was unable to talk about it to anyone – the marks on his body were evidence enough. The art therapist was the only worker who had this kind of information directly from Michael – information which the social services needed to remove Michael from the care of his father. A difficult and distressing situation for Michael, but there was also a dilemma for the therapist in that this information was

shared in the safety and trust of the session. It was easy to feel that some degree of betrayal would happen by showing the drawing. As Michael was adamant that he wanted to stay with his father, this might have been his way of working out his feelings about it and coming to that decision – the alternative he was offered was extremely bleak. The art therapist is increasingly facing situations like this and obviously must share essential information, but how much does this potentially compromise the relationship? It seems ironic that this possibility of clearer communication for the child is itself being put at risk.

RECORDING

The art therapist, as we have seen, will be making notes for colleagues, contributing to 'day sheets', and reporting to case conferences but the foundation of these communications to the team of which she will be a part are her own working notes. Here we are going to look at some different approaches to recording art therapy sessions with individuals and groups. Working with groups it is often difficult to get a clear sense of group process and the individual process for each member at the end of a busy session and in a busy day. As the status of art therapy and the depth of work has become established it has become normal for periods of note-taking and administration to become established rather than seeing the function of art therapist as purely 'the artist' working in a studio. Working with children, each individual may be making pictures, sand trays, telling stories or play enacting apart from the interactions and interventions between group members and group and therapist. Group themes will also emerge, with individual significance for each member. Equally, working individually for example with adults, sessions can vary enormously in content and activity. One could be working with a client with learning difficulties, without speech, painting swiftly, using fifteen sheets of paper, making many non-verbal forms of communication or with a depressed adult patient slowly painting in one small area of a sheet of paper or another psychiatric client talking non-stop throughout the session, briefly making a mark before leaving.

In the early days of art therapy, when work was largely studio based, the ratio of clients to art therapists was huge, and any recording was necessarily brief, at the simplest, dating and storing pictures with perhaps a few words scribbled down about the main topic of conversation. Indeed, why record at all when one could argue that the product of the session, often a picture, contains in coded form the image of the relationship between therapist, client and group and it is this that should be the focus for exploration and reflection? There are always symbolic communications in the client's working process as well as in the form and content of the products which she creates, but traces of these will be visible in the final product. If a

record of a session remains in the form of an image, this can disguise all other forms of communication taking place, which contribute to the understanding of the image. Experience of relying on the image to do the work of recording, thinking at the time 'It would be difficult to forget this session', is rarely borne out several months later when the therapist will be thinking 'If only that had been written down in detail'. Part of the work of the therapist is to make connections for the client so that within a session one is recalling earlier events, themes and retrieving past images. If the recording is done well, then this later work of retrieving is much smoother. Recording well enables reflection and patterns of behaviour and emotional disclosure to emerge. Probably most importantly, it feeds back into the work itself by fostering interest in the sessions which facilitates the therapeutic process. One immediate feedback occurs in the relative difficulty in recording by whatever method.

To be able to share a therapeutic space one has to be 'in the world of your patient but not of it' (Cox 1978), to develop the ability to be involved yet detached. It is very difficult to record if one has been sucked into a patient's world or has taken into oneself a strong projection so that the very difficulty, a feeling of absence from the session, forgetting a session, whatever, is information about the relationship.

All recording is going to be subjective and open to personal bias but one can aim at making an objective summary. If one has several methods available the current and flow of a session may suggest which pattern would be most appropriate. Here we are going to look at three different methods of recording, and their advantages and disadvantages. This by no means exhausts possible methods; each therapist will develop her own style to suit her client groups and daily pattern.

We begin by looking at the 'observation' method which is like traditional notes in long hand but which tries to 'develop a capacity to suspend judgement when writing their notes and to record observable data irrespective of their relevance at the moment' (Henry 1975). This method is an adaptation of a note-taking method from the Infant Observation Course at the Tavistock Institute (Waddell 1988, Miller 1990). This approach to a session and method of recording has a particular usefulness when one is receiving a battering of projections from child or children. To draw from examples of a group of children in art therapy at a normal primary school, one child in the group of three had been coming for several weeks saying he 'didn't want to come', he 'would rather stay in the classroom, it's much more interesting', he gets 'bored all the time in this group, there's nothing to do'. At the time of this example the therapist had begun to take this in, thinking 'perhaps I'm really not a very good therapist, etc.'.

Short observation recording of a session

A group of three children: Hassan, Betty and Imran aged 8

Hassan said 'Oh no!' dramatically as I came to collect them. Betty greeted me, friendly and normal. Imran too, but he seemed quiet, subdued and didn't really answer my questions about his being ill and absent last week. He decided to paint his horse yellow, then orange, then red base. Betty sat beside him painting her money box, both steadily absorbed. Imran next began to make a tree, feeling very certain of using clay, confident. Betty said she would make a pig money-box. Talk of going to sell them, of starting a shop. Imran joined in saying he and his brother wanted to have shop – a sweet shop, then later a restaurant.

Hassan was very dominant through all this time: loud, showing off, shouting, provoking and angry. Talking and walking like a robot around the room, and pacing up and down. Saying he didn't want to come because Imran was here, singing loudly and making robot noises, speech. Tales of his uncle in Morocco giving him everything to eat, of his uncle in USA being Knightrider. Writing on the blackboard: 'I love Mrs C', 'I love Mrs M'. He interrupted every time Imran or Betty spoke to me.

Imran suddenly smashed his fist on the tree saying he couldn't do it, he wanted to make a farm. I sat by him encouragingly and he began the tree again. Clearly affected by Hassan's bombardment of noise, he sometimes echoed him. Hassan either laughed or rounded on him saying he would hit him. Imran finally made a branch upwards and a nest, with three birds (see Figure 7.1). He began to dig a hole in the tree – saying it was a tree house. He put a boy outside and inside a bell – alarm – magic – something about if someone was there, he would know. He made a perch for the birds to land and stuck white polystyrene chips as the bell, as snow all over. A sort of fence around the tree. He seemed older today.

Betty began her pig, telling me how she was going to make it, she had seen on TV two cup shapes joined with paint. This went smeary, she used brown paint, later 'dirty pig'. She put the face on last, for the first time suddenly asked for help with the ears, suddenly decided it was a dog, 'dirty dog', much laughter and very pleased with it.

Hassan finally gathered up scraps of polystyrene and clay (the remains of Imran's materials) and asked for plasticine and said he was going to make something. He made a woman with body and head, no legs, arms or facial features. He laughed at it mockingly (?), then said it was me. Having decided this, he added squidges of plasticine as eyes, mouth and gave it to me as a present as he left very amused.

Observation method

1. In running the session like a film through your head, the therapist is

enabled to have a reverie about the group of children, or individual with whom one is working.

2. It gives an opportunity to reflect on one's interventions and in this way gives one's 'therapist part' feedback from the 'critical observer' part.

3. The whole child in the whole session can be seen. For instance, through the hour, Hassan's need for constant movement and accompanying noise as a way of containing his fear of unintegration can be traced. He is an only child living with his mother, gaining much structure from the visits from an uncle abroad. The mention of uncle causes the therapist to speculate that his uncle has recently departed, causing Hassan's present anxiety and lack of boundary. He therefore feels an intolerable split between the art therapy room and classroom: 'I love Mrs C', 'I love Mrs M'.

4. The way Hassan finally makes something is very informative. He gathers up the debris left by Imran's concentrated work, makes a pathetic figure, rubbishy, of scrap materials, saying it is the therapist, and giving it to the therapist, really an evacuation of pain, a mocking of that inept part of himself, that for the time being is being held for him.

Figure 7.1 A tree, a nest, and three birds

5. Allowing the therapist to observe, to try to be receptive, rather than to feel that she must do something with Hassan's anxiety, allows her to see more clearly, to see where the rubbishy thoughts of 'I'm not being a very good therapist' are coming from. Now that these are embodied in an object we can begin to work with them.

6. If one can suspend immediate judgement on what is of significance in the session, it means that one records observable data, irrespective of their relevance at that moment. For example, Imran's not really answering the concern about his absence the week previously. It emerged later in the year that he missed days at school in order to do a part-time job and earn money because his father was ill and off work.

7. Careful observation and reflection on it enables patterns to emerge; for instance, how little one child may figure in the observations, and why is there nothing to record?

8. Gaps in memory after a session become clear. One week in recording a session the therapist wrote 'Betty told a dream she had had the night before'. Then the therapist realised she couldn't remember the dream and that another child had knocked over a water-pot immediately following it. This had literally wiped out the memory. Some days later it floated back into mind and the therapist realised its disturbing content had caused the 'accident' at that moment.

9. This method of recording enables focus on what was said, when things were made.

10. It's good for recalling detail, in order, and for rhythm through a session.

11. It's very time consuming.

12. There are no easy comparisons between sessions.

Let's now move on to the check-list method of recording, taking one child from the same session. With this method photocopies can be prepared, ready to fill under whatever headings one wants to focus upon.

Check-list method

Name	Imran.
Group	9.30–10.30.
Materials	Clay, polystyrene chips.
Verbalisation	Talk with Betty, sweet shop, restaurant with brother. Story around the tree.
Body language	
	Inward, subdued, but brightened, alternating tense/giggles, smashed clay.

Interactions	Betty – over shop fantasy, projection into the future. Hassan – copying actions, shadow-like, would like to let rip? Therapist – sharing difficulties, needing me by him, telling the tree story.
Choice	Confident decisions.
Attitude	Involved in the work, upset by Hassan's disturbances, retreat into magic? Pleasure in end product.
Process	Rare moment of anger expressed, frustration; otherwise very solid, clear working atmosphere around him.
Product	Painted last week's flying horse, yellow, orange base red. Tree, one strong branch, nest, three birds, boy, bell, alarm. Fence around it, snow. Well made, strong, kept.
Content	3 children = 3 birds? Possible defence, Hassan, refuge in magic, wish for containment, link with magic flying horse.
Insight	No quiet moment possible to discuss story further.

Photograph/drawing and check-list method

1. This method is probably most useful for individual clients or for an individual 'look' at a group member. For instance, in a group such as this with one very anxious active member, the more contained children can be overlooked.
2. Comparisons between different sessions are quite easy – one can see, at a glance, patterns of behaviour, and unusual occurrences.
3. It is fairly quick to fill in, which is an advantage when rushed for time, end products can be hand drawn or photographed.
4. It reminds one to think under these categories, literally a check-list, so it can often broaden the scope of the 'observation method'.
5. Thinking under categories focuses attention on parts of behaviour rather than a whole, e.g. it gives little sense of what was said while something was being made.
6. It makes immediately clear what one has missed, and the 'missing' child from one's attention in a group.
7. It gives focus to the child, not the therapist and child or children.
8. It is hard to show group interactions in complexity.
9. It gives no sense of time within the session.

Group therapy interaction chronogram

The last example of a recording method is an adaptation of the 'Group

Therapy Interaction Chronogram' borrowed from the writings of Murray Cox (1978). This is usually used for recording verbal therapy, but if accompanied by drawings or photographs it adapts quite well to art therapy.

Figure 7.2 shows how a basic unit of the chronogram is used. A circle represents each person's therapy hour, the first quarter (I) the initial phase of the session. The following half hour (II) the main substance, and the last quarter (III) the terminal phase.

Figure 7.2 Group therapy interaction chronogram

Depending on the membership of the group, photostated sheets can be prepared in advance, ready to fill in, so that, for example, a group of eight members including the therapist can be mapped as shown in Figure 7.3.

Arrows between the circles can show simply the positive or negative communication. Content of images made can be put in thumbnail sketches beside each circle, representing a member of the group. If pictures are discussed in a circle on the floor by the group, they can reflect the actual positioning, i.e. put away from the person, under or behind the chair, hidden under another person's work or across the whole circle dominating the space. Figure 7.4 is an example of this method used to record an earlier session of the same group of three children.

Advantages and disadvantages

1. It is quick to fill in.
2. It breaks up the session into a focus on phases, and time particularly.
3. It gives equal attention to the therapist as part of the group.
4. It enables one to focus on ending and beginning as there are often outbursts of behaviour at these moments of change.

Figure 7.3 Mapping the progress of group members

5. It gives focus to the interaction between group members quite simply in terms of positive and negative.
6. It gives focus to the isolated or, as in this case, two members apparently unaware of each other.
7. It shows clearly how the group is able to feel contained and as 'one' at the story time.
8. It records the main actions, rather than any detail or conversation.
9. Images made and clay work would have to be recorded separately by drawing or photograph.
10. Reasonable easy comparison of patterns of behaviour between different sessions.

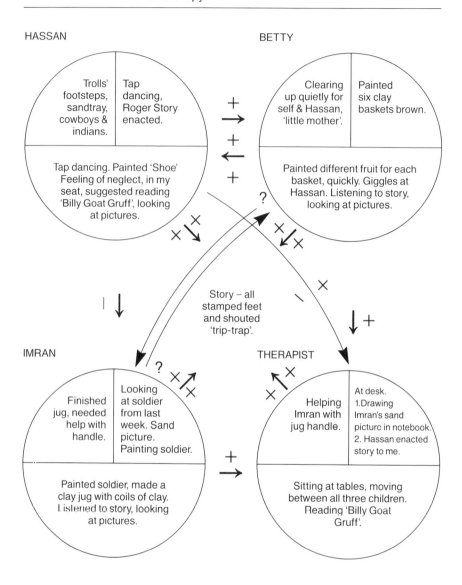

Figure 7.4 Recording the work of three children and the therapist

11. It's difficult to record the odd comment of significance, e.g. in this session a previous group member who had left three months previously was mentioned in a derogatory way by one child, then hotly defended by another, which was all over in a few seconds.
12. It's difficult to record body language, e.g. in this session, Hassan's facial grimaces at the pictures of the Ogre which appeared in altered form in his drawings the following week.

Conclusions

In this session Imran made a 'picture' in the sand tray. Images like these and fragile clay constructions are better recorded by diagram, thumbnail sketch or polaroid. Some art therapists, particularly those working within a family therapy framework, may video all sessions to explore with the team and family during the treatment process. This method of recording which is integral to the theoretical bias of family therapy is rare outside such settings, although it may be used for training purposes.

SUPERVISION

Qualified art therapists continue to debate as to the emphasis and approach to their clinical practice, but this is influenced by the client group, the institution and the ethos of the working team. Art therapists seldom work in complete isolation without reference to other professionals and colleagues. However, they do usually work on their own – working one-to-one with clients, or the only facilitator of a group, or running a department single-handedly. As a result, access to regular, good supervision is important for on-going working practice and extending the dialogue of understanding.

Supervision of the work in art therapy is considered essential for all practitioners. After graduation and during the first years of work, the art therapist needs not only support and guidance but also extensive understanding of the dynamics of the complex relationships that develop in the clinical work. Even after years of experience most art therapists should have a regular supervision session built into their working programme as, continually, new light can be placed on the working practice with objective insights and new understandings of the work.

What is supervision?

An art therapist will bring to a supervisor aspects of the work with which she is having difficulties, or when she simply wants to explore the dynamics of a relationship in more depth. Firstly, this could be a management or institutional problem. For instance, a newly appointed therapist might have

an interest in establishing an art therapy session on a particular ward with a specialist client group. She finds that attempts to discuss this with relevant staff are thwarted as if they wish to avoid the issue. What anxieties or fears might lie behind this behaviour and what is the best way of tackling this problem creatively?

Secondly, and most usually, a therapist might bring paintings of a particular client or group to discuss. She might come with feelings about the work – for example, that she feels worried about the client and cannot stop thinking about her, or that the paintings might worry her or mystify her. She might feel flooded with involved feelings or feel unable to enter the client's world. She might present doubts about her ability to work with a client and feel a lack of confidence. On exploration it might become apparent that past parts of her life are being transferred onto present-day interactions. It is one of the main focal points of supervision to explore the 'counter-transference', particularly in relation to clients so that it may inform and aid the progress of the work rather than impede it. Within the supervision itself, issues, possibly unconscious, might emerge out of the discussion which again can bring understanding and clarity to the working relationship. If the sessions are presented in detail, including all aspects of what happened, preferably in the form of process notes, then this allows a close scrutiny of the process which can facilitate a deep understanding of what is happening.

A third area that might be brought to supervision is staff relationships and the therapist's general working life. In some institutions the therapist may not be the client's sole therapist; for instance, a client may have individual art therapy and also group psychotherapy. A disturbed client might find it difficult to integrate two approaches, two 'parents', and exploit the differences leading to possible ill-feeling between parties unless carefully managed. This last example shows clearly how all three areas inevitably overlap and cannot usefully be looked at separately; they are part of a whole process. Part of the supervisor's task is to help the therapist in supervision to integrate the different areas of her work life.

The boundary between supervision and therapy

Peter Hawkins writes expressively on how a therapist needs to 'establish and negotiate the boundaries between his private world and that of his work life' (Hawkins and Shohet 1989). One way that the supervisor can help the supervisee to enter the world of the client, but not to get lost in it herself, is to be clear about what is material for supervision and what is material for therapy. Also to assist someone into therapy when appropriate. Since the beginnings of psychoanalytic training in the 1930s there has been debate over therapy and supervision. At this time the Hungarian school thought that the students' training analyst should also supervise their

analytic work as they knew them best and could work better with counter-transference issues. The Viennese school wanted a clear separation of training analyst to deal with all 'personal material' and a supervisor in a purely 'didactic' role. Let us look at two scenarios from supervision sessions.

In the first example, the supervisee began to present material only to break down in tears. Exploring these feelings it became apparent that the therapist had been dealing with an absent ill colleague and an escalation of potentially violent incidents in the hospital art therapy room. This situation had led to a build up of stress. It became apparent that the incidents had been dealt with extremely well. The tears were largely relief at being able to share aspects of anxiety – personal and on behalf of clients threatening suicide. The therapist needed help to cut down the number of sessions or clients she was seeing single-handedly while her colleague was ill. She was able to explore her guilty feelings about this and was helped to see that her own health must be given priority or the quality of her work would deteriorate. Her confidence in her ability to defuse potentially violent incidents and to work with the residual anger was reinforced. This exploration of exposed feelings is clearly around institutional issues.

Let us look at the second scenario where again, at the beginning of a supervision session, the art therapist began to present material and broke down in tears. Here, the content of her distress seemed to be totally about her home situation. It became apparent that she was in the middle of a divorce after deciding that she could no longer live with a partner with long standing drug-related problems. She expressed a fear of being alone. Then for the first time she mentioned work in the context of not wanting to take holiday leave as she couldn't bear to be at home. A fruitful area of exploration proved to be the way that her work had become a shield for her private life, her lack of confidence in living alone was another aspect of having to be needed by others, reflected in her original choice of partner but also a factor in her work situation. In this session she was helped and encouraged to re-enter therapy and support for her work was reiterated, confirming her knowledge and experience. Other structures of support were examined.

After this crisis she used the sessions creatively to explore all aspects of her work. In subsequent sessions it became very clear that the home situation parallelled changes at the hospital. The art therapy department was moving into the community and her fear of leaving the 'safety' of the hospital to 'set up alone' outside the hospital environment could be explored. In this exploration of exposed feelings the move from the hospital to the community and the ensuing crisis of confidence, dependence on the mother institution and fear of going it alone are clearly material for supervision, whereas the decision to attempt to change a repetitive cycle of dependence and support around an 'ill' partner is more suitable material for personal therapy.

The border between therapy and supervision can be quite difficult for the supervisor to negotiate, partly because one uses similar skills and also because the therapy content and role is so familiar. It is 'easier' to step into this at times than to withdraw from the material being presented and look as objectively as possible at the issues that need to be confronted. The nature of supervision is not just to look at the work 'out there' in the life of the supervisee. The dynamics being discussed will usually be mirrored in the session itself. For instance, a supervisee brought a long detailed account of several sessions which she ploughed through in a monotonous voice. There was much talk of arrangements but little discussion of content. The paintings from the group had been 'forgotten' and left at the hospital. In the session, the supervisor and co-supervisee were feeling sleepy, lulled by the presenter's voice which suggested that 'everything was alright'. When the supervisor emerged from this soporific encounter and was able to question herself and co-supervisees on what was happening, it gradually became apparent that these feelings mirrored the art therapy sessions described. Fear of taking the work deeper was keeping the art therapy group on a surface level; the art therapist colluding with the group that 'everything was alright' and that nothing beneath the surface needed to be explored. At this point the art therapist's fears could be explored, ambivalence about re-entering personal therapy emerged which again reflected the ambivalence of going deeper into the art therapy group that was first brought for discussion.

The image in supervision

Images can be brought to supervision to help the process, although they need to be carefully looked after and, preferably, the client's permission should be sought for this purpose. This is not always possible, however, if for example a group is being considered that has made the decision to keep all the images safe in the room. It would undermine the trust and indeed the contact for the group leader to begin to take them for supervision purposes. Some art therapists feel it is integral to the nature of the working practice and philosophy that the images remain secure in the framework of treatment. If the progress of the work of supervision is being impeded by images not being available, the supervisor may need to explore if this is integral to the working practice or a defence against looking deeper at the nature of the work. Some people argue, however, that the internal image the therapist brings with her is the important thing – counter-transference response and the therapist's inner feelings about the process are the real guides to the nature of the therapeutic interaction.

Let us look at an example of this complex process. An art therapist brought a dream of a client to supervision. In the dream the two of them were painting side by side as members of a group. In the dream the client

had painted a picture of a girl with a rope around her neck. The client commented half jokingly, 'Look at her, she's in real trouble'. The solution would be to unwrap it. The picture then came to life and the girl climbed up out of the picture. The dream continues; but let us stop here, already a wealth of material. In exploring the dream the art therapist was reminded of a childhood friend and to a parallel feeling about the friend and client that both hid a childhood deprivation under a jokey manner. This led her to realise that she had been unable to comment on a real painting the client had made in an art therapy group that week that suggested a 'sleeping' undeveloped part of the client. She had been unconsciously protecting her 'deprived friend'. Here it can be seen that a 'phantasy' painting in a dream is as valid an item for exploration as a real painting by a client; and the therapist's response to the client's picture is as valid as the exploration of the picture itself.

Supervision in the three main areas of practice

In an NHS setting the concept of supervision has been firmly established. Supervision can be organised privately by an individual art therapist who can contact another experienced art therapist, or it can be arranged with a psychotherapist or analyst who would be prepared to work with images in a psychodynamic framework. Some large hospitals have several art therapists who may be supervised by the Head of Department or arrange periods of peer group supervision together.

Within all institutions of work, supervision should be provided for by the employer in terms of time and payment of supervision fees. As the profession develops, this is gradually being recognised as essential to the difficult job an art therapist undertakes. This can take place within the department, institution or outside but should be guided by the briefs of confidentiality that are always maintained in this work.

The situation in the social services differs, partly because it is rare to find anyone working with a clear designation of art therapist. People with art therapy training are likely to be working with various titles, group worker, project worker, residential worker, etc. They may have established their working day as purely art therapy or may be in a difficult position of switching roles throughout the work, i.e. working as a centre worker with several sessions of art therapy. Some people may have chosen this way of working because it enables them to utilise training they may have had previous to art therapy; others may be working in this way as a form of pioneering, to 'prove' that art therapy is a useful additional method of treatment of the centre programme, perhaps in an effort to get establishment for a full-time post. Supervision in a social work setting has been usefully explored by Peter Hawkins' 'Mapping Staff Supervision' where he discusses the types of content of supervision and the difficult nature of

social work settings where the supervisor may have a complexity of roles to the supervisee, e.g. immediate line manager (power of promotion, references, etc), colleague, sharer of living accommodation, friend, etc. Although the concept of supervision is well established in social work sessions, there is likely to be little choice of supervisor so that the art therapist may find the supervisor adequate on management, staff and client issues but lacking when it comes to the experience of working with images. This will then have to be arranged separately and often privately.

Difficulties arise in the education services where, unless one is working in a child guidance team, the concept of supervision is alien. The nature of the difficulty partly arises from the lack of established posts in the educational services. Maladjusted schools which are dynamically orientated may have supervision sessions arranged with a visiting psychologist, psychiatrist, or psychotherapist but these are likely to concentrate on reviews of particular children rather than offer an exploration of the individual working process of each member of the team. Supervision will therefore have to be arranged privately.

Qualities and responsibilities of a good supervisor

It is the responsibility of the supervisor to keep to the agreed boundaries of space and time, and to keep to the objective task of supervision and draw up a clear contract of work in the first session. If these are held then confidence for self-exploration will develop. In some settings the supervisor will be responsible for the work of staff and students. In all settings she has some responsibility to the clients and to the referring agencies. She also has responsibility to the supervisees to aid healthy survival in the midst of often difficult work and to help them in their desire to learn and their personal development. The supervisor is also responsible for providing support and professional contact beyond herself, i.e. to know when a supervisee could be better aided in her work by another professional. This could happen if a supervisee's job changes or a new aspect develops in her work which is unfamiliar to the supervisor.

What are the qualities of a good supervisor? She needs to have a strong theoretical and practical background and above all a fascination for the nature of the work which will contribute enthusiasm and imagination to the sessions. She needs to have empathy, a capacity to enter the other person's experience, open to both supervisee and the client being discussed. Keeping the boundaries should create a degree of safety to enable the supervisee to bear self-exposure but also both sides need to feel safe enough to risk saying difficult things. A supervisor doesn't have to be omniscient! Confusion and doubt are part of the process but they can provide a model to the supervisee on how to deal with this. A supervisor needs to know what the supervisee is doing, but not to swamp her with

theory, so there needs to be a pace of learning that will extend both partici-
pants' experience. Then, finally, the supervisee needs to feel that she is
accepted, supported and cared for.

Supervision in groups or individual supervision

Supervision in a group and individual supervision both have advantages
and disadvantages. In individual supervision, one is likely to establish inti-
macy more quickly which will enable counter-transference issues of diffi-
culty to be looked at more readily. In individual supervision the supervisee
presents at each meeting, which builds up a continuation of experience for
both participants in the process. In group supervision it may take longer to
establish a feeling of trust and safety; however, it has the advantage of a
sharing with peers of fantasies and fears and all the areas of discussion will
benefit from the variety of points of view contributed. There is less likeli-
hood of supervisor and supervisee sharing blind spots or of an authori-
tarian/dependence relationship being established because both of these
possibilities will be challenged by other members. Group supervision is
more economical in terms of time and money. For a good peer group to
develop the members need to be at a similar stage of development in their
experience and learning, or a member may feel frustrated at the lack of
depth in the work or feel completely out of her depth.

Problems in the supervisor/supervisee relationship

> The supervisor ... is an active participant in an affectively-charged
> helping process, the focus of which is learning and personal growth.
> (Ekstein and Wallerstein 1958: 178)

Supervision can swing between extremes of the supervisee 'being treated'
for therapy to a 'didactic' approach which avoids the therapist's emotional
life at all costs. Like all relationships it is also open to any abuse of power, a
possible dynamic which can undermine the therapist's individual style of
working. If the supervisor has an authoritative approach there is the danger
of the therapist getting into a dependent relationship. Art therapists can
experience particular problems if they have to arrange supervision with
someone unfamiliar with making images. Either party in the relationship
can feel mystified, devalued or defensive about her own or the other's
approach. If she is authoritative, transference reactions, usually parental,
can be activated from a supervisee to her supervisor. Equally the supervisor
may see a younger therapist as a rival or competitor. The patient(s), as a
third party, always enter the room too in each session, which makes a
triangular relationship. Supervisees may feel protective to their patients,
identified with them as children. Despite all these possible difficulties,

supervision offers the exciting possibility of learning more about the nature and process of art therapy and is essential for the development and further exploration of all art therapy practice.

ART THERAPY TRAINING

Pre-course experience

We have already seen earlier in the chapter that entry to postgraduate training requires an initial degree in art, and sometimes other relevant degrees will be accepted. Applicants for the one-year full time courses have an average age of 28 and for the part-time courses which run over two years, 35 to 38. Applicants are required to have obtained relevant work experience in the caring professions before entry. Some are fortunate to have held a post as an art therapy aide or technician in a department but many will come with a variety of experience in different institutions. This will make an equally interesting and useful background. Applicants are required to bring to the interview a folder of previous art work and work in progress to show an on-going commitment to their personal art process.

It is preferable that applicants have previous or current experience of personal or group therapy. The courses are very testing on every level and the student has to make adjustments in developing a professional identity as an art therapist during the year. Art therapist and client develop a personal relationship within the framework of professional treatment using conscious and unconscious processes. Even though the art therapist will have supervision to help her monitor and understand counter-transference phenomenon, she will have to have worked on herself in therapy if she is not to unintentionally cause problems between herself and the client. She could, for example, become jealous of the client receiving therapy through her own unacknowledged deprivation or have a blind spot or inability to work with anger because of her own primitive unexpressed anger. She would then unconsciously steer the sessions away from areas parallel to her own unexplored feelings.

The would-be art therapist is therefore asked to take on the task that she would wish her clients to face, both before training and during it. To train as an art therapist requires a concentrated and relentless period of self-examination and the working through of resistances which requires attentiveness and self-exposure. It is likely that the novice art therapist will find out things about herself that she does not like and will have to learn to understand and accommodate them.

Before applying for training it would seem wise to gain some short-term experience of art therapy. There are several well-established week and weekend courses including foundation courses for those thinking of applying to train. The Spring School at Leeds Polytechnic has been running

for ten years and offers an intensive week of experiential groups, lectures and workshops. This is a residential experience, as is the Jungian based week in the summer at Cumberland Lodge. At the Easter and Summer Schools at Herts College of Art and Design, a mixture of different thera-peutic learning experiences are offered in art, dance, and drama.

Units of postgraduate training

1. *Academic*

Art therapy theory is the main focus for theoretical input. Art therapists aim to enable clients to make personally significant objects or images within the context of a clearly defined relationship. There can be seen to be two basic threads to this process. One central thread is the knowledge, understanding and experience of psychotherapeutic relationships. It is within such a relationship that the products and processes may be shared and discussed and valued. Another thread is the knowledge of symbolic communication, be this in words, pictures or through the making of objects. This encompasses the understanding of pictorial imagery and its interrelationship with intrapsychic and interpersonal dynamics. Three further areas of clinical study – psychotherapy, psychology and psychiatry – extend this understanding.

2. *Practical*

The student carries out different kinds of investigations of image-making on a personal and practical level. Central to these is the art therapy training group which meets weekly for the duration of the training, lasting $2^1/_2$ hours, with approximately eight members. Each group is led by a qualified art therapist with extensive experience of psychotherapy and group work. Students are provided with the experience of a group therapy setting, that offers the opportunity for personal development and self-understanding through a process of group interactions. The groups aim to increase the students' ability to tolerate ambiguity, uncertainty, expression of feelings in others and to confront their own reactions and responses. They learn to trust pictorial and plastic imagery as a central mode of expression of feeling and meaning. By participating in group dynamic processes, the training groups enable students to observe the way in which these are echoed in imagery and within the group context. The art objects are of central importance as the focus for illuminating and channelling individual and group feeling and processes.

The students also experience short-term theme-centred workshops which focus on a selection of different techniques and approaches to different client groups. Throughout the year, one whole day is also set aside

for studio practice where the students continue to develop their art work. They are encouraged to understand the processes involved in creative activity. It is a further way of understanding and articulating the experiences of the year and an opportunity to reflect on making art, in all its emotional, spiritual, intellectual and physical aspects.

3. *Placements*

Students are on placement during the year within established art therapy departments and also sometimes testing new settings. They are under the supervision of qualified and experienced art therapists and develop their clinical work with referred clients. Students also attend supervision groups at college to help them allow theory and practice to inform each other. During the placement, college tutors also visit for supportive supervision and maintain contact with the students' progress.

4. *General*

Each student has an assigned personal tutor. Teaching takes place in lectures, clinical seminars, groups and individual tutorials. Students are required to write case studies, one based on their observations, the other based on in-depth clinical work. Also a long dissertation based on a subject of particular interest to the student in art therapy.

The three main training courses are standardised qualifying courses according to the criteria laid down by the British Association of Art Therapists. Currently, discussions are under way to extend the training to two years. Each course has a slightly different emphasis according to the particular orientation of the staff, available resources and so on. The history and background to the training programmes are described in depth by Waller (1991), which provides a useful introduction to the particular nature of the various courses. Prospective candidates are advised to get information from each course and preferably visit to understand the particular aspects of each of them. After training at postgraduate level, further training is also possible on advanced training courses for MA, MPhil or PhD level. The addresses of the main courses are detailed on pages 256 and 257.

REFERENCES

Adamson, E. (1984) *Art as Healing.* London, Coventure.
Case, C. (1987) 'Group Art Therapy with Children: Problems of Recording', in *Image and Enactment in Childhood.* Herts College of Art and Design Conference Proceedings.
Case, C. and Dalley, T. (eds) (1990) *Working with Children in Art Therapy.* London, Tavistock/Routledge.
Cox, M. (1978) *Coding the Therapeutic Process: Emblems of Encounter.* London, Pergamon.

Department of Health and Social Security (1982) Personnel Memorandum PM (82) (6 March).

Dewey, J. (1934) *Art as Experience.* New York, Minter Balch.

Edwards, D. (1989) 'Five Years On; Further Thoughts on the Issue of Surviving as an Art Therapist', in Gilroy, A. and Dalley, T. (eds) *Pictures at an Exhibition.* London, Tavistock/Routledge.

Ekstein, R. and Wallerstein, R. (1958) *The Teaching and Learning of Psycho-therapy.* New York, Basic Books.

Hawkins, P. (1982) 'Mapping Staff Supervision', unpublished paper from Richmond Fellowship.

Hawkins, P. and Shohet, R. (1989) *Supervision in the Helping Professions.* Milton Keynes, O.U.P.

Henry, G. (1975) 'The Significance of the Insights in both Infant Observation and Applied Psychoanalysis in Clinical Work', unpublished paper.

Lillitos, A. (1990) 'Control, Uncontrol, Order and Chaos: Working with Children with Intestinal Motility Problems', in Case, C. and Dalley, T. (eds) *Working with Children in Art Therapy.* London, Tavistock/Routledge.

Miller, B. (1984), 'Art Therapy with the Elderly and the Terminally Ill', in Dalley, T. (ed.) *Art as Therapy.* London, Tavistock.

Miller, B. (1990) *Closely Observed Infants.* Perth, Clunie Press.

Rabiger, S. (1990) 'Art Therapy as a Container', in Case, C. and Dalley, T. (eds) *Working with Children in Art Therapy.* London, Tavistock/Routledge.

Read, H. (1943) *Education through Art.* New York, Pantheon.

Sagar, C. (1990) 'Working with Cases of Child Sexual Abuse', in Case, C. and Dalley, T. (eds) *Working with Children in Art Therapy.* London, Tavistock/Routledge.

Schaverien, J. (1989) 'The Picture within the Frame', in Gilroy, A. and Dalley, T. (eds) *Pictures at an Exhibition.* London, Tavistock/Routledge.

Stott, J. and Males, B. (1984) 'Art Therapy for People who are Mentally Handi-capped', in Dalley, T. (ed.) *Art as Therapy.* London, Tavistock.

Viola, W. (1944) *Child Art.* London, University of London Press.

Waddell, M. (1988) 'Infantile Development: Kleinian and Post-Kleinian Theory of Infant Observational Practice', *British Journal of Psychotherapy,* **IV** (3), pp. 313–28.

Waller, D. (1984) 'A Consideration of the Similarities and Differences between Art Teaching and Art Therapy', in Dalley, T. (ed.) *Art as Therapy.* London, Tavistock.

Waller, D. (1987) 'Art Therapy in Adolescence', in Dalley, T. *et al. Images of Art Therapy.* London, Tavistock.

Waller, D. (1991) *Becoming a Profession: History of Art Therapy 1940–1982.* London, Routledge.

Waller, D. and Dryden, W. (1991) *Handbook of Art Therapy in Britain.* Open University Press.

Wood, C. (1990) 'The Beginnings and Endings of Art Therapy Relationships', *Inscape* (Autumn).

Art therapy with individual clients

In this chapter the process of art therapy in a one-to-one relationship will be considered in some depth. Much clinical work has been documented in case studies which closely describe the detailed process of working with one client in art therapy. Reference to these will enable an understanding of the wide range of clients in art therapy and also the variety of different approaches used by art therapists working in many clinical settings. More and more art therapists use a framework of psychoanalytic concepts as a means of understanding the dynamics of the process of the sessions. Ideas such as resistance, negative therapeutic reaction, acting out, working through, the uses of interpretation and insight were all explained originally by Freud, but more recently some of these have been revised to be used in a broader context (Sandler *et al.* 1973). Other art therapists might take a Jungian or Kleinian approach and, as has been discussed in theoretical chapters in the book, these different theoretical positions provide the basis for informing the on-going practice of our work (Nowell Hall 1987, Weir 1987). For the purposes of this chapter, the detail of how one 7-year-old child, John, came to art therapy and the process that he engaged in will be followed, but this is to provide an example and not necessarily the definitive model.

Patients are referred to art therapy from many different sources. In a hospital setting the art therapist is clinically responsible to the consultant and so the referrals usually come through ward rounds, case conferences where these decisions are reached. Ward managers, social workers and other professionals are also encouraged to make direct referrals to the art therapist and occasionally some self-referrals are considered. In clinics and other settings where intake meetings take place on a weekly basis, and are attended by a multi-disciplinary team, the art therapist will be allocated patients whom the team feels would benefit from working in art therapy rather than other sorts of therapy.

John was referred by his school to a clinic such as this. The teacher had found his behaviour too difficult to manage. He was showing signs of aggression, fighting with peers and not able to concentrate in the class-

room. He was becoming increasingly restless and badly behaved. John was an only child and, at the time, his parents were engaged in a custody battle following their separation six months earlier. It was felt that John was confused, angry and worried about his parents, as he wanted them to get back together. However, this was not a realistic hope. He was bottling up his feelings and not able to talk about his distress. The educational psychologist, part of the multi-disciplinary clinic team, had already seen him at school and found him to be an intelligent but verbally inarticulate child and during the interview John drew several pictures to describe his experience. He showed anxiety about getting things right and not making mistakes, which made him jumpy and appear lacking in self-confidence. At the intake meeting, it was felt that John would benefit from art therapy as he could make good use of imagery but had difficulty in articulating his feelings about his situation.

The reasons why a patient is considered more suitable for one type of therapy than another are complex. For example, some types of behaviour modification programmes might be most appropriate for specific problems such as phobias. Where problems need to be looked at more in terms of internal difficulties and resolution, there are many different possibilities for treatment programmes. Cox (1978) explains this clearly in terms of referrals for psychotherapy:

> The reasons why a patient is referred to psychotherapy are legion, ranging from the need for symptom relief, or the resolution of internal conflict, to the reduction of social isolation and anomic experience, or the modification of anti-social behaviour. It may be stated in general terms that the therapist's attention and initiative is aimed at facilitating the patient's increased self-awareness, at a depth and pace which is tolerable, as he is confronted by those aspects of this life which were hitherto intolerable and thus banished from consciousness. This effect is accelerated and intensified in a group situation, where the patient is confronted by many images of himself reflected in other group members.
>
> (Cox 1978: 54)

Many of these criteria also apply to art therapy referrals, although when working with either groups or individual clients the structure of art therapy differs from that of the other psychotherapies, and this will affect the referrals and acceptance of clients. The reference to groups will be looked at in more depth in Chapter 9.

SUITABILITY OF CLIENTS FOR ART THERAPY

This decision is based on a number of factors mainly concerned with the particular nature of using art in therapy. The process of art therapy offers

the opportunity to work non-verbally, through image-making, which might be central in the consideration of potentially suitable clients. For example, problems connected with speech difficulties, in articulation, or confused states of mind, patients who are withdrawn or depressed, or children with emotional and behavioural difficulties who are possibly less articulate and sophisticated in speech and language skills but are more able to express their experience through the art work made in the session (Case and Dalley, 1990).

Consideration for art therapy is based on the information from the referring agent, which should contain basic details of background and presenting issues. Some art therapists make use of referral forms and, on the basis of this initial information, the art therapist will arrange a meeting with the patient and preferably with the referring agent as well. For John, the detailed information given by the school and educational psychologist was sufficient to set up an initial interview with mother, John, educational psychologist Mr T, and art therapist.

INITIAL INTERVIEW

The first time the patient meets the art therapist is important. Firstly, the art therapist will give some space to the client to talk about herself, her situation, reasons for coming and the problems being encountered. Using a relaxed manner, the art therapist must gain some impressions of the client, such as if she can make use of the sessions and if she is motivated to do so. The art therapist will explain in simple terms what is involved in art therapy and how the materials and the room can be used, and it is preferable if some degree of understanding and motivation is in evidence even though this might take the form of just agreeing to come. It is difficult to explain what the process will involve at this stage and, indeed, what the outcome will be, but it is possible to allay some initial anxiety by creating an atmosphere of the art therapy room being a safe space in which to explore and try to make sense of what is troubling the particular client and what has brought her into therapy. Agreement must be reached as to the regular time of the sessions, how long the sessions last, and for how long they will continue – that is: is this a short-term contract of a certain number of weeks?; will the patient's attendance be constrained by issue of discharge from hospital?, etc. If the client has any questions, the art therapist must try to answer them as clearly as possible, which helps to reduce to a minimum any confusion about the commitment to the sessions.

If there are any other managerial issues then these should be sorted out in this initial session which can then free the future time for the associative work to begin. Most psychoanalytic sessions last for fifty minutes, but many art therapists prefer to work for a whole hour as the painting process generally takes longer to develop and the material to unfold through the images.

This decision must also be based on the needs of the client – aspects of restlessness, poor concentration, physical constraints – so the boundaries of the session are made with the client with these kinds of issues in mind. Once made, the time and space of the session are maintained for that client and must not be interrupted unless another agreement is reached.

Confidentiality should be stressed. Discussion outside of the session only occurs where appropriate, such as with the referring agent or other members of the professional team. Showing the art work from the sessions should not be included in this consultation process with other colleagues as it is possible to share sufficient information in terms of process rather than give specific detail of content. The art work remains in the safe keeping of the art therapist until the sessions come to an end. The room provides the containing space for the art work and for the duration of the therapy process.

Other issues need to be established, such as reliability of transport to the sessions; issues such as smoking and eating may need to be clarified; what happens if a session is missed, and so on. These add up to the establishment of a therapeutic contract which, by definition, is mutually agreed at the outset by client and therapist. This has been defined as 'the non-neurotic rational reasonable rapport which the patient has with his analyst and which enables him to work purposefully in the analytic situation' (Greenson and Wexler 1969).

In the case of John, the meeting took place in the art therapy room to familiarise him with the room. All these details were explained to him and his mother and John's situation was discussed in detail – why he came to the clinic and what the art therapy sessions would offer him. Mother had some initial questions as to why the sessions should be any different from doing art at school. It was explained to her that the sessions offered John a separate space in which he could explore and express his feelings which seemed to be bottled up and then become uncontrollable in aggressive outbursts at school. This was causing him to get into trouble and was leading him to be ostracised by his peers. The sessions would give John an opportunity to use the art materials to express how he felt about the current situation and enable him to come to some understanding about the confused and angry feelings that he felt towards both mother and father. Mother also used the opportunity to talk about her feelings and it was felt she might need some help and support. While recognising her son needed help, she could not control him or make any sense of his bad behaviour, particularly after staying with father. She wanted help for John but was working full time and so would have to ask for time off and did not know if this was possible. This addressed the practicalities of bringing him, providing mother with an outlet for her ambivalence and uncertainty of commiting herself and her son to the sessions.

Throughout the interview, John sat restlessly, constantly moving around

and being told to sit still by mother. He only spoke when spoken to, looked around the room with interest but agreed to come to the sessions. He was carefully told about the room and how it was for him to use as he wanted during the time he was here. While mother was talking, he got up and began to explore the materials. He began to draw with the pencils and felt pens, found some toys, looked in the cupboards and was given permission by the art therapist to get out the clay he found and began to take some out of the bag. He was absorbed in this until the end of the interview, by which time the day and time and duration of the sessions was agreed. The contract was for ten sessions until the court case was heard, which would decide the custody arrangements. Pending this decision, it was agreed that another meeting would be set up to review the sessions, and if mother was granted custody, whether further work was required. It was agreed that the school and the GP would be informed of his attendance at the sessions.

ON-GOING WORK

In this first meeting, some initial impressions were made of John, his mother and his confusing and complicated experience. His restlessness and difficulty in engaging with mother in terms of obeying her requests seemed to be an indication of his underlying distress when the painful situation he was facing in his daily life was overtly discussed. He was an active and lively child; exploring the cupboards enabled him to find the clay which provided a link for him for the first session – asking if he could use it when he came next time.

Thus, in all initial interviews, some initial rapport will be established between therapist and client which will influence the beginning of the therapeutic relationship. First impressions, expectations and even some preconceptions might be at work in influencing the therapeutic alliance. Three important variables inevitably influence the meeting of the client and therapist: what the client brings, what the therapist brings and the setting in which they meet. Wherever this happens, each views the other through the eye of the past, which colours present expectations. There is thus an emotional impact of the patient on the therapist and vice versa. As Cox points out:

> It is impossible to discuss structuring the therapeutic process and the therapist's use of time, depth and mutuality without describing those essential prerequisites, namely the patient's emotional impact on the therapist and the therapist's impact on the patient. Adequate emotional work cannot be done in any therapeutic situation without thoughtful consideration being given to the Siamese twins of transference and counter-transference.
>
> (Cox 1978: 120)

These both occur in the shared therapeutic space and are influenced by the setting in which this takes place – ranging from a well-equipped art room to a prison cell. Transference in different settings needs different handling and may be appropriate in one setting and not at all in another.

> We return again and again to the fact that in order to be maximally therapeutic to this patient, in this place, in this time, the therapist must be sufficiently at ease within himself so that he can move from one setting to another and enter into the life of each patient in an appropriate way.
>
> (Cox 1978: 120)

Cox is therefore calling for a degree of flexibility in therapeutic approach according to the needs of the client. The therapist is gathering a sense of these needs and concerns, while the client is in possession of a few facts about the therapist. This area of ignorance is maintained although the client is encouraged to express his thoughts, feelings and ideas as freely as possible using the materials provided. The first images produced will contain overt or covert reference to thoughts and feelings about the therapist and, in the course of these associations, a therapeutic relationship begins to develop which may include some resistance to the therapeutic procedure.

John's first session (from the therapist's process notes)

> He came down to the room eagerly and when he came in said 'Where is Mr T?'. He sat down, looked around and without taking off his coat his eye was caught by the communal box of cars, toys and other playthings. He went over and began playing with them – taking the cars out in turn. 'I've got one like this – this is a police car – this is like my friend Nick's.' He pushed them across the room, pushing some away from him, keeping hold of others. This entrance seemed to indicate his need for both father and mother figures, or that only mother figure was not enough. He took one of the racing cars out of the box and it jumped over the track as he whizzed it round the room. 'You said last week we would do some painting – shall we do some?' 'Do you want to do some?' and he replied, 'I don't know – could do.' He got up and looked at my umbrella – he mumbled, 'Is Mr T coming?' 'Do you want him to come?' 'Not really.' After playing with the umbrella – putting it over his head and then the therapist's head – he took it down and left it on the floor. He came over to the table and said, 'Shall we do some painting?'

In art therapy engaging with the therapist is often focused on tentative steps to use the art materials. In John's case, he played with cars and trains, and the game with the umbrella felt like some testing out about space and the therapist before he felt safe enough to experiment with the art

materials. He needed to feel that the activity of painting could be contained. Interestingly he did not remember about the clay. Some clients may not have used art materials for many years and so comments like 'I feel I am back at school' or 'I don't know what to do' or 'I can't draw you know' are often statements made to the art therapist at the outset.

There are sometimes very different beginnings – some over-anxious clients come and cannot wait to begin and make images without stopping throughout the session. Some parallels can be drawn with clients who are initially silent and reticent to speak and those who begin by talking so much that the therapist does not feel able to get a word in. The art therapist must stay with the silence and wait for the process to happen. If, when the client begins to use art materials, any anxiety is transmitted then it might interfere with the client's process of allowing the imagery to emerge. There may be a temptation to interrupt, to prompt, to help the client out in suggestions or freeing exercises. This does not address the real feelings of the client but has the effect of attending to the difficulties of the therapist in being able to contain the anxiety and wait with the silence and the non-production of images.

For example, it might have been easier for the therapist to mention to John that he had wanted to use the clay – instead he chose to play with cars and then trains as a way to affirm his situation and express some ideas of familiarity, travel, reaching destinations. On building the train, he had asked 'Is this a nice train – it's a very long train – is it a nice train?' – needing reassurance from the therapist. These pieces of play helped him express some initial anxieties and test out the space before committing himself to anything that felt more uncomfortable for him. The therapist was able to wait for this process to happen.

In this way, the art therapist must from the outset attend to the non-verbal cues that the patient brings. For example, where she chooses to sit, does she have eye contact with the therapist? or is she largely interested in avoiding that and exploring the room and its contents? Does she ask for reassurance or how to begin from the art therapist? Does she pick up one material and then change it for another, showing uncertainty or hesitation about what to choose or commit herself to? How do these clues manifest themselves in the shared space between therapist and client? The art therapist must be open to all these subtle observations as the initial contact allows the therapeutic process to begin.

The following describes how John began to use the materials (from the therapist's process notes)

After talking about his tee-shirt, which his nan had given him, he asked for an apron, which he got out of the cupboard, and sat down at the table, began to squeeze out some paints into the palettes – red first, then

yellow – blocked. The therapist helped him take off the top and the yellow flowed out. The black – 'I like black' – then brown and blue. The palette was completely full. 'Have you got any more of these?' 'No, there aren't any more. Do you feel you need some more?' 'I want to make grey.' He took a paint brush and put it into the black and then into the white and put it straight onto the paper – did circle of thick paint. 'It's all black' he said in dismay. He tried again – and repeated it the same way. 'Oh no, that's wrong.' He stood there anxiously holding the paint brush. 'I'll have to throw it away.' He didn't seem to know what to do with the brush but decided to put it into the water and folded up the paper carefully and asked me where the bin was.

This process felt as though he was trying to mix together two different components of his life without success – the mess made him worried and anxious, which perhaps mirrored his inner experience. John went on to make a cracker out of folded paper and he asked the therapist to pull it with him. He made a black mark to show the middle and he found some scissors in order to cut it. This led onto some printing as some of the pieces of paper accidentally fell into the paint with which he then began to experiment and use for this picture. He was more relaxed and less anxious about making mistakes as he became involved in the activity.

The most important issue is that the picture surface has a 'voice' of its own and gradually a dialogue builds up through which both patient and therapist communicate. The image provides a third dimension in the relationship. Aspects of the client's experience, feelings and situation, previously hidden or unconscious, will begin to emerge through the image and once again the art therapist must wait for these to be fully formed as the client completes the image or decides on its course, rather than respond to any intervention from the therapist which will be experienced as intrusive. The client engages in the image-making process, although configurations in the image might not yet be clearly understood or indeed consciously made. Again the therapist must wait with this uncertainty, lack of clarity, even ambiguity as images contain many different meanings on many different layers. The art therapist will be feeling many things as this process takes place and the picture surface begins to speak to her inner experience and feelings as well. However, it will be of most benefit to the client to arrive at her own personal meaning of the image that is made in the therapeutic space and it might be that she does not fully share it with the therapist at this particular stage. The meaning or impact of the image might change over time and again the permanence of the image allows for this on-going work to be done.

Throughout the first session, John continually made reference to things 'in the middle'. He asked the therapist what her middle name was, to which she responded, telling him her middle name but wondered aloud

why he felt it was important. He made a folder with his name on it and added his middle name; using a paint brush that he was washing out he began to flick it into the basin and then holding it between their faces he pretended to flick it first at himself and then at the therapist. 'Shall I flick it at her or him?' The therapist replied, 'That paint brush seems as though it's in the middle – it doesn't know which way to go.' Several references to his experience of being stuck in the middle became overtly expressed through his interaction with the medium. The therapist was able to make sense of this and reflect it back to him.

It is here that the transference and counter-transference responses begin to be established between therapist and client and through the various responses to the images produced. As these relationships unfold, and the art activity proceeds or not, transference issues will affect the images produced in the sessions. Likewise, how they are received by the therapist will be affected by her counter-transference response: what are the feelings evoked in the therapist by them? These are important in the communication of the client's experience and inner processes that are struggling to emerge. At this stage, it seems that John had some sense that the therapist was 'in the middle' – perhaps both mother and father for him. There was a question about whether he might also see the therapist as someone who ultimately might make some decision about his future. (For a clear and thorough account of transference processes in art therapy, see Schaverien 1987 and 1991.)

ART THERAPY IN PROCESS

In art therapy the art materials become the focus for the expression of the relationship between client and therapist. The client will choose what media to work in and this gives an indication of process as the image builds up and develops. It is how this activity is undertaken which is also important – i.e. with hesitation, or enthusiasm, or there may be long periods of talking before any decision about art activity is made.

Some children get very excited by what they feel they have achieved in their work, when in previous weeks they were more worried about making mistakes, about doing nothing, or making a mess. John was very worried about making mistakes or doing things wrong, but this occurred noticeably when he was more anxious, perhaps feeling that the therapist was judge in some way. When he felt free to use the materials, this relieved his anxiety as he was able to express many different feelings which were coming to the surface as the activity overtook him and he became 'lost' in his image-making. Initially, this was predominantly his experience of being in the middle but then deeper issues began to surface.

In some art therapy sessions, there is no art activity at all, and where

verbal exchange between therapist and client is predominant, or where there may be long periods of silence, the dynamics of this process can be explored. Some patients refer back to earlier work that is always available in their folders; they might walk around the room, picking up and looking at things but not engaging with anything in particular. For the therapist this is often experienced as a kind of testing out in terms of availability of materials which can be directly equated to how the therapist is experienced. For example, if the materials seem ample, wide-ranging and generous the therapist might be perceived as all giving, intriguing, exciting or even indulgent. The opposite can occur in the situation when the same selection of materials is perceived by a patient as not enough when she asks for the one item that is not there. The anxiety of not having enough is transferred to the therapist and is probably based in some early childhood experience. Other clients might inwardly register some lack of materials but 'make do' with what they have – another aspect that manifests itself within the therapist–client relationship.

John said initially he would use clay but when he first came he played with cars and chose to do painting. However, in the subsequent sessions, he would begin by playing with the cars but then chose to experiment with the clay. As father began to emerge as an important figure for John, he spoke about him more and more. This coincided with his making two round objects in clay to which he put faces. He called them mummy and daddy, and then proceeded to make a third which he called the baby. He left them and moved on to some more playing with the trains, making the track and anxiously wanted it to be complete. In the next session he went straight to the faces, took them off the shelf, got out the paint and added two blue marks to the baby's face. When asked what they were he retorted 'tears of course', and then began to make crying noises like a baby. This was a poignant way for him to describe his lost and unhappy state – crying like a baby. He felt caught and needing to be looked after. He made several other things out of clay – a car, a football post, but many of these did not survive from week to week. The faces survived, which he looked at most weeks. They felt very important to him.

The following week he came in and tried to make something with clay, but got frustrated as he could not do it and so began to make several objects out of plasticine. He spoke about the book *The Enormous Crocodile* [Dahl 1978] and then carefully made two men behind a wall, with guns pointing over it, and a crocodile with a small one beside it. He said they were hunters shooting at the crocodile with her baby. He then made two tiny objects, separate from the rest, which he said were breasts for the mummy crocodile to feed her baby with. He spoke spontaneously about what he had made – hunters shooting at the mummy crocodile – they are behind a wall and so are safe – like parents fighting

over him? The breasts were placed slightly away from the scene and so it looked as though they would be hard to reach. It seemed he had been able to make a separation between the parts of his vulnerable 'baby' self that he experienced being under attack and the parts that were waiting to be fed once it was all over. He had made these with great care and delicacy and it felt like a very significant session. The clay had become a frustrating medium for him to work in – he had found the plasticine, with the different colours and durability, the safest means to allow these important feelings to emerge and to communicate his experience. He kept these tiny things carefully, and every time he returned to the room he would make sure they were still there. This intricate scene he had made so carefully seemed to suggest many different meanings. Whether it was some attempt to come to terms with the judgement of the impending court case – was he the 'daddy hunter' with a penis/gun fighting for his 'mummy/ crocodile' or was he the baby being protected by mother? The nurturing breasts were placed safely away from the battle zone and in her counter-transference response, the therapist watching this scene unfold wondered if this was in some way an attempt to integrate the mummy and daddy parts in him.

As the sessions were coming to an end, he became more worried about doing things right. For example, he tried to make a book for his baby cousin but constantly rubbed out the lines and soon abandoned the idea. One session he did a picture of Batman, the Joker and other figures, again with great emphasis on getting it right. During this session he spoke about the fact that his mother was in court today and expressed some anxiety about her and his situation. He said he worried about his mum when she gets upset. At the end of the session he wanted to take his drawing for her, which was an indication to the therapist that he was feeling the need to connect with her and give her something. He was in touch with his anxiety about the possibility of separation and so the therapist suggested he should ask his mother down into the room to show it to her. He readily agreed to this, possibly feeling that he could connect together the disparate adults in his life.

The provision of art materials forms an important dimension in the relationship between art therapist and client. The medium that the client chooses to use, and how she uses it, is a means of expression in itself. Does she stay with one type of material or explore many different ones? Does the way she uses them develop over time or is this process a static one? Is there a lot of mess and chaos in handling the materials or is there a concentration on keeping neat and tidy? John was able to explore and use different materials, and it can be clearly seen how using the paint he was able symbolically to express being 'blocked' but in a mess, his carefully made clay and plasticine objects emerged in a solid and delicate way, indi-

cating deeper, inner experience, and then his use of pencil and rubbers was an indication of his frustrated baby needs and some underlying anxiety about ending and what will happen to him.

There are some real restraints and limitations that have to be worked with in these times of financial restraint but form an important part of the process. The feelings experienced by some art therapists when asked for some materials they cannot provide can be likened to a mother who does not provide sufficiently for her infant. Inevitably, clients often ask for the one type of material that might have run out or for some reason is not in the room, and has the effect on the therapist of not being 'good enough'. Art materials can also be equated with food in the sense of giving or withholding and how they are 'consumed' by the patient. These are all important indications of the transference and counter-transference responses through the art materials as soon as the patient enters the room and responds to the setting and the art materials.

Essentially, the process of art therapy involves the therapist and client and the art work produced in the sessions. The understanding and sense that can be made from the images will emerge over time so that the client can make some connection to what she is making in terms of her experience and towards some internal resolution of conflict.

> John was able to openly express his feelings about his parents and his confused and angry feelings about his situation, which was the reason he came into therapy. In the process, however, he was able to express some deep infantile needs and fears about needing to be fed and cared for by mother but fearing that this would cause him to be annihilated or shot by the hunters (father?). It represented literally his experience of being caught in the cross-fire which he had not previously been able to clarify in his mind. As the contract was to work over a short period of time, the particular issue of his parents' separation was addressed with quite direct reference to the problem, but there was enough time for him to allow internal conflicts to emerge and work towards some resolution in himself.

The duration of the work may be affected by other limitations such as in-patient stay of many psychiatric patients referred to art therapy. Where these limits are not imposed and therapy is entered into on an open-ended basis, this may last for several years and the relationship becomes intense and intimate. The process of change can be clearly seen in the images or art work produced, and over time the sequence can occasionally be looked through together to understand how this process has taken place. Some art therapists like to choose to review the work with the patient as a way of clarifying the process of the work so far. This has the advantage of making some aspects of the work conscious and understood, but has the disadvantage of interrupting the flow or process and on-going nature of the work in

the sessions. It might be after a period of absence that a recap over time might help the client re-enter the process of image-making, but the purpose of using reviews must be clear in the therapist's mind. It is possible they might have some defensive function such as dealing with a difficult ending or preventing more painful issues to emerge in the present.

Basically, the therapist follows the patient throughout the process, being available to her with a capacity to understand the most subtle communications. The important elements for this to happen within the relationship depend on how the experience of the client is contained, reflected back or interpreted. The safety and trust is established in the therapeutic alliance and is held by the therapist as the client attempts to struggle with difficult, sensitive and sometimes painful issues in the work. The images survive over time and so even if these issues cannot be talked through immediately, and might remain on an unconscious level, it is possible to return to them in later weeks when the patient feels more able to look at the content of the imagery. For example, John made his faces, and then the next week returned to them to add the tears which enabled him to communicate his experience of being the sad baby caught in the middle. It took several weeks before he could express this.

Another aspect of using images is that over the process of the therapy the images change in terms of meaning and significance for the patient. A flower drawn during an intense grief reaction representing the person who died becomes a different object in the child's mind when the feelings have been expressed and worked with and a degree of resolution is beginning. A house drawn at the outset of therapy is empty, dead and remote in the patient's view. As the therapy proceeds, this house becomes more accessible and there are fantasies about moving into it, living in it with the therapist, even having a relationship inside it. The house changes from a cold shell to having a habitable inside – an indication of how the patient has moved in terms of her capacity to look inside, to have an inner experience, to feel contained and not shut out. The image remains the same throughout.

TERMINATION

There are various reasons for the termination of therapy, such as its usefulness for the client, when it is felt that most of the presenting problems have been worked with and some resolution, both internal and external, has taken place. Personal cirumstances of either therapist or client – such as job changes, moving house, etc. – might promote a decision to end working together. Where a set number of sessions have been completed, the ending takes a different shape in that it is more clearly anticipated but involves the same disengagement from the therapeutic process. It might be that the contract can be renegotiated if it is felt appropriate to continue but this

must be based on a mutual understanding of the basis of the decision to continue in therapy.

John knew that the agreement was to come for ten sessions and he was reminded about the end in terms of how many sessions were remaining. He expressed his disengagement from the therapist in different ways. In the last session, he was very reluctant to come, but once in the room enthusiastically expressed the wish to finish his model aeroplane that he had started and asked for the therapist's help in doing so. When reminded by the therapist that this was his last session he said 'I know' very firmly, and then began to work in pencil, making lines on paper. 'That's wrong', he said in frustration. He started again and asked the therapist to hold the ruler. After doing several lines and saying he wanted to write the story of Thomas's train, he picked up a stencil set of letters and wrote ONE DAY, scratching on the stencils. By asking the therapist to hold the ruler and then confining his writing to the stencils, it felt as though he needed to be held together. She was able to offer him some solid structure in his perceived need for guidelines. At the end of the session, he wanted to take the stencil with him, wanting to take something from the session. When this was reflected back to him, he asked if he could show his mother the work in his folder. As it was the last session, the agreement that he could take anything he wanted was mentioned, and so, after the session had ended, he asked his mother to come and see. Mother looked at the various objects and images, and, pointing to the tiny breasts, asked what they were. John whispered in her ear what they were, and mother, looking at the therapist, sought some clarification. She confirmed that that is what they were and that it had been useful for John to be able to think about himself as a baby as sometimes he felt he had to be tough, but in fact was feeling vulnerable, dependent and needed looking after like a baby. Mother looked relieved as she had understood this – again a useful way of helping mother to be included in the therapeutic process by looking together at the images in this way. It is interesting in itself that it was these that mother chose to ask about which perhaps connected unconsciously with her. This was also useful as there was to be another meeting with mother, John, Mr T and the art therapist to assess the need for further work with John.

Whatever the situation, a good deal of warning is required to end such an intense process so that the work is terminated in a satisfactory way for both client and therapist. As much notice as possible should be given. When patients are abruptly discharged, this is not possible and is most unsatisfactory. However, where the ending is in control of both client and therapist, it must be addressed and worked through. The ending is often expressed through significantly changed imagery such as doodling, cartoons. Some children even turn away from using the materials altogether

and concentrate on playing with toys or other objects in the room to re-establish their defences and prepare for leaving and doing without the therapist. An ending is sometimes painful and difficult as it inevitably will bring back memories of some other experiences of ending in the past. These can be looked at to help the process to a satisfactory conclusion.

Many series of painting produced in therapy show this process very clearly and act as statements of the psychic, closing down of the relationship, and the feelings that this evokes. These have been illustrated in Chapter 5 and have also been evident in John's attitude: he wanted to play with a car, to make things for other people, and show his work to his mother to connect the sessions with her rather than with the therapist, thus thinking about his outer rather than his inner experiences. There are other examples, such as the child who had produced many spontaneous paintings during the therapy, drawing in pencil and ruler, repeating patterns starting on the outside and going into the middle. Peter, who was mentioned in Chapter 3, spent his final session drawing on a minute 'post card' intricate details of flowers, which had a multitude of possible meanings – flowers on the grave, message from afar, closing down of personal statements and so on. Other children are more expansive – a tiny model aeroplane is made in the first session and, in the last session, an enormous one is made to hang from the ceiling – possibly to be remembered by going away with a splash? The process is a fascinating one and the therapist must guard against putting her own feelings about ending into the client. She will be feeling sad at the loss of the relationship and it is easy to accept momentos and be given drawings and paintings, feeling the need to create a situation for her that the child takes something with her as a means to remember the therapist by. All these responses must come from the client – often the art therapist is left with the whole folder of work but this must be the choice of the client, who might see this as just leaving them behind or not wishing to take them.

How the art work is used by clients has already been covered in previous chapters, but usually at the end of the therapy the client is asked if she wants to take her work. The answer to this is often an indication of the way the client feels about the end. If she leaves it in the safe keeping of the therapist, this might be an indication that she wants to go away with the feeling that there is a possibility to return. Taking them can give the impression that this option is now closed, but at the same time puts a different sort of value or emphasis on the time in the art therapy room and part of that can now be physically taken. Very occasionally, the patient may want to destroy her work, and in that case there is an opportunity for the therapist to intervene to ask why this should happen and that this is possibly some sabotage or destruction of the process that had been engaged in. If the paintings are left it is standard practice for them to be kept safely for some years in the art therapy room. They are records of the work and

as such should be stored and kept safely, as in any filing system of past therapeutic contact. John chose to take away his models and left his drawings and paintings – the clay and plasticine became the medium which for him most significantly expressed his experience. He had indicated this in the first meeting but the significance of this was made clear as the therapeutic process developed over time.

From the initial meeting with the client, the establishment of contract and therapeutic alliance and developing of the relationship over time – the images, models and the other objects made or destroyed or allowed to disintegrate during this time – are records of the process of the art therapy sessions. It is important to emphasise, however, that it is the continuity and containment by the art therapist of the therapeutic space – that is, the art room – that allows this process to develop. It can be a most intense, painful, active or passive experience but it is the safe holding of the space for the client that facilitates the basic trust for these emotions to unfold. The therapist must not allow herself to intervene in the process. Some unconscious defences might come into play when grappling with intense emotional experiences which are graphically exposed in the image-making. Some paintings can be horrific but the therapist must not respond to these in a way which cuts off from this experience – perhaps like suggesting working in a new medium, or washing palettes or engaging in some other activity with the materials as a means of diverting the process. Likewise, where the therapist does not know what is going on, perhaps there are no images or just chaos or mess and nothing 'constructive' emerging, the art therapist must stay with the sense of chaos, destructiveness or mess as this is what is being communicated.

The reception of the image within the therapeutic relationship is as important as staying with the process of making it. Our experience of seeing paintings in galleries that bring up difficult feelings for us is usually to turn away and look at something else. This is not a possible option for the art therapist grappling with the feeling of the client who is creating it. When these images are looked at in hindsight, they hold the associations of that experience and that session, and so although the art therapist will always put the date on the back of the painting, it has already found an important place in the evolution of the process it has been engaged in. Therefore, a patient's folder contains the poignant experiences and feelings of the various stages of the process in art therapy and it is because of this significance that consideration of the images, and how they are stored and kept by the therapist, is so important.

REFERENCES

Case, C. and Dalley, T. (eds) (1990) *Working with Children in Art Therapy.* London, Tavistock/Routledge.

Cox, M. (1978) *Coding the Therapeutic Process: Emblems of Encounter.* Oxford, Pergamon.

Dahl, R. (1978) *The Enormous Crocodile.* London, Puffin Books.

Greenson, R. and Wexler, M. (1969) 'The Nontransference Relationship in the Psychoanalytic Situation', *International Journal of Psychoanalysis,* L.

Nowell Hall, P. (1987) 'A Way of Healing the Split', in Dalley *et al. Images of Art Therapy.* London, Tavistock.

Sandler, J. *et al.* (1973) *The Patient and the Analyst: The Basis of the Psychoanalytic Process.* London, Maresfield Reprints.

Schaverien, J. (1987) 'The Scapegoat and the Talisman: Transference in Art Therapy', in Dalley, T. *et al. Images of Art Therapy.* London, Tavistock.

Schaverien, J. (1991) 'The Revealing Image', in *Analytical Art Psychotherapy* (in press).

Weir, F. (1987) 'The Role of Symbolic Expression in its Relation to Art Therapy: a Kleinian Approach', in Dalley, T. *et al. Images of Art Therapy.* London, Tavistock.

Chapter 9

Working with groups in art therapy

A company of porcupines crowded themselves very close together one
cold winter's day so as to profit by one another's warmth and so save
themselves from being frozen to death. But soon they felt one another's
quills which induced them to separate again. And now, when the need
for warmth brought them nearer together again, the second evil arose
once more. So that they were driven backwards and forwards from one
trouble to the other, until they had discovered a mean distance at which
they could most tolerably exist. (*Parerga und Paralipomena*, Part II
'Gleichnisse und Parabeln': Freud quotes in 'Group Psychology and the
Analysis of the Ego', 1921: 33)

INTRODUCTION

The philosophy underlying all group therapy is that man is a social being.
Humans live in family and social groups and children cannot survive
infancy without firstly a prime carer, usually mother, but also a further
supportive network for the mother whether it is nuclear family, extended
family or state. The development of object-relations theory in psycho-
analysis, which we looked at earlier in Chapter 4, has suggested ways that
early internalised family relationships can distort experience of current adult
relationships. We also pass through a series of institutions from nurseries,
schools, colleges, workplaces, all of which will have their small group
dynamics and institutional dynamics affecting our lives. Therefore a basic
knowledge of group theory is essential for all therapeutic work both to aid
our understanding of our own and clients' experiences in the past and to
help us understand our experiences of being art therapists and clients
within the institution in which we are working.

The influence on art therapy work in groups derives from the two main
bodies of knowledge of art therapy and verbal group therapy. It should be
stated at the outset that the basic difference between all forms of group art
therapy and all forms of verbal group therapy is that at some point in group
art therapy each member becomes 'separated' from the group to work indi-

vidually on her own process through the medium of art. This has a profound shaping on the group dynamics and on the art object formed, which we shall be exploring in this chapter.

All groups express a tension between dependence, the desire to merge into a group identity, and separation, a wish to express individual difference. Art therapy groups uniquely differ from verbal groups in having a structure which can give time and space for each side of this tension to be explored. Several different formats have become established in art therapy practice and we shall be considering them in turn, looking at influences upon them and the role and function of the art therapist in each.

The first group format can be loosely designated as a 'studio-based open' group where the art process is seen as the curative factor. In this way of working, 'spontaneity' is a key word, the therapist has a 'non-directive' role and group processes will not be worked with directly. The second form of group could be called an 'analytic' group. This group has a direct influence from verbal group therapy and is usually a 'closed' group. The therapist will be aware of group processes though may choose to work with either the individual in the group, with the individual and group processes or only group processes. The 'analytic' group has a similar respect and trust for the art process and will be non-directive about the content of paintings, working with the unconscious themes that arise from the group each week.

The third group we shall be looking at is the 'theme centred' group where either the therapist chooses an experience to explore in painting or the group may talk until a 'group theme' emerges from a free-floating discussion that they will then agree to paint. This way of working generally cuts across and blurs the development of group dynamics, which means that working with the group process is not applicable. These groups therefore tend to run for a short series of sessions and have perhaps an equal emphasis on 'social' factors as well as the 'healing art process'. They have developed from and inherited some features of encounter groups.

THE STUDIO-BASED OPEN GROUP

The studio-based open group could be described as the classic form of art therapy and was the main way of working before training was available in the early 1970s. Before formal art therapy training, a therapist's art school background and individual experience of therapy largely informed her practice. It therefore had antecedents in the atelier, studio or workshop of artistic tradition. In hospitals or large institutions from where this type of group has evolved, and still tends to be located, a group of patients will come to work in the studio but art is regarded as the medium of treatment rather than the group. The therapist relates to each member working individually and will probably talk to each one in turn, sometimes at some length, or there may be an alternative private space available, an office for

example, for individual discussion of work. There will be a communal feel in that there may be music playing and shared coffee breaks during the long session which might last a whole morning or afternoon. The patients in the group may all come from the same ward, having a morning session assigned to them or they could form a group made up from individuals from many wards who have been referred and accepted into the department. The groups are usually composed of long-term residents living in psychiatric hospitals or those for mentally handicapped people.

Within the hospital this may be the only 'private' and 'personal' space a resident has in an institution. For those who are long term and institutionalised, the studio may offer an important possibility for individual decision-making and outlet for creativity in the content and medium used in the art objects made. Some patients work as artists in the studios with their own space as if in an art school. As in any studio, group processes will affect the use of the space, the phases and pace of work and the images made. The art therapist will be working with individuals within the group rather than with these processes.

The theoretical orientation of the art therapist will decide how the art objects are explored. For example, a Rogerian approach is described in a psychiatric hospital by Warsi (1975a, 6). The most comprehensive account is given in Lyddiatt (1971). Lyddiatt worked from a Jungian framework with emphasis on 'spontaneity', the release of hitherto unrecognised feelings. The whole curative factor is seen to rest on the effect of the patient in contact with their unconscious through the making of art objects. Lyddiatt is particularly influenced in her style of work by the Jungian concepts of 'amplification' and 'active imagination' (see Chapter 4). There is little emphasis on understanding and reflecting between therapist and client, but on helping the patients to treat themselves through painting. Lyddiatt was reluctant to interpret patients' work, feeling that projection was all too easy.

> The idea, i.e. the 'technique', is to watch what one's imagination is doing.... Yet patient, therapist, or onlooker can unwittingly kill the spark unless experienced in this inner way – kill it because the patient is tentatively trying to find, feel and experience for himself new values through his painting, and this, in fact, is exceedingly difficult.
>
> (Lyddiatt 1971: 4)

In this way of working an art therapist would not be working directly with the transference although an individual personality theory would be illuminating the therapist's relationship to the client group. In this kind of 'open group', where individuals may also drift in and out during a session, staying for three minutes to three hours, the kind of ambiance built up in the studio is extremely important because this is a group who will feel that this is 'their' room. Many relationships will be developing and changing between

the members – some, for instance, always painting side by side. One client's decision to use clay, for example, may be a catalyst for many other people's development and change. The art therapist will be creating an atmosphere of trust and acceptance, of receiving and valuing the products and of experiencing them largely non-verbally. A further account of this type of work in hospitals is given by Edward Adamson (1984) and the products of many years of these sessions can be seen in the Adamson Collection, which is well worth a visit.*

Groups of this kind still have a place in hospital settings of mainly long-term populations, although change is inevitable as hospitals close and patients move out into the community. Other places that run this type of group can be found in maladjusted schools, social services day centres and therapeutic communities. In fact, wherever there might be 'free time' in therapeutic programmes, patients are often permitted to use the studio for their own private work.

In an effort to reach patients not able to leave the wards where they live, art therapists frequently run an open-studio type session taking a mixed range of materials with them. For instance, the following describes the use of such sessions by three clients on a psycho-geriatric ward. These often institutionalised, non-ambulant residents normally spend a large part of the day sitting in chairs. It was possible, by using a regular meeting area, the dining tables, to attract the participation of those able to benefit. 'Place settings' were equipped with paper, brushes and pencils and clients would tentatively begin mark-making at their own pace and level. In one such group an elderly man, who had had a stroke, was able to scribble with one hand, gradually extending to a range of colours, developing an investment in the pictures as well as helping his coordination and motor skills. He also became involved with conversations around the table and benefited socially.

On the same ward, a middle-aged man who had entered the hospital in adolescence, probably due to shell shock, began a huge output of colourful paintings of vehicles and fires on black paper, often making twenty to twenty-five pictures a session. It became apparent that he was reliving experiences of bombing at night. He was mute and habitually avoided all personal contact. He made sense of the experience by one day printing 'SCHOOL' on a painting which began a long series of cryptic communications. The development of this patient was very gradual, forty years of institutional life had taken its toll, but the quality of his life improved with the introduction of the sessions. Socially he had a sense of belonging to the

*Adamson Collection, Ashton, nr Oundle, Northamptonshire. People wanting to visit the gallery should write to: Adamson Collection, 16 Hollywood Road, London SW10.

group and the paintings clearly had a meaning for him.

A further example was a depressed elderly man who had suffered multiple bereavements. After a slow beginning, copying scenes from calendars, he began to paint small pictures of remembered scenes from his life and would allow memories and feelings to surface to share with the group. The group can be seen to support very individual use by its members, co-operation by simple sharing of materials and care for others through positive comments on each other's work.

WORKING WITH THE INDIVIDUAL IN THE GROUP

When working with individuals within a group, the art therapist will be working with the group but informed by individual psychological theory rather than group theory. This way of working is probably most successful with small groups of pre-latency or latency children. The problem of working with adults in this way is that a group is not just a collection of individuals but a coherent group with its own laws, group culture and developing its own unique dynamics. It is not possible to look at the behaviour of one group member independently of other group members or from commenting on group interaction generally.

However, with children it can work very successfully in an art and play therapy room context. The children identify with the group which comes on a particular time on a particular day but will usually very quickly disperse to work individually on their own current themes and preoccupations. The therapist will move among them, stopping to sit and talk as conversation is initiated, or the child will directly interact with the therapist. Children may pair and group in different ways but with the development of a good 'work group' atmosphere there will be a sense of acceptance and tolerance for each child to pursue her own ends without interference. The group will often be useful for the children's social development and understanding as they take in the therapist's model of relating and acceptance of differences. They also learn from each other and begin to negotiate their relationships, as the therapist might address and work through with the group areas of conflict, difference or cohesion that will inevitably arise as the group interacts. The child can also benefit from some personal space to explore preoccupations within the protective group atmosphere. The trust that is established enables the children to tolerate differences but also to begin to understand and help each other.

The following two examples show a slice of group life. The first shows a group of young children alternating between art and play; the second a group of older children more aware of themselves consciously as a group and working through art.

Example from a group in a primary school, age 7

In this setting the art therapist worked with small groups of chldren with special needs referred by the headteacher and class teacher. This was reviewed at the end of each term; the three children described came for an hour a week and this was the fifth group. Tracey was referred because her parents were in the middle of a bitter, argumentative divorce. Dean was referred for rather manic, extrovert behaviour with a tendency to lie and steal, and his family life was generally disturbed. Louis was a shy, introverted child, withdrawn in the classroom. His academic progress was very poor.

Group

> In this session the children had a brief discussion around the table and had decided unanimously to paint. The two boys got diverted at the sink, originally to fetch water, and became involved in some water play. At Dean's instigation, toys were fetched from the sand tray and they played at Tarzan and animal fights: Tarzan, leaping off the taps, fights with crocodiles under the water. Tracey began a picture of her friend in a very watery style, saying 'She's black but I'm doing her white'. She gave a wry smile to therapist to communicate that she'd drawn the head rather big. Reflecting on the image, she did 'freckles on her face', then said, 'Not freckles – just water marks.'

Commentary

It can be seen at this stage that an unconscious theme around water has arisen. Louis taking the part of Tarzan; Dean, identified with the 'aggressive' crocodile; each boy is carrying a part of the other's projection. Dean needs to control his 'wild' impulses but with Louis taking the part of Tarzan he can 'play' them out. Dean, however, is expressing much 'wild' feeling that Louis is unable to contact for himself. It is happening largely beneath the water. Although Tracey is working alone, her watery painting starts simultaneously with the water play and the comment on colour contains many possible meanings. It comments on 'difference' in her sense of being left out or not included in the game, her different sex and also her different colour. She was the only white child in the group, which was emphasised by her picture of her friend whom she wants to be 'the same'. Tracey is also painting an aspect of herself identified with her friend, in that she feels guilty, as if she might be to blame for the divorce and so does a picture that changes the features and skin colour of her friend. The aspect of herself is confirmed by the freckles, which she has, but her friend does not. These then transmute to water-marks, i.e. tears.

This is a clear example of how a group process can enable children to express their own difficulties, but the unconscious dynamics and inter-actions within the group facilitate the expression of problems faced in their daily lives.

Group

Tracey began to talk about the death of her cat's mother. This happened when Tracey was 5. She then became even more sad and preoccupied because she had forgotten the cat's name. She had been going to do a dog in the picture but now did a cat instead. She told the therapist about her cat called 'Kitty', saying 'People called her 'Kit-e-Kat' to annoy me.' She then said, 'A lot of pets have died.' The painting finished, she moved to the sand tray. Meanwhile Dean had begun to dip the animal's feet in the paint by the sink and was walking them over the table tops in a trail and back to the sink. As the paint on the animal's feet 'coloured' the water it became apparent that getting the water dirty was important: an emphatic 'Yes' as the therapist commented on the dirty water and mess. A lot of excitement as the fights under the murky water continued with no clear outcome. Dean, attracted to the involved demeanour of Tracey at the sand tray, said he wanted to use it but before this devel-oped into an argument his eye caught a picture of Superman drying from a previous group, and he went to look in his folder for a picture of Superman he had started the previous week.

Commentary

In this part of the group, Tracey's sadness emerges and is shared with the therapist. Dean's approach, as the animal footprints, makes contact but does not disturb her. The talk of cats is quite complex and perhaps repre-sents in her mind a way of exploring the changes in her own mother and herself since the fights and arguments started two years ago (when she was 5). She seems to have lost contact with that earlier, happier self, 'forgotten the cat's name' and her anxiety is expressed about whether she will be looked after properly 'in between the parents' through the divorce as 'a lot of pets have died'. Forces in conflict in the boys are being fought out, but it is a murky area – the water gets very dirty and it all reaches an impasse.

Group

At the sand tray Tracey puts an igloo in the corner and builds a fence around it. She fills a small bowl with water and places it in the sand, like a breathing hole in the ice. She places an Eskimo figure with a spear surrounded by encroaching Arctic animals – seals, polar bears, a walrus

and a crocodile. Dean finishes off last week's picture of Superman and asks the therapist to write his name on it. He is pleased with his and wants it up on the wall. Louis started and finished his own picture of Superman which he copied off one already on the wall, done by an older child. He is very anxious about his drawing although it is competently and carefully executed.

Commentary

Unable to solve the conflict under water the boys separate and move into fantasy. Superman does not have to work things out on a real level but can rise above these problems. In identifying with the older boy's Superman, Louis shows a wish to be mature and 'in control'. His need to copy or imitate indicated his lack of self-confidence, and he was not able to feel that what he had done was good enough, in spite of the fact that he had done a more competent drawing than the one he copied. Tracey and the boys swap kinds of activity, and by changing places attempt to resolve the issues that have emerged for each of them, aware of each other but not interacting very much in this session. Tracey's frozen landscape and Eskimo figure might indicate her feelings of being 'out in the cold' and 'under siege' both within the group and in her family. But the crocodile was there and her breathing hole in the ice, which might indicate signs of hope and life. Her play could be seen as a metaphor for the group where contents of the unconscious meet in the art therapy room and are then reintegrated. The hole in the ice could be seen as the link to the unconscious under the frozen 'conscious' wasteland. She is using the sessions slightly differently from the boys at this time. The igloo in the corner gives her a safe space within which she can reflect, withdraw to and emerge when ready, whereas the boys choose a more active form of drawing for their own sense of space.

Example from a group in a primary school, age 9–11

The art therapist worked with a group of children referred for learning difficulties and it was felt that their difficulties were compounded by the fact that they had all experienced significant loss in their lives. The children had one individual session per week and one session a week as a group. This built up a strong, but rivalrous relationship between therapist and group, although they knew they were being seen for equal amounts of time. This enabled more opportunity for self-disclosure as well as aiding further understanding through their interactions as a group. The group had been formed for one term and was to be reviewed at the end of term.

Abdul, age 11: older siblings in care, father deserted, mother physically damaged by accident. Obsessive child, uncontrollable temper. (Figure 9.1 (a).)

Colin, age 10: mother died when very young, now lives with father and siblings. (Figure 9.1 (b).)

Graham, age 9: mother white, father black African, worried about father who visits but does not live with them, macho cover hides sensitivity. (Figure 9.1 (c).)

Susie, age 9: divorce after father violent to mother and children, speech defect psychologically based on experiences as a young child, clings to adults, silently cries. (Figure 9.1 (d).)

Jane, age 11: divorce after father violent to mother who suffered deafness as a result. Step-father and new sibling. (Figure 9.1 (e).)

Georgina, age 9: mother does not speak to her following birth of several siblings in close succession. All contact is through her father and siblings. (Figure 9.1 (f).)

Group Week 7

In this first meeting after half-term, the children all rushed to look at folders and pieces of work in progress from before the half-term break. They all remembered what they had been working on and exclaimed at finding it safely kept. They chose to sit around a group table and began to finish paintings, paint pottery and so on.

Twenty minutes into the group the three older children, Abdul, Colin and Jane, began a round of sniping attacks on each other, expressing the rivalrous undercurrent of who will dominate the group. Abdul was causing disturbance in the group, behaving with continual, minor destructiveness, splashing paint and water near or over people's work. At the beginning of the group he had started to make a machine-gun from pieces of wood. The therapist had intervened, reminding him of basic rules when he had tried to break up another child's model to get a piece of wood he wanted. By making derogatory comments on other children's work, he ignored the therapist's comments about his anger really being directed at her. Jane kept up an intermittent 'If you want to be in our group . . .' which irritated him further.

Colin worked with solid involvement, letting Abdul's aggressive criticisms slide off him, until Abdul returned to the group and, beginning to paint a witch, began to use it to make comments about Colin's dead mother. Colin left his previous painting and began to paint a 'lone' shark 'which is a dangerous fish'. The younger boy, Graham, had retreated to a desk apart, making a dinosaur, a Tyranosaurus Rex with open mouth and full of teeth. He came growling with it to the group, where seeing a lot of 'fish' painting going on, he too began to paint a 'goldfish'. The 'fish' painting had been started by Susie who had drawn, then painted a 'fish in a net'. She said of it, 'It's a flat fish [a plaice], a life boat's caught it in a net, he's happy because he's caught. He doesn't want to have to

a

b

c

Figure 9.1 (a)–(f) Six group pictures: (a) Abdul, (b) Colin, (c) Graham, (d) Susie,
(e) Jane, (f) Georgina

d

e

f

live'. Jane, admiring the fish, got Susie to draw her one too. She then
added sharp teeth, half painted it brown with spots, and left it. Graham's
fish is in the sea, painted blue, no nets in evidence. 'It's a spotty gold-
fish.' While this is going on around her, Georgina has been struggling to
draw a 'cow being milked'. She had a lot of trouble both drawing and
painting it. It had to have horns, but no ears, like all her animals made in
art therapy. She commented, 'This is a cow getting milked in her barn
and a little girl is bringing another bucket because one of them is over-
flowing.' She wrote 'MILK' on the picture. She interacted a little with
Jane and Susie, but mostly all her energy went on the drawing.

Commentary

This older group of children are coming to an age where they can begin to
respond to simple comments on group process. Colin, for instance, listened
to the therapist's comments to Abdul, took them in and remained solid and
in control over Abdul's aggression. His work, however, was a direct
response to the group situation and encoded the need for defence. A 'lone
black shark' both says something about Abdul and himself, in his depres-
sion after his mother's death. Abdul's witch is used to try to taunt Colin, a
projection of Abdul's aggressive feelings to his own mother. He is haunted
by obsessive anxiety about her and this is transferred onto the therapist.
Graham's dinosaur expressed and is formed partly by the free-floating
aggressive bickering from Jane and Abdul, his defence in the face of it. It
also parallels his 'macho' image in the face of difficulties and shows how he
retreats behind it.

It is the quiet Susie who instigates a creative flow within the group. In
some ways the sparring between the older children going on over her head
has made a cover for both her and Georgina to work to an individual
depth. The fish painting suggests the net reflecting the boundaries of the art
therapy session, felt by her as a respite from the normal struggle with
speech and life generally.

Identifying with the 'happy fish', Jane tried to emulate its qualities but
the teeth which emerge show her very different feelings. At home she is
struggling with jealousy with her step-sister and this rivalry is being played
out in the group. Georgina has been struggling with the complex 'mother'
image of the cow. Both Georgina and Jane share the problem around
'hearing' or being heard, with Jane's mother being partially deaf and
Georgina's mother electing 'not to hear her'. The mother cow is over-
flowing with milk and has horns but no ears. In her pictures, which are
made in the classroom, all the animals have ears but in the art therapy
sessions, the pictures silently state part of her problem at home. The paint
runs and is smeared and mixed up over the cow so that in the end it has no
facial features. Clearly painted and standing out are the cow's pink udders

and a green bucket containing milk beneath them. Attention is focused on the breast and the milk, the object of most envy at home as the babies have been fed, but she is no longer 'fed' by mother.

As in all groups the members have different ways of sharing feelings and expressing pain and happiness. Some paintings seemed to be more about the experience of being in the group and interpersonal relationships, affected by familial patterns. Others seemed to withdraw into an individual process, their contribution to the group tests the willingness of the group to receive it and work with what it arouses. Susie's last comment on her fish, 'He doesn't want to have to live', seems to speak for the life and death struggle she went through in infancy and perhaps signifies some current ambivalence in her depression in how much she can identify with the fish.

WORKING WITH THE INDIVIDUAL AND THE GROUP PROCESS

This way of working is best explained by looking at each component of the group process in turn. At the beginning of a group, the therapist will have arranged the correct number of seats in a circle and the clients enter to take up a place. Respecting the time boundaries is important and the group will start and finish exactly on time, regardless of whether everybody has arrived, and ends even if conversation has suddenly become animated, intimate, emotional. By keeping to the boundaries of time and space and consistent behaviour, the group will come to build up a trust in this symbolic space for them to explore feelings and anxieties and the developing relationships in the group.

Group Session 6

It is a closed group meeting weekly in a day centre. The group lasts for two hours, talk may vary from ten minutes to one hour at the beginning. It is formed of seven clients and therapist, for women who have felt threatened by male figures in their lives or are divorced and separated. It is an optimum size so that everyone can make eye contact in the circle and also the pictures or art objects made can be placed and contained in the middle of the space for reflection and exploration. The therapist normally sits in the same place and remains there throughout the session.

Mrs B arrived first and told the therapist she was feeling nervous and worried about what might come up in the group.

Miss C asked, across this, to the therapist: 'Are we going to paint alone or together?' She said it had felt good last week (when she had been able to share her fear of talking in a group).

The therapist suggested she was feeling good from being able to share difficulties of talking.

Miss D was drawn in to say that she felt nearly the same as Miss C, but she would never be able to talk about some things ever.

Mrs A asked Mrs B how she was feeling after last week.

Mrs B burst into tears. (Last week she had shared some family history and the suicide of a relative.)

Mrs A and Miss C put arms across to touch her.

Mrs B, between tears, said, 'If only I had done more' about a friend's recent suicide attempt and linking back to relative's successful attempt. She had lost work through relative's illness and suicide: 'one had to go on'. Sometimes she 'felt nothing' when people told her things, unhappy things.

General talk about anxiety of helping friends, relatives, how they relied on you, how could one 'get it right'.

Therapist suggested 'hard to get it right' in the group, how much to say, how much to keep private. Talk then developed around crying.

Miss D said she only ever cried alone, she wouldn't be able to bring it here, men couldn't bear you to cry, her family couldn't bear it. She always solved things alone.

Miss E said how affected she had been by Mrs B last week; she too could only cry alone. She could cry most easily at sad films, but only if alone. She had to keep it in.

Therapist commented on how it did seem possible to cry here, it took up a lot of energy to keep things in.

Miss C echoed: 'It was never done at home.'

Mrs F, speaking for the first time, 'I solve things alone.'

Miss G said in a whisper that she could cry easily, but not speak.

Mrs A: 'I always say too much, I get nervous, it's hard not to talk.'

Therapist made a general comment on the amount of pain and sadness, and suggested painting as a distance seemed to be emerging from feeling.

The first part of the group is quite a free-floating discussion. Mrs B's disclosure last week has moved the group on so that a new depth of sharing has become possible, but this is also quite scary. Mrs B is feeling guilty at 'taking up time' at the beginning, worried that people will resent her 'talking' last week. Miss C is relieved that one can talk intimately but would half like to hide in a group painting.

Discussion on 'what it was right' to do contains fears of contamination by mental illness and an exploration of defences, 'feeling nothing', 'losing oneself in work', how to keep a boundary around oneself, outside the group, but also of course in the group being affected by other members. In the discussion on crying is the shame of breaking down, a lot of loneliness revealed and 'holding things in'. The difference between 'family culture' – 'never done at home' – and the forming of the group culture where it was

alright to cry and share feelings is being established.

Art therapists will have different styles of working while people are painting. Perhaps the first question to be addressed is whether the therapist should be painting or not. Some therapists argue the virtue of painting as a 'working' model for clients. Following on from this, first premise is that the therapist will then also talk about her painting and that this will help to create intimacy and trust in the group. This approach is more likely to be seen at work in a 'thematic' group, which will be discussed later. Generally it can be seen to negate the difference between the role and function of therapist and client. However, if the therapist is working analytically, exploring differences which may be perceived both positively and negatively will be part of the work of the group. The therapist's stance will be central to the exploration of parental figures and authority in general as transference relationships develop. So there is little point in trying to negate 'difference' if this exploration is seen as part of the task of the group.

If the therapist paints in the group, this cannot be done honestly at any level of depth without the clients 'going out of mind'. It is possible to paint in one's own style in a superficial way but this is hardly a good model for the group. Therapists have been known to use the art materials as their way of getting in touch with unconscious processes at work in the group and help some clarification of what is going on in the counter-transference response. However, as has already been stated, this involves the therapist working on her own internal processes which involves withdrawal of attention from the group as a whole. Another disadvantage is that the art therapist is likely to have a mature developed style of work, to be a competent artist which may equally provoke feelings of admiration, envy and despair in clients.

If the therapist is working analytically with transference phenomena both interpersonally and through the pictures, then the therapist's difference of role and function will be a crucial factor. The art therapist also needs to be free to observe clients' working processes, both the history and development of each art object and also the state of body tension and general atmosphere in the group. Clients will also place themselves in the room in relation to the therapist and to each other and this, over a period of time, will develop a slow-changing pattern. Group members might establish 'their' area or group according to events in the group. A client choosing to work almost under the therapist's feet or behind her will carry essential information about transference phenomena. They may quite unconsciously be painting 'by her skirts' for safety because the picture will make a break through to previously undisclosed material.

Group

During the individual painting time, two of the members painted on the floor, and one gradually spread out around the therapist's feet. She had commented several times on a strong silent mother and during this period of the group, when a quiet working silence ensued, the therapist became centrally part of the quiet; sitting, observing, which gave this member an unconscious playful air. The transference was not ready to be acknowledged, however, as at this time she kept up a continual line of 'solving things alone'. Only two of the seven paintings were discussed this session although all carried individual contributions to the group themes that emerged of 'finding a balance' and of 'boundaries'. Three of the pictures were clearly about making a boundary between self and a sense of inner chaos which threatened to overwhelm and had clearly defined boundaries between self and the outside world. The energy needed to keep in the sensed chaos effectively formed a barrier with the outside world. An aspect of 'solving things alone' was these powerful boundaries which gave the members an outward feel of fierce independence.

There were two images of spinning and whirling. It was one of these pictures that was discussed for some time, returning to the theme in the first part of the group on how to support other 'ill' people. Feelings of guilt if one withdrew through lack of strength to be supportive, 'putting oneself first'. Mrs B's self-disclosure last week had thrown the group back on themselves in how were they able to deal with another member's distress, how did they retain defence of their own pain while helping another. They had begun by looking to the therapist. Part of the 'I solve things alone' was a defence against longing for a one-to-one relationship. In a group this cannot be provided by the therapist. The group has to work with each other, pooling their abilities to find solutions.

This was reflected in one member's use of materials. She had painted a growing plant, but had been able to take more paper to give it more room, so that it bulged to the sides of the economical choice of original size of the picture. There is often an analogy between therapist's materials and food, another dynamic of family and group juxtaposed together in the group's mind. If the therapist is the provider of meals, 'is there enough to go round?', 'can one ask for more?', 'be greedy?'. The first undercurrents of transferred sibling rivalry may be expressed in this way.

In this session the first painting discussed concentrated on the boundaries between self and other, but all in terms of relationships in the past or outside the group. There was a lack of willingness to hear from the therapist that relationships inside the group could be causing these feel-

ings of spinning and whirling, and of guilt at not being able to do more. The second painting discussed centred on 'finding a balance' internally and was exploring the border between sanity and feeling mad. It was an unusual picture in atmosphere, a mystical feel of light, blue, yellow and white, ill-defined shapes but also a partially obscured tangle of chaos. The picture brought forth many comments from other members about its semi-mystical religious qualities. The member who had painted it described a very painful situation at work in a competitive commercial environment and suddenly 'feeling nothing' one day as if she didn't exist. This loss of conscious attention of ego would have been acceptable as part of a religious occasion but not in a busy commercial venture and through fear of it happening again she had left. Her illness had a positive side in expressing the dis-ease she had always felt in working in com-modities and how she felt life might begin again working with people.

The juxtaposition of light and tangle of chaos and the degree of interest expressed by group members perhaps indicated that it represented some feelings for the group as a whole – a relief at seeing the light ahead but also a wish to escape from the stressful feelings spinning around the group. The group member's description of when she felt nothing was not a mystical joy but more a 'blanking out' under stress, a defence mechanism so as not to feel any more. The interest of the group showed them able to listen to the pain expressed, which suggested their wish as a group to find 'new values' but also a wish to blank out the painful feelings in the group.

The placing of paintings, art objects in the middle of the circle ackow-ledges their central importance, gives them value and shows that they are owned by and are part of the group. Placing in the boundary of chairs also gives room for paintings to be left outside in some way, sometimes to communicate, a need for attention (to be drawn in), or because it is felt they are unacceptable images to the group or feel too secretive, individual or personal to be shown. They may feel 'too large' for the group in the sense that the feelings might not be contained in the group.

ANALYTIC GROUP ART THERAPY

This is a complex process working with both art therapy and verbal group therapy within a matrix of group art therapy. The mode of communication will change from free-floating verbal interaction to making an art object to verbal discussion. Individuals can leave the fixed circle seating of verbal therapy and change and shift their physical relationship to each other. While making an art object individuals withdraw internally to express themselves in the space of their choice, whereas if one moved to another part of the room in verbal therapy it would be material for interpretation. Although the positions of the group members will be observed and some-

times commented on by the therapist, it does allow a more flexible flow of possibilities. There is also more opportunity for physical interaction from a simple sharing of materials or bumping into another member at the sink, to helping solve a technical problem or holding something in place. One is able to express and maintain individuality while still identifying and working with the group.

There is usually a sense of joint sharing through getting materials, sharing tools, clearing up which establishes a sense of intimacy that comes from physical work together. One is aware of the opportunity for accidents, and not only when working with children. These happen on every level from the spilt paint that reminds someone of something in its own right, or a new painting may develop from it, to the water 'accidentally' knocked over another member's work which all form part of the dynamics of the group.

Clients are more able to control how much they are active in an art therapy group and to which part they actively contribute. They can participate with a 'speaking' picture without actually speaking. They may actively help other members to explore their images while their own has no time for attention that week. They might move the group on at the beginning by contributing how they are feeling or some useful comment from the previous week.

Having two clearly different modes of communication does make the group dynamics very complex but can also make them stand out at times. If, for example, the group is avoiding an issue because they do not feel safe or strong enough to confront it, they could equally talk to avoid painting or paint to avoid talking. Of course each group will develop its own rhythm and flow and the therapist will learn to understand the changing pattern of confronting or avoiding issues and be aware of superficiality in either medium. One advantage of working with a concrete medium in a group is that everybody's work will have been seen, even if they do not speak. Where the paintings are brought into the circle for discussion there will be an immediate 'here and now' reaction to the painting receiving focus of attention. Part of this will be an 'aesthetic' reaction. This is complex because an individual painting will be seen in a 'field' of other art objects, all influencing each other visually and each group member's perception of them. Each person in the group will be interacting not only interpersonally but also interpictorially. Pictures may be attracting them or repelling them. They will also be projecting into them as well as into other group members. Anyone who has worked in a shared studio will know the special quality of painting with others. It is an experience that offers time alone while being in the presence of others. It powerfully relates and offers opportunity for transferences to early relationships through sensations and memories of playing in the presence of an adult. During painting time the therapist will be having a reverie about the group members, about the art objects being made as they unfold before her, about individuals' painting processes and

relation to materials. Some members may find it difficult 'to come out of' the painting. They may have experienced this individual time so intensely that they will feel 'lost' in the painting as they emerge from a state of being in touch with the unconscious into consciousness. Others will feel unable to enter the process and may sit with a blank piece of paper.

There is probably less chance of polarised roles in relation to each other becoming fixed in an art therapy group because of the stimulus of paintings and media available, unless there is some investment psychically in staying in a known role. For instance, one member's decision to work largely in 'blues' and 'reds' will have an unconscious effect around the studio. In this way members are influenced and creative opportunities occur quite subtly, although people may be consciously unaware of why they suddenly feel a release through using a different colour combination or new medium.

A group culture is established and develops in the way that the group can be open to explore the images in depth and allow both a personal and a group meaning to be felt. The group culture is based on the way that the images are formed and worked with and how this is facilitated by the therapist. The images develop both as an expression of and a concrete holding of the history of the group. Each image holds meaning for the past, present and future of group member and group. Meanings will gradually unravel within the matrix of the group process which the therapist will comment on in terms of the dynamics of the group and also how the images contain these dynamics both in terms of the individuals and group as a whole.

Developments in group psychotherapy

Early developments in theories of group psychotherapy have contributed to influencing different styles of analytic group art therapy. Freud and Adler were among the first people to apply psychoanalytic insights to social groups (Adler 1929). In 'Group Psychology and the Analysis of the Ego', Freud (1921) explored both crowd behaviour and the relationships of groups and leaders. Adler was to attribute greater importance to social factors than Freud and innovated groups in kindergartens for children and child guidance clinics for mothers. Moreno (1948) coined the term 'group therapy' and developed psychodrama. In psychodrama the members of the group are used as both cast and audience for the exploration of individual problems.

Group methods were used by psychoanalysts and psychiatrists for officer selection purposes in the War Office Selection Boards. The same psychoanalysts, Bion and Rickman, Foulkes and Main were given the opportunity to run army psychiatric units along group lines. From these two 'Northfield Experiments' came the impetus for social therapy through the therapeutic community movement (Main 1946) and the use of small groups for the treatment of neurotic and personality disorders (Foulkes 1964).

Kurt Lewin, a psychologist, termed the expression 'group dynamics' and inspired the development of Sensitivity Training Groups' (T-Groups). He developed his own field theory of social interaction which emphasises the 'here and now' more than the influence of past events. He is best known for a fascinating experiment comparing the effects of autocratic, democratic and *laissez-faire* styles of leadership on groups of children (Lewin *et al.* 1939). In this experiment, and in later work in industry, he explored the effects of leadership on the functioning and social climate of groups.

Here we are able to look briefly at three models of analytic group psychotherapy. For a fuller exposition of different models of group therapy, the reader is referred to Shaffer and Galinsky (1974), Yalom (1975) and Brown and Pedder (1979).

Analysis in the group

This way of working has developed particularly in the USA (Schilder 1939, Wolf and Schwartz 1962) with patients already in individual therapeutic relationship with the group analyst. Emphasis is put on individual transference relationships and the therapist has a very active role in directing therapeutic work on transference and resistance.

Analysis of the group

A style developed at the Tavistock Clinic where group processes are seen to reflect the common motives, anxieties and defences of the individuals in the group. Ezriel (1950) invented the term 'common group tension' to describe the group conflict resulting from a shared wished for but 'avoided' relationship with the therapist (to be their only child). This arouses fear of the consequences if it were to be acknowledged – 'the calamitous relationship' (fear of retaliation by abandonment) – and is resolved by a compromise, 'the required relationship' (concealing resentment under an attitude of helpful compliance). In some ways he combined analysis of the group and in the group, working with each individual's contribution to the common group tensions (Ezriel 1950, 1952). In this way of working, the therapist has an impassive exterior, actively encouraging transference to herself.

Bion contributed the idea of basic assumptions, or primitive states of mind, which are generated automatically when people combine in a group. The fantasies and emotional drives associated with these basic assumptions unconsciously dominate the group's behaviour in a way that is apt to interfere with its explicit work task and so prevent creative change and development (Bion 1961).

Basic assumptions

1 Dependence: expecting solutions from the therapist leader.
2. Fight/flight: fleeing from or engaging in battle with adversaries particularly outside the group.
3. Pairing: encouraging or hoping for a coupling of individuals which could lead to the birth of a person or idea that would provide salvation.

Bion's ideas have had influence on the study of the dynamics of institutions, including therapeutic communities and training groups.

Analysis through the group

This is particularly associated with Foulkes who founded the Group Analytic Society in 1952. A psychoanalyst, he was influenced by gestalt psychology and its interest in the interrelation of sum and part. He regarded the group as the therapeutic medium and the therapist's task as that of nurturing therapeutic potential by allowing the individuals in it to function increasingly as active and responsible agents themselves. The analysis of the individual remains a primary concern. 'The individual is being treated in the context of the group with the active participation of the group' (Foulkes and Anthony 1973: 16). Foulkes came to see the individual as one point in a network of relationships, and illness as a disturbance in the network that comes to light through the vulnerable individual. This approach antecedes family therapy. Foulkes described the four levels on which a group functions:

1 Current adult relationships, social, cultural, political and economic contexts.
2 Individual transference relationships.
3 Shared feelings and fantasies, intrapsychic processes.
4 Archetypal universal images.

For a full exposition of this approach the reader is referred to Foulkes and Anthony (1973).

As will be appreciated, the various theories on group psychotherapy clearly inform and influence the styles of art therapy groups. The essential difference and additional complexity, however, is how the art process and object made within the group is worked with. The therapist must therefore work with the group and with the images of the individuals within the group and those of the group as a whole, and how the transference relationships that develop within this are understood.

THEME-CENTRED GROUPS

Thematic groups offer a specific issue, theme or direction to the group which will either be suggested by the therapist or will arise out of an initial group discussion. Therapists working with this format argue that themes are 'enabling', offering a starting point to those clients new to therapy or overcome with anxiety. They can be seen to give a safe structure, with guidance, a leader in an authoritative or parental role or one actively including all in general decision-making rather than a conductor taking a more outwardly passive role as in an analytic group. A second argument used in their favour is that the art therapist can give suitable themes to allow people to understand the creative process in a fairly controlled way, so that they can 'see things happen' in a guided session. Themes can 'weld' a group together by their experiencing something in common and that, although 'universality' may be a benefit, they can experience the theme at their own level. People can work intensely, and others more superficially, within the same group but can feel part of the same process. They may be suitable for short-stay clients who need to explore specific issues or for those not able to benefit from working with the anxiety that attends an analytically oriented group.

The influence from encounter groups can be seen in the basic format of thematic groups, which are usually divided into three parts. They tend to begin with a 'warm up' activity to facilitate a 'readiness' to explore or to promote group cohesion and direction. 'Sometimes a session would begin with 'centring' or relaxation exercises, meditation or yoga (like looking into water – one can see into the depths and what lies below more clearly when the surface is calm). 'Sometimes we would begin with techniques designed to heighten sensory awareness and help energy to flow' (Nowell Hall 1987: 159).

The exercises used might vary from quick paintings to physical activity, dance, movement, music, massage – a whole variety of possibilities, many of which involve putting people more in touch with body sensations and awareness of tension.

The group will then separate to paint to the chosen theme; the therapist may join in, or may talk to individuals or may sit observing the work in progress using her impressions for the last part of the group session, which will be a discussion of the images. There tends to be a more didactic role played by the therapist in the last section as the discussion is more likely to be 'led' by her. There is less likely to be a full exchange between members in a short-term group as this will take time to develop and also the structure of the group with the leader directing more overtly will encourage a positive transference and 'knowledge' to be seen to be held by her. The leader will structure the use of time to include all pictures which may be discussed by being placed within the circle or pinned to the wall. It is more

likely that all the pictures will be given an 'equal' consideration in a thematic group rather than it being the responsibility of the group to discuss whatever they choose to focus on.

Thematic groups have as much a 'social' function in helping people to contact each other in the 'here and now' as they do working with deeper levels of disturbance from specific client groups. They are more likely to be used in day and community centres, with staff groups and members of the public or for general social purposes and widening of experience of those in longer term care. The use of thematic groups can be deceptive because of the 'game and exercises' component which looks superficial but can plunge people into unexpected levels of intensity. Some of the exchange of letters over *Art Therapy for Groups* (Liebmann 1986) expressed this concern (Thornton 1985, McNeilly 1987, Malloy 1988). Although the author acknowledges the extremes of intensity and dissatisfaction over superficiality, she emphasises that in between 'there is a wide variety of group experiences using art structures which can be interesting and revealing and also enjoyable' (Liebmann 1986: 12).

This places such experiences firmly in the 'growth' arena rather than in long-term or analytically oriented therapy. Practitioners from the latter criticise this approach in its ethos of suggestion to those not art trained, and fearing the unskilled getting out of their depth with clients without the necessary support and follow-up programmes being available. People working with groups need a group training and people working with art therapy need a full art therapy training to protect both workers and clients from unmanageable stress.

Example of a theme-centred group

The following illustrations are from a group run in a social services psychiatric day centre. The whole programme was run on therapeutic community lines. Members attended on a 'contract' basis which included an expectation that they would participate in all the therapeutic activities and maintain a certain regular commitment to the group. The group structure contributed to the whole ethos of self help, cooperation and sharing between members of the community. All members attended the art therapy group held once a week. This lasted two hours – the first hour was used for painting and the second for discussion. The theme was chosen by the staff team as a way of capturing or focusing on particular dynamics that were important at the centre at the time. Such themes as anger, what makes you feel sad, how you would like to be, your ideal partner, a bad dream were some of the themes used. If a client suggested one, it would perhaps be taken up, but generally the staff, who all attended the group and fully participated in it, would put forward the theme at the beginning.

The members, who were of different ages with a wide variety and

c

d

a

b

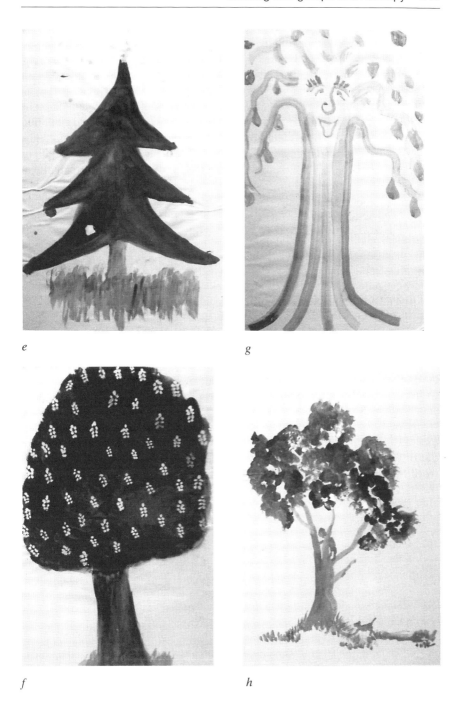

e

g

f

h

Figure 9.2 (a)–(h) 'Draw Yourself as a Tree'

severity of problems, would all be seated at tables on which painting materials were readily available. If any new members or students were present they would be introduced to the rest of the group and told about the format of the group. There was an expectation that people would show their work if they felt they wanted to, but they were under no obligation to do so. Generally, during the painting time, silence fell, which seemed to be acceptable to all, and then at the agreed time the painting would end, and the art therapist would ask members of the group to share their work. The art therapist remained sensitive to the needs of the individual to take the appropriate amount of time in talking about the work and answering questions and comments from the rest of the group. The therapist would direct the group and take overall control of how the group was going, would comment on the contributions that were being made and connect certain images and emergent themes from the group discussion. The group would end on time, even if some people had not shown their work, as it was made clear that everyone had an equal opportunity for this and it was their choice to show it or not. The similarities and differences between the images form the focus of the discussion and, more importantly, what each member sees in her own and others' images that resonates with her own experience. Members therefore project onto others certain aspects of themselves, and this is one of the most useful functions of this type of group.

This particular group theme was 'Draw Yourself as a Tree'. This was chosen because several new members were joining the centre and were new to the group, and it was felt that this theme was relatively simple to understand and relate to in a personal way. The images speak for themselves in terms of how each individual described herself symbolically and further exploration was done to each individual piece. It is interesting to see how the different characteristics are clearly shown in the pictures. This way of working is helpful to enable people with identity problems to conceptualise themselves and come to understand a sense of self in these concrete but also abstract ways. Short comments are given to describe each one, as a detailed process of the group would take too long to transcribe (see Figure 9.2).

Figure 9.2 (a): 45-year-old woman – rather confused and unable to articulate her feelings to any real depth. She was able to say that the three 'bits' at the top were new growth. (She had been a long-term patient, recently settled in the community.) Another woman asked if this was in any way hope for the future, and she nodded. She was asked about the small 'tree' on the right – she laughed and said it looks like a 'shadow'.

Figure 9.2 (b): Not discussed. (Man now living in the community after a long hospital admission.)

Figure 9.2 (c): 60-year-old woman, withdrawn and physically thin, lonely and silent. She was able to connect her picture with her feelings about 'being apart' from other people as if lost in a dark forest, but not

knowing how to get out. Someone commented how it looked difficult to get in.

Figure 9.2 (d): 19-year-old. 'I couldn't draw a tree – wanted to do a pattern – I don't know what that says about me – I wanted to do pink behind to show complex web of tangles in my life – leading nowhere.' (She had been in care, involved in petty crime and drug abuse.)

Figure 9.2 (e): 'A Christmas tree – the only tree I could draw but reminds me of the good times with my family. I miss them and wish they would visit me, but I know they won't.' 'What about the decorations?' 'The star is bright and perhaps it will beckon them to come – I hope so – I hadn't thought of it like that but I know that's what I want.' (50-year-old man, living alone after chronic alcohol problem.)

Figure 9.2 (f): 'It's full – strong – how I feel now – blossom and spring – it's optimistic and filling the page. I am really looking forward to my new job.' (39-year-old secretary.)

Figure 9.2 (g): 'It's a pear tree – I don't know why I drew it like this – it's my face in the middle – smiling but I don't feel at all happy – in fact I feel miserable – it's like a mask – I feel I have to pretend to be happy with my family otherwise they will reject me completely and it's such a strain. I feel trapped behind the mask – I suppose they could be tears coming out from behind the face.' (25-year-old, young mother and housewife.)

Figure 9.2 (h): The group spent the longest time discussing this image as the woman who painted it told a long and involved story from her childhood. This is her climbing the tree, with her dog whom she adored. They were happy memories but she was lonely and felt as though she did not know what was happening in her life now. Staying with her, the group dwelt on the image, feeling that it contained great significance for her. There were a lot of questions about the tree: where it was, the branches, leaves and the dead spike coming off the trunk. She became tearful as she began to talk about the loss of her beloved brother, who used to climb with her and she had never been able to look at that loss and certainly not share it with anyone before. The group ended with this sense of sadness and loss that had been acknowledged.

THE DEBATE BETWEEN ANALYTIC AND THEMATIC GROUPS

Over the last few years there has been an interesting and provocative exchange of articles and letters in *Inscape*, the journal of the British Association of Art Therapists, debating the 'two approaches that art therapists in Britain use as the tools of their trade' (McNeilly 1984: 7) As in any argument, the two approaches have become polarised and to some extent the issues simplified over which is the 'better' method. In fact, of course, art therapists may utilise several approaches with differing client groups over a

working week; much will depend upon the context within which the therapist is working.

However, one useful aspect of the polarisation is that each 'camp' has had to reflect on their working practices in order to defend their theoretical position and this has been useful to the profession as a whole in developing ideas. In a series of papers, Gerry McNeilly has developed thinking about a style of working he has called 'Group Analytic Art Therapy' (McNeilly 1984, 1987, 1989). This way of working combines group analysis and art therapy. The works of Foulkes and Bion are central to his thesis. 'The approach is psychodynamic allowing for the totality of the group experience' (McNeilly 1987: 9).

He developed his approach through working within a psychotherapeutic community which functions on group analytic principles. The time for painting and discussion is roughly divided in half and no theme is given, no verbal interventions being made in the painting time. He allows the group to find its own direction and treat itself. It is a mutual learning process with communication being the most important factor. His aim is to aid neurotic symptoms to transform to shareable experience.

Basing his theory on Foulkes, he sees the task of the group to be 'analysis of the group by the group, including the conductor'. Working non-directively, he leaves the group to struggle with their dependency wishes. By refusing to take on responsibility for this, he therefore seeks a greater understanding by the group of the group process. When a group intervention is made it will be a 'group interpretation' as comments to individuals are seen to encourage dependency and the power to the conductor. The group is encouraged to use their own self-healing capacities as the conductor cannot be an individual therapist to each member. The conductor does not need to say anything that cannot be said by another group member.

McNeilly challenges the practice of providing a theme for the group; he argues that this is directly due to the therapist's own needs. By not allowing the group to feel anxiety, the therapist is seen as gentle, nurturing and caring and therefore defends against any group anger. The conductor's role is 'to nurture the group dynamics'.

As in all approaches to art therapy, the image-making is set within a relationship whether to individual, group or institution or aspects of all three. In group analytic art therapy the image-making is given a particular role and, as McNeilly describes, the individual image is not explored.

'However I would concede that I do not chase the in-depth symbolic nature of the individual image and some pictures are not commented upon by me at all' (McNeilly 1987: 9), but 'with the applied use of art materials, the process will be illuminated, leading to understanding of the collective imagery' (McNeilly 1984: 10).

This particular style of working is most likely to be used with psycho-

neurotic patients in a therapeutic community, with outpatients, in staff groups and in art therapy training. Members of these groups need to have sufficient ego-strength to be able to articulate and show a capacity for insight. Other art therapists work from a group analytic base but explore the individual image in more depth. This in fact is more in keeping with Foulkes' original premise of the deep 'respect for individuality', although McNeilly rarely comments in this way.

Group analytic art therapy essentially allows feelings to emerge from the group by the group. The argument against theme-centred or more directive approaches is that there is 'a tendency to uncover, possibly too rapidly, powerful feelings which may be difficult for the individual in the group and the therapist to contain and understand' (McNeilly 1984: 7). The therapist might well be accused of provoking the exposed feelings aroused at this time, and he questions whether the 'produced exposure' has any long-term validity and benefit. It can be seen to be rawer as a way of working than the classical studio-based style where each individual unfolds, undirected in their own time. Group analytic art therapy can also be experienced as 'raw emotion' by working with anxiety and it might be as well to think about what happens if someone is 'pushed' into revealing too much, too soon, as the powerful nature of the art process can easily produce overwhelming feelings. Terry Malloy (1988) points out that using themes can be 'emotion-ally provocative' and 'invasive' and that by its power, art therapy can provide 'detrimental change' as well as 'real emotional growth'. In a critique of McNeilly's work, Roy Thornton defends the use of themes: 'does it not occur that themes can be used with careful thought for clinically based purposes, as suggestions, quite free from obligations, in full knowledge of transference issues, not evasively, but to create intensity' (Thornton 1985: 23). Thornton is critical of the 'slowness' of McNeilly's approach and the 'drop-out-rate', feeling that the use of a non-directive role in inter-pretation and lack of theme is provocative and hostile to people who are needy. Instead he chooses 'a theme which introduces creative play and the creative process through direction to particular materials'.

When looking at each counter-argument, it makes clear the undesir-ability of a blanket approach in art therapy for all client groups. Thornton has developed his ideas which incorporate family and systems theory through work in short-term settings and crisis work, where the aim is to engage people directly on core issues. In this context, the internal dynamics of the group are not the key concerns. As well as the influence of context on practice, is that of the personal background of the therapist. Some therapists will have lived through the 'human potential movement' of the 1960s and their group practice may have been influenced by experience of 'encounter groups'. These encouraged a nurturing positive transference, a being 'there' and warm for somebody, rather than a more existential exploration of oneself in a group. This movement has undoubtedly been

influential in the development of thematic groups.

The different styles of working enables the groups to have very different experiences. For instance, analytic groups allow unconscious themes to emerge and thematic groups use a 'set theme', which implies an imposed consciousness whether applied by the therapist or chosen by the group.

Therapists may be more likely to paint in thematic groups but in an analytic group remain in a separate role as leader or conductor to allow natural transferences to develop. Both, however, could be said to work largely with 'group' or 'social' factors rather than other styles of art therapy which help the client to develop a relationship with her 'inner life'.

In a thematic group the therapist is more likely to encourage a positive social culture. The given theme structures any natural level of chaos in the group as the provided focus channels the group energies into a directed exploration. The group relationship may be masked by a clear struggle to gain a favourable relationship with the leader, who will be seen as the person to fulfil individual needs. Working analytically may be experienced as being more uncomfortable as members struggle with their inhibitions, restrictions and ability to take risks in a group. In an analytic group, many natural transferences between different members as well as the group leader will occur, and the potential richness of this experience can be explored. McNeilly (1989) has drawn attention to the phenomenon in analytic groups of people painting similar or closely related images and symbols quite unconsciously. This synchronistic process or resonance allows focus 'on the universality in the group and its symbolic life'. Roberts suggests that resonance is the 'language of the dynamic silence, and once it is shaped, it pulls with it the unconscious' (Roberts 1985: 11).

During this process each member responds to an incident or event in group life and becomes highly charged with energy. A theme emerges and evokes powerful responses in each group member 'resonating as it were to the group theme at his own natural frequency.' This experience often evokes new material, a recovered memory, new insights. It differs from the consecutive expression of shared, previously unconscious material of a verbal group as the images express this simultaneously. The phenomena links to Foulkes' 'foundation matrix' – what members have in common, culturally and constitutionally – and to Jung's collective unconscious. This means that the group unconscious emerges in the images made by the individuals in the group and therefore the unconscious provides the 'theme' of the group. Alternatively, the group consciousness is imposed to which the group unconscious then relates.

Group painting

Part of the process of the emergence of the group unconscious is sometimes enacted by the group by forming small groups to paint together on one

large piece of paper. Alternatively, the whole group might decide to work together on one piece of paper, or with one block of clay, which acts as a kind of fusion and is often a defence against the anxiety of separating to paint individually or some collusion to defend some underlying dynamic. It is important that the underlying reasons for members of the group choosing to paint together are addressed as part of the process, and the discussion generally explores this in depth. The following gives an example of how this comes about.

> Group A then began to discuss how they would paint. One member suggested a group painting. The group then split, many wavering, attracted to both a combined group activity and work individually. The group commented on anxiety, the desire to merge and form a 'good' group, the need to protect individuality. After a twenty minute discussion, two members suddenly leapt up, seized materials and started painting. The group was composed of ten members; four of them began work on a group painting which was extended with pieces of paper until it was being worked on literally under the group leader's feet. It moved from tentative marks, to playfulness, to a serious working atmosphere. It ended with all colours and shapes so interwoven that, although the group leader had plenty of opportunity to observe its progress, no individual marks stood out.
>
> There was little comment from the four 'group' painters at the end of the session. Two of them made some defensive comments about it being a good experience, whereas two felt that they wanted to 'hide' in it and one of them felt she had missed the opportunity of working on 'herself'. The tensions between an idealised 'group unity' and separateness was being expressed, but also it was difficult for people to see that in working in a group they were working on themselves. This pairing, as a defence, was a strongly shared dynamic in the whole group.

Other themes that emerge from the unconscious of the group, and are expressed by this enactment on the paper, include issues such as anger, sexuality, death. It is very interesting in the life of a group, when the group chooses to work together in this way, as it enables some of the shared unconscious processes to become conscious. A group painting is the product of a group who all choose to work together on one piece of paper. An example of this was at an early stage in the life of a group and the underlying theme of sexuality that emerged was seen to be about the need of the group to remain fused together in some way and identify some shared aspects of sexuality rather than tolerate any anxiety that separating to work individually would engender.

Group painting sessions can also take on a more structured format. These groups can evoke powerful aspects of the group dynamics and tend

to concentrate on interpersonal interaction rather than unconscious processes. For further details of this way of working, see Evans (1985).

GROUP PROCESSES: PHASES OF DEVELOPMENT IN GROUPS

All groups go through a series of development from inception to termination. This process may vary according to the type of group. For example, it is likely to be more hidden or disguised in a thematic group where the leader takes an active role in choosing the theme than in an analytic group, which is less structured in task. Everyone will probably arrive feeling anxious, and defend against their anxiety in different ways. First, groups are often unusually passive because everyone has held back in participating in some way. In the first phase of development group members could be said to be 'leader centred' as they regress into dependency. It is a time of making projections, and as each person is a clean slate to the others, unconscious identifications, splitting and idealisations will take place. Other members may deal with their anxiety by feeling omnipotent or denying their anxiety altogether. An example of anxiety expressed as a group can be seen in one group where the initial discussion centred on doctors and medicines that did not work, and so it was better not to take them as the symptoms were better than the cure. Anxiety about the group and whether it was worth while – 'medicine' – was being expressed.

In the first phase, the painting tends to take on a defensive function, pulling against the rest of the group, feeling dependent towards the leader by either seeking reassurance or wanting to be as a child again and 'play' with the protective circle of the group. The group leader will be a role model to encourage the group to develop their own skills and will remain quiet in spite of the group trying to engage her in their anxiety. The therapist must resist the wishes of the group for her to participate 'like them' as this establishes the first experience of 'difference' and separates the group leader in her role and function. The group will then begin to work on each other across the group rather than comments being addressed to her.

In the second phase, as this withdrawal is experienced by the group, they will feel more anxious and dissatisfied and the leader needs to be able to tolerate the hostility of the group and its disappointments. There is more exchange of negative as well as positive idealised transference. Members may begin to act out and drop out of the group. The group may become quite depressed and regressed, refusing to see that they hold the creative potential, and may express anger towards the leader for not making everything all right. The group discussed on page 210 were at this stage, with their feelings of spinning and whirling and disclosure of sadness and depression. Occasional comments by the therapist were either ignored or apparently 'not heard': a variety of passive hostility, but also a refusal to take responsibility for any necessary action.

In the following phases ambivalent feelings need to be acknowledged and relationships in the group explored. Different aspects of each individual in the group emerge and projections onto members and their 'real selves' can be looked at. It could be said to be a challenging period of 'healthy rivalries'. The group is able to contain the different transferences and facilitate members' understanding and growth. After the resolution of the regressive wishes and dependencies earlier, the group develops a productive work atmosphere and group culture. The group has a sense of cohesion and identifies with the group aims. The second group of children age 9–11 were at this stage. A strong sense of belonging was shown in Jane's comments: 'If you want to be in our group ...' They are able to express a range of feelings, hostilities, rivalries as well as sadness, hope and explore past and present relationships. They have developed a good working ethos, seen in their rush to look at folders of work as they came in to reconnect with the group history.

When a group nears its ending point there will be a renewal of anxiety. The group needs to be reminded as the termination time nears so that there is time to prepare. The anxiety produced leads again to regression and defensive patterns. There may be a denial of sadness or a manic defence. Some members may attempt to pair as a way of preventing loss or behave promiscuously as a way of producing a solution to the loss of the group. These are all defences against mourning and recognition of loss. The group will have been internalised as a healthy vital structure and has to be given up, sadness and loss need to be felt and let go.

For example, the group that began talking about doctors and medicine returned to this theme at the end. A verbal image developed around the idea of being in hospital 'having the tube taken out'. It hurt less if you do it quickly but you needed someone to do it for you. At the end of this group the therapist had felt overwhelmed by sad feelings on leaving and had to work out what was being projected onto her by the group members. She commented on this in the group and by giving back their feelings had the effect of releasing a lot more held-back emotion. In some way this seemed to connect to 'someone taking out the tube for you' 'in the naming of tears, sadness and fear of leaving'. Often members reconnect to early visual and verbal images. Children quite often look through their folders and repaint or finish an early picture, like completing a circle.

TRANSFERENCES AND PROJECTIVE PROCESSES

References have been made to a number of interpersonal and intrapsychic processes during the chapter while discussing different aspects of group experience. In this section we shall outline the general understanding behind the terms used. It is complex to describe such processes because

they take place simultaneously in the group. It may be easier to understand the nature of the processes by picturing them as happening on different levels. The first level is that of the current relationships, based in reality, at a conscious level. This reflects the social and cultural aspects as well as political and economic aspects of the members and the wider social content in which they are living. This level of relationships affects all interactions in the group but may be particularly resonant at the beginning of the group, people's first impressions of each other or when a new member joins a slow-changing group.

An example of this phenomenon can be seen in a group of children of mixed race in a multi-cultural school. This had been depleted to two boy members, Paul of African origin, and Imran from Pakistan, due to unusual circumstances of the girl members coincidentally leaving the area. A new girl member, Cathy, of West Indian origin, joined the group. During her first session when all children were working in clay, Paul began a long anti-Indian talk directed at Imran. He attempted to pair with Cathy saying they were both from 'Africa' and despite Imran's protest that he was not Indian, and Cathy indignantly saying that she was British, this confused situation continued. Throughout the long exchanges, all children continued to make their clay objects. The group leader made the comment that in spite of different backgrounds, everyone was a member of this group. The tension immediately eased and the group was able to accept that it sometimes made it easier to feel belonging to a group by excluding someone else, as a new member joining had the effect that there was not enough room in the group. In exploring each other's backgrounds, the boys discovered that they were both Muslim. This was not the end of an exploration of similarities and differences at a reality level as it needed to be addressed many times in different forms throughout the group.

While this exchange was happening, Imran was making a figure of a man in clay. As the argument progressed, the figure was gradually 'dressed' in a national costume, with spear, scimitar and shield, becoming a warrior, laid flat on the surface, not free standing (Figure 9.3). This seemed to symbolise the forces at work in the group. It shows the taking on of national identity in defence but also the flattened feel of being used as a scapegoat for projections from the other boy. It held the ambiguity of being affirming in identity and also the difficulty of being in a racial minority in this particular institution.

The second level of interactions is concerned with transferences between therapist and members and between members themselves. Transference relationships can be understood in term of feelings and wishes once experienced in relation to significant figures in the past. As we have seen, the placing of oneself in relation to the therapist in an art therapy room may reflect a transference to the therapist in relation to previous modes of relating to a parent and/or authority. For example, in an adult group, three

Figure 9.3 Imran's clay soldier

women chose to work behind some partitions in a studio, forming a subgroup through their choice of work space. Their pictures remained hidden from the rest of the group and therapist during the period of painting. Indeed, it would have felt intrusive to have entered it. Over the weeks it gradually became disclosed that all three were working on aspects of abuse as children. This was not known to the therapist or between themselves but they had unconsciously come together to work. The sharing of their different experiences enabled the complex issues to be explored. For all three the working 'together' reflected aspects of relationship to sisters, having secrets between them, and to the therapist as mother – did she know what was going on 'behind a screen'? The rest of the group reflected different aspects of 'maleness' and 'the public' in 'what they would think about this secret'. The transference will also be implicit or explicit in the images. For instance, in this case will mother/therapist recognise the 'signs' of abuse in the picture? The child tries to tell mother by presenting self or tries to hide it in the picture encoded in a disguise, as she tried to hide it as

a child. Just as the child may have desperately wanted mother to know, the adult may desperately want the therapist to know from an abstract picture. In thinking about transferences, the transference to the institution should not be forgotten and the way it is experienced in relation to past issues and incidents in other institutions.

The third level of interactions is concerned with intrapsychic processes where other members in the group, including the therapist, come to reflect unconscious elements of any one person. This is to do with the internal world of the individual and how internal objects are projected onto external members of the group. In individual psychoanalysis these processes have individual names as separate concepts such as projection, introjection, identification. In a group these processes naturally occur rather differently so are sometimes given a collective term of mirroring or the mirror reaction (Foulkes 1964). Mirroring can be seen as having a developmental aspect in that it originally occurs in every infant's experience as a way of learning from others and understanding the environment. It also has a therapeutic aspect by the way in which people recognise parts of themselves by first recognising them in others. It often takes hard work to analyse projective and introjective processes at work in a group before these recognitions can be made and understood.

All projective mechanisms are mechanisms of defence, to protect the ego from overwhelming anxiety. Part of the projective process is splitting. In this situation different parts of one person's inner experience can be experienced simultaneously but projected onto different people. When a person feels two perhaps very different emotions, to split in this way can be a defence against the anxiety. For instance, in the first group of children discussed, Louis and Dean were able to play out control of instinct versus aggressive instinct in the separate roles of Tarzan and crocodile, each child accepted the other's part and it was played out with no apparent outcome because it is battling equally inside them, but they were able to explore the two sides in the play. The projection has to 'fit'. In a projection there is usually some characteristic of the person that 'hooks' that particular aspect. Projection between Louis and Dean has happened at an accepted amicable level, which is workable until one person develops and wishes to change role in a group.

In the second group of children discussed, Abdul was more disturbed than the other children. His feelings are frequently split off and denied and perceived by him as being located in another. Intense anxiety does not enable him to locate in himself frustration, feelings of worthlessness and anger towards his own mother, whom he also loves. These are constantly projected onto other children, by aggressive acts and taunts. He attacks other children's mothers, for instance, through the 'witch' picture in this session.

In this group we can also see another process at work, of identification.

For instance, Susie drew a fish and Jane, admiring it, asked her to draw her one too. She is trying to emulate Susie's qualities but, in the process of painting the fish that Susie drew, it transforms into a very different fish with sharp teeth and spots. The fish combines the ambivalent feelings as she may wish to emulate Susie's qualities, but also envy them and wish to spoil them. Graham also admires Susie's qualities and paints a fish too. Susie has a real and deep investment in the work of the group and this is felt by the other children.

These projective processes are very powerful as they can lead to someone being allotted a role in a group that they outgrow. If the projection, however, stays on them they can really lose their 'freedom' to develop. This is perhaps most powerfully seen in the mechanism of projective identification. It is the transforming of unwanted mental contents onto another by projection. The other person identifies with the 'unwanted content' and begins to behave in that way. It can be seen to be both an intrapsychic mechanism and an interpersonal transaction.

An example of 'unwanted mental contents' being transferred onto the group leader can be seen in Chapter 7 in the section on recording (page 160). Here the therapist had been feeling 'ineffectual' and 'no good'. Hassan made a figure from the pieces of 'rubbish' and 'left overs' from Imran's clay work, saying to the therapist 'It's you'. The difficult nature of working with these powerful group processes can leave the group leader very vulnerable, which is why supervision and monitoring of counter-transference responses are so necessary. Hassan had been projecting these feelings to the group leader for some weeks but it had been hard to see it clearly among the other exchanges and activities in the group. Its sudden embodiment in an image, given with amusement to the therapist as a 'gift', crystallised a whole series of previous interactions so that these 'worthless feelings' could be talked about with Hassan and he could be helped to own them.

The fourth level is sometimes called the primordial level or foundation matrix (Foulkes), which roughly corresponds to Jung's collective unconscious. The phenomenon of resonance has been discussed when members in a group paint a similar theme apparently coincidentally. This is sometimes an unconscious response to an incident in the group's life and really shows the universality of human experience at a deeper level. This can also occur in the therapist, as the following example illustrates.

The group leader heard that a relative had died and her feelings of loss were compounded on learning that there would be no funeral because the relative had left her body to medical research. The group began to talk about 'children leaving home', talking of losing their old rooms and that there was no longer room for them. However, as the group began to speak about their images, each one contained different aspects of

funerals with different religious and cultural backgrounds being displayed. Deaths of young people and old people were discussed and the rituals surrounding the loss.

A connection could be made with the earlier discussion as, for the loss or death of a person, a funeral exists in whatever cultural form, but there is no ritual for the loss of childhood, the loss of one's continued symbolic space at home, one's childhood bedroom. Beneath these interactions lay a common or collective mourning for loss of childhood and the lack of ritual to express these feelings which linked unconsciously to the therapist's feelings of the lack of opportunity to mourn the relative at a funeral. Various group members had been unable to negotiate the developmental move from family home to independence successfully and had broken down and been hospitalised for short periods of time.

The complexity of the different levels discussed is vast and are all seen to be taking place simultaneously. There was a basic cultural exchange on a reality level as well as a collective exchange of loss unconsciously to do with childhood and change.

PRACTICAL ISSUES FOR GROUP WORK

In whatever form the art therapy group might take, the art therapist is faced with some practical decisions which are informed by theoretical orientation. For example, how does one select members for each type of group and on what basis is the decision made? After a referral is made the art therapist will have a choice of either holding verbal interviews with the prospective clients or, if there are the facilities, may invite them to join some open sessions in the studio. They are likely to meet with the referring agent or clinical team to discuss a final decision or may make an autonomous decision within the department.

In a verbal interview the therapist will be mainly listening and observing, encouraging the patient or client to talk about herself and the reasons for referral. By making comments and connections she will be able to evaluate the client's response to intervention and her feelings to the therapist. Does she respond passively, reject, or is she able to think, reflect and take in what the therapist is saying? Can she think about herself and events in a new way and is she well motivated to enter therapy? Both client and therapist need to be able to conceptualise the client's problems in psychological terms. The client has to be able to accept her part in the situation.

In most groups there needs to be a capacity to form and sustain relationships, although this may not be needed in an open group which works less tangibly with group processes. For analytic modes of art therapy groups there needs to be sufficient ego-strength to evaluate internal and external reality and to form a working alliance and yet also contact the disturbed

and helpless parts of the person. Members need to be able to function between sessions. For this reason, clients with psychotic disorders, severe depression, schizophrenic breakdown, repeated hospital admissions, many clients with severe learning difficulties, severe psychopathy, hyperactive children are contra-indicated.

Developmental crises, neurotic and character problems can be treated very well in a number of different group styles. Art therapists might either run outpatient groups or groups on wards with one type of disorder or problem or crisis, such as eating disorders, alcoholism, drug-related difficulties, bereavement, some adolescent problems. Group therapy is very useful for people with problems in relating because of the possibilities for interpersonal learning. It may be a useful mode of treatment for those who feel life is meaningless, general dissatisfaction with relationships, those inhibited or anxious. Many patients have problems with intimacy either remaining aloof, cold and preoccupied with self or have unrealistic demands for instant intimacy which cannot be satisfied and may lead to their premature leaving. Other problems of relating in a group may therefore be of emotional contagion or being overwhelmed by images of other clients, although if this can be contained in the group, the client's sensitivity and openness to the images may be a very positive factor for all members. Clients who cannot share the therapist or who have difficulty in tolerating other members in a group, or whose needs are very great, might be better in individual therapy. The client's needs must be taken into consideration when choosing the right type of group. A client may need a supportive group to express feeling and to receive positive encouragement. She may benefit from airing her problems with people available to listen and understand. An open studio setting or a thematic group will allow both a growing awareness of the complexity of working with images and an individual exploration to different depths. Clients gain a sense of mutual encouragement, a sense of belonging and a growing awareness and interaction with other members. They may begin to see how they contribute to difficulties. These type of groups may be open groups with a short-stay, regularly altering membership.

Other groups, which will be closed, will work actively with the relationship between therapist and group membership. These groups will work with awareness of past life, how childhood experiences affect the present, and transference material within the images and interpersonally will be recognised and commented on. Some less dynamically oriented groups may work with a positive transference to reinforce a working alliance. Here, the work with the client will be going mainly into the exploration of the image, and the relationship with the therapist less fully explored. In an analytic group, however, there is greater emphasis on the client's responsibility to face herself and the interpersonal relationships with membership, including the therapist. The patient will be able to work with the whole

group and its images to explore different aspects of relationships, intra-psychically and interpersonally.

The sizes of the group depend on the group style and the particular client group. For instance, an analytic group traditionally comprises six to eight members to allow verbal and visual contact and the need to contain the images made within the circle. This allows a suitable dynamic to foster group cohesiveness and gives opportunity and time for all to be involved in the discussion. However, if one was working with clients with severe physical handicaps, i.e. referral for psychological problems, the numbers will be much smaller with other staff to aid the therapist in basic preparation of materials. Other clients might need assistance from the ward to the art therapy room, and the nursing staff may stay for the duration of the group. Other groups may have a co-leader, either another art therapist or a colleague from a different discipline. Open studio groups may be as large as twelve members – a combination of different clients and staff.

We have discussed the art therapy room (Chapter 2) in some depth and mention was made of areas for group work. All arrangements in a room are dictated by theoretical bias as well as the physical constraints of the room available. It may be useful to have a separate painting and discussion area, or members may paint and discuss around large tables or pin them onto the wall for this purpose. The room may need to be large enough to allow all members to sit in a circle containing the images made. It may be important that individual spaces are available for people to be 'private' in their working area, or that the therapist has a clear view to observe all clients working. Access to sink and materials is always important and it is essential that the room is neither a thoroughfare nor overlooked by glass partitions otherwise the sense of containment and symbolic space will be lost. It is better if there is only one entrance and quiet can be maintained, as noise is very intrusive. The floor covering should be washable. Unless the floor can be dripped on or splashed upon, there will be no sense in letting the medium 'take one over' and no true interaction will be possible. It is helpful to have space for work to dry afterwards, near the storage of clients' work, so that very wet paintings can be left undisturbed in their drying process.

The duration of the group and the timing of different activities within this period will depend on group style. An open-based studio group may last all morning and in a sense be 'all painting time', with the therapist circulating gradually to talk to members. All styles of analytic and thematic groups may vary according to context and client group, but will vary from one and a half hours to two and a half hours. There will either be a structure suggested by the therapist for a certain length of time for painting and talking or this might be left entirely for the group to decide and negotiate, and the therapist might comment on the process of doing this. For example, there might be complete avoidance of using any time for image-

making in the group, or the group may decide to paint immediately and use the majority of time in their private work without coming together to discuss it. The art therapist's task is to point this out and make the group aware of these dynamics and think about why this might be happening.

The therapist's task is also to set up and maintain the symbolic space for the group. The group leader will explain time boundaries, and the breaking of these boundaries becomes material to be worked with during the course of therapy. Basic rules include those of confidentiality so that anything that belongs to the group is kept within it and not dissipated outside. Other issues, such as attendance, equally apply to the therapist, so that if this includes not leaving the room, the therapist also has to observe this confinement. Even if a member leaves the room, it is not the therapist's task to follow her, but to remain with the group and work with the consequences of this action. Rules may also be made about radios, food, drink, smoking and toilet breaks. These may be crucial and essential with some client groups. Adolescent groups may particularly challenge the boundaries but all groups will have a member who takes on this type of role. The exploration of the symbolic meaning of breaking a particular role will be useful learning for the whole group, as the group will have feelings about it and this is a way of treating the symbolic space for all members. By testing the limits of the group, they can be found to be firm and reliable and safety can be felt to be established. Limits also include interference with individuals and property and that disruptive behaviour might lead to exclusion. All group members need to feel secure from physical harm, and limits must be set by the therapist for the group as a whole. Mess, graffiti, and destruction of consumables may all be tolerated, but again the extent of limits must be made clear before there is an overwhelming sense of chaos and lack of control. Some rules might also be set concerning clearing up and protecting the space in the room for the next group.

CURATIVE FACTORS IN ART THERAPY

Central to group art therapy is the healing capacity of the artistic process, the release of unconscious material which, when consciously assimilated, can lead to the release of creative potential for the individual. It is fascinating and inspiring to be part of a group where this is happening. It can only happen within a particular group because of the nature of the group, and cannot happen in the same way to individuals.

Through the artistic process the expression of ambiguous feelings and conflicts are possible, also the freeing of inhibitions or blocks through the release of unconscious material. The making of art objects can be an acceptable way of expressing 'unacceptable' emotions, whether they are love, hate, envy, jealousy, aggression. The physical nature of making can be an enormous relief of tension. Group members also react physically to the

art objects of other members. It is an extraordinary powerful moment when paintings and models are laid within the circle, exciting, exposing, frightening or seductive. The images work on each other as they reveal the unconscious theme of the group.

Within the art therapy group there are different forms of self-disclosure either through the making of art objects or through verbal interaction. The flexibility of movement and seating within the group may make this a less threatening experience than the fixed mode of verbal therapy. The art objects give a concrete product for discussion. All members in the group contribute just by sharing their objects for view within the circle, they need not necessarily speak. Similarly, an object can be withheld from the group by being left on a table or wall or hidden beneath another member's piece of work. The art objects provide a record of the group's journey together and also form the basis of the group's culture in the way the group chooses to explore them. Everyone's difference or uniqueness is instantly seen when the paintings are placed on the ground, but almost paradoxically the universality of experience is recognised through the sharing of paintings – one person's emotion and life events bringing forth another's.

During the interaction of the group, much interpersonal learning will take place. People make immediate judgements of each other on first meeting, based on appearance, age, style of dress, etc. These become adjusted as the group works together, and respect will be gained as others observe and benefit from particular skills that members will find they have. There is opportunity to find out how one makes judgements and to try out different aspects of oneself, to take risks. It is possible for members to get feedback from the group about themselves, either through exploring the images or through an exploration of developing relationships within the group which will be encoded in the pictures. The group offers the opportunity to improve general life skills and also to leave with an internalised group experience which can help them to deal with issues in the future. This can be true in every sense from the gaining of some basic trust in a group of people, to having learnt to use making art objects within a relationship, as a way of healing dis-ease by sharing the most intimate thoughts and feelings of others.

REFERENCES

Adamson, E. (1984) *Art as Healing.* London, Coventure.
Adler, A. (1929) *The Practice and Theory of Individual Psychology.*
Bion, W.R. (1961) *Experiences in Groups.* London, Tavistock.
Brown, D. and Pedder, J. (1979) *Introduction to Psychotherapy.* London, Tavistock, Social Science Paperback.
Evans, J. (1985) 'Identity and Survival: The Imagery and Process of Group Painting', unpublished paper presented to International Society for the Study of Art and Psychotherapy.

Ezriel, H. (1950) 'A Psycho-Analytic Approach to Group Treatment', *British Journal of Medical Psychology*, **XXIII**, pp. 59–74.

Ezriel, H. (1952) 'Notes on Psycho-Analysis Group Therapy: II: Interpretations and Research', *Psychiatry*, **XV**, pp. 119–26.

Foulkes, S.H. (1964) *Therapeutic Group Analysis*. London, Allen and Unwin.

Foulkes, S.H. and Anthony, E.J. (1973) *Group Psychotherapy*. Harmondsworth, Penguin.

Freud, S. (1921) 'Group Psychology and the Analysis of the Ego', in *Standard Edition*, Vol. XVIII. London, The Hogarth Press.

Lewin, K., Lippitt, R. and White, R.K. (1939) 'Patterns of Aggressive Behaviour in Experimentally Created Social Climates', *Journal of Social Psychology*, **X**, pp. 271–99.

Liebmann, M. (1986) *Art Therapy for Groups*. London.

Lyddiatt, E.M. (1971) *Spontaneous Painting and Modelling*. London, Constable.

Main, T.F. (1946) 'The Hospital as a Therapeutic Institution', *Bulletin of the Meninger Clinic*, **X**, pp. 66–70.

Malloy, T. (1988) Letter to *Inscape*.

McNeilly, G. (1984) 'Directive and Non-directive Approaches in Art Therapy', *Inscape* (December).

McNeilly, G. (1987) 'Further Contributions to Group Analytic Art Therapy', *Inscape* (Summer).

McNeilly, G. (1989) 'Group Analytic Art Groups', in Gilroy, A. and Dalley, T. (eds) *Pictures at an Exhibition*. London, Tavistock/Routledge.

Moreno, J.C. (1948) *Psychodrama*. New York, Beacon.

Nowell Hall, P. (1987) 'Art Therapy: a Way of Healing the Split', in Dalley *et al. Images of Art Therapy*. London, Tavistock.

Roberts, J.P. (1985) 'Resonance in Art Groups', *Inscape*, No. 1.

Schilder, P. (1939) 'Results and Problems of Group Psychotherapy in Severe Neurosis', *Mental Hygiene*, **XXIII**, pp. 87–98.

Shaffer, J.B.P. and Galinsky, M.D. (1974) *Models of Group Therapy and Sensitivity Training*. New Jersey, Prentice-Hall.

Thornton, R. (1985) Letter to *Inscape*.

Warsi, B. (1975a) 'Art Therapy in a Large Psychiatric Hospital', *Inscape*, **12**.

Warsi, B. (1975b) 'Art Therapy – a Way to Self-Knowledge', *Inscape*, **14**.

Wolf, A. and Schwartz, E.K. (1962) *Psychoanalysis in Groups*. New York, Grune and Stratton.

Yalom, I. (1975) *The Theory and Practice of Group Psychotherapy*. New York, Basic Books.

Bibliography

ART THERAPY THEORY AND RELATED AREAS

Adamson, E. (1984) *Art as Healing*. London, Coventure.

Axline, V. (1969) *Play Therapy*. New York, Ballantine Books.

Axline, V. (1973) *Dibs in Search of Self*. Gollancz.

Barnes, M. and Berke, J. (1973) *Two Accounts of a Journey through Madness*. Harmondsworth, Penguin.

Baynes, H.G. (1940) *The Mythology of the Soul*. Tindall and Cox.

Betensky, M. (1973) *Self-discovery through Self-expression*. Springfield, Thomas.

Bowyer, R. (1970) *The Lowenfeld Play Technique*. Oxford, Pergamon Press.

Cardinal, R. (1972) Outside Art Studio Vista.

Case, C. and Dalley, T. (eds) (1990) *Working with Children in Art Therapy*. London, Tavistock/Routledge.

Chetwynd, T. (1982) *A Dictionary of Symbols*. London, Paladin.

Circlot, J.E. (1971) *A Dictionary of Symbols*. London, Routledge and Kegan Paul.

Dalley, T. (ed.) (1984) *Art as Therapy. An introduction to the use of art as a therapeutic technique*. London, Tavistock.

Dalley, T. *et al.* (1987) *Images of Art Therapy*. London, Tavistock.

Ehrenzweig, A. (1967) *The Hidden Order of Art*. London, Paladin.

Fuller, P. (1980) *Art and Psychoanalysis*. London, Writers and Readers.

Fuller, P. (1983) *Aesthetics after Modernism*. London, Writers and Readers.

Gardner, H. (1980) *Artful Scribbles*. Norman.

Gilroy, A. and Dalley, T. (eds) (1989) *Pictures at an Exhibition. Selected Essays on Art and Art Therapy*. London, Tavistock/Routledge.

Gordon, R. (1978) *Dying and Creating*. Society of Analytical Psychology.

Hill, A. (1941) *Art versus Illness*. London, Allen and Unwin.

Kalff, D. (1980) *Sand Play – a Psychotherapeutic Approach to the Psyche*. Sigo Press.

Koestler, A. (1976) *Act of Creation*. Hutchinson.

Kramer, E. (1973) *Art as Therapy with Children*. London, Elek.

Kramer, E. (1979) *Childhood and Art Therapy*. New York, Schocken.

Kris, E. (1953) *Psychoanalytic Explorations in Art*. London, Allen and Unwin.

Kwaitkowska, H. (1978) *Family Therapy and Evaluation through Art*. Springfield, C.C. Thomas.

Laing, J. (1979) *The Special Unit, Barlinnie Prison, its Evaluation through its Art*. Glasgow, Third Eye Publications.

Landgarten, H. (1981) *Clinical Art Therapy*. Bruner Mazel.

Landgarten, H. (1988) *Family Art Psychotherapy*. Bruner Mazel.

Langer, S. (1980) *Philosophy in a New Key.* Cambridge, Harvard University Press.

Lyddiatt, E. (1971) *Spontaneous Painting and Modelling.* London, Constable.

McNiff, S. (1988) *Fundamentals of Art Therapy.* Springfield, C.C. Thomas.

May, R. (1976) *The Courage to Create.* Bantam.

Melly, G. (1986) 'Its all Writ Out for You', *The Life and Work of Scottie Wilson.* Thames and Hudson.

Miller, A. (1990) *The Untouched Key.* London, Virago.

Milner, M. (1977) *On Not being able to Paint.* Heinemann.

Milner, M. (1989) *The Suppressed Madness of Sane Men.* London, Routledge.

Naumburg, M. (1966) *Dynamically Oriented Art Therapy.* New York, Grune and Stratton.

Naumburg, M. (1973) *Introduction to Art Therapy.* Teachers College Press.

Neumann, E. (1959) *Art and the Creative Unconscious,* Princeton University Press.

Prinzhorn, H. (1972) *The Artistry of the Mentally Ill.* Berlin, Springer-Verlag.

Rhyne, J. (1973) *The Gestalt Art Experience.* Books/Cole Monteray California.

Robbins, A. (1986) *The Artist as Therapist.* Human Sciences Press Inc.

Rubin, J. (1984) *The Art of Art Therapy.* Bruner/Mazel.

Rubin, J. (1984) *Child Art Therapy.* Van Nostrand Reinhold.

Schaverien, J. (1991) 'The Revealing Image', in *Analytical Art Psychotherapy* (in press).

Simon R. (1991) (in press).

Stevens, A. (1986) *Withymead: A Jungian Community for the Healing Arts.* London, Coventure.

Storr, A. (1972) *The Dynamics of Creation.* Harmondsworth, Penguin.

Thomson, M. (1990) *On Art and Therapy, an exploration.* London, Virago.

Ulman, E. (ed.) (1975) *Art Therapy in Theory and Practice.* New York, Schocken.

Ulman, E. (1980) *Art Therapy Viewpoints.* New York, Schocken.

Vernon, P. (ed.) (1970) *Creativity.* Harmondsworth, Penguin.

Wadeson, H. (1980) *Art Psychotherapy.* New York, Wiley.

Wadeson, H., Durkin, J. and Perench, D. (1989) *Advances in Art Therapy.* New York, Wiley.

Waller, D. (1991) *Becoming a Profession. History of Art Therapy.* London, Routledge.

Waller, D. and Dryden, W. (1991) *Handbook of Art Therapy in Britain.* Open University Press.

Winnicott, D.W. (1988) *Playing and Reality.* Harmondsworth, Penguin.

Winnicott, D.W. (1980) *The Piggle.* Harmondsworth, Penguin.

Wollheim, R. (1980) *Art and its Objects.* Cambridge.

PSYCHOTHERAPY/PSYCHOANALYSIS AND RELATED AREAS

Aveline, M. and Dryden, W. (1988) *Group Therapy in Britain.* Open University Press.

Barrett, M. and Trevitt, J. (1990) *Attachment Behaviour and the Schoolchild.* London, Routledge.

Bateson, G. (1973) *Steps to an Ecology of Mind.* London, Paladin.

Bion, W.R. (1961) *Experiences in Groups.* London, Tavistock.

Bion, W.R. (1984) *Learning from Experience.* London, Karnac.

Bloch, S. (1982) *What is Psychotherapy?* Oxford University Press.

Bollas, C. (1989) *Forces of Destiny.* London, Free Association Press.

Bowlby, J. (1988) *A Secure Base: Clinical Applications of Attachment Theory.* London, Routledge.

Brown, D. and Pedder, J. (1979) *Introduction to Psychotherapy.* London, Tavistock.

Casement, P. (1985) *On Learning from the Patient.* London, Tavistock.

Clare, A. (1980) *Psychiatry in Dissent.* London, Tavistock.

Copley, B. (1987) *Therapeutic Work with Children and Young People.* Perth, Clunie Press.

Cox, M. (1978) *Coding the Therapeutic Process.* Oxford, Pergamon Press.

Cox, M. (1978) *Structuring the Therapeutic Process.* Oxford, Pergamon Press.

Cox, M. and Theilgaard, A. (1987) *Mutative Metaphors in Psychotherapy.* London, Tavistock.

Davis, M. and Wallbridge, D. (1981) *Boundary and Space: Introduction to the work of D.W. Winnicott.* Harmondsworth, Penguin.

Daws, D. and Boston, M. (eds) (1988) *The Child Psychotherapist and Problems of Young People.* London, Karnac.

Douglas, M. (1984) *Purity and Danger.* Ark.

Eichenbaum, L. and Orbach, S. (1982) *Outside In, Inside Out.* Harmondsworth, Penguin.

Ernst, S. (ed.) (1987) *Living with the Sphinx: Papers from the Women's Therapy Centre.* London, Women's Press.

Fordham, F. (1966) *An Introduction to Jung's Psychology.* Harmondsworth, Penguin.

Fordham M. (1978) *Jungian Psychotherapy.* New York, Wiley.

Foucault, M. (1971) *Madness and Civilisation.* London, Tavistock.

Foulkes, S.H. and Anthony, E.S. (1973) *Group Psychotherapy.* Harmondsworth, Penguin.

Freud, A. (1979) *The Ego and the Mechanisms of Defence.* London, The Hogarth Press.

Freud, S. (1962) *Two Short Accounts of Psychoanalysis.* Harmondsworth, Penguin.

Freud, S. (1973) *Introductory Lectures on Psychoanalysis.* Harmondsworth, Penguin.

Freud, S. (1973) *New Introductory Lectures on Psychoanalysis.* Harmondsworth, Penguin.

Freud, S. (1975) *Five Lectures on Psychoanalysis: Leonardo da Vinci and Other Works.* London, The Hogarth Press.

Freud, S. (1975) *The Interpretation of Dreams.* London, The Hogarth Press.

Frosch, S. (1987) *The Politics of Psychoanalysis: an Introduction to Freudian and Post-Freudian Theory.* London, Macmillan Education Books.

Goffman, E. (1968) *Asylums.* Harmondsworth, Penguin.

Hawkins, P. and Shohet, R. (1989) *Supervision in the Helping Professions.* Milton Keynes, O.U.P.

Hillman, J. (1975) *Re-visioning Psychology.* Colphon.

Hillman, J. (1979) *The Dream and the Underworld.* Harper and Row.

Hobson, R. (1985) *Forms of Feeling.* London, Tavistock.

Jung, C.G. (1963) *Memories, Dreams and Reflections.* London, Routledge.

Jung, C.G. (1964) *Man and his Symbols.* Aldus Books.

Jung, C.G. (1970) *Modern Man in Search of a Soul.* London, Routledge.

Jung, C.G. (1980) *Psychology and Alchemy.* Princeton, Bollingen Series.

Klein, M. (1961) *Narrative of Child Analysis.* London, The Hogarth Press.

Klein, M. (1961) *Envy and Gratitude and Other Works 1946–1963.* London, The Hogarth Press.

Klein, M. (1961) *Love, Guilt and Reparation and Other Works 1921–1945.* London, The Hogarth Press.

Klein, M. (1977) *New Directions in Psychoanalysis.* London, Karnac.

Laing, R.D. (1965) *The Divided Self.* Harmondsworth, Penguin.

Malan, D.H. (1975) *A Study of Brief Psychotherapy.* London, Plenum Press.

Masson, J. (1989) *Against Therapy.* London, Collier.

Milner, M. (1969) *The Hands of the Living God.* London, Virago.

Minuchin, S. (1977) *Families and Family Therapy.* London, Tavistock.

Phillips, A. (1988) *Winnicott.* London, Fontana.

Pines, M. (1985) *Bion and Group Psychotherapy.* London, Routledge and Kegan Paul.

Priest, R. (1986) *Handbook of Psychiatry.* London, Heinemann Medical.

Samuels, A. (1986) *Jung and the Post-Jungians.* London, Routledge.

Segal, H. (1979) *Melanie Klein.* London, Fontana/Collins.

Segal, H. (1990) *Dream, Phantasy and Art.* London, Routledge.

Shakespeare, R. (1981) *The Psychology of Handicap.* London, Methuen.

Skynner, R. and Cleese, J. (1983) *Families and How to Survive Them.* London, Methuen.

Steinberg, D. (1986) *The Adolescent Unit: Work and Teamwork in Adolescent Psychiatry.* London, Wiley.

Storr, A. (1979) *The Art of Psychotherapy.* London, Secker and Warburg.

Storr, A. (1983) *Jung, Selected Writings.* London, Fontana/Collins.

Street, E. and Dryden, W. (1988) *Family Therapy in Britain.* Open University Press.

Szasz, T. (1962) *The Myth of Mental Illness.* London, Secker and Warburg.

Wollheim, R. (1971) *Freud.* London, Fontana.

Winnicott, D.W. (1965) *The Maturational Processes and the Facilitating Environment.* London, The Hogarth Press.

Yalom, I.D. (1975) *The Theory and Practice of Group Psychotherapy.* New York, Basic Books.

Videos

Art Therapy (1985). Tavistock Publications.

Art Therapy – Children with Special Needs (1987). Tavistock Publications.

Glossary

This glossary is of mainly psychoanalytic terms used in the book. It is intended to aid a basic understanding of the text and does not enter into the history and development of quite complex concepts. For further elucidation, the reader is referred to:

Hinshelwood, R.H. (1989) *A Dictionary of Kleinian Thought.* London, Free Association Books.
Laplanche, J. and Pontalis, J.B. (1980) *The Language of Psychoanalysis.* London, The Hogarth Press.
Rycroft, C. (1972) *A Critical Dictionary of Psychoanalysis.* Harmondsworth, Penguin.
Samuels, A., Shorter, B. and Plaut, F. (1986) *A Critical Dictionary of Jungian Analysis.* London, Routledge.

Abreaction An emotional discharge which frees the subject from a previously repressed experience. It may happen spontaneously after the original trauma or come about during therapy. See *Repression.*

Active imagination A Jungian term for a method which tries to release creative possibilities latent in the patient. This technique involves intense concentration on the 'background of consciousness' starting with a dream or phantasy image and allowing it to develop through further images that are noted down.

Amplification A Jungian term for the elaboration and clarification of a dream image by ideas associated to it and by parallels from mythology, folklore, ethnology, etc.

Analysand A person who is being treated by psychoanalysis.

Analytical psychology Jung's term for his own approach in treating the psyche, a way of healing but also of developing the personality through the individuation process. The symptoms of a neurosis are an unsuccessful attempt to compensate for a one-sided attitude to life. Jung placed more importance on the cultural or spiritual drive than the sexual drives, particularly in the second half of life.

Anomie In therapy this refers to a condition of hopelessness in a person through loss of belief and sense of purpose.

Anxiety A response to something as yet unknown, either in the environment or by the sensation of unconscious repressed forces in the self. Anxiety is the response of

the ego to increases of instinctual or emotional tension which are impending threats to its equilibrium. The ego can then take defensive precautions. See *Repression.*

Archetype A Jungian term for the tendency to organise experience in innately predetermined patterns. The archetypes are contents of the collective unconscious.

Autism Sometimes referred to as childhood schizophrenia, is a childhood psychosis. The child or older patient lacks capacity to trust or communicate and may be mute or have very disturbed speech. It may be an organic disease which causes these symptoms or it may sometimes have a psychological explanation based on early patterns of relating with the family.

Behaviour therapy A form of treatment based on learning theory. Symptoms are seen to be caused by faulty learning and conditioning and aims to remove them by deconditioning and reconditioning methods. It differs from analytic methods of working in rejecting the idea that there is an underlying process of which the symptoms are a manifestation. To a behaviourist the symptom is the illness.

Catharsis The purging of emotions through the therapeutic effect of abreaction.

Collective unconscious Jung divides the unconscious into a personal unconscious and a collective unconscious. The collective unconscious is a deeper stratum of the unconscious. It contains psychic contents common to many, not to one individual. It is not so much that experience is inherited but rather that the mind has been shaped and influenced by our ancestors.

Condensation The process by which different images can combine to form a new composite image which takes meaning and energy from both. It is one of the primary processes and characteristic of unconscious thinking. It can be observed in dreams and symptom formation.

Conscious In psychoanalytical theory mental activity can take place in two modes, one conscious, the other unconscious. Conscious mental activity is what one is immediately aware of and knows and works through secondary processes.

Containing A term developed by Kleinians and Bion particularly to describe the way in which one person can contain and understand another's experience. It relates clearly to the concept of projective identification. Bion used the term 'maternal reverie' to describe the mother's state of mind when she contains the infant's projected anxiety, enabling it to be reintrojected by the infant, from the mother, in a bearable form. This concept also extends to the analytic situation where the analyst allows the same process to take place for the person being treated. Both mother and analyst allow infant and patient to introject an object capable of containing and dealing with anxiety.

Counter-transference Refers to the process by which the analyst or therapist transfers thoughts and feelings from her past relationships onto the patient. By working with this process in supervision particularly, one can clarify and elucidate the progress of the therapeutic relationship.

Defence A general term for all the techniques and mechanisms which the ego makes use of in conflicts which might lead to a neurosis. The function of defence is to protect the ego against anxiety. See *Denial, Regression, Repression, Splitting, Projection, Introjection,* and *Idealisation.*

Dementia An organic disease of the brain characterised by progressive mental deterioration.

Denial A defence mechanism by which either a painful experience is denied or some aspect of the self is denied.

Depressive position A Kleinian term for the position reached, normally four to six months when the infant realises that her love and hate are directed towards the same object. The mother is earlier experienced as 'good' and 'bad' part objects but at this stage is experienced as a whole object. It gives rise to sadness, guilt at earlier attacks and a sense of the whole object being damaged by these attacks. There is a desire to make reparation. It also gives rise to manic defences.

Deprivation This generally refers to a lack of something that is needed by a person. In this book it is usually maternal deprivation which is referred to, i.e. physical absence of mother, lack of emotional holding, lack of love received from mother. Deprivation beyond a certain threshold will initiate defences leading to the development of neuroses.

Displacement Through this process, energy is transferred from one mental image to another. It is one of the primary processes and enables one image to symbolise another, in a dream. Symbolisation and sublimation depend on serial displacements.

Dream Mental activity in the form of pictures or events which are imagined during sleep. Dreams have meaning to the individual which is arrived at through exploration and interpretation. See *Manifest content, Latent content, Wish fulfilment* and *Primary processes.*

Ego A Freudian term for that part of the id that has been modified by the direct influence of the external world, i.e. the organised parts of the psyche in contrast to the disorganised id. Representing reason and common sense in contrast to the id which contains the passions. It can be seen to mediate between the demands of the id, superego and external world. See *Reality principle* and *Secondary processes.*

Ego – Kleinian The Kleinian concept of the ego differs from classical analysis in that she understood it to exist at birth rather than develop some months later. The ego develops by a continual process of projection and introjection of objects.

External object An object is recognised by the subject as being external to herself in contrast to an internal object. In Kleinian terms the patient's perception of an external object may be distorted by his projection onto it which will include unconscious phantasies.

Family therapy Looks at the whole unit of the family if one member is disturbed. It focuses treatment, after diagnosis, on something being disturbed in the natural system formed by the family members in relationship, rather than on individual psychopathology. See *Systems theory.*

Fantasy Tends to be used as a term for a conscious wish to daydream by British writers. The Oxford English Dictionary distinguishes its use as a term for caprice, whim, fanciful invention as contrasted to phantasy as a term for imagination, visionary notion. See *Phantasy* and *Unconscious phantasy.*

Free association A Freudian term. The analysand is encouraged to talk spontaneously, just speaking her thoughts as they come, making no attempt to strain for connections or to concentrate.

Freudian A follower of Sigmund Freud (1856–1939), the founder of psychoanalysis, who was born in Moravia but spent nearly all his life in Vienna until forced to seek asylum in London in 1938.

Id A Freudian term for the psychic apparatus which begins undifferentiated but part of it develops into the structured ego. Its contents – the instinctual part of the personality – are unconscious, partly hereditary and innate, partly repressed and acquired. Described as being full of energy, chaotic and striving to fulfil instinctual needs. See *Pleasure principle* and *Primary processes.*

Idealisation This is a defence mechanism by which an internal object to which one feels ambivalent is split into two part objects, one ideally good and the other completely bad. It avoids the disillusion and depression at recognising the inherent ambivalence one feels towards loved objects.

Identification Refers to a psychological process where one assimilates desired characteristics or aspects of another person, and is changed by modelling oneself upon these aspects. Identification with parental figures is part of normal development and helps to form personality.

Incorporation A Kleinian term which refers to the phantasy of taking an external object into one's inside. It is felt to be physically present inside one's body. It is related to the concept of introjection, which is a defence mechanism, being the person's experience of introjecting an external object. See *Introjection.*

Individuation process As used by Jung, a quest for wholeness, linking conscious and unconscious aspects of the psyche, one of the tasks of middle age.

Instinct An innate biologically determined drive to action. In Freudian terms, an instinct has a biological source, an aim, energy, and an object. Failure to find an object leads to instinctual tension. See *Pleasure principle, Sublimation,* and *Instinct theory.*

Instinct theory Freud proposed a dual instinct theory, i.e. two groups of instincts which were opposed to each other. Usually referred to as life instincts and death instincts. The life instinct includes both sexual and self-preservative instincts and the death instinct the drive to return to the inanimate state.

Internal object A Kleinian term which refers to an unconscious experience of a concrete object which is reacted to as real and as being physically located in internal psychical reality. Although it is a phantasy, it is experienced as having independent motives and intentions. Internal objects have a relationship to external objects. Internal objects partly mirror external objects and are derived from them by introjection.

Interpersonal Refers to the interactions of people upon one another.

Interpretation (reductive, premature, projective, group) The process by which the analyst finds meaning in the dreams, free associations and symptoms of a patient. The patient may be aware of the manifest content but working with the analyst may discover the latent content. The patient needs to respond to the interpretation to verify its accuracy. Freudian or classical psychoanalysis is sometimes criticised for offering reductive interpretations, i.e. which refer everything back to infant sexuality rather than allowing a symbol to say 'something new' to the person. Premature interpretation refers to an interpretation made to a person in therapy before they are ready to understand it. In art therapy one might also refer to projective interpretations where members of a group might 'project' an aspect of themselves into a picture and attribute it to the person who made the picture under discussion. Group interpretation refers to either group art therapy or verbal group therapy where the leader makes an interpretation of the group process rather than addressing an individual.

Intrapsychic Refers to processes occurring within the mind.

Introjection A Kleinian concept which describes the process by which the ego develops, taking into its boundaries external objects. These introjected objects populate each person's internal world. It is a defence mechanism in that external objects are introjected when anxiety is felt about 'bad objects' inside, i.e. 'good objects' are introjected at these times.

Jungian A follower of C.G. Jung (1875–1961), a Swiss psychiatrist who was a disciple of Freud from 1907 to 1913 but then founded his own school and system of analytical psychology.

Kleinian A follower of Melanie Klein (1882–1960), pioneer of child analysis. Kleinian theory both develops from and departs from classical Freudian theory of analysis. It ascribes to a dual instinct theory giving greater emphasis to the death instinct. It is also an object theory. It rejects the concept of stages of development in favour of a theory of positions. It attributes greater importance to the first year of life than to childhood as a whole.

Latent content In Freud's investigations into dreams the latent content is the content which is discovered through interpretation. This content was originally a wish which has been fulfilled in hallucinatory form.

Libido (oral, anal and genital phases) A Freudian term for inferred mental energy with which mental processes, structures and images are invested. Libido is imagined as having a source in the id. Oral stage: the first stage of libidinal and ego development in which the mouth is the main source of pleasure and hence the centre of experience. Anal stage: the second stage of libidinal and ego development in which the anus and defaecation are the major source of sensuous pleasure and centre of the infant's self-awareness. Mastery of the body and socialisation of impulses are the infant's major preoccupations. Phallic phase: the third phase of libidinal development in which the child is preoccupied with genitals. Genital phase: the last stage of libidinal development after passing through the latency period into puberty, when relationship to another develops.

Mania A psychosis characterised by elation and acceleration of both physical and mental activity. It is one phase of manic-depressive psychosis.

Manic defences A Kleinian concept of defences mobilised in the depressive position. Defences are needed against anxiety, guilt and depression at the realisation of the harm done by one's earlier aggressive impulses towards one's objects – defences: denial, omnipotence, identification and projection.

Manifest content In Freud's investigations into dreams the manifest content is the dream content as it is experienced on waking and remembered and told to the analyst. See *Latent content.*

Material In psychoanalysis and psychotherapy, 'material' usually refers to 'what the patient says' as this is the base from which an analyst makes interpretations. In art therapy it usually refers to pictures and models made in the course of therapy but also encompasses verbal utterances as the art therapist works between images and words.

Mental handicap (or *Mental retardation*) Diagnostic criteria as outlined in 1987: (A) Significantly subaverage general intellectual functioning: an IQ of 70 or below on an individually administered IQ test. (B) Concurrent deficits or impairments in adaptive functioning, i.e. the person's effectiveness in meeting the standards

expected for her age by her cultural group in areas such as social skills and respon-
sibility, communication, daily living skills, personal independence and self-suffi-
ciency. (C) Onset before the age of 18.

There are four specific levels of severity, reflecting the degree of intellectual
impairment and designated as mild, moderate, severe and profound:

Mild mental retardation	IQ 50–55 to approx. 70
Moderate mental retardation	IQ 35–40 to 50–55
Severe mental retardation	IQ 20–25 to 35–40
Profound mental retardation	Below 20 or 25

The term 'learning difficulties' can be interchangeable with the term 'mental handi-
cap' or 'mental retardation'.

Unspecified mental retardation This category should be used when there is a
strong presumption of mental retardation, but the person is untestable by standard
intelligence tests. This may be the case when children, adolescents or adults are too
impaired or uncooperative to be tested. This may also be the case with infants when
there is a clinical judgement of significantly subaverage intellectual functioning, but
the available tests, such as Bayley, Cattell, and others, do not yield IQ values. In
general, the younger the age, the more difficult it is to make a diagnosis of mental
retardation, except for those with profound impairment.

Negative therapeutic reaction Refers to the increasing or worsening of the
patient's symptoms in response to the treatment which is aimed at lessening them.
Originally used only for interpretations having this effect in psychoanalysis but now
a broader usage. The effect is explained in terms of guilt provoked by the idea of
being healthy at the expense of someone else.

Neurosis Used to describe mental disorders which are not diseases of the nervous
system. Neurotic usually describes behaviour which is not healthy or normal, not
organically or physically based, not psychotic and which can be explained psycho-
logically.

Object relations theory In the 1930s object relations became the major focus for
the school of psychoanalysis developed particularly within Britain. Klein developed
object relations theory but still remained firmly with Freudian theory in her belief in
a theory of instincts. Major theorists in Britain include Fairbairn, Winnicott and
Balint. In object relations theory, the subject's need to relate to objects occupies the
central position, in contrast to instinct theory, which centres round the subject's need
to reduce instinctual tension.

Object(s) A term used in psychoanalysis to refer to the object of an instinctual
impulse, i.e. that towards which action or desire is directed. It nearly always means a
person, or part of a person or symbols of one or the other.

Oceanic feeling A sense of oneness with the world, a loss of ego boundaries. A re-
living of the experience when one was an infant at the breast before the ego was
distinguishable from the external world. Can also refer to mystical or religious
experience.

Oedipus complex A Freudian term for the desire to get rid of the parent of the
same sex in order to possess the parent of the opposite sex, sexually. This is experi-
enced by the child between the ages of three to five. According to Freud a universal
phenomenon. Resolution is achieved at puberty by identification with parent of
same sex and eventual choice of sexual partner.

Omnipotence Thoughts and fantasies that one has unlimited power over the external world.

Ontogeny The development of the individual.

Paranoia See *Psychosis.*

Paranoid-schizoid position A Kleinian term for an early state of mind in the infant who deals with innate destructive impulses by splitting processes. Parts of the ego and object representations are split into 'good' and 'bad' parts. Bad parts are projected onto an object by whom the subject then feels persecuted, i.e. her own destructive impulses are felt as coming after her from outside. See *Projective identification* and *Splitting.*

Part objects A Kleinian term for the infant's experience of one part of the person who cares for her, e.g. a breast. The part object is experienced as being there solely to satisfy the infant's needs or as frustrating them, i.e. if the infant is hungry, she experiences a frustrating 'bad object', if she is warm and fed, a satisfying 'good object'. Her inner world is 'peopled' by her representations of her instinctual impulses, only later does she come to recognise the part objects as forming a whole object.

Personal unconscious Jung divides the unconscious into a personal unconscious and a collective unconscious. The personal unconscious belongs to the individual; it is formed from repressed memories, impulses and wishes, subliminal perceptions and forgotten experiences.

Personality disorder A term in psychiatric diagnosis which encompasses psychopathy, perversions and addictions. They have, in common, society's disapproval of their behaviour, which is also their form of symptom.

Phantasy British psychoanalytic writers invariably use phantasy to refer to the imaginative activity which underlies all thought and feeling. It can also be used to refer to imagining, daydreaming and fancying as contrasted to adaptive thought and behaviour. American writers may use phantasy and fantasy interchangeably. See *Fantasy* and *Unconscious phantasy.*

Phobia The experiencing of unnecessary and excessive anxiety in some specific situation or in the presence of some specific object, e.g. agoraphobia – anxiety in open spaces, or phobia of spiders. Schools of thought agree that the phobic situation or object arouses anxiety not for itself but because it has become a symbol of something else.

Phylogeny The development of the race or species.

Play technique Klein developed her play technique in order to analyse children younger than three. Her technique used little toys in the psychoanalytic setting to allow the expression of unconscious phantasy. The children's play was regarded as the equivalent of free association in adults. Her interpretations addressed the unconscious anxiety expressed symbolically in the play. Her development of object relations theory is profoundly based on observation of children's play in analysis.

Pleasure principle A Freudian term for one of the two principles which govern mental functioning. Psychic activity is aimed at avoiding non-pleasure and pain aroused by increases in instinctual tension by hallucinating what is needed to reduce the tension. Pleasure principle is innate and primitive. See *Reality theory.*

Pre-conscious Refers to thoughts which although at the moment unconscious are

not repressed and can therefore become conscious. They conform to the secondary processes.

Primary processes The primary processes are characteristic of unconscious mental activity. Images tend to become fused and can readily replace and symbolise one another. Primary process thinking uses mobile energy, ignores the categories of time and space, and is governed by the pleasure principle, reducing instinctual tension by hallucinating wish fulfilment. It is the mode of thinking operative in the id. Freud believed them to be ontogenetically and phylogenetically earlier than the secondary processes. He thought they were maladaptive. This view has been challenged by later thinkers developing theory of mental processes and creativity (see Rycroft (1962), Langer (1980)). The primary process is exemplified in dreams. See *Secondary processes.*

Projection The process by which aspects of the self or internal objects are imagined to be located in some other person in one's environment. One first of all denies that one has the feeling but then 'sees' it in another person and reacts to it accordingly.

Projective identification A Kleinian term for an aggressive attack on an object, forcing parts of oneself into it in order to take it over. See *Projection* and *Paranoid-schizoid position.* Projective identification relies on an idea that it is possible to locate parts of the self 'somewhere else'. It leaves the subject feeling depleted with loss of identity.

Psyche The soul, spirit, mind, encompassing mental and emotional life, conscious and unconscious.

Psychiatrist One who treats diseases of the mind.

Psychoanalysis A form of treatment invented by Freud in the 1890s, which explains psychic symptoms in terms of repressed infantile sexual impulses, tracing neuroses back to their roots in infancy. Key concepts: free association, interpretation, transference. Psychoanalysis could be described as long-term, intensive, interpretative psychotherapy.

Psychoanalyst A person who practises psychoanalytical treatment after receiving training at a recognised institute.

Psychologist A person trained in or practising any form of psychology.

Psychology The science of the mind, but also the science of behaviour. Specialists may be qualified in one branch of the subject, e.g. child, abnormal, educational, etc., or in a particular system of thought, e.g. Gestalt, Jungian, Freudian.

Psychopathology Refers to the study of abnormal mental functioning or to a theoretical formulation of the abnormal workings of a person's mind.

Psychosis Used to describe mental illnesses which are characterised by detachment from reality, a lack of insight into one's condition and bizarre symptoms such as delusions and hallucinations. Organic psychoses are due to organic disease of the brain. In functional psychoses there is no apparent organic lesion. Three of these are distinguished: (a) schizophrenia; (b) manic-depressive psychosis; and (c) paranoia.

Psychosomatic (psyche, soul, spirit, mind; soma, body) Therefore, psychosomatic, of mind and body as a unit, is concerned with physical diseases having emotional origin, from a patient's life situation as well as an organic or physical basis.

Psychotherapist Someone who practises psychotherapy, of any school, who could have a medical or a lay background and who has received a training at a recognised institute.

Psychotherapy The treatment of the mind or psyche by psychological methods which encompasses the concept of a 'talking cure'. Psychotherapy may be either individual or group, superficial or deep. It can have different intentions, being either interpretative, supportive or suggestive.

Psychotic art Refers to pictures and models made by someone suffering a psychotic mental illness.

Reality, external External reality refers to objective phenomena external to the subject.

Reality, internal Internal reality refers to images, thoughts, phantasies, feelings which are imagined to occupy a space inside the subject. Also refers to a psychical reality.

Reality principle A Freudian term for one of the two principles which govern mental functioning. After the ego has developed, the pleasure principle is modified by the reality principle which leads the individual to replace hallucinatory wish-fulfilment by adaptive behaviour; e.g. one can postpone the attainment of a goal according to the situation in the outside world, whether conditions are right for satisfaction. See *Pleasure principle.*

Regression Going back to an earlier way or stage of functioning. A defence to enable the subject to avoid anxiety by returning to an earlier stage of libidinal and ego development. See *Libido.*

Reparation A Kleinian term for one of the main constituents of all constructive and creative urges. Distress is felt after aggressive impulses and there is an urge to make good the harm done to an object to whom one has ambivalent feeling. If an internal object has been harmed or destroyed in phantasy, this refers to the process of recreating it.

Repression The process by which an unacceptable idea or impulse to action is made unconscious. It is a defence mechanism. Ego development, which means adapting to one's environment, involves the process of repression of unacceptable impulses.

Resistance A term in psychoanalysis which refers to a defence against having unconscious processes made conscious, i.e. opposing the analyst's interpretations.

Restitution or *Restoration* A defensive process which is an impulse to make 'good' again after aggressive impulses. It reduces guilt felt towards an object to whom one has ambivalent feeling. See *Reparation*, which is more commonly used.

Schizophrenia See *Psychosis.*

Secondary processes The secondary processes are characteristic of conscious mental activity. Secondary processes are exemplified by thought, obeying the laws of grammar and formal logic. They use bound energy and are governed by the reality principle, reducing the non-pleasure of instinctual tension by adaptive behaviour. In Freud's view the secondary processes develop with the ego with adaption to the external world and have an intimate connection with verbal thinking. See *Primary processes.*

Shadow A Jungian term for the inferior parts of ourselves that we do not own up

to. They are the primitive, uncontrolled and animal parts of ourselves that form the personal unconscious because they are incompatible with the chosen conscious attitude.

Splitting A defence mechanism. It refers to a process by which one mental structure is replaced by two part structures, i.e. in splitting of the ego, one part remains conscious, experienced as 'the self', the other 'unacceptable' part becomes an unconscious split-off part of the ego. If an internal object is split, one part is usually a 'good object' and the other a 'bad object'. See *Denial, Projection* and *Idealisation.*

Sublimation The process by which energy, originally instinctual, is displaced and discharged in ways which are not obviously instinctual. Sometimes seen as also being socially acceptable, e.g. energy is displaced from activities and objects of primary interest, the emotion becomes desexualised and deaggressified. Sublimation depends on symbolisation. Ego development depends on sublimation.

Superego A Freudian term. The superego is formed through the internalisation of parental prohibitions and demands. Its role in relation to the ego is of a judge or censor. It also contains the reflective activities, self-observation, self-criticism as well as being the basis for the formation of conscience and ideals.

Symbiotic relationship A union between mother and child where each depends totally and exclusively on the other, which becomes abnormal after the first few weeks of life.

Symbol A symbol is a way of indirectly, but figuratively representing something else, i.e. in psychoanalytic terms an unconscious idea, conflict or wish. It can be contrasted to a sign which can only indicate the presence of something. Psychoanalysis is concerned in symbolism with the unconscious substitution of one image or idea or activity for another. Theories of symbolism explore the constant relationship between the symbol and what it symbolises in the unconscious. This constant relationship can be found in different individuals as well as in very different and widely separated cultures. Symbolisation is one of the primary processes governing unconscious thinking, e.g. dreams, symptom formation. See *Displacement* and *Condensation.*

Symptom formation Classical psychoanalytical theory looks at symptoms formed in neurosis as being on a par with dream work. The symptom is formed by a compromise made between the repressed wish and the defence mechanism which represses the wish. See *Repression* and *Defence.*

Systems Theory In family therapy, systems theory has developed as a way of conceptualising what is happening to a family when they come with a disturbed member to therapy. A single family member cannot be understood without looking at the whole family. Their internal interactions as well as their interactions with the environment need to be studied before the disturbance is explicable.

The self A Jungian term for the centre of the totality of conscious and unconscious. It is the function which unites all the opposing elements in man or woman. To reach this position involves accepting what is inferior in our nature (*the shadow*). To know it, is to know a sense of oneness with oneself and the world which is accepted as it is.

Therapy The process of treating or healing or curing. *Therapeutic alliance* refers to the alliance between the healthy part of the client in therapy and the therapist to treat or heal the sick part of the client. *Therapeutic relationship*, sometimes used interchangeably with therapeutic alliance or working alliance, refers to all other

aspects of the treatment relationship with the exception of the transference and counter-transference relationships. *Therapeutic encounter* refers to the meeting of two people in the therapy relationship. *Therapeutic process(es)* refers to the events and stages that therapist and patient pass through in the course of therapy, and also the psychic mechanisms that are brought into play during its course.

Transcendent function (of the symbol) In Jungian terms, a symbol can carry a wide meaning and express a psychic fact which cannot be formulated more exactly. The transcendent function of the symbol is its capacity to unite opposites within the psyche into a new synthesis which can become a new point of departure.

Transference Refers to the process by which a person in analysis or therapy displaces feelings on to the person of her analyst or therapist which were originally felt in relation to previous figures in her life, i.e. the patient behaves as though her therapist were her father, mother, etc. It is the resolving of conflicts dating from infancy and childhood through 'transference interpretations' that form the basis of the work in psychoanalysis. In art therapy one works with the twin concepts of transference to the picture as well as transference to the person of the art therapist, i.e. the picture embodies thoughts and feelings towards relationships in the past.

Transitional object (a term coined by Winnicott) This is an object which the child treats as being halfway between herself and another person; initially usually mother. It can be any object, often a toy or piece of blanket, which is precious to the child but can be ill-treated because it is not a person. The child is able to express both feelings of love and hate to the object.

Trauma Refers to a completely unexpected experience which the patient was unable to assimilate. When it happens, the immediate response to psychological trauma is shock. One might either recover spontaneously or develop a neurosis because defences come into play and try to repress the experience.

Unconscious In psychoanalytical theory, mental activity can take place in two modes, one conscious, the other unconscious. Unconscious mental activity refers to processes of which one is not aware, and works through the primary processes. Some unconscious processes can become conscious easily but some are subject to repression.

Unconscious phantasy A Kleinian term which delineates the imaginative activity that underlies all mental processes and accompanies all thoughts and feelings. Unconscious phantasies are concerned with biological processes, body based, and relationships with objects to satisfy instincts towards them. Unconscious phantasies are therefore psychic representatives of instincts. The Kleinian working method is characterised by the interpretation of unconscious phantasy which releases inhibition, frees anxiety, and allows further phantasy to emerge. See *Fantasy* and *Phantasy*.

Whole object A Kleinian term for an object whom the person comes to perceive as a person similar to herself or as a person in his or her own right. The whole object is no longer either 'good' or 'bad' but the infant recognises that the 'good' and 'bad' part objects are one, i.e. she is able to accept ambivalent feelings towards a loved person, rather than defining them by her own instinctual needs.

Wish-fulfilment A Freudian term associated with his theory of dreams. The products of the unconscious, i.e. dreams, symptoms and phantasies are all wish-fulfilments wherein the wish is to be found expressed in a more or less disguised form.

British Association of Art Therapists

This association was formed in 1964 from a group of artists and therapists interested in the development of art therapy. It therefore formed a central organisation to which the general public and employing authorities could refer.

Since its inception, BAAT has negotiated for members on questions of salary and conditions of employment, as well as setting up a Register of Art Therapists. Application for State Registration in the profession is being considered by the Council for Professions Supplementary to Medicine (CPSM) and negotiations are currently in progress.

A Registered Art Therapist (R.A.Th) has:
- Reached academic standards approved by the British Association of Art Therapists. These standards are endorsed by the Department of Health and Social Security as qualifications for work in the National Health Service.
- Agreed to work according to the objects and constitution of the Association, and within its guidelines, 'The Principles of Professional Practice', printed in the register.
- Satisfied the Association as to their legal indemnity cover, either through Trades Union membership (sufficient for employing institutions) or with additional cover (self-employed therapists).

(BAAT Register 1990)

The current Register of Art Therapists (updated annually) is available from BAAT. The Register is intended mainly for the use of employing institutions but also indicates people who will take self-referrals and individuals who may be contacted for talks, lectures or workshops. It is organised regionally as follows:

Cornwall, Devon, Somerset, Avon	Region 1
Dorset, Wiltshire, Hampshire, Isle of Wight	Region 2
Surrey, W. Sussex, E. Sussex, Kent, South London	Region 3

Bedford, Hertford, Essex, North London	Region	4
Gloucester, Berkshire, Buckingham, Northampton	Region	5
Worcester, Salop, Stafford, West Midlands, Warwick, Hereford.	Region	6
Powys, Dyfed, W. Glamorgan, Mid-Glam, S. Glam, Gwynedd, Clwyd.	Region	7
Norfolk, Suffolk, Cambridge	Region	8
Derbyshire, Nottingham, Lincoln, Leicester	Region	9
Lancashire, Cheshire, Greater Manchester	Region	10
N. Yorks, S. Yorks, W. Yorks, Humberside	Region	11
Tyne and Wear, Cleveland, Cumbria, Durham, Northumberland	Region	12
London	Region	13
Reading, Swindon, Oxford	Region	14
West Scotland	Region	15
East Scotland	Region	16
International		

A regional contact name is found at the beginning of each section. These people have volunteered their time to organise and coordinate local events and information.

Further work of BAAT has been to suggest criteria for training courses and standards of professional practice. Two committees are working to campaign for the establishment of art therapy posts in the community through local authority and non-statutory care services and also in the field of education.

BAAT acts as a forum for ideas and innovations in art therapy, organises conferences and seminars, publishes journals and newsletters and runs a book service. It is always pleased to be of assistance to groups and individuals seeking information about art therapy.

Any individual interested in art therapy can become an associate member. For an annual fee you will receive two copies of *Inscape*, the journal of BAAT, a quarterly newsletter, information regarding national and local meetings and events. Corporate membership is also open to any group of people. To join, or for further information, please write to the Membership Secretary.

If you wish to subscribe to *Inscape*, payment can be made to the British Association of Art Therapists. For a list of back copies of *Inscape*, and of other BAAT publications, send a SAE.

The address for all enquiries and orders, including the Register, is:

British Association of Art Therapists,
11a Richmond Road,
Brighton BN2 3RL.

PRINCIPLES OF PROFESSIONAL PRACTICE FOR ART THERAPISTS*

- *Confidentiality* Transactions between the art therapist and the client should be confidential and kept within the framework of the therapeutic team.

- *Record-keeping* A record of attendance should be kept and all art work should be named, dated, and stored during the therapeutic relationship. For very long-term clients problems of storage may mean that the position needs to be reviewed. It is advisable that art therapy case notes and art work should be kept for a minimum of three years.

- *Exhibitions* The art therapist should obtain permission from the client for the use of any information, verbal, recorded, written, or pictorial, acquired within the therapeutic relationship for the purposes of publication or education or exhibition, after fully disclosing to the client the nature of the use of such materials. This principle may be waived three years after the close of treatment. In all cases anonymity should be respected. Art therapists should never be involved in the sale of work produced in the therapeutic setting.

- *The referral system* A written referral should be sought from an accountable agent. In the case of self-referrals, a written referral would follow after the initial contact where possible. Art therapists should retain the right not to treat certain clients, following an agreed assessment procedure.

- *Case load* Art therapists should have adequate time to attend ward rounds, staff meetings, case conferences, etc., and should negotiate one half day per week (or pro rata) for the administration of the art therapy department. Art therapists, whilst liaising with other disciplines, should ultimately specify their own case loads to suit their own preferred method of working, i.e. individual and/or group sessions. It is recommended that a 'closed' group should not exceed 8–10 people and an 'open' session should not exceed 12–15 people. There should be adequate time between sessions for preparation and record keeping, and some record should be kept of all sessions.

*The aim of the Principles is to set *guidelines* for the practice of art therapy rather than specific rules. As guidelines they should be seen as being adaptable to meet the specialised therapeutic needs of a variety of institutions and organisations.

- *Professional support/supervision* It is in the interests of art therapists to seek regular clinical supervision, ideally within the workplace. This may take the form of individual or group sessions conducted preferably by an experienced art therapist. Art therapists should also seek support from other institutions, regional groups of BAAT, or related professionals.

- *Training* It is desirable that art therapists should have both study leave and financial support from their employment in order to attend in-service training programmes, lectures, workshops and professional conferences. Art therapists contributing to training programmes for colleagues or students should receive payment from their employers.

- *Minimum conditions* Art therapists should have adequate facilities within which to practise. At the absolute minimum this would include: a self-contained room large enough for group work, a sink and running water, storage space and an administration area and telephone. Naturally this facility should comply with the standards set by the health and safety act.

- *Management* Art therapists should have control over a financial allocation for materials and equipment and see maintenance of equipment levels as their responsibility. Art therapy should be directly represented on institutional management structures.

Self-employed art therapists

- Art therapists should adhere to professional rather than commercial standards in making known the availability of their service.
- Art therapists should communicate the availability of their service to related professions and referring agencies.
- Art therapists in private practice should ensure that they receive adequate clinical supervision.
- Art therapists who work privately are advised to carry suitable insurance.

COLLEGES OFFERING POST-GRADUATE TRAINING IN ART THERAPY

Art Psychotherapy Unit, Goldsmiths College, 23 St James, London SE14

Tel: 081-692 1424

Postgraduate Art Therapies Programme, Herts College of Art and Design, 7 Hatfield Rd, St Albans, Herts.

Tel: 0727 45544

Centre for Art and Psychotherapy Studies, Floor 0, Dept of Psychiatry, Royal Hallamshire Hospital, Glossop Rd, Sheffield, S10 2JF

Tel: 0742 766222 ext. 2422

Short courses

Leeds Spring School, Dept of Visual Studies, Leeds Polytechnic, Leeds 2.

Champernowne Trust, Jill Dowding, 3 Western Terrace, Orchard Lane, Brimscombe, Glos. GL5 2QT

Name index

Subject index

Aberlour Child Care Trust (Stirling) 35–7
Adamson Collection 198
adolescents 11
aesthetic experience 127–36; caricature 129; 'failure' of 130; Fairbairn on 129–31; Freud on 127–8; Fuller on 135; illusionary area 132–3; Kleinian views of 132–5 *passim*; Kris on 128–9; Milner on 132–3; object-relations approach to 135; Segal on 132; Stokes on 133–5; Surrealism 130; ugliness and the 132; Winnicott on 132–3
analytical view of art (Freud) 70–7; *see also* psychoanalysis
anxiety: containment of 57, 65; defined 242–3; in group work 222–3, 226–7; about mess (art therapy) 105–6; and symbolism (Klein) 139
archetypes (Jung) 93, 243
art materials, *see* materials
art therapist (work of the) 146–77; artistic participation of in therapy 209; case conferences 154–5; case load of the 255; and the clinical team 153–4; communication with colleagues 156; ethical dilemmas 156–8; feedback 155–8; meeting the client 152–3; referral procedure 151–2, 178–9, 255; self-employment 256; *see also* art therapy, principles of professional practice, recording, supervision, therapy in art therapy, training
art therapy: adolescents 11; autism 9–11, 139; client groups in 5–6, 8–16 *passim*; colours in 104–5; in the

community 14–16; confidentiality in 153, 181, 235, 255; disturbed children 9, 200–7; within education 11–12, 200–7; healing properties of 2, 54, 235–6; historical aspects 1–3, 146–8; institutional context of 149–51, 153–4; links with psychotherapy 147; mentally handicapped 8–9 (children), 13–14 (adults); in old age 15–16; in penal institutions 15; in process 186–90; as a profession 150–1; promoting 149; for the psychiatric institutionalised 12–13; for the psychotic 44–6; recent British literature 4–5; Rogerian approach to 197; setting up a department 22–31; suitability for 179–80; work settings for 6–16 *passim; see also* art therapist, art therapy room, creativity (process), group work, image (the) in art therapy, individual art therapy, materials, psychoanalysis, therapeutic frame, therapy in art therapy, training
art therapy room 19–49, 99; described 20–2, 25–47 *passim*; display of art work 48–9; for group work 234; minimum conditions 256; peripatetic context 35–47; 'potential space' 19–22; sharing space 31–5
assessment, *see* client assessment
autism 9–11, 139; defined 243

Barlinnie special unit 15
Bloomfield Clinic, Guy's Hospital (London) 39–40
boundaries: between supervision and